For Stella

Contents

List of plates

Acknowledgements

My first debt of thanks is due to Paul Langford, who thoughtfully supervised this research in its early stages. James Raven offered valuable advice at a formative stage of the book's development. I am grateful to the National Maritime Museum for generously supporting my research on Admiral John Byng and the Minorca crisis through the Caird Senior Research Fellowship; I would especially like to thank Nigel Rigby and Margarette Lincoln for their insight.

This research would not have been possible without the assistance of the staffs of many libraries in Britain, the United States, Canada and Europe, including the Bodleian Library, the British Library, the Cambridge University Library, and the Caird Library of the National Maritime Museum. I am particularly thankful for the enthusiastic cooperation of those libraries I could not visit, including the Boston Public Library and the University of Texas at Austin.

Abbreviations

REFERENCES

BMC *Catalogue of Prints and Drawings in the British Museum*
DNB *Dictionary of* National Biography
HMC Historical Manuscripts Commission

PERIODICALS AND NEWSPAPERS

A *Auditor*
ABG *Aris's Birmingham Gazette*
B *Briton*
BA *Bath Advertiser*
BC *Bath Chronicle*
BBJ *Bodley's Bath Journal*
BN *Belfast News-Letter*
BWJ *Berrow's Worcester Journal*
C *Con-test*
CR *Critical Review*
CT *Crab-Tree*
DM *Derby Mercury*
FFBJ *Felix Farley's Bristol Journal*
Gaz *Gazetteer*
GM *Gentleman's Magazine*
GMA *General Magazine of Arts and Sciences*
IJ *Ipswich Journal*
LC *London Chronicle*
LEP *London Evening Post*
LG *London Gazette*
LiM *Literary Magazine*
Ll *Lloyd's Evening Post*
LM *London Magazine*
LNJ *Leicester and Nottingham Journal*
Mon *Monitor*
MR *Monthly Review*

NB *North Briton*
NC *Newcastle Courant*
NJ *Newcastle Journal*
NM *Northampton Mercury*
NoM *Norwich Mercury*
PA *Public Advertiser*
PC *Political Controversy*
RWJ *Read's Weekly Journal*
SJC *St James's Chronicle*
SM *Scots Magazine*
SMJ *Schofield's Middlewich Journal*
T *Test*
UC *Universal Chronicle*
YC *York Courant*

Textual and bibliographical notes

Quotations from eighteenth-century sources have retained contemporary punctuation, capitalisation, spelling and use of italics.

Compiling a bibliography of more than 1000 independently published works of political commentary examined in this study has required compromise in the interest of economy. All political prints and ballads published between 1754 and 1763 in the collection of the British Museum have been examined. They have been omitted from the bibliography, but those discussed have been listed in the notes with their reference number from the museum's catalogue of personal and political satires. Although many political pamphlets and broadsides have also been consulted, only those mentioned in the text have been included in the bibliography. The lengthy titles of literary works and pamphlets have been shortened.

1

Introduction:
a literary-political culture

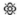

For arts and arms above mankind rever'd
By Europe honour'd, and by Europe fear'd,
 (*The Patriot Enterprise*, 1758)

WHETHER he writes from the gloomy corner, of a shelving garret; or from the
midst of an elegant and sumptuous study – WHETHER he dips his pen into a
silver standish; or into a broken bottle – WHETHER he figures in a drawing-
room, glittering with embroidery; or is clothed in a rusty black, the character-
istick habit of an author – All these considerations, are immaterial to the reader.
If his sentiments are just, and his arguments are conclusive, he will engage the
attention of the judicious, and command their respect. (*Con-test*, 6 August 1756)

'ARTS AND ARMS', an evocative expression which featured prominently
in the literature of the early 1750s, reflects the domestic and international
political problems confronting Britain during a critical era in its history. These
were the inextricably entwined arts of diplomacy, war and peace; politics and
government; and commerce, industry and imperial expansion. The Treaty
of Aix-la-Chapelle, which concluded the War of the Austrian Succession in
1748, failed to resolve the chronic territorial conflicts between Britain and
France in North America. These intensified during 1753–54. Hostility be-
tween the two great imperial rivals was exacerbated by increasingly bitter
commercial competition. The struggle for possession of the Ohio Valley and
the other disputed regions in North America led to the renewal of war in
1756, which spread to Europe where the French retaliated against George II's
electorate of Hanover.[1]

This is an examination of the representation of the Seven Years War in
contemporary political literature. Discussion begins with the disruption of
domestic political stability following the death of Henry Pelham in March
1754, which coincided with the escalation of military conflict in North America.

It concentrates upon the literary response to the war's most intense, politically significant crises, and is not a comprehensive history of the conflict. As a result, a great deal of discussion is devoted to the fall of Minorca in 1756, while controversies with relatively minor political repercussions, such as that caused by Lord George Sackville's behaviour at the Battle of Minden in 1759, receive little consideration.

Political poetry, ballads, drama, fiction and prose satire are invaluable historical sources. They illustrate the major foreign policy issues commanding the attention of the British people at mid-century, such as commercial and imperial competition with France, and the extent to which national self-interest could best be advanced by participation in or isolation from European affairs. Literary works shed important light upon the cultural and ideological framework of contemporary political discussion, as in the resurgence of belligerent patriotism, which encouraged demands for aggressive action against France, and in the accusation that the early defeats of the war were the consequence of the political, moral and cultural degeneracy of the nation's political leadership. Literature also records public perceptions of leading politicians such as William Pitt, Henry Fox, the Duke of Newcastle and Lord Bute, and suggests how their changing reputations affected their careers.

The close relationship between politics and letters in the first half of the eighteenth century has inspired a number of fine studies concentrating upon the era of the Hanoverian succession and the literary opposition to Walpole.[2] Less consideration has been devoted to the decades following Walpole's resignation in 1742 or the death of Alexander Pope in 1744, which have been taken to represent the end of a golden age of literary engagement with politics. The lack of attention devoted to political literature at mid-century is emphasised by the existence of few major studies, which tend to concentrate upon the satiric poetry of Pope and Charles Churchill.[3] This investigation into the literature of the Seven Years War reveals the genre's continuing vitality as a vehicle for the expression of political ideas and debate. The great diversity in the levels of artistic quality, and political knowledge and sophistication, revealed in poetry, ballads, fiction, prose satire and drama demonstrates the presence of a thriving literary-political culture, which incorporated all stations of society. The universality of political literature is illustrated by the wide range of patrons and authors involved in its composition, extending from leading courtiers, ministers and members of the parliamentary classes such as Newcastle, Fox, Bute, the Duke of Bedford, Sir Charles Hanbury Williams and Soame Jenyns through the middling commercial and professional orders represented by Richard Glover, John Shebbeare, Joseph Reed and John Freeth, to the semi-literate ballad singers whose identities are unknown. The intimate knowledge of the inner political world of court,

ministry and Parliament displayed in many works indicates that they were written by senior political figures or their clients. Their publication was important for the political education of the middle classes and the humbler members of the nation, providing them with insight into issues, conflicts and personalities, and increasing their understanding of the operation of the political system. In this respect, one of their most significant contributions was made in conveying the substance of parliamentary debates to a wider audience in an era when the national legislature vigilantly guarded its rights to free, unreported speech.

Independently published works are the primary focus of examination. Although most were published in London, reflecting its dominance of national print culture, some were printed in other major centres including Edinburgh, Glasgow, Manchester, Birmingham, Coventry, Warwick, Oxford, and Cambridge. Many works were sold through the intermediary of London's trade publishers, who provided concealment for authors and booksellers reluctant to risk the notoriety and danger of open involvement in political controversy. Trade publishers offered access to well-developed distribution networks in the capital and the provinces, which ensured the rapid dissemination of literature during a political crisis.[4] Until her death in 1761, much of the war's political poetry was published through Mary Cooper of the Globe in Paternoster Row. Her success illustrates the avid market for political commentary and the commercial incentive to produce and distribute it.[5] In order to demonstrate the importance of poetry and ballads as genres, which attained the widest possible circulation, it is necessary to trace their dissemination through newspapers and periodicals, and in union with political prints. Republication in the provincial, Scottish and Irish press gave the war's most important political poems a more national audience. Investigations into the political significance of mid-eighteenth-century newspapers, periodicals, essay papers and pamphlets have neglected fully to integrate political literature into their discussions.[6] It is hoped that this study will contribute towards establishing a more comprehensive portrait of a diverse, informative, flourishing political press.

Emphasis will be placed upon investigating the circumstances of political literature's authorship, patronage, publication and distribution. Literary works will be placed in as close a political context as possible, by analysing their contents, and testing the accuracy of the information they conveyed against the correspondence and memoirs of politicians, parliamentary debates, and other genres of political propaganda.[7] Once these questions have been considered, it will be possible to explore the degree to which literature not only mirrored, but also helped to mould the political attitudes of its readers, both polite and popular, by assessing its interaction with these and other manifestations of opinion, such as the effigy burnings, popular protests, and the

addresses and instructions instigated by the Minorca crisis, and the 'rain' of gold boxes which followed Williams Pitt's dismissal in April 1757.

Before analysing in detail the practical interrelationship between politics and letters during 1754–63, it will be useful to provide a brief discussion of the nature and dissemination of ballads and poetry, the dominant genres of political literature. Since the mid-sixteenth century, the broadside ballad had functioned as a powerful vehicle for the transmission of news and political ideas, especially among the common people. The ballad's diverse range of authors, who were drawn from every social rank, including courtiers, politicians, men of letters, printers, journalists, booksellers, professionals, tradesmen, labourers and the hawkers themselves, enhanced its importance as the one genre of political literature which embraced all strata of society. Literary merit, polemical effectiveness and social rank, however, were not necessarily related. Some of the most compelling works were produced by the humbler pens. Much of the ballad's success derived from its powerful musical attraction, although very few were set to original compositions. To achieve a swift,

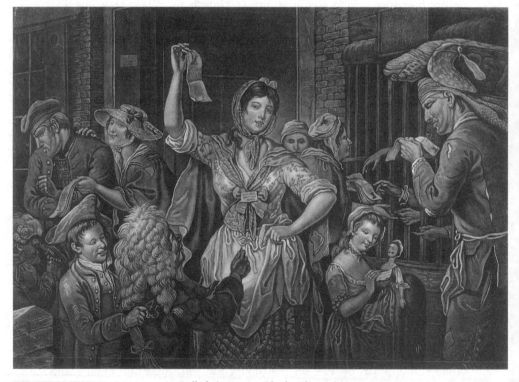

1 Ballad singers outside the Fleet prison

nearly instantaneous response to the development of a political crisis, the author grafted topical lyrics on to the melodies of the most universally cherished folk songs, or set them to the most fashionable contemporary airs, a formula applied with such success in John Gay's *The Beggar's Opera*. The same ballad, sung to an immediately recognisable folk tune, might be heard in the elegant salon of a town or country house, after dinner at a gentlemen's club, in a coffee-house or tavern, on a street corner, in a country market or fair, and at an electioneering meeting.[8]

Although references in correspondence, memoirs and literature, and portrayals in prints by William Hogarth, Thomas Rowlandson and others, emphasise that ballad singers were an integral part of the urban and rural landscape, the identity of the vast majority of authors, singers, and hawkers remains clothed in anonymity (Plate 1). The career of John Freeth, 'the Birmingham Poet', one of the eighteenth century's most famous balladeers, illustrates the significant place that the street-song occupied in contemporary political culture. Apprenticed as a brass-founder, by 1768 Freeth had become an innkeeper; and a slip-song, perhaps autobiographical, describing his own early experiences as a street poet journeying to London at the time of the Peace of Paris in 1763, highlights the ballad's pervasive influence. The ballad singer performs and sells copies of the latest compositions – many of which would have been inspired by the most hotly-debated contemporary political questions, such as the peace terms – to a vast, multifarious audience:

> THE first of April 'SIXTY-THREE,
> To London I went *budging*,
> For know you all of my degree,
> Go on their Ten toes trudging;
> At COVENTRY, I stopp'd to see
> If anything was wanting,
> From pocket lodge – pull'd out my *fodge*,
> And straight 'way fell to chanting.
>
> And as I passed the Streets along,
> The people round me gazing!
> Some cry'd out "tis nobly sung,
> And worthy of our praising';
> My Voice was clear, my Heart was stout,
> Then why should I repent it,
> A decent penny soon I got
> And in the Evening spent it.[9]

While much of Freeth's writing evoked the time-honoured romantic, social and sporting themes of ballad literature, he was deeply involved in local and national politics, and described himself as 'a veteran of that class of

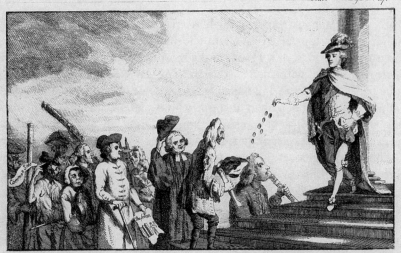

Scots Scourge No 27.

Ala? Mackenzie Inv! et Sculp -1762 L? Bute hired a number of writers, as Smollett, &c &c See Almons Anecdotes L? Bute.
Vol. 11. P.9.

The HUNGRY MOB of SCRIBLERS and Etchers

If thine Enemy be hungry give him Bread to eat;
and if he be thirsty, give him water to drink Proverbs. 25. 21.

Let each Scribler that will ply his Needle or Quill
In Despite. of the Beadle or Gallows
And their Venom throw out all the Kingdom about
No Regard should be paid to such Fellows

Was a God to alight from Olimpus height
Or Pallas to Guide in this Nation
The hungry Tribe 'gainst her Rules would Subscribe.
And endeavour to blacken her Station.

Then in Pit-y behold; how they Scratch and they Scold
And Spew from their Airy Dominions.
Not any of Sense can sure take Offence?
Or be Bi-Assd by such weak Opinions?

If their snarling youd stop give the Hellhounds a Sop
Like Cerberus, that Infernal Growler.
They'l Riggle and bow; and Praises bestow,
Tho' now they breathe nothing but Foul Air. 1762

2 *The hungry mob of scriblers and etchers*

political-ballad street-scribbler' who flourished during this period. During elections, he supported candidates who advocated similar political views. In an astonishing career, which encompassed nearly half a century, and began with the Seven Years War, Freeth published twelve books of his songs, which included commentary upon a wide variety of events, issues and personalities including: the American War, the India Bill, the Gordon Riots, the French Revolution, the game laws, enclosures, John Wilkes, Warren Hastings, Lord North, Charles James Fox, the younger Pitt, Horatio Nelson, and Napoleon. Reflecting the immediacy of composition which informed the political ballad with its great relevance, when preparing collections for later publication, Freeth apologised for flaws in works which 'were written during the heat and hurry of contested elections' and whose creation was motivated by the 'clamours of party zeal'.[10] In an example of how ballads formed such a central feature of political life and social entertainment, the ballad-singer's inn, the Leicester Arms Tavern, was popularly nicknamed Freeth's Coffee House, after its proprietor, who performed his works there to the delight of an extensive and influential company. Freeth's ballads were regularly printed in *Aris's Birmingham Gazette*, and occasionally in London newspapers. The Leicester Arms hosted the meetings of local political clubs, such as the Constitutional Society, and cultural and voluntary societies, such as that which became the Birmingham Book Club.[11]

For the common ballad writer, and certainly for the ballad singer, Freeth's prosperity was atypical. The plight of the many poor men and women who eked out a precarious existence from the composition and hawking of halfpenny ballads is illustrated by the veteran soldier William Catton, who produced a series of poetic chronicles celebrating the heroics of William Blakeney, James Wolfe, the Marquis of Granby and other soldiers and sailors of the Seven Years War. Discharged at the peace of 1748 without a pension after fifteen years' service in the Royal Regiment of Ireland, Catton turned to the writing of ballads and poems:

> as I am not wounded, so I am not provided for; therefore I am most humbly obliged to all gentlemen, ladies, and others, who are so good as to accept of my poems, and encourage my performances, since, having neither trade nor friend, I am constrain'd to write the same for a maintenance.[12]

For the historian of the eighteenth century, ballad literature offers invaluable insight into the political experience of the entire nation, but especially into popular politics, the behaviour of the crowd, and the *mentalité* of the common people.[13]

Many of the mid-eighteenth century's prominent politicians possessed wide-ranging literary interests, and lent their support to the world of letters. These included patrons such as the Earl of Chesterfield, Sir George Lyttelton,

George Bubb Dodington, and Lord Bute. As Chancellor of Cambridge University, Newcastle was a generous benefactor of learning.[14] The correspondence, memoirs and private papers of politicians reveal their appreciation of literature, and how many wrote poetry themselves. Henry Fox advocated poetic composition as excellent preparation for eloquent writing and public speaking.[15] As a young man, William Pitt moved in the circle of Lyttelton and Pope, and earned a reputation for his knowledge of classical, British and European literature. In 1772 he sent a poetic invitation to his friend David Garrick to visit him at his estate, Burton Pynsent, which demonstrated the patriot image he attempted to cultivate in his political career:

> To my plain roof repair, primeval seat!
> Yet no wonders your quick eye can meet;
> Save, should you deem it wonderful to find,
> Ambition cured, and an unpassion'd mind;
> A statesman without power, and without gall,
> Hating no courtiers, happier than them all;
> Bow'd to no yoke, nor crouching for applause;
> Votr'y alone to freedom, and the laws.[16]

Voltaire wrote to Pitt in 1761 requesting him to subscribe to an edition of Corneille's letters that he was editing, reflecting the tradition for politicians to patronise the literary arts, ''tis worthy of the greatest ministers to protect the greatest writers'.[17]

This background helps to explain why poetry remained an important medium of political communication. During the Seven Years War, many political poems were produced, whose literary and political sophistication indicates that they were written or sponsored by members of the parliamentary classes. Many were modelled upon Swift and Pope. These 'high political' works were composed to advance the ambitions of politicians by discrediting their rivals and appealing for the support of their peers. They circulated widely among the milieu of court, ministry and Parliament sometimes in manuscript like earlier 'poems of affairs of state', or in published form if an appeal to constituency and extra-parliamentary opinion was also intended. This tradition is illustrated by the diplomat Sir Charles Hanbury Williams, one of the most famous mid-century political satirists. Hanbury Williams was ambassador to Russia, who negotiated the contentious 1755 subsidy treaty, and a political ally of Henry Fox. Insight into the popularity of political verse among the political and social elite, is emphasised by Fox's repeated requests for Hanbury Williams to bring his most recent compositions to town or country-house parties, and recite them for the entertainment of guests.[18] The behaviour of the President of the Privy Council, Lord Granville, at a cabinet council meeting offers another example of politicians' taste for political satire,

'The Earl was in extreme good humour, repeated epigrams, ballads, anecdotes, stories.'[19] The letters of politicians and courtiers often refer to political works they had written, patronised, or read. Dodington sent a copy of a satire he had written against Newcastle and Pitt for the amusement of Bute and George III, and John Wilkes posted copies of his latest ballads to Earl Temple.[20] Earl Waldegrave, George III's governor as Prince of Wales, composed satires expressing his hostility towards Princess Augusta and Lord Bute, either for publication or transmission in manuscript.[21] Bute's desperation to recover compromising material from the library of the poet and writer James Ralph, whose collection of political literature was sold by auction following his death in 1762, illustrates the embarrassment sometimes caused politicians by their sponsorship of or collaboration with political writers. Ralph, a former Leicester House propagandist, had annotated many of his own publications and those of his opponents with confidential information regarding their provenance. An agent of Bute's outbid Ralph's friend Benjamin Franklin to purchase the entire library, apparently to recover one annotated pamphlet.[22] When First Minister, Bute was accused of abusing government powers of patronage to encourage literary support for his administration (Plate 2).

Although the Licensing Act of 1737 prevented the performance of anti-ministerial political satire upon the stage during the Seven Years War, important political commentary was published in dramatic form. The patriot campaign for the renewal of public spirit and civic virtue was supported by the production of a series of tragedies written by the Scottish playwright John Home. During 1755 Bute became Home's patron and friend, and appointed him his private secretary in 1757. Bute assisted Home in writing and adapting the 'Leicester House tragedies' for performance, and Pitt was instrumental in arranging for the staging of *Douglas* at Covent Garden in 1757. The other two tragedies, *Agis* and *The Siege of Aquileia* were produced by Garrick at Drury Lane. Although not overtly partisan, Home's plays complemented the patriot ideology championed by Bute and Pitt, whose patronage was encouraged by a belief in their ability to positively influence opinion.[23]

The Seven Years War was perhaps the first world war, a conflict which encompassed five continents and three oceans, creating a great demand for news. Public appetite for journalistic coverage of the war was satisfied primarily by the newspaper, which had enjoyed steady, continuous growth during the century, encouraged by the development of joint-stock ownership and the exploitation of advertising revenue, which provided commercial stability.[24] At mid century, the most popular metropolitan newspapers, such as the *London Evening Post*, the *Gazetteer* and the *Public Advertiser* may have achieved sales of over 5000 copies per issue, while average circulation probably ranged between 2000 and 3000. In 1760, London supported four daily, five or six tri-weekly, and four weekly newspapers. The tri-weeklies were printed on

post days, and with the weeklies, were widely distributed into the countryside by an efficient, comprehensive road and postal network. Provincial news-papers also flourished during this period. They continued to rely almost exclusively on the London papers for their news, and most of their political comment, but the timing and process of selection, and local contributions, often in verse, offer evidence of distinctive provincial responses to the war's political issues.[25] In 1760, approximately thirty-five provincial papers were in existence, and many attained a substantial regional circulation. The social, cultural and political impact of the press at this time is measured by estim-ates of its circulation. It has been calculated that in 1746, 100,000 newspapers were sold in London each week, reaching more than half a million readers, and total annual circulation in Britain is revealed by the purchase of newspaper stamps, which rose from approximately 7.3 million in 1750 to 9.4 million by 1760.[26] Periodicals also functioned as important weekly or monthly sources of news and political discussion.[27] The two leading monthly magazines, the *Gentleman's* and the *London* (LM), closely followed the progress of the war and domestic political developments. They printed an impressive range of official documents, and a generally balanced, objective selection of extracts from the most influential political pamphlets and essay papers. Dr Johnson's calculation that the *Gentleman's Magazine* enjoyed a circulation of 10,000 emphasises its influence.[28]

In the mid-eighteenth century, newspapers and periodicals acted as signific-ant vehicles for the transmission of political literature to a large audience.[29] Contemporary newspapers were restricted in length, and the majority of available space was devoted to advertisements, and to the reporting of national and local news. There was little space left for political commentary, which was provided by poetry, letters, occasional essays, or more rarely, by direct editorial intervention. Verse on an astonishing variety of subjects was a staple feature of the eighteenth-century newspaper, illustrated by the *Salisbury Jour-nal*, which printed over 1100 poems, many by local authors, between 1736 and 1770.[30] Poetry's economy and concision, its ability to symbolically encapsu-late political ideas, events and personalities in vivid images, made it an ideal genre for political dialogue. In this respect, it was well suited to overcome the practical physical constraints of the early newspaper. Furthermore, political verse challenged and entertained, appealing to its readers' wit, humour, intel-lect and imagination.[31] As Horace Walpole commented upon the productions of the political press, 'they shall not make me pay till they make me laugh'.[32] Mid-eighteenth-century newspapers relied upon political poetry for the expres-sion of opinion at all times, but during the Minorca controversy, it took on an influential role, to the extent that it dominated discussion in the provincial papers.[33] Political works also occupied a prominent position in the poetry sections of the monthly magazines and in the essay papers.

Investigations into the impact of the mid-eighteenth-century press upon the formation of political opinion have emphasised the relatively high literacy rates in Britain, not only among the middle classes, but also among the labouring classes, especially those skilled artisans and craftsmen who lived and worked in an urban environment. In examining readership, they have demonstrated how circulation figures must be multiplied to account for the ways in which men and women could gain access to the information contained in newspapers, pamphlets, magazines, essay papers and literature without purchasing a copy themselves. Estimates of the actual number who were able to gain initiation into the growing popular political culture of the mid-eighteenth century, by acquiring the information disseminated by the press, have ranged from twenty to fifty people per printed copy.[34]

Newspapers, essay journals, pamphlets, political poetry and ballads were available to the patrons of the many of coffee-houses, gentlemen's clubs, inns and taverns like Freeth's which were such a prominent feature of the social life of London and provincial centres (Plate 3). In this context, it is important to emphasise that coffee-houses were frequented by tradesmen, mechanics and apprentices, as well as by members of the commercial, professional and polite classes. It has been estimated that a single newspaper edition could pass through the hands of 20,000 coffee-house patrons in one day.[35] Many coffee-houses which were closely associated with overseas trade developed reputations as sources of the most recent and accurate news from abroad. In June 1755 Thomas Birch informed Lord Royston that the earliest reports of Admiral Edward Boscawen's attempt to intercept a French fleet in the Gulf of St Lawrence were brought to Lloyd's Coffee-House by commercial vessels from North America.[36] Some coffee-houses subscribed to a variety of European or colonial newspapers. Later in 1755, Birch replied to Royston's inquiry for first-hand accounts of General Edward Braddock's defeat on the Monongahela by advising him of the coffee-houses near the Royal Exchange which received the Virginia *Gazette*.[37]

Circulating libraries, reading rooms and pamphlet clubs organised by booksellers, coffee-house proprietors and inn-keepers offered additional opportunities for middle-class readers to satisfy their curiosity in political developments. The poet, William Shenstone, who avidly followed political affairs, participated in a scheme operated by his favourite coffee-house, which gave him access to a wide range of political publications: 'What do you think must be my expence, who love to pry into every thing of this kind? Why, truly, one shilling. My company goes to George's Coffee-house, where, for that small subscription, I read all pamphlets under a three-shilling dimension.'[38]

Similar subscription and loan systems were practised among the poor, who would pool their resources to buy or hire a newspaper or broadside

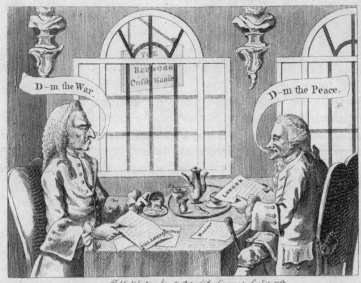

The GRUMBLERS of GREAT BRITAIN;
A New Humorous POLITICAL SONG.
By a GRUMBLETONIAN.

TUNE. *The Roaſt Beef of England.*

I.

GOOD People attend (if you can but ſpare Time)
To a Grumbling Poet, who grumbles in Rhyme,
To ſit down in Silence—is now deem'd a Crime.
O the rum Grumblers of England!
And O the Old Engliſh Grumblers!

II.

When Stateſmen miſcarry and Things go awry
The Coffee-Houſe Grumblers their Rancour let fly,
And ſnarl, ſnap and worry—yet know not for why.
O the rum Grumblers, &c.

III.

Muckle Glee fills the Heart of brave *Sawney* the *Scot*,
Becauſe he has ſlily the upper Hand got.
The *Engliſhman* grumbles—becauſe he has not.
O the rum Grumblers, &c.

IV.

Some *Grumblers* poſſeſs'd of more Money than Senſe,
Complain of the Land-Tax, the War and Expence,
That *Conqueſt brings Ruin*—they plead for Defence.
O the rum Grumblers, &c.

V.

The poor People grumble about the Strong Beer,
Our Soldiers and Sailors too grumble for Fear,
Of loſing the *Dollars*—they hope to bring here.
O the rum Grumblers, &c.

VI.

The *Pittamites* grumble at *Hogarth*'s new Print,
With Countenance crabbed, they juſt take a Squint,
And ſwear from * *John Bull*—he has pilfer'd the Hint.
O the rum Grumblers, &c.

VII.

Old *Formal* exclaims thus againſt the Qee-n's Aſe,
" What Pity the Author unpuniſh'd ſhould paſs ?"
" Let them grumble, cries *Hal*—while I add to the
 [Maſs."
O the rum Grumblers, &c.

VIII.

Thus grumbling and growling from Morning till Night
The Nation remains in a terrible Plight ;
For Grumbling will never—ſet Matters to right.
O the rum Grumblers, &c.

IX.

Then let us not into ſuch ſtrange Madneſs fall,
And loudly for *Peace*, and no *Peace* rave and bawl ;
But pray for a Good One—or elſe none at all.
O the rum Grumblers of England!
And O ye Old Engliſh Grumblers!

* *John Bull*'s Houſe in Flames. Vol.1. 13

Sold by W. TRINGHAM, Engraver in Caſtle-Alley, Royal Exchange, and at the Print-Shop under St. Dunſtan's-Church.
And by all the Print and Pamphlet-Shops.

[Price SIX-PENCE.]

3 *The grumblers of Great Britain*

ballad from a coffee-house or tavern, or from one of the many hawkers who canvassed the busiest public places and thoroughfares of London and the countryside. Even the illiterate could achieve some familiarity with the most hotly-debated current affairs through the public reading of newspapers, conversation, or by listening to a ballad singer.[39]

The print represented another important medium for the transmission of political ideas. It had established itself as a thriving genre of political and social satire during the reign of George II, stimulated by the genesis of an articulate opposition to Walpole, and the drama of the two great wars at mid-century.[40] International affairs were subjects of great interest among the political nation, which the print's techniques of ideographical interpretation were well-equipped to exploit. The monumental military and political events of the Seven Years War created an enthusiastic market, not only for the political press, but also for the graphic artist's work as well.

Much remains to be learned about the production, distribution and consumption of political prints. More research needs to be conducted into how far the production of prints was determined by political partisanship or the entrepreneurial impulses of the print seller. In addition, a more accurate assessment of the market for political prints and of their viewers must be achieved before their exact significance as historical evidence may be evaluated. It is unclear to what extent the consumption of political prints was confined to the parliamentary elite, or whether they were also readily accessible and their messages comprehensible to spectators from among the politically aware members of the middling and labouring classes, and even the illiterate.[41] As with political ballads, the extraordinary diversity of the prints published during the war warns against any naive generalisations about the social composition of their audience. Fine engravings containing complex iconography and caricatures of politicians that required familiarity upon the part of the viewer with the issues and individuals of high politics, appear in collections beside simple, poorly-executed works, which were intended for more plebeian consumers. Evidence that the parliamentary classes regarded graphic art as an effective weapon of political polemic is provided by George Townshend's political prints, which were widely circulated by his allies, and by Horace Walpole's interest to secure copies of the most striking prints, and share them with his friends. Tracing the dissemination of political prints among the middling ranks and the common people, who were less able to afford them, is more difficult. Political prints like ballads were hung upon the walls of coffee-houses, taverns and alehouses, and passed about by their patrons from the professional, commercial and labouring classes.[42] They were also pasted on the walls of street corners and public buildings, and exhibited for the inspection of any passer-by in the windows of print shops. Essay papers emphasised their familiar sight in the city landscape, 'disaffection,

and treason, stares with impunity through the windows of every print-shop', and the great attraction of graphic satire among the people which, 'assembled the gazing multitude at the windows of print-shops'.[43]

Unfortunately, there is only scope in this study to consider graphic art in its relation to the war's political literature. Satiric prints and literature were intimately connected; they shared a common political mythology, expressed by many of the same symbols and images.[44] Prints were usually sold by the same booksellers who specialised in political literature and current affairs.[45] There was an important verbal dimension to the contemporary political print. Complementary stanzas of poetry were printed beneath or alongside an engraving to clarify and drive home its symbolic message. Many of these verse commentaries were often taken from the most admired works of classical and contemporary literature, but many appear to have been original. To enhance their appeal, prints frequently incorporated passages, or sometimes the entire text, of the most influential contemporary ballads, epigrams or political poems. The verse hieroglyph, a poem partly composed of phonetic rebuses, represented the most complete union of the two art forms. These satiric picture puzzles, like verse riddles and fables, were popular because they challenged the decipherer's curiosity and ingenuity. Ten hieroglyphic prints from 1756 reacting to the Minorca crisis have survived. In many cases, the affinity between the print and the broadside ballad at mid-century was so close that the two became indistinguishable, almost an early form of multimedia, the merging of visual image, text and music for the purpose of political persuasion.

NOTES

1 T. R. Clayton, 'The Duke of Newcastle, the Earl of Halifax and the American Origins of the Seven Years' War', *The Historical Journal*, XXIV (1981), 571–603.

2 J. A. Downie, *Robert Harley and the Press: Propaganda and Public Opinion in the Age of Swift and Defoe* (London, 1979) and *To Settle the Succession of the State: Literature and Politics 1678–1750* (London, 1994); Bertrand Goldgar, *Walpole and the Wits: The Relation of Politics to Literature 1722–42* (Lincoln, Neb., 1976); J. A. Downie, 'Walpole, the "Poet's Foe"', in J. Black (ed.), *Britain in the Age of Walpole* (London, 1984), pp. 171–88; Christine Gerrard, *The Patriot Opposition to Walpole: Politics, Poetry, and National Myth* (Oxford, 1994); W. A. Speck, *Society and Literature in England 1700–1760* (Dublin, 1981).

3 Vincent Carretta, *The Snarling Muse: Verbal and Visual Political Satire From Pope to Churchill* (Philadelphia, 1983), p. 177.

4 Michael Treadwell, 'London Trade Publishing 1675–1750', *Library* IV (1982), 99–134.

5 Beverly Schneller, 'Mary Cooper, Eighteenth-Century London Bookseller, 1743–1761', (Catholic University of America PhD thesis 1987) and 'Mary Cooper and Periodical Publishing, 1743–61', *Journal of Newspaper and Periodical History* VI (1990), 31–5.

6 Robert Rea, *The English Press in Politics 1760–1774* (Lincoln, Neb., 1963); Robert Spector, *English Literary Periodicals and the Climate of Opinion During the Seven Years' War*

(The Hague, 1966) and *Political Controversy: A Study in Eighteenth-Century Propaganda* (Westport, 1992); Marie Peters, *Pitt and Popularity: The Patriot Minister and London Opinion during the Seven Years' War* (Oxford, 1980); Michael Harris, *London Newspapers in the Age of Walpole* (London, 1987); Robert Harris, *A Patriot Press: National Politics and the London Press in the 1740s* (Oxford, 1993); Hermann Wellenreuther, 'Pamphlets in the Seven Years' War: More Change than Continuity?', Anglistentag 1995 Greifswald, *Proceedings*, ed. J. Klein (Tübingen, 1996), pp. 59–72.

7 Newspapers, periodicals and the two literary reviews, the *Monthly* and the *Critical*, record the appearance of most political literature printed during the war, allowing it to be more precisely related to political developments. Reviews often provide valuable insight into a work's authorship, antecedents, and political impact.

8 Roy Palmer, *The Sound of History: Songs and Social Comment* (Oxford, 1988), pp. 1–29; Milton Percival, *Political Ballads Illustrating the Administration of Sir Robert Walpole* (Oxford, 1916), pp. i–liii; 'An Essay on Ballads', *LM*, 1769, 580–1.

9 'A Strolling Ballad-Singers Ramble to London', in John Horden (ed.), *John Freeth (1731–1803) Political Ballad-writer and Innkeeper* (Oxford, 1993), pp. 175–6.

10 *Ibid.*, pp. 1–34.

11 An examination of Birmingham has outlined Freeth's important role in the political life of the city, 'the history of popular political consciousness in Birmingham, especially during the years of the American Revolution, is in good part the history of the Leicester Arms', John Money, *Experience and Identity: Birmingham and the West Midlands 1760–1800* (London, 1977), p. 103.

12 William Catton, *An Encomium on the Magnanimous Ferdinand, Prince of Brunswick*, 1758.

13 R. L. Capraro, 'Political Broadside Ballads in Early Hanoverian London', *Eighteenth Century Life*, XI (1987), 17; T. Crawford, 'Political and Protest Songs in Eighteenth-Century Scotland I Jacobite and Anti-Jacobite', *Scottish Studies*, XIV (1970), 1–33.

14 Ray Kelch, *Newcastle: A Duke Without Money* (London, 1974), pp. 126–33; *GM*, May 1755, 231.

15 *Recollections of the Table-Talk of Samuel Rogers*, ed. M. Bishop (London, 1952), p. 61.

16 Lyttelton to Chatham 20 Feb. 1772, *Correspondence of William Pitt, Earl of Chatham*, ed. W. Taylor and J. Pringle (London 1838), IV. 197.

17 Voltaire to Pitt, 19 July 1761, *Ibid.*, II. 131.

18 Earl of Ilchester and E. Langford-Brooke, *The Life of Sir Charles Hanbury Williams Poet, Wit and Diplomatist* (London, 1928), pp. 86, 115; Charles Hanbury Williams, *The Works of the Right Honourable Sir Charles Hanbury Williams* (London, 1822).

19 Walpole to Chute, 8 June 1756, *Corr.*, XXXV. 94.

20 Dodington to Bute, 22 Dec. 1760, Dodington, p. 407; Wilkes to Temple 12 Oct. 1762, Smith, II. 485.

21 Clark, *Waldegrave*, pp. 226–41.

22 BL Add. MSS, 35,399, fo. 275. Birch to Royston, 15 Apr. 1762.

23 Richard Sher, 'The Favourite of the Favourite: John Home, Bute and the Politics of Patriot Poetry', in Karl Schweizer (ed.), *Lord Bute: Essays in Re-interpretation* (Leicester, 1988) pp. 181–222.

24 M. Harris, *London Newspapers*, pp. 189–97; J. Black, *The English Press in the Eighteenth Century* (London, 1987), pp. 277–308; John Brewer, *Party Ideology and Popular Politics at the Accession of George III* (Cambridge, 1976), pp. 139–47.

25 Gee, pp. 45–112.

26 Harris, *London Newspapers*, p. 190; Brewer, *Party Ideology*, p. 142; H. T. Dickinson, *Politics and Literature in the Eighteenth Century* (London, 1974), p. xx.

27 Spector, *Literary Periodicals*, pp. 13–24.

28 Brewer, *Party Ideology*, p. 147. The *LM* probably commanded similar sales.

29 Harris, *London Newspapers*, pp. 1–46; Rea, pp. 1–11.

30 C. Y. Ferdinand, *Benjamin Collins and the Provincial Newspaper Trade in the Eighteenth Century* (Oxford, 1997), p. 169. Its persuasive power was underlined by its use in advertising.

31 The popularity of newspaper verse is illustrated by the City merchant Stephen Monteage, who regularly copied pieces from the *Daily Advertiser* into his diary; Harris, *London Newspapers*, p. 191; Spector, *Political Controversy*, pp. i–x.

32 Walpole to Conway, 29 Oct. 1762, *Corr.*, XXXVIII. 194.

33 Gee, p. 121.

34 Brewer, *Party Ideology*, pp. 139–59; Harris, *London Newspapers*, p. 194.

35 Harris, *London Newspapers*, p. 47.

36 BL, Add. MSS 35,398 (Hardwicke Papers), fo. 246: Birch to Royston, 21 June 1755.

37 *Ibid.*, fo. 302: Birch to Royston, 21 Oct. 1755.

38 William Shenstone to Richard Graves, Feb. 1741, *The Letters of William Shenstone*, ed. Marjorie Williams (Oxford, 1939), p. 21. Shenstone also appreciated political poetry, often transcribing verses published in the newspapers.

39 John Feather, 'The Power of Print', in J. Black (ed.), *Culture and Society in Britain 1660–1800* (Manchester, 1997), pp. 61–2.

40 Herbert M. Atherton, *Political Prints in the Age of Hogarth: A Study of the Ideographic Representation of Politics* (Oxford, 1974), pp. 257–70; Dorothy George, *English Political Caricature to 1792: A Study of Opinion and Propaganda* (Oxford, 1959), pp. 1–13.

41 E. Nicholson, 'Consumers and Spectators: The Public of the Political Print in Eighteenth-Century England', *History*, LXXXI (1996), 5–22.

42 Atherton, pp. 1–24, 61–85.

43 *Con-test*, 11 June 1757; *Test*, 7 May 1757.

44 Carretta, pp. xiii–xx.

45 Timothy Clayton, *The English Print 1688–1802* (London, 1997), p. 148.

2

Pelham's death,
Pitt and patriotism

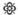

HENRY PELHAM's death on 6 March 1754 inspired a number of poetic eulogies. David Garrick praised him for promoting policies which secured peace, economic prosperity and political harmony. David Mallet's collected edition of Lord Bolingbroke's works was published on the same day, and Garrick took advantage of the remarkable coincidence to warn of a possible rebirth of factious political opposition. He feared that faithless friends might destroy Pelham's legacy in a struggle for power, following the example of Bolingbroke and William Pulteney, and concealing their aspirations behind a mask of patriot rhetoric:

> The same sad morn to Church and State
> So for our sins 'twas fix'd by fate,
> A double stroke was giv'n;
> Black as the whirlwinds of the north,
> St. J[oh]n's fell *genius* issu'd forth,
> And PELHAM fled to heav'n!¹

George II consulted the Lord Chancellor, the Earl of Hardwicke, upon the formation of a new ministry. Hardwicke, who was anxious to maintain the Old Corps dominance in government, convinced the King that Henry Fox, Secretary at War and a prominent Whig in the House of Commons, failed to command the confidence of the party, which would allow him to claim Pelham's position. Hardwicke's recommendation that the Duke of Newcastle assume the Treasury was seconded by a meeting of the Cabinet Council on 12 March, and accepted by the King.² Fox rejected an offer of promotion to become a secretary of state when he realised that it would not include leadership of the Commons and management of parliamentary patronage. Fox justified his refusal to the King by asserting that Newcastle had failed to honour the terms of his original proposal.³ William Pitt, Paymaster of the Forces and an important ministerial spokesman in the

Commons, was also considered as a candidate for advancement.[4] As the younger son of a family of only moderate landed wealth and social standing, however, Pitt lacked the political influence endowed by parliamentary interest. Arrogant, abrasive and introverted by nature, he had not cultivated the friendship of powerful patrons at court. Above all, Pitt's hopes of promotion to secretary of state were frustrated by the aversion of George II, who had never forgiven him for his alliance in opposition with Frederick, the Prince of Wales, and his violent abuse of Hanover during the War of the Austrian Succession. When the ministerial reconstruction was complete, leadership of the House of Commons was entrusted to Sir Thomas Robinson, an experienced diplomat, who was appointed Southern Secretary of State; the Earl of Holdernesse replaced Newcastle as his colleague for the North; and Henry Bilson Legge became the new Chancellor of the Exchequer.[5] The immediate literary reaction to the new ministry was positive. Devotion to the Hanoverian dynasty, royal favour, connections among the Whig nobility, experience, parliamentary interest and dedication to public business distinguished Newcastle as the natural successor to the leadership of the party and the office of first minister.[6]

Pitt had hoped to win a greater role in government by benefiting from Hardwicke and Newcastle's distrust of Fox. When it became clear that Pitt would not profit from Fox's exclusion, and that Newcastle believed he could manage the Commons without taking one of its leading members into the cabinet, Pitt came to doubt the sincerity of the duke's promises to alleviate the royal hostility that blocked his advancement.[7] Pitt's commentary upon an apologetic letter from Newcastle emphasises his growing conviction of neglect: 'I am almost tempted to think there is kindness at the bottom of it, *which if left to itself, would before now have shewed itself* in effects. If I have not the fruit, I have the leaves of it in abundence: a beautiful foliage of fine words.'[8]

Both Pitt and Fox felt betrayed by Newcastle, and although Fox was restrained from overt opposition by fear of forfeiting royal favour, in that sense Pitt had nothing to lose, and with the opening of Parliament in November 1754, he launched a campaign to undermine Newcastle's system in the Commons.

On 25 November, John Delaval's facetious defence of electoral bribery provoked Pitt to deliver an eloquent exhortation for the House to preserve its threatened dignity and freedom. Pitt denounced Newcastle for intending to rule as a tyrannical minister, and called upon the Commons to resist, lest it '*degenerate into a little assembly, serving no other purpose than to register the arbitrary edicts of one too powerful subject*'.[9] Later Pitt fell upon Robinson for an indiscreet comment upon the Reading petition. Pitt castigated him for his ignorance of House of Commons procedure, and declared that such a remark upon an untried cause by a senior minister illustrated the administration's

ambition to dictate to Parliament, and abolish electoral independence, the very foundation of national freedom itself.[10] Pitt exploited any opening during the session to assert his commitment to act upon Revolution principles, making the Bristol Nightly Watch Bill the occasion to acclaim the glories of the British constitution, and during debate upon the Scottish Justices Bill, he presented 'one of his best worded and most spirited declamations for liberty'.[11] Pitt's speeches drawing upon his recent experiences at Oxford to demonstrate the continuing menace posed by Jacobitism were interpreted as a ploy to silence the only first-rate debater fully committed to Newcastle, the Attorney General William Murray, a Scot, whose brother had served the pretender.[12]

Statements by parliamentary observers demonstrate that Pitt's pretensions to cast himself as a guardian against arbitrary rule were dismissed as a tactical ploy to distress the ministry. Historians and biographers of Pitt have quoted descriptions of his speeches during this period which concentrate upon assessing their rhetorical excellence, while overlooking their immediate, practical significance, their reception by their audience. Pitt's onslaught against Robinson was greeted with disapproval by the House, and the general response to his oration upon the Scottish Justices Bill was equally hostile. Fox's praise of the speech, perhaps ironical, 'that he reverenced liberty and Pitt, because nobody could speak so well on its behalf', has often been cited, but the reaction of the majority of backbenchers may have been more accurately expressed by the Newcastle supporter Thomas Nugent. His reply to Pitt offers illuminating insight into what must have been the opinion of many businesslike MPs, who preferred simple, direct speech, and were suspicious of the ulterior motives lying behind the Paymaster's flowery words. Recalling the patriot oppositions of the previous decade, and Pitt's own participation in them, Nugent repudiated his present conduct as a cynical manipulation of libertarian rhetoric for selfish ends. He impeached the 'professors of liberty, who always became bankrupts of the public', and asserted a cynical resistance to the blandishments of patriotism: 'The Craftsman and Common Sense, which had often very little common sense, had wound the notions of liberty too high. That he had read The Craftsman over again two years ago, and had found it poor stuff.'[13]

The literary response to Pitt's renewed opposition during the parliamentary session of 1754–55 was critical. Pitt's behaviour inspired an effective prose satire, which reassessed his political career in the light of his turn against the ministry, charging him with irresponsible, unlimited lust for power, arrogance, insincerity and ingratitude. The satire is cast in the form of an interior monologue, in which he ruminates upon his political goals and strategy. The immense distance between Pitt's self-image and his true character becomes immediately apparent, and the reader enjoys hearing the great orator condemned out of his own mouth. Much of the satire's success lies in its

acerbic mimicry of Pitt's grandiloquent speech, which suggests that the author must have been a frequent observer of parliamentary proceedings, or had access to reliable first-hand accounts. Its close analysis of the 1754–55 debates in the Commons, before regular published accounts became available, reinforces this idea. Pitt confesses how renewed opposition will provoke charges of inconsistency and opportunism, accusations he had endured upon joining the Pelhams in February 1746, after abusing them for corrupt and arbitrary rule, and for pandering to the King's Hanoverian predilections.[14] Pitt dreads taunts inspired by his speech in April 1746, when he advocated taking Hanoverian troops into British pay after fiercely denouncing the measure. In referring to this debate, the satirist has Pitt repeat one of his most notorious passages of anti-Hanoverian oratory to emphasise how he had broken his word: 'Must I not expect to have the *Name of Hanover* resounded in my Ears, as I once wished it might be branded on my Forehead, if ever I voted for the Hire of the Troops of that Electorate?'[15]

Pitt repeats another famous expression made during his recantation when he meditates appeasing the Whigs by condemning his former conduct 'with a Countenance unshaken and unembarrassed'. Readers would have appreciated the allusion to one of the most devastating poetic satires on Pitt's defection, written by the Old Corps loyalist Hanbury Williams, which took its title, 'The Unembarrassed Countenance', from the protests of honest conversion that Pitt proclaimed.[16] During 1754–55 Pitt's harassment of the ministry, of which he remained a member, was condemned as being motivated by the aim of coercing the King into surrendering the secretary's seals. Pitt's close friend and ally Lyttelton broke with him over opposition 'which had not even the pretence of any public cause, but was purely personal against the Duke of Newcastle'.[17]

Broadside ballads evolved as one of the earliest vehicles for the reporting of political news, and functioned as vital bridges for the transmission of developments within the Commons to an audience out-of-doors. This is illustrated by a ballad of January 1755, which astutely commented upon the motives of Pitt's parliamentary outburst, comparing his assaults upon Robinson and Murray to the clamours of a mercenary suitor in a court of law:

> But as in Theatres of Prize
> When all things seem most quiet,
> An angry Hero may arise
> And set them all in Riot.
>
> So Pitt (who never was afraid)
> Did Robinson assail,
> And on th' Attorney too he laid
> Full sorely with his Flail.

> He swore the Knight was a mere jest
> Altho' he *High German* writes,
> And said whatever some suggest
> There still are Jacobites.[18]

The ballad also comments upon George II's violent reaction to Pitt's rebellion. Many ballads which contained accurate information of the innermost circles of court and ministry were written by political insiders and circulated extensively among the political elite. Fascinating insight into the authorship of this example is provided by the Duke of Bedford, who implied that his political man of business Richard Rigby was the author: 'The ballad which I believe Mr. Rigby sent you, though wrote with no pretence to wit, yet as a plain narrative will be instructive as to the only event of moment which has happened during this session of parliament.'[19]

The Orator's Political Meditation considers Pitt's brief alliance with Fox, who had joined him in his campaign to cripple the ministry's parliamentary leaders. The satire compares their confederacy to that of two starving predators stalking the same prey, torn between hunger, and mutual fear and hatred.[20] Given the two men's common ambition and parliamentary pre-eminence, conflicting personalities and political paths, their alliance could only be transitory. Fox's ties to the Duke of Cumberland and the king, and Pitt's determination to stand alone, made their parting inevitable. The two men's harassment of Robinson had revealed his incapacity to lead the Commons, and Newcastle realised that his system could never survive without conciliating at least one of its two most effective speakers. After unsuccessful overtures to Pitt in September, in December 1754 Fox was engaged to support Robinson with a seat in the cabinet.[21] Fox's promotion marked the end of his confederacy with Pitt.[22] Cumberland's appointment as President of the Regency Council in March 1755, and the growing influence of Fox, heightened Princess Augusta's anxiety that Cumberland might seek to dominate the future king in the event that George II died before George, Prince of Wales, reached his majority in May 1756. Newcastle too, after his treaty with Fox, was suspected of cooperating with Cumberland to extend his power into the next reign.[23] To counterbalance possible threats from Cumberland and Newcastle, the princess was advised by her confidant, the Earl of Bute, to approach Pitt. An association with Leicester House appeared as an attractive alternative for Pitt once his alliance with Fox had disintegrated. Leicester House's commitment could only marginally strengthen Pitt's support in the Commons should it join him in overt opposition, but the reversionary interest provided powerful leverage in any negotiation with Newcastle, who wanted to avoid division within the royal family. In May 1755 Pitt and Leicester House concluded an agreement in which each party pledged to defend the interests of the other.[24]

The ministry's reaction to the confrontation with French forces in the Ohio Valley during 1754 made war in North America inevitable.[25] In January 1755, General Edward Braddock was sent with two regular regiments to capture Fort Duquesne, and offensives were to be launched against French forts in Acadia, Niagara and the Champlain Valley. In April, Admiral Edward Boscawen was dispatched to American waters to intercept French reinforcements, leading to the capture of two ships in the mouth of the St Lawrence on 10 June. Boscawen's action provoked the French to break off diplomatic relations on 22 July. The Newcastle ministry was confronted with the problem of preventing the war from spreading to Europe, where a French invasion of Hanover was expected. Britain's traditional allies, the Austrians and the Dutch, refused to assist in the defence of the electorate. The ministry sought to deter aggression by France or her ally Prussia by concluding subsidy treaties with Hesse-Cassel and Russia for the hire of 12,000 and 55,000 troops respectively. It was anticipated that the treaties would encounter a hostile reception in the Commons, and Robinson was ill-equipped to confront a vociferous opposition, especially if inflamed by Pitt.[26] Newcastle and Hardwicke attempted to reach an accommodation with him during August and September.[27] Pitt was recalcitrant, perhaps calculating that the deteriorating situation in North America and Europe would enable him to hold out for high terms. His demands for the secretary's seals, a major role in decision making and the cancellation of the Hessian and Russian treaties were rejected.[28] Newcastle approached Fox, who agreed to organise and direct the defence of the treaties, when offered a secretaryship and the leadership of the Commons.[29]

For Pitt the subsidy treaties seemed to provide an issue around which a powerful coalition could be constructed, a foundation which had been conspicuously lacking during his earlier opposition. Denunciations of the treaties as Hanoverian measures, which would embroil Britain in an expensive, bloody continental war would appeal to Leicester House, and might also attract the Tories and independent Whigs such as Bedford.[30] Legge had refused to countersign the warrant for paying the subsidies until the treaties had been ratified by Parliament.[31] Senior members of the Old Corps such as the Duke of Devonshire and Horatio Walpole were also known to have reservations about the treaties.

Extra-parliamentary political opinion usually exerted its greatest pressure during war or times of international crisis, as the patriotic campaigns to overthrow Walpole and Granville had demonstrated. There appeared to be the prospect of mobilising popular support in the City of London and within the extended political nation by accusing Newcastle of sacrificing British maritime and colonial interests for the protection of Hanover. Lord Bute and Pitt's former political ally, the patriot poet and merchant Richard Glover,

began to exert their influence in the City to provoke an uproar against the subsidies.[32] In September 1755 Horace Walpole reported that Pitt was 'scouring his old Hanoverian trumpet', and would challenge Newcastle within Parliament and without as the champion of a patriot opposition focused upon the subsidy treaties.[33]

Before discussing the fortunes of the anti-ministerial offensive, it is necessary to review the salient features of the patriot ideology it sought to revive. Following the accession of the Hanoverians, transformations in the structure of politics, the development of an ideological consensus about the nature of the British constitution, and a decline in religious controversy, combined to moderate the bitter Whig–Tory party divisions. The financial, administrative and military revolutions, which occurred during the wars against Louis XIV, had increased the scope of the central government, and placed an unprecedented range of patronage appointments in the hands of the Crown.[34] Under George I, the Tories were banished from office for their hostility to the Hanoverian Succession, and secure in royal favour, the Whigs assumed a firm grasp upon power. Political manipulation of these new powers by Whig ministries increasingly provoked conflict between the court and a loose alliance of opposition groups who resisted these developments, and claimed to defend the entire nation against the tyranny of a narrow, self-interested faction. In Parliament, the Tories and independent country gentlemen comprised the largest bodies of this opposition, although they were joined by factions of dissident Whigs, the losers in the many internal power struggles that racked the Whig leadership.[35]

Patriotism was dedicated to the preservation of mixed government, the balanced constitution, and the subjects' traditional liberties from invasion by the executive. Patriots envisaged political life as a struggle between a narrow clique of courtiers, who usurped royal power, and the vast majority of those they preyed upon, the country itself. They claimed that the old Whig–Tory division had lost its relevance, and rejected political parties as factions devoted entirely to the pursuit of selfish ends. Men were exhorted to act as individuals motivated solely by the good of their king and country.[36] To maintain the balance of the constitution by protecting the independence of its democratic institution, the House of Commons, patriots demanded more frequent national elections, and the passage of place and pension bills. It was hoped that triennial or annual Parliaments would reduce venality in office and electoral corruption. More frequent contests would make MPs more responsible to their constituents, allowing voters to repudiate those who had succumbed to the seduction of the court. The expulsion of placemen and pensioners from the Commons, whose votes had been bought by the ministry in exchange for income, office and honour, would preserve its freedom to function as an objective judge of

the national interest, and as a restraint against the misuse of the Crown's prerogative.[37]

Patriots were deeply suspicious of the financial revolution, and feared that the inception of the funded national debt, the Bank of England, and the great chartered corporations had established an alien moneyed interest. They believed that, in exchange for their privileged status, these great financiers bolstered ministerial influence. This aversion was strongly felt among land-owners, who believed that the possession of property endowed them with the independence to be society's natural political leaders, and the City of London's independent middling merchants, tradesmen and shopkeepers, who resented the great creditors' financial power. Hostility to speculators and stockjobbers, fuelled by sensational scandals such as the South Sea Bubble (1720), was also widely shared by the labouring classes and the poor, and its persistence contributed to the hysterical uproar against the Jewish Naturalisa-tion Act (1754).[38]

In the context of foreign policy, patriots were vigilant to ensure that Britain's welfare as a maritime and colonial power was not imperilled by her connection to Hanover. The significance of patriotism's international dimension was sharpened by the commercial and imperial conflicts with Spain and France during 1739–48, and Britain's thriving trade with her North American colonies. During war with France, national goals demanded a predominantly 'blue-water' strategy to cripple her economic power by des-troying her navy and commerce, and seizing her overseas possessions and markets.[39] Direct military intervention upon the continent in support of Hanover, or to preserve a European balance of power, were rejected, especi-ally after the disillusioning experience of the War of the Austrian Succession. In 1748, Britain was compelled to surrender her only great conquest of the war, the strategic North Atlantic fortress of Louisbourg, to recover territories lost by her allies. Confronting France in Europe was enormously expensive, requiring the commitment of British troops, the hiring of large numbers of mercenaries, and the payment of subsidies to allies. Ambitious continental operations were sustained by onerous increases in taxes upon land, trade and many basic commodities, which aroused the animosity of the gentry, merchants, tradesmen, and the poor. Economic adversity was intensified when European military conflicts degenerated into exhausting battles of attri-tion as in 1700–13 and 1740–48. War upon land required the expansion of the unpopular standing army, which was viewed as a potential weapon of minis-terial oppression. To restrict the threat, patriots supported the recruitment of a constitutional militia for home defence, which should be under the control of Parliament. They asserted that bearing arms was one of the fundamental duties of every citizen, and a means of fostering public spirit and love of liberty.[40] Firmly entrenched isolationism and xenophobia in all stations of

British society, but particularly among the gentry, the middling classes and the poor, were stimulated by the accusation that continental wars were promoted by the slavish courtiers of a German monarch. In 1755, Pitt appealed to these sentiments by portraying the Hessian and Russian subsidy treaties as 'incoherent un-British measures', and demanding a maritime-colonial war for the 'long-injured, long-neglected, long-forgotten people of America'.[41]

Finally, as the ideology of perpetual opposition, patriotism was defined by an appeal to political opinion. Attempts were made, not only to engage the support of those who possessed the franchise, but also increasingly to rally the extra-parliamentary classes to protest against policies, which violated traditional liberties or endangered national security.[42] Leadership in the agitation for greater popular participation in politics was given by the urban bourgeoisie and the corporate bodies of the City of London, who claimed to speak for the entire nation. The patriots' ability to mobilise political opinion was achieved by exploiting the flourishing newspaper, periodical, pamphlet and literary press to disseminate their ideas.[43] The impact of the press and political opinion was highlighted by the patriot oppositions against the Excise Bill and Walpole's appeasement of Spain, which provoked popular demonstrations and influential campaigns of addresses and instructions.[44] Because of its emphasis upon civic virtue and personal integrity, patriotism became as much a moral and cultural, as a political movement, and profoundly influenced the world of letters, inspiring Bolingbroke's friend and admirer Alexander Pope, the spiritual patron of the opposition, and other major literary figures such as Jonathan Swift and John Gay, and the Patriot Poets who indicted the Robinocracy during the 1730s.[45]

The downfall of Walpole had produced hopes of a millenarian reform of government. In what was reviled as an act of the most consummate hypocrisy, Pulteney, Carteret and other patriot leaders broke their promises to punish Walpole and purify the political system. Instead they sold themselves to his heirs for a share of political power and the fruits of corruption they had pledged to abolish. Dissident Whigs left out of the reorganised ministry joined the Tories in condemning the betrayal of their comrades, yet when many were recruited by the Pelhams in 1744, their followers suffered another staggering breach of faith. The Broad Bottom conspicuously failed to implement the patriot programme, leaving its supporters with the bitter conviction that once more they had been duped by fraudulent adventurers. Pitt's renunciation in 1746, the third time that a distinguished patriot had denied his faith within so short a period of time, seemed decisively to discredit patriotism in the eyes of the political nation. The successive defections alienated many of the opposition's literary allies, who had contrasted patriot virtue with the political, spiritual and artistic depravity of the Robinocracy. Pope reproached Pulteney and Carteret for their betrayal in the unfinished

satiric poem *One Thousand Seven Hundred and Forty*, and the *Dunciad* (1743), which concluded with a dark vision of national decay. In 1746, Horace Walpole neatly emphasised the intimate connection between the worlds of politics and literature, when as symbols of patriotism's demise, he linked the passing of the greatest poet and satirist of the age with Pitt's defection, 'Pope and poetry are dead! Patriotism has kissed hands on accepting a place.'[46]

Literary sources from 1754–55 suggest how severely patriotism had been disgraced by the compromises of the 1740s. Garrick's scornful comment upon the republication of Bolingbroke's works, which were echoed in a pamphlet written as an ironic defence, and Nugent's parliamentary dismissal, serve as excellent examples of contemporary disenchantment.[47] Additional evidence of patriotism's notoriety is given in a poem offering sarcastic sympathy to Newcastle upon his inheriting the Treasury. It commiserates with the plight of an ambitious man, who cannot enjoy his newly acquired supremacy, because he is besieged by a mob of equally office-hungry politicians. Newcastle had acquired a reputation for shrewd manipulation of government patronage, yet despite great efforts to 'put in, put out, buy, sell, chop, change, remove', even he finds it impossible to satisfy their voracious appetites. The poem seeks to enlighten the beleaguered first minister of the cause of his predicament, which is the degenerate state of political morality. It acknowledges no difference in the motives of politicians, whether in office or opposition, who crave wealth, rank and power, and readily violate public interest, honour, and loyalty in the mad scramble for place:

> Thus prepossess'd, Ambition is our Aim,
> Courtiers and patriots are in this the same;
> Their Monarch's Int'rest, those affect in all;
> Whilst for the People, these as loudly bawl;
> The *ousted* Courtier to the People flies,
> The succeeding Patriots see with Courtier's Eyes.[48]

The patriot appears as the most shameless mercenary, a distinction probably earned by Pitt for turning on his ministerial colleagues:

> Lost to the World, who hate him to a Man
> Who follows nothing but Ambition's Plan.
> 'What shall I do? Turn Patriot! – Be it so;
> '*Hang Ministers – Damn Courtiers* – Will this, Sir, do?'[49]

Arguments against the Hessian and Russian subsidy treaties failed to evoke a sympathetic reaction in Parliament or set the wider political world aflame. During debate of the Commons' Address on 13 November 1755, which expressed approval of the subsidies and promises of aid for Hanover, Pitt delivered one of his most impassioned speeches, accusing the ministry of

abandoning the North American colonies, and taking steps which would plunge the nation into a ruinous continental war. Nonetheless, it was approved by a firm majority of 311–105.[50] A week later Pitt was dismissed from the Paymastership. When the Hessian and Russian treaties were debated in the Commons again on 10, 12 and 15 December, Pitt again distinguished himself as their most vociferous critic. The final vote ratifying the subsidy treaties however (259–72) emphasised that Pitt's audience had been unmoved by his rhetorical flourishes. Pitt's ally, Earl Temple, objected in the Lords, yet the ministry's triumph there was even more overwhelming.[51] During the 1755–56 session, Pitt is recorded to have spoken at least twenty-six times during a vigorous anti-ministerial campaign, concentrating upon the alleged mis-management of international affairs since 1748. He lamented the decayed state of the navy, simultaneously proclaiming his resistance to reductions of seamen in 1751.[52] Legislation to increase the army's strength, and the introduc-tion of George Townshend's Militia Bill, provided opportunities to condemn the nation's military vulnerability.[53]

French plans for an invasion of Britain in the spring of 1756 motivated the ministry to bring over the Hessian troops. On 29 March, Parliament addressed the king to send for Hanoverian reinforcements.[54] Though ill, Pitt was carried into the Commons to dispute the request, hoping to arouse support by appealing to popular xenophobia and militant nationalism. Pitt deplored the measures as an insult to the nation's warlike spirit, and argued that resources should be directed instead to the recruitment of British forces.[55] On 12 May 1756, the House considered a request for a £1 million vote of credit to cover the exigencies of war, which included a payment to settle a financial dispute with Prussia. It was one of the terms of a defensive alliance with Frederick II, the Convention of Westminster, signed on 16 January. The ministry had sought to secure Hanover from French attack by cooperating with Prussia to resist the entry of foreign troops into Germany.[56] Pitt launched his final great assault before the recess, repeating his accusations that the ministry had allowed British power to deteriorate, acquiesced in French aggression in North America, and was desperate to procure peace at any price. He indicted the Prussian treaty as another surrender of British rights, bought for Hanover by obsequious ministers. Pitt even accused the govern-ment of plotting to misappropriate part of the £1 million to the electorate. Nevertheless, the supplies were raised by a decisive victory (210–55) emphas-ising the total defeat of the new patriot opposition.[57]

A survey of literary works published during the 1755–56 session seems to confirm statements by contemporaries that the political nation responded to Pitt's anti-Hanoverian rhetoric and his attacks upon the ministry with hostility or scepticism. The cost and relative sophistication of the literature suggests that the discussion was confined to the parliamentary classes. There

was no torrent of ballads and ephemeral verse, which recorded the extensive popular support for the patriot campaigns of 1737–44. An analysis of these commentaries offers insight into the reasons why Pitt's opposition failed. The most striking political satire provides a comprehensive critique of the new opposition, including an analysis of the subsidy debates in the Commons. *Patriot Policy* begins with further confirmation that in the eyes of Parliament and political spectators, the opposition could not escape the stigma of opportunism cast upon patriotism by the events of the preceding decade. Pitt, Legge and George Grenville led the assault upon the subsidy treaties despite holding government offices, prompting Walpole's sardonic remark, 'it used to be an imputation on our senators, that they opposed to get places; they now oppose to get better places!'[58] The indictment is intensified by *Patriot Policy*'s religious language and imagery, which exploit the emotional power, gravity and moral authority associated with Holy Scripture for the purpose of political satire. The introductory section contains parodies of some of Christianity's most sacred prayers, which is followed by a narrative imitating the historical chronicles of the Old Testament.

Acknowledging no other Divinity but himself, Pitt alternatively prostrates himself to adore the powerful or cynically opposes depending upon which course may yield a richer reward. The Lord's Prayer and Apostle's Creed are perverted into testaments of Pitt's political faith:

> Our *P[rim]e M[iniste]r* who sittest on high, glorified be thy Name. May thy *A[dministratio]n Last.* Thy Will be accomplished in the *U[ppe]r H[ous]e,* as it is in the *Lower. Give us this year our promised Pension, and forgive Us our past Opposition,* as we forgive them who *oppose* us. And tempt us not to turn *Patriots,* but deliver us from our Country: For thine is the Power and the Glory, *while thy Office continues.*[59]

One of the central texts of the New Testament, St Paul's reflections on the nature of Love in Corinthians 1. 13, is also burlesqued to reproach Pitt for hypocrisy. Conscience is substituted for Love in Pitt's version, which begins: 'THOUGH I have the Eloquence of *Men and of Angels,* and have not *Conscience,* I am as a *sounding Drum, or a noisy Rattle.*'[60]

The rest of the text is a pastiche of vivid phrases and images drawn from the Old and New Testaments, which would have been readily recognised by contemporary readers of the King James Bible. Unfortunately this study does not allow justice to be done to *Patriot Policy*'s allusive depth. Two examples must suffice. Pitt's surname provided a wealth of satiric applications signifying: mischief or evil means of temptation, Psal. 28. 1; trouble, Psal. 40. 2; the grave, Psal. 28. 1; and Hell, in which he is the Anti-Christ or Beast rising out of the bottomless pit, Rev. 9. 2, 20. 1.[61] When Pitt and his allies 'communed together' to destroy the ministry, readers would recognise a reference

to Judas Iscariot's conspiracy with the Pharisees, 'Judas communed to betray Jesus unto them' (Luke 22. 4). Thus Pitt becomes the arch-traitor to the Whig party. At different times biblical echoes associate Pitt with Lucifer, the Angel thrust out of Heaven for his pride; the subtle-tongued serpent who tempted Eve; and Simon the Magician, who performed sham miracles.

The second part of *Patriot Policy* provides a history of the Protestant Succession in which the Old Corps Whigs are associated with the leaders of Israel, who shepherded their people into the promised land. Like Britain, the White Island of *Patriot Policy* is threatened by foreign invasion and protects itself by negotiating subsidy treaties with neighbouring powers, which must be approved by the assembly of chiefs. Through this allegory, the author offers an astute dramatisation of the 1755–56 parliamentary session, focusing upon the subsidy debates in the Commons. Pitt addresses the assembly proclaiming himself to be a prophet ordained by God to warn the people that their Pelhamite rulers have sacrificed their welfare for the sake of Hanover. He exposes a plot to neglect their defence *'by Whoring after Foreign Folks'*, and hiring mercenaries to protect a feckless country whose citizens 'swarm like Locusts upon the Face of the Earth' and 'will devour the Fruits of the land'.[62] Pitt's dire predictions of financial catastrophe are meant to deride his claim during the debate on the Address that within two years the King 'will not be able to sleep in St James's for the cries of a bankrupt people'.[63]

Patriot Policy recognises the success of ministerial advocates in presenting solid arguments in support of the treaties. The satire also compares the different styles of public speaking which distinguished the leading government spokesmen Murray and Fox from their principal rival Pitt. The satire emphasises how the ministry's victory depended as much upon the superior expression of its message as upon the substance itself. *Patriot Policy*'s dramatisation of the 1755–56 session begins with Pitt's criticisms against the subsidies, which Murray had refuted during the debates of 13 November and 15 December 1755. Murray asserted that justice, honour and gratitude demanded that the nation succour Hanover if it were assaulted by France in reprisal for Britain's attempt to enforce her legitimate territorial rights in North America.[64] Reinforcing this argument with a personal appeal of sympathy for George II, who was willing to risk the devastation of his homeland in order to see British claims vindicated, Murray accused those who refused aid to Hanover of a determination to 'sow the King's pillow with thorns'.[65] *Patriot Policy*'s religious imagery allows the author to make the most of its portrayal of George II and Hanover as martyrs suffering persecution in a British cause.[66] The appeal to national honour and devotion to the king was supported by arguments that the subsidies were preventative measures calculated to preserve the peace in Europe. This was a powerful justification to those who dreaded being drawn as a direct participant into another punishing continental conflict

such as the War of the Austrian Succession. Murray cited a famous fable in his portrayal of the Russian and Hessian subsidies as a wise precaution:

> He applied with great aptness and told with great address the fable of the shepherd treating with the wolf. The beast objected that the shepherd had damned dogs, whom he mentioned like Cossacks and Calmucs – not that he feared them! – but their barking disturbed him. The shepherd would not give up his dogs – yet the neutrality he well kept.[67]

Murray repeats this argument in the mock debate, 'they are of Use to annoy our Enemies, from afar, and be a bridle to their evil Designs'.[68] The Convention of Westminster appeared to vindicate the subsidy treaties by inspiring France's ally Frederick II to sign a pact guaranteeing the neutrality of Germany. The new alliances were defended by the necessity of maintaining the balance of power in Europe by creating a new coalition against France, 'Since it is not meet and profitable for us to suffer our Enemies to wax strong, by overwhelming our Friends.'[69] Similar arguments were advanced by a letter ostensibly written by a veteran who had served as a cobbler with Marlborough, and had learnt 'where the Shoe of the Nation pinches' and 'how to cobble the State'. The state cobbler emphasised that Britain's commerce and North American colonies were her principal sources of national wealth and power, and advocated the annihilation of France's trade and navy. Nevertheless, he recognised that continental alliances would be inevitable to prevent the French from occupying the Low Countries and using their maritime and financial resources against Britain, 'For the Ambition, Tyranny and Policy of the French Court must burst out that Way, if they cannot this.'[70] He appealed to the opposition to accept strategic necessity and support the ministry's moves to frustrate French aggression in Europe. The Hessians and Hanoverians proved to be a welcome reinforcement during the invasion threat of 1755–56, as Pitt's parliamentary supporter Thomas Potter confessed.[71] *Patriot Policy* makes Pitt's objection to their employment appear as an irresponsible risk of national security in order to score political points.[72]

Of all the charges against the opposition, none carried greater weight than that it undermined the security of the Protestant Succession at a time of national crisis. The prospect of a French invasion, perhaps supported by another Jacobite uprising, seemed very real during 1755–56.[73] The threat inspired Hogarth to produce two popular engravings with verses by Garrick exhorting the people to resist French political and religious tyranny.[74] Anxiety that Jacobite agents were actively instigating rebellion were encouraged by reports such as that given by Sir Thomas Parker, Chief Baron of the Exchequer, who collected manuscript copies of treasonable ballads and poems disseminated during the western assize circuit. According to the Mayor of Taunton, one of the ballads was written by a woolstapler's apprentice or servant named Isaac Fouler or

Fowler. It represented Britain as groaning under a heavy burden of taxation, revenue which George II lavished upon his beloved Hanover. The author exhorted the people to free themselves from the yoke of the German usurper:

> Under this bondage let's no longer Burn
> From whelps to stewarts let ye crown return.[75]

The state cobbler, a former High Church Jacobite, warned of French plans to exploit the Stuarts as pawns, and plunge Britain into a bloody civil war.[76] Whatever the true nature of the Jacobite menace, the decade-old memory of the '45 retained a powerful hold over the contemporary imagination.[77] For the Old Corps and their literary supporters, it provided an unanswerable argument. *Patriot Policy*'s religious structure made it an ideal vehicle to project an appeal for the nation to rally against the dual threat to church and state. The author conjures up evocative images of Israel's captivity in Egypt and Babylon in a metaphoric attack upon the religious and political slavery, which would be imposed by the Franco-Catholic Stuarts:

> And they harbour among them a *wandering Outcast*, who is a *worshipper of Images*, and a Follower of foolish Fancies; and him they would make Lord over ye, to the End that ye may become as Slaves to their Power, and bow the Knee to the Nod of Superstition.[78]

Damaging rumours circulated in the autumn of 1755, which implicated the opposition in efforts to destroy the government. In the Commons, George Grenville had to deny newspaper allegations that French agents had distributed £250,000 among opposition members to foment discord.[79] This indictment had been taken up in a suppositious letter from the French Minister of War, Marshal Belleisle, to a spy operating in Britain. The agent was ordered to coordinate a propaganda campaign to alienate George II's subjects by misrepresenting the subsidy treaties as Hanoverian jobs. Not only would British Jacobites propagate these lies, but the agent was also given a list of disaffected MPs, who could be bought to incite division in Parliament and without doors, thus paralysing preparations to resist a French descent.[80]

The strident anti-Hanoverianism of the 1742–44 patriot opposition led to accusations that it precipitated the Jacobite rising by creating a false impression of rampant disaffection. Pitt in particular had been censured for sowing the seeds of rebellion. *Instructions to a French Spy* revived these charges against the contemporary opposition by comparing their activities to those which preceded the '45.[81] When condemning Pitt's *'eternal invectives'* in the Commons, the Scottish ministerial advocate Hume Campbell drew a parallel with the Jacobite rebellion, asserting that the opposition's inflammatory attacks upon the government 'were transplanted into the Pretender's manifestoes', and 'lamented their misleading his unhappy countrymen'.[82] Charges of offering

comfort to the enemy must have been even more embarrassing to Pitt after he had so recently proclaimed the perils of Jacobitism. The opposition's reputation was further tarnished by accusations of reckless self-serving over its attempt to turn the Prince of Wales against his grandfather at a juncture when unity in the royal family was essential.[83]

Traditional historical accounts of Pitt's opposition have exaggerated the effectiveness of his parliamentary campaign, while denigrating the performance of his ministerial rivals.[84] Literary sources, however, which are substantiated by contemporary evidence, emphasise that Pitt's failure to win converts both within doors and among political observers, was directly related to his weaknesses as a parliamentary speaker. In comparing Pitt's merits as a speaker with his competitors Murray and Fox, *Patriot Policy* charges that his speeches often suffered from two serious flaws: lack of self-control and weakness in argument. During the army estimates debate, Murray himself emphasised the difference between Pitt's 'florid eloquence' and 'the talent of solid judgment', which probably inspired the devastating rebuke Pitt receives from 'a Man of Might among the people, who was well-skilled in the Laws of the Land' in their fictional confrontation:

> Thy Tongue is *loud* and *petulant*, but thy
> Words are not *wise* and *discreet*; and the
> Gift of *Judgment* doth not dwell within thee.
> Thy Wit is as the *Fumes of new Wine*, which
> cause the *Head to* ach, but doth not make the
> *Heart glad*.
> And thine *Eloquence*, of which thou vauntest,
> is not an *Eloquence* which pleaseth – For it is
> even as a *Torrent of Mud*, which rusheth
> from a *foul Channel*, and *bespattereth the*
> *By-stander*.
> Thou knowest how to *rail and cavil*, but
> thou can'st not argue like a *Man of Reason*:
> And out of thy *own Mouth* does thou stand
> *condemned*.[85]

Walpole detected similar deficiencies in Pitt's speeches, 'his greatest failure was in argument', and 'his talent for dazzling was exposed to whoever did not fear his sword and abuse, or could detect the weakness of his arguments'.[86] Waldegrave concurred in *Patriot Policy*'s assertion that the ministry prevailed because of its fluent, compelling advocacy. He identified the same inadequacy in Pitt's rhetorical appeals: 'But the Court did not prevail by Numbers only: in all Debates of Consequence, Murray the Attorney General had greatly the Advantage over Pitt, in point of argument; and, abuse only excepted, was not much his inferior in any Part of Oratory.'[87]

In commenting upon the opposing natures and rhetorical geniuses of the two men, that Pitt was best-equipped to attack and Murray to defend, Walpole isolated the excitement stimulated by the clash of these two impressive, but very different speakers.[88] Murray distinguished himself in answering Pitt, calmly exposing his errors of fact or conclusion, and highlighting inconsistencies with his former statements. A notable example occurred during the vote to increase the Royal Navy, when Pitt claimed that he alone had anticipated France's expansionist aims, which would have been contained had his advice to augment the fleet not been ignored. Murray belittled Pitt's contention by placing it within its narrow context, 'how great the power of eloquence that could dress up the want of 2000 seamen in 1751 into the source of the war!'[89] A panegyric upon Murray's statesmanlike demeanour compared him to the great preservers of classical liberty, and praised his speeches for their powerful weight of conviction:

> Wisdom and Truth are the celestial Springs
> Of what the Pleader speaks or Poet sings.[90]

In contrast, *Patriot Policy* harasses Pitt for his losses of temper and descent into outrageous accusations and personal abuse, depicting him as a raving demon from Hell: 'His Eye-balls glared with Anger; his Looks were the Looks of Envy; the poison of Asps was under his Tongue; his Words mangled like a *Saw*; and his Voice, was like a Voice issuing from a *hollow* PIT.'[91]

To reinforce his caricature, the author refers to one of Pitt's most notorious outbursts of invective, in which he excoriated Hume Campbell as a '*servile, wretched* lawyer ... a mercenary, miserable slavish lawyer'.[92] Pitt's listeners were also alienated by his arrogant, dictatorial manner. The Scottish clergyman Alexander Carlyle and historian William Robertson, who attended the Commons during discussion of the Habeas Corpus Act in 1758, emphasised this reaction:

> With all our Admiration of Pitts Eloquence which was surely of the highest Order Robertson and I felt the same S[en]timent which was a Desire to Resist a Tyrant, who like a Domineering Schoolmaster kept his Boys in Order by raising their Fears without wasting Argument upon them.[93]

Bitter animosity against Newcastle and Fox for their alleged betrayals, and frustration at the ill-success of his opposition, at times propelled Pitt into wild charges. On 21 November 1755 and 7 May 1756 he accused the ministry of treason, declaring that it had colluded in the capture of Minorca to justify a disgraceful peace.[94] He impeached Fox for plotting to embezzle a grant to the American colonies so that he could 'sink it in some avaricious corner of the court'.[95] Pitt may even have arraigned Lady Yarmouth, George II's mistress,

for the sale of offices and honours, an outrageous accusation which could only have intensified the king's hatred.[96]

Patriot Policy praised Fox for his poised, responsible leadership of the Commons. He was described as being 'well skilled in the Business of the Nation' and an efficient, judicious communicator, 'His Words were strong and weighty, and the Matter of his Speech was solid and discreet.'[97] Waldegrave characterised Fox more as an able debater than a formal speaker, 'quick and concise Replication, is his peculiar Excellence'.[98] Cool headed and quick witted, Fox maintained his temper and dignity, and took advantage of Pitt's unfounded accusations, which he deftly turned against him in *Patriot Policy*, 'And he sorely rebuked the *frothy One* who had *first spoken*, and exposed him before the Assembly as a *vain Prater*.'[99] In describing how he deflated Pitt's assaults as the proofs of disappointed ambition, Fox emphasised how Pitt's plunges into personal defamation often distracted him from the subject of discussion, in this case the subsidy treaties. Furthermore, Fox stressed how it interfered with his ability to deliver an insightful, well-connected criticism, 'In the argument (which he is not good at), we had much the better of it.'[100] It appears that the Commons in general soon wearied of Pitt's excesses. During the army estimates debate, he was admonished for disruptive negativism during an emergency when men of good will should unite by Lord George Sackville who:

> disapproved of Mr. Pitt's present style of debating, that if our country is in such a deplorable condition, we ought to be considering how to remedy it. If he had accusations against any minister he ought to appoint a day for the purpose of hearing them; but all ministers are unworthy our consideration in comparison of relieving the public, which seemed to be forgot, and abuse or defence of our ministers to engross our whole thoughts.[101]

As the session progressed, the moral and intellectual exhaustion of the opposition was reflected in the deteriorating quality and effect of Pitt's speeches.[102] Waldegrave emphasised patriotism's poverty as the primary cause: 'the Hessian and Russian Subsidies afforded only a small supply of new matter; and the old Topics of Declamation, like Jests too frequently repeated, had lost their force and Poignancy'.[103] Walpole argued that the decline after Christmas 1755 was explained in part by Pitt's sensitivity to complaints against 'the pomp and invective' of his orations.[104]

Pitt's audience was often impressed by his striking, original metaphors. In a memorable depiction of Newcastle's alleged incompetence as first minister, he imagined the duke as a child clinging to an out of control go-kart, bearing king and country, as it careered to the edge of a precipice.[105] Most celebrated of all was his simile comparing the uneasy Newcastle–Fox alliance to the meeting of the Rhône and Saône Rivers, an analogy which accentuated their opposing character traits:

'Yes', cried he, clapping his hand suddenly to his forehead, 'I too am inspired now!' I remember at Lyons to have been carried to see the conflux of the Rhône and Saône, this a gentle, feeble, languid steam, and though languid, of no depth – the other, a boisterous and impetuous torrent – but they meet at last; and long may they continue united to the comfort of each other, and to the glory, honour, and security of this nation!'[106]

Pitt also embellished his speeches with quotations from classical and English literature, and historical allusions. When dismissing the subsidies as venal violations of the Act of Settlement, Pitt declared, 'He would quote poetry, for truth in verse was as good as if delivered in the dullest prose' and recited a passage which he claimed came from *Measure For Measure*, 'Corruptions gilded hand/May put by justice.'[107] Pitt developed a parallel between the destruction of Hannibal and Carthage, and Britain's probable fate if she abandoned her natural naval strength, and became embroiled in a continental war, twice quoting Juvenal, 'Another poet, I recollect', continued he, 'a good deal of poetry today'.[108]

Pitt's letters to his nephew Thomas, who was studying at Cambridge during this time, offer fascinating insight into his own interests in English literature, the classics and history. Pitt characteristically recommended the heroic epics of 'the two greatest poets', Homer and Virgil, urging Thomas to 'drink as deep as you can of these divine springs', as well as Horace, Terence, Dryden, Pope, Addison and Molière.[109] His library also included Shakespeare, Marvell and Racine. Pitt's correspondence demonstrates his great admiration and careful study of classical rhetoric, and especially of Demosthenes and Cicero, whom he adopted as his models. Pitt advised his nephew:

> arm yourself with all the variety of manner, copiousness and beauty of diction, nobleness and magnificence of ideas, of the Roman consul; and render the powers of eloquence complete by the irresistible torrent of vehement argumentation, the close and forceful reasoning, and depth and fortitude of the mind, of the Grecian statesman.[110]

Those who found Pitt's speeches, like his correspondence, often verbose, convoluted, pedantic and patronising, would not be surprised to learn that he twice read through Bailey's dictionary to expand his vocabulary, and that he studied sermons for style.[111] The latter influence did not escape the attentive ear of *Patriot Policy*'s satirist, who at times makes Pitt sound as if he is a self-righteous preacher hectoring his congregation.

Despite the originality, force, aptness and grace of much of Pitt's rhetoric, it appears that it often failed to appeal to an audience, at least within Parliament and higher political circles, which preferred a more practical discussion of issues. In explaining the limited impact of Pitt's speeches, Walpole emphasised that by the mid-eighteenth century, historical analogy and 'the pomp

and artful resources of oratory were in a great measure banished': 'Similes, and quotations and metaphors were fallen into disrepute, deservedly: even the parallels from old story, which during the virulence against Sir R. Walpole had been so much encouraged, were exhausted and disregarded'.[112]

Patriot Policy's allegorical debate suggests that MPs would respond much more readily to Fox's precise brevity and Murray's appeals to reason and logic. Walpole seems to agree that their conduct was considered most appropriate for political discourse, 'the style that prevailed, was plain, manly, argumentative'.[113] In this context, Nugent's pun upon Pitt and the patriot journal *Common Sense* should not be forgotten. A poem addressed to Newcastle at the conclusion of the 1755–56 parliamentary session, probably written by the Whig clergyman Thomas Newcomb, contains a satiric parade of all the enemies of his administration.[114] In jeering at the Rhône and Saône metaphor, Newcomb warns Pitt that he cannot conceal a superficial understanding of complex domestic and foreign policy problems behind a dazzling, but shallow veneer of rhetorical tricks:

> Hark! hark! I hear a midnight roar!
> St Stephen shakes his strong-based floor:
> Sure there's some Irish Bully!
> No – 'tis two Rivers from the South,
> Now disemboguing at the Mouth
> Of our unpension'd Tully.
>
> 'Tis fine! 'tis full! the period's round!
> How clear! how musical the Sound!
> The Gesture – oh! quite striking!
> What Flows! what Flow'rs of Eloquence!
> I grant it – Yet, a little Sense
> Were much more to my Liking.
>
> On this side flows the gentle Soan:
> On that, the rushing Rapid Rhone:
> Are these our great Abilities?
> I'll teach a Magpye out of Pow'r,
> To chatter to ye, by the hour,
> Full as good Puerilities.[115]

Pitt had committed himself to several rash propositions, which must have been poorly received by informed opinion. When advocating an exclusively maritime and colonial war, he exaggerated the strategic effect of British sea power in claiming that the capture of Cape Breton coerced the French into making major territorial concessions in the Low Countries in 1748. At the same time his analysis underestimated the dangers of diplomatic isolation if the country turned her back upon the continent. Pitt's assertion that the

money spent upon the Hessians 'would have conquered America' could not have been taken seriously.[116]

The State Farce also alludes to another closely-related criticism of Pitt's parliamentary speeches: that he performed for the gallery. Because Pitt lacked diplomatic experience and competence, and the intellect to compete with his political and social equals, he courted popularity among the mob to compensate for his deficiencies. Waldegrave wrote: 'He is not always a fair or conclusive Reasoner, but commands the Passions with Sovereign Authority, and to inflame or captivate a popular Assembly, is a consummate Orator.'[117]

Patriot Policy takes up this charge in its portrayal of Pitt as false prophet or demagogue. He shamelessly flatters the people by giving them an exaggerated sense of their wisdom and importance, and manipulates them with simplistic, emotional addresses. In seeking to whip up popular outrage against the subsidies, Pitt had offended many by his declaration of extreme Whiggism, 'the King owes a supreme service to his people'.[118] *Patriot Policy* accuses Pitt of mobilising the mob to thrust himself into power, tearing down the justly balanced constitutional fabric of the state. He commences with an effort to ingratiate himself with the multitude, which echoes his controversial statement of the people's ultimate authority, 'O ye *chosen Men*! Ye are a mighty People, and there is none above you – No not the *K[in]g* himself.'[119]

The passage from *Instructions to a French Spy* is important for its assessment of the potential impact of a popular opposition emanating from the City of London. The patriots, however, were unable to mobilise extra-parliamentary pressure upon their behalf. Indications suggest that the many groups that were active in City and national politics, and historically had been aligned against the court – bankers and merchants independent of the plutocratic financial elite, professionals, tradesmen and shopkeepers – endorsed the ministry's international initiatives. The failure of an attempt by Lord Poulett, a disgruntled Lord of the Bedchamber, to instigate the City to address the King against departing for the electorate in April 1755, when Britain was on the brink of war, emphasises the moderation of those elements which might have been expected to embrace such an explosive anti-Hanoverian issue. Walpole commented that Poulett's patriotism futilely 'vented itself in reams of papers without meaning, and of verses without metre'.[120] An anthology of loyal poems defended the King's decision, perhaps in rebuttal to Poulett's presumption.[121] Bute and Glover also failed to promote a petition against the subsidy treaties soon after. In fact, loyal addresses in September 1755 and April 1756 demonstrated the City's agreement with the measures implemented by the administration for safeguarding commerce, persecuting the North American war, and frustrating a French invasion.[122] The ease with which the supplies were raised in the autumn of 1755 offers confirmation of the City's

confidence in the ministry. Merchants were elated by the success of attacks upon the French merchant marine begun in August 1755, which by November had captured over 300 vessels and 6000 seamen.[123]

The decision of the ministry to fund its wartime expenditure with new taxes proved to be the only issue upon which some popular interest could be created. Although an increase in the land tax to 4 shillings was readily passed, the fiscal measures proposed by Lyttelton, the new Chancellor of the Exchequer, stirred some dissatisfaction within the City in early 1756. On 25 February, he laid plans for taxes before the Commons, including one upon plate.[124] The City instructed its MPs to oppose the plate tax and petitioned Parliament against it. The opposition was unable to exploit the initial signs of disapproval over the plate tax, however, which soon lost its momentum. Pitt revealed his limited understanding of financial affairs during the budget debates. It was a subject of great importance to the country gentlemen, backbenchers and the tax-paying public, who respected leaders for providing fiscally responsible government. Pitt's refusal to take any interest in financial administration proved to be a handicap throughout his political career. The issue of the new taxes was recorded in a poem satirising Lyttelton for abandoning Pitt, and accepting promotion within the Newcastle ministry. The dissolution of the 'historic friendship' between Pitt and Lyttelton, who began their careers in opposition as the Boy Patriots under the patronage of Lyttelton's uncle Lord Cobham, led to heated exchanges in the Commons. On 12 May 1756, Lyttelton censured the violence of the opposition, rebuking Pitt for stooping to employ the language of Billingsgate and advising 'if he assumed fewer airs of superiority, it would do him more honour'.[125] Pitt had sneered at Lyttelton's reputation as a man of letters, claiming that as 'a pretty poetical genius; with his pen in his hand, nobody respected him more', but that he was unfit to manage national finance.[126]

Lyttelton had embraced the Christian faith in 1747, and his personal experience inspired him to write a reflection upon St Paul, which won the admiration of Dr Johnson.[127] *The Converts* plays upon Lyttelton's piety to attack him for not going into opposition:

> Had you a *Call*? or was't a Light,
> From Court that shone upon your Sight,
> Made you a Politician:
> *Ordained* to teach, and propagate,
> The *Doctrines*, and the *Creeds* of State,
> By Min[is]t[eria]l *Mission*?[128]

The author exploits the financial meaning of conversion to ridicule Lyttelton's alleged incapacity in his office. Lyttelton was one of the age's most respected men of letters and literary patrons, enjoying the friendship of Pope, Thomson

and Fielding, who dedicated *Tom Jones* to him. He was unprepared by experience or nature for his responsibilities as Chancellor of the Exchequer, and his reputation as a poet was seized upon as proof of his incompetence:

> Of you conceiv'd they better Hope,
> Charm'd with the Strain to Poyntz and Pope,
> And pleas'd with Letters Persian:
> But all in Tears, alas! they burst,
> And mourn that fatal Hour, when first
> You meddl'd with Conversion.[129]

Lyttelton is warned of Newcastle, who uses and discards colleagues depending upon political expediency:

> Conversion favour'd by the Great,
> Encouraged both in Church and State;
> How wisely, who can say?
> For Dealers in that shifting Trade,
> Who their *Old* Friends have once betray'd
> May *New* Ones too betray.[130]

The Converts, with its complementary political and literary attacks, and Lyttelton's career as minister and man of letters, emphasise the important position occupied by poetry in eighteenth-century public affairs. It is also noteworthy as the only major anti-ministerial poem of 1755–56, but as such concentrates upon Lyttelton, and has nothing positive to say in favour of the opposition.

A comparison of *An Orator's Political Meditation, A New Historical Ballad, Patriot Policy*, and *The State Farce* with eye-witness accounts of the 1754–56 parliamentary sessions demonstrates the accuracy with which they recorded the renewal of conflict within the Commons. In an era before the printing of regular, reliable parliamentary debates, they emphasise the important role played by political literature in quickly disseminating knowledge of issues and events at Westminster among the governing elite and the wider political nation.[131] Although the *London Magazine* continued its reporting of debates into the 1750s, to avoid prosecution for a breach of privilege, the speeches that it printed appeared so long after the crisis that inspired them, that their publication made little contribution to current discussion. During the autumn of 1755, while Pitt clashed with Murray and Fox over the subsidy treaties, the magazine printed four debates from the King's Address of November 1754. The irrelevance of many of the magazine's debates was illustrated by the publication of the Commons' February 1756 deliberations upon imported linen in July, after war had been declared, and the public were anxiously awaiting to learn whether the besieged fortress of Minorca had fallen to the

French.[132] The authors of these ballads, poems and prose satires almost certainly possessed first-hand knowledge of speeches, suggesting that they attended the debates themselves or received information from sources who had. The involvement of Bedford, Rigby, Newcastle and Newcomb in their patronage, composition and distribution suggests that leading politicians recognised political literature's value as a vehicle for appealing to opinion within the parliamentary classes and beyond the confines of Whitehall and Westminster.

Political prints, by their themes and the scale of their production, serve as reliable indicators of the issues which occupied the attention of the political nation, and of the intensity of political controversies. Approximately ten prints appeared between 1755 and the spring of 1756, almost equally divided between censure and commendation of the administration's handling of the international crisis. Four accused the ministers of neglecting British maritime and colonial interests out of deference to Hanover.[133] But they were balanced by three that praised its military initiatives in North America and attacks upon the French merchant marine and navy.[134] Perhaps what is most significant is the modest number of engravings, which reinforces the impression given by literary sources that the patriot opposition was as unsuccessful in its endeavours to attract extra-parliamentary support as it was in persuading the legislature to endorse its criticisms.

The ministry's victories in the votes of the 1755–56 session not only indicate that the vast majority of the Whig party rejected the opposition, but also emphasise Pitt's failure to cement an alliance with the Tories. Although many voted against the subsidies, thereafter most refused to commit themselves to the opposition. Suspicion of the patriots' motives and wariness of being branded Jacobite sympathisers probably made the Tories reluctant to cooperate with the opposition.[135] The arguments of the literary works justifying the response to French aggression reflect those which inspired the majority of the Whig party and the political nation to rally behind the Newcastle ministry. Two major reasons may be identified. First was the conviction that the subsidies represented the best available means of restricting the conflict to North America and the high seas. Second, many politicians were distressed by the prospect of political division, including a breach in the royal family, when Britain was commencing a war against her most powerful enemy, and confronted by the threat of invasion. These were the considerations which motivated influential Whig statesmen such as Horatio Walpole, Devonshire and Bedford to overcome their doubts and support the treaties.[136] A panegyric emphasised Newcastle and Hardwicke's triumph in reimposing Old Corps control of government after the death of Pelham, and retaining public confidence as the international crisis developed. They were honoured as the realm's true patriots:

But hail, illumin'd at fair Virtue's Shrine,
Ye, for whose Brows Fame wreaths th' eternal Twine,
Who wake for Justice, pant for Freedom's Cause,
The YORKES and PELHAMS of the State and Laws,
Wield Britain's Thunder on th' embattled Plain,
Or spread her Flag triumphant o'er the Main;
Rare Lot, alas! by Arts lie these to rise,
Giv'n to the few, the daring and the wise.[137]

In June 1756 however, reports of a British naval reverse in the Mediterranean, and the fall of the strategic island of Minorca, would radically transform the situation.

NOTES

1 David Garrick, *An Ode on the Death of Mr. Pelham*, 1754, p. 6.
2 Earl of Hardwicke to the Archbishop of Canterbury, 11 Mar. 1754 and Minute of the Cabinet 12 Mar. 1754, in Philip C. Yorke, *The Life and Correspondence of Philip Yorke, Earl of Hardwicke* (Cambridge, 1913), II. 208, 191–2; George Bubb Dodington, *Political Journal*, ed. John Carswell and Lewis Dralle (Oxford, 1965), pp. 251–5; J. C. D. Clark, *The Dynamics of Change* (Cambridge, 1982), pp. 44–98.
3 G. S. Fox-Strangeways, *Henry Fox, First Lord Holland, His Family and Relations* (London, 1920), I. 206–10; J. C. D. Clarke (ed.) *Memoirs and Speeches of James, 2nd Earl Waldegrave 1742–1763* (Cambridge, 1988), pp. 152–5; Horace Walpole, *Memoirs of George II*, ed. John Brooke (New Haven, 1985), II. 7; Dodington, pp. 251–6.
4 Horace Walpole to Sir Horace Mann, 7 Mar. 1754, *Horace Walpole's Correspondence*, ed. W. S. Lewis *et al.* (New Haven, 1937–83), XXI. 412.
5 Newcastle to Hardwicke, 21 Sept. 1754, Yorke, II. 217.
6 Henry Jones, *Verses to His Grace of Newcastle*, 1754; *An Ode to the Duke of Newcastle*, 1754.
7 Pitt to Newcastle, 24 Mar. 1754 in Lord Rosebury, *Chatham: His Early Life and Connections* (London, 1910). p. 329; Hardwicke to Pitt, 2 Apr. 1754, Newcastle to Pitt, 2 Apr. 1754, Chatham, I. 89–100.
8 Pitt to Lyttelton, 4 Apr. 1754, George, Lord Lyttelton, *Memoirs and Correspondence*, ed. Robert J. Phillimore (London, 1845), II. 467.
9 Fox to Hartington, 26 Nov. 1754, James Earl Waldegrave, *The Memoirs and Speeches* (London, 1821), p. 147; Walpole, *Memoirs*, II. 25; John Calcraft to Digby, 26 Nov. 1754, HMC, *Eighth Report*, Pt. I. 225b.
10 Fox to Hartington, 26 Nov. 1754, Waldegrave, *Memoirs*, p. 149; Walpole, *Memoirs*, II. 25.
11 Walpole, *Memoirs*, II. 39; Cobbett, XV. 500–4; Williams, I. 258.
12 Fox to Hartington, 28 Nov. 1754, Waldegrave, *Memoirs*, pp. 151–2; Walpole, *Memoirs*, II. 28; Clark, *Waldegrave*, pp. 161–3.
13 Walpole, *Memoirs*, II. 40. The patriot journal *The Craftsman* was chiefly written by Bolingbroke and Pulteney. *Common Sense* was another influential opposition essay paper established by Sir George Lyttelton and the Earl of Chesterfield.
14 Williams, I. 60–122.
15 *The Orator's Political Meditation*, 1754, p. 24.

16 Charles Hanbury Williams, 'The Unembarrassed Countenance', *The National Journal*, 29 May 1746.
17 Phillimore, II. 478; Grenville, 'Narrative', Smith, I. 431.
18 *An Excellent New & Long Historical Ballad*, 1755.
19 Bedford to Hanbury Williams, 28 Jan. 1755, *Correspondence of John, Fourth Duke of Bedford* ed. Lord John Russell (London, 1843), II. 156.
20 *Orator's*, pp. 28–30.
21 Clark, *Waldegrave*, pp. 161–2; Hardwicke to Newcastle, 15 Dec. 1754, Yorke, II. 221.
22 Chatham, I. 124–37; Waldegrave, *Memoirs*, pp. 155–62; Dodington, pp. 292–6.
23 Dodington, pp. 298–302; Clark, *Waldegrave*, pp. 160–4.
24 James Lee McKelvey, *George III and Lord Bute* (Durham NC, 1973), pp. 18–21.
25 Clayton, 571–603.
26 Dodington, p. 320.
27 Newcastle and Hardwicke correspondence, 26 July to 6 Sept. 1755, Yorke, II. 230–49.
28 Dodington, pp. 321–7.
29 Clark, *Waldegrave*, pp. 170–71; Ilchester, *Fox*, I. 267–73.
30 Richard Rigby to the Duke of Bedford, 21 Aug. 1755, Bedford, II. 167.
31 Newcastle to Hardwicke, 22 Aug. 1755, Yorke, II. 235.
32 Richard Glover, *Memoirs of a Celebrated Literary and Political Character* (London, 1814), p. 65; John Yorke to Lord Royston, 28 Oct. 1755, Yorke, II. 252.
33 Walpole to Chute, 29 Sept. 1755, *Corr.*, XXXV. 89.
34 John Brewer, *The Sinews of Power: War, Money and the English State 1688–1783* (London, 1989), pp. xi–xxi.
35 J. G. A. Pocock, *The Machiavellian Moment: Florentine Political Thought and the Atlantic Republican Tradition* (Princeton, 1975), pp. 477–86; *Virtue, Commerce and History: Essays on Political Thought, Chiefly Eighteenth Century* (Cambridge, 1985), pp. 215–310; H. T. Dickinson, *Liberty and Property: Political Ideology in Eighteenth-Century Britain* (London, 1977), pp. 91–118; R. Harris, *Politics and the Nation: Britain in the Mid-Eighteenth Century* (Oxford, 2002), pp. 67–101.
36 Brewer, *Party Ideology*, pp. 43–111.
37 Dickinson, *Liberty and Property*, pp. 181–4.
38 Nicholas Rogers, *Whigs and Cities: Popular Politics in the Age of Walpole and Pitt* (Oxford, 1989), pp. 15–22, 89–93.
39 Richard Pares, 'American Versus Continental Warfare 1739–1763', *English Historical Review*, LI (1936), 429–69; D. A. Baugh, 'Great Britain's "Blue-Water Policy", 1689–1815', *International History Review*, X (1988), 33–58.
40 J. R. Western, *The English Militia in the Eighteenth Century* (London, 1965), pp. 104–14.
41 Walpole, *Memoirs*, II. 70.
42 H. T. Dickinson, 'Popular Politics in the Age of Walpole', in J. Black (ed.), *Britain in the Age of Walpole* (London, 1984), pp. 45–69; Rogers, *Whigs*, pp. 1–5, 391–405.
43 Isaac Kramnick, *Bolingbroke and His Circle: The Politics of Nostalgia in the Age of Walpole* (Cambridge, Mass., 1968); Quentin Skinner, 'The Principles and Practice of Opposition: The Case of Bolingbroke versus Walpole', in Neil McKendrick ed., *Historical Perspectives* (London, 1974), 93–128; R. Harris, *A Patriot Press*, pp. 1–46, 147–86; M. Harris, *London Newspapers*, pp. 113–34 and 'Print and Politics in the Age of Walpole', in J. Black (ed.), *Britain in the Age of Walpole* (London, 1984), pp. 171–89.
44 Paul Langford, *The Excise Crisis* (Oxford, 1975); Kathleen Wilson, 'Empire, Trade and Popular Politics in Mid-Hanoverian Britain: The Case of Admiral Vernon', *Past and Present*, CXI (1988), 74–109.

45 Goldgar, pp. 5–7, 87–150, 166–93; Gerrard, pp. 1–16, 99–107.
46 Walpole to Mann, 21 Mar. 1746, *Corr.*, XIX. 229.
47 *A Letter to the Author of the Ode on Mr. Pelham's Death*, 1754.
48 *The Courtier and Patriot*, 1755, pp. 4–5.
49 *Ibid.*, p. 7.
50 Cobbett, XV. 527; Walpole, *Memoirs*, II. 68–73; Ilchester, *Fox*, I. 285.
51 Cobbett, XV. 529–42, 616–63; Debrett, III. 235–40; Walpole, *Memoirs*, II. 99–105.
52 Ellis to Hartington, 22 Nov. 1755, Ilchester, *Fox*, I. 288–9.
53 Cobbett, XV. 696–9; Debrett, III. 241–3; Walpole, *Memoirs*, II. 85–91, 126–8.
54 Cobbett, XV. 700–2; Clark, *Waldegrave*, p. 173.
55 Walpole, *Memoirs*, II. 140–2.
56 Karl Schweizer, *Frederick the Great, William Pitt, and Lord Bute: The Anglo-Prussian Alliance, 1756–1763* (London, 1991).
57 Cobbett, XV. 703; Walpole, *Memoirs*, II. 139–47.
58 Walpole to Mann, 27 Oct. 1755, *Corr.*, XXI. 506.
59 *A New System of Patriot Policy*, 1756, pp. 5–6.
60 *Ibid.*, p. 7. To appreciate its parodies, *Patriot Policy* should be read with a King James Bible and concordance.
61 Alexander Cruden, *A Complete Concordance to the Holy Scriptures* (London, 1769), p. 360.
62 *Patriot Policy*, pp. 12–20.
63 Walpole, *Memoirs*, II. 71.
64 *Ibid.*, 70.
65 *Ibid.*, 68.
66 *Patriot Policy*, pp. 25, 27.
67 Walpole, *Memoirs*, II, 111.
68 *Patriot Policy*, p. 26.
69 *Ibid.*, p. 27.
70 *A Letter from a Cobler to the People of England*, 1756, p. 32.
71 Thomas Potter to Pitt, 4 June 1756, Chatham, I. 161.
72 *Patriot Policy*, pp. 19–20, 25–7.
73 *Great Britain's Resolution to Fight the French*, 1755; *The Dream; or, England Invaded*, 1756; *Invasion: an Occasional Ode*, 1756; 'On the Present Prospect of an Invasion', *GM*, Apr. 1756, 191; *The Soldier's Song*, 1756.
74 *The Invasion*, BMC 3446; *The Invasion, Plate II.* BMC 3454.
75 SP 36/132 Pt. I. 24.
76 *Letter from a Cobler*, pp. 4–5, 37–46.
77 Daniel Szechi, *The Jacobites* (London, 1994).
78 *Patriot Policy*, p. 17.
79 Walpole, *Memoirs*, II, 83.
80 *The King of France's Instructions to a French Spy*, 1755, pp. 3–5.
81 *Ibid.*, pp. 4–5.
82 Walpole, Memoirs, II. 96.
83 Clark, *Waldegrave*, p. 171.
84 Williams, *Pitt*, I. 268–78.
85 *Patriot Policy*, pp. 23–4.
86 Walpole, *Memoirs*, II. 118.
87 Clark, *Waldegrave*, p. 171.
88 Walpole, *Memoirs*, II. 118.
89 *Ibid.*, 80.

90 *An Ode on the Powers of Eloquence*, 1755, p. 6.

91 *Patriot Policy*, 9.

92 *Ibid.*, p. 28; Fox to Devonshire, 11 Dec. 1755, Ilchester, *Fox*, I. 294; Rosebury, p. 431; Walpole, *Memoirs*, II. 99.

93 Alexander Carlyle, *Anecdotes and Characters of the Times*, ed. J. Kinsley (London, 1973), p. 171. Carlyle also observed that Pitt's oratory depended upon the 'overpowering Force of persuasion, more than the clear Conviction of Argument'.

94 Newcastle to Hardwicke, 8 May 1756, Yorke, II. 289; Walpole, *Memoirs*, II. 76, 142–3.

95 Williams, I. 275; Ilchester, *Fox*, I. 313.

96 Narrative, Smith, I. 435.

97 *Patriot Policy*, p. 30.

98 Clark, *Waldegrave*, p. 157; Walpole, *Memoirs*, II. 119.

99 *Patriot Policy*, p. 30.

100 Fox to Devonshire, 11 Dec. 1755, Ilchester, *Fox*, I. 295.

101 Rigby to Bedford, 6 Dec. 1755, Bedford, II. 180.

102 Walpole to Mann, 23 Jan., 23 Feb. 1756, and to Henry Seymour Conway, 12 Feb., 4 Mar. 1756, *Corr.*, XX. 525, 531; XXXVII. 442, 444; W. M. Torrens, *History of Cabinets* (London, 1894), II. 273; Williams, I. 275.

103 Clark, *Waldegrave*, p. 169.

104 Walpole, *Memoirs*, II. 118.

105 *Ibid.*, p. 112; John Yorke to Royston, 13 May 1756, Yorke, II. 290.

106 Walpole, *Memoirs*, II. 71; Ellis to Hartington, 15 Nov. 1756, Ilchester, *Fox*, I. 285.

107 Walpole, *Memoirs*, II. 111. According to the editors of the Yale edition, no such line appears in any Shakespeare play. Although the flaw may lie in Walpole's transcription, Pitt's critics would attribute the error to a vain attempt to exhibit shallow learning.

108 *Ibid.*, 112.

109 Pitt to Thomas Pitt, 12 Oct. 1752, Chatham, I. 62–3.

110 Pitt to Thomas Pitt, 13 Jan. 1756, *Ibid.*, 152.

111 Williams, I. 213.

112 Walpole, *Memoirs*, II. 117.

113 *Ibid.*, 116.

114 BL, Add. MSS 32,948 (Newcastle Papers) fo. 381: Newcomb to Newcastle, 25 May 1763.

115 *The State Farce: a Lyrick*, 1756, p. 4. At least two editions were printed.

116 Walpole, *Memoirs*, II. 142.

117 Clark, *Waldegrave*, p. 152.

118 Walpole, *Memoirs*, II. 70.

119 *Patriot Policy*, p. 9.

120 Walpole to Richard Bentley, 6 May 1755, *Corr.*, XXXV. 225; Earl Poulett, *Sibyline Leaves*, 1755; Debrett, III. 232–5.

121 *State Poems*, 1755, p. 4.

122 BL, Add MSS 35,398, fo. 279: Birch to Royston, 23 Oct. 1755.

123 Walpole to Mann, 21 Aug. 1755, *Corr.*, XX. 493; *Great Britain's Resolution to Fight the French*, 1755.

124 Walpole to Conway, 4, 6 Mar. 1756, *Corr.*, XXXVII, 444, 451.

125 Walpole, *Memoirs*, II. 147.

126 *Ibid.*, II. 147.

127 Phillimore, I. 297.

128 *The Converts*, 1756, p. 3.

129 *Ibid.*, p. 6.

130 *Ibid.*, p. 5.

131 B. B. Hoover, *Samuel Johnson's Parliamentary Reporting* (Los Angeles, 1953), pp. 1–32.

132 *LM*, Nov., Dec. 1755, 516–21, 561–9, July 1756, 213–21.

133 *The American Moose-Deer*, BMC 3280; *The Grand Monarch in a Fright*, BMC 3284; *A Goose of Old*, BMC 3330; *Oliver Cromwell's Ghost*, BMC 3340.

134 *Britain's Rights Maintained*, BMC 3331; *British Resentment*, BMC 3332; *Britannia's Revival*, BMC 3377.

135 Walpole to Mann, 16 Nov. 1755, *Corr.*, XX. 510; Lyttelton to William Lyttelton, 28 Apr. 1756, Phillimore, II. 507.

136 W. Coxe (ed.), *Memoirs of Horatio, Lord Walpole* (London, 1802), pp. 417–19; Hardwicke to Newcastle, 3 Nov. 1755, Yorke, II. 252.

137 *The Seventeenth Epistle of the First Book of Horace Imitated*, 1756, p. 13.

3

Byng and the fall of Minorca

IN APRIL 1756 the French attacked the Mediterranean island of Minorca, an operation originally conceived as a diversion to facilitate an invasion of Britain. An army led by the Duc de Richelieu sailed from Toulon, escorted by a fleet commanded by the Marquis de la Galissonière, and landed at Cuidadela on 18 April. Richelieu laid siege to the fortress of St Philips, which covered the naval base at Port Mahon, where the Lieutenant Governor of the island, General William Blakeney, had withdrawn his garrison. British intelligence sources had warned of a possible assault upon Minorca, but these were dismissed by Lord Anson, the First Lord of the Admiralty. Reliable reports of invasion preparations were received in January and February, however, and on 8 March 1756 they were confirmed by an agent at Versailles. Newcastle, Holdernesse and Fox instructed Anson to dispatch a fleet to the Mediterranean, carrying an infantry battalion to reinforce Minorca's garrison. The Governor of Gibraltar was ordered to supply an additional battalion if an attack appeared imminent.

John Byng was appointed to the command. He appeared to be well qualified, having served in the Mediterranean during the War of the Austrian Succession, becoming Commander-in-Chief of the station; and next to Anson, was the most senior serving officer. Byng was dissatisfied with the state of his command: his crews were 722 men below strength, and several of his ships were in poor condition. Byng's preparations were hampered by orders granting sailing priority to a squadron of ships of the line intended to attack a French convoy of merchantmen trapped in Cherbourg. The relief expedition weighed anchor on 6 April, only four days before Galissonière sailed from Toulon, and reached Gibraltar on 2 May.[1]

The Governor of Gibraltar Thomas Fowke was reluctant to weaken his garrison by surrendering the battalion to reinforce Minorca. He summoned a council of engineering experts, which declared that French artillery occupying the heights above Port Mahon would make landing the troops impossible,

and Byng failed to insist that he release the troops. Byng was dismayed by the decayed state of Gibraltar's dockyards, and the dearth of naval stores, which he would need for refitting, and his pessimistic appreciation of the situation, written on 4 May, provided the first intimation that he was ill-suited for the challenges of high command. He magnified the difficulties confronting him, and appeared to accept Fowke's assumption that any effort to relieve Minorca would be futile.[2]

Byng arrived off Port Mahon on 19 May, and was seeking to establish communication with the garrison when Galissonière appeared. He immediately deployed his fleet to engage the French. The lateness of the day and light winds delayed the battle until the following afternoon. The two forces were evenly matched. The British enjoyed a slight advantage in ships, thirteen to twelve, and in total number of guns, 826 to 796, but the French warships were larger and carried heavier cannon. Galissonière's ships were more completely manned and in better condition, with newer rigging, and hulls which were less encrusted with barnacles, giving them superior speed. Byng had maintained control of the weather gauge and the initiative to attack. The van under Rear Admiral Temple West was first into action. West's ships inflicted considerable damage upon their opponents and soon drove them to leeward. The advance of Byng's centre division was halted by the *Intrepid*, whose foretop mast had been shot away. Byng's flagship, the *Ramillies,* was forced to shorten sail and bear away three points to starboard. To preserve his formation, Byng ordered the following ships to brace-to. By the time Byng's division had closed the gap which had opened between it and West, Galissonière had decided to break off the engagement. The greater speed of the French ships and the battered rigging of his own convinced Byng that it would be futile to pursue.[3] Although the British might claim that they had won the battle, in reality it was a strategic victory for the French, for Galissonière had frustrated Byng's attempt to deliver reinforcements to Minorca. Byng maintained his position off Minorca for three days. On 24 May he summoned a Council of War. Byng read out extracts of his instructions, and placed a series of questions before his officers. The questions reveal that they were drafted in order to justify the decision he had already taken: that it was impossible to defeat Galissonière given the size and condition of his current force, and that a return to guarantee the security of Gibraltar was his primary responsibility. The next day Byng dispatched an official report of the battle and this resolution to the Secretary of the Admiralty, John Cleveland, and a private letter to Anson describing in more detail the damage suffered by his fleet.[4]

News of the French landing on Minorca reached London on 6 May, a revelation very unwelcome to ministers now aware of how badly they had misjudged the reality of the threat. The Cabinet Council ordered an immediate

naval reinforcement to be sent to the Mediterranean. Dodington, the Treasurer of the Navy, recorded Newcastle and Fox's anxiety. Both conceded that the ministry had responded too slowly and with too little force, but each denied personal responsibility. Newcastle censured Anson for the faulty deployment of the fleet, while Fox asserted that he had recommended augmenting Minorca's garrison and British naval strength in the Mediterranean.[5] The invasion of Minorca seemed to give substance to Pitt's charges in Parliament on 7 and 12 May that an unprepared, indecisive ministry had completely mismanaged the entire international situation. Fox's presumption that the relief effort would fail discouraged him from defending Newcastle's leadership and the ministry's record.[6] On 31 May, the ministers received Byng's dispatch from Gibraltar. Their confidence in Byng was shaken by his acquiescence in Fowke's refusal to send reinforcements on the questionable assumption that communication with Port Mahon would be cut off. They must have been even more disconcerted by Byng's statement that delivering the battalion would only swell the number of prisoners taken by the French, because its fall appeared to be inevitable.[7] On 2 June, the ministry's hopes that Minorca would be saved by a naval victory were shattered when the Spanish ambassador supplied Fox with a copy of Galissonière's report of the battle.[8] Galissonière claimed that the British broke off the engagement and abandoned any intention of relief. Byng's behaviour at Gibraltar and the pessimistic tone of his assessment had so biased the ministry against him that on the following day, without waiting to receive his own account, it relieved him of his command.[9]

Conscious of their own responsibility for neglecting the security of Minorca, and the criticism which the naval reverse and the probable loss of the island would produce, Newcastle, Fox and Anson convinced themselves that Byng's conduct revealed an appalling failure of nerve and initiative.[10] Alluding to the proceedings at Gibraltar, Fox cynically had predicted that a dispatch would soon be received from Byng, in which his retreat was endorsed by a council of war. On 23 June, the arrival of Byng's letters confirmed the ministers' suspicions that he was guilty of dereliction of duty, and sought to shield himself behind the resolutions of the Council of War. Two days later they decided to court martial him under the Twelfth Article of War.[11] The ministry's determination to concentrate blame upon Byng was stimulated by his complaints about its belated response, the insufficiency of his fleet, and the wretched condition of Gibraltar's naval facilities, which it anticipated would become public. A description of the Council of War, posted to Fox by Augustus Hervey, emphasised the danger to the ministry's reputation posed by charges of negligence: 'Everyone here calls out loudly on the manner this fleet was sent and how late, how equipped, no storeships, no hospital ship, no fireship, nor no tender. The Council of War had liked to have ran into very strong reasons for their resolutions.'[12] Newcastle was

incensed by Byng's criticisms, and a desire to stifle them must have contributed to the decision to try the admiral, 'The sea officers should be learnt [not] to talk in this manner and not to think to fling the blame upon civil ministers.'[13]

Since the report of the French landing, public attention had been absorbed by the fate of Minorca. Newspaper and magazine articles had underlined the strategic importance of the island, which provided an excellent base for a fleet blockading Toulon or Cartagena, and dominated the great Mediterranean trade routes from Gibraltar to the wealthy commercial centres of Spain, France, Italy, North Africa and the Levant.[14] Originally expectations were high that Minorca would be preserved. Walpole expressed the people's optimism by joking that they awaited the arrival of Richelieu's head, which would be exhibited upon Temple Bar as a trophy of victory.[15] Galissonière's report of a drawn battle shocked a nation complacent in the belief of its naval superiority. As an unsubstantiated enemy report, initially it was discounted by London and provincial newspapers, and the ministry's decision to sack the admiral solely upon its evidence had not been unquestioned.[16] Many still refused to believe that Byng had forsaken Minorca. Rumours and contradictory reports circulated. As late as the end of June, many newspapers published a report from Barcelona that Byng had driven off the French fleet, and landed troops at Port Mahon.[17] In Edinburgh, Carlyle recorded how 'the First Accounts made it be Believ'd that the French were Defeated'.[18] The long wait for Byng's dispatches, which it was hoped would contradict Galissonière, increased the already high level of tension. Byng's recall and his retreat to Gibraltar had been announced immediately, but during the three-week interval, bewilderment and disbelief remained the dominant reactions, despite signs of simmering discontent, which some observers thought might break out against the Admiralty and others against Byng.[19] Coffee-house scenes in a satirical play inspired by the invasion of Minorca dramatise the gathering of a representative group of ship's captains, merchants, stockjobbers, gentlemen and tradesmen who urgently call for the London Gazette, the Daily Advertiser, and the Gazetteer in their anxiety to receive the latest intelligence about the prospect of relief. The company exchange rumours and opinions, and speculate upon the commercial implications of the loss of so important a base for the control of Mediterranean trade.[20] The intense disappointment created by Byng's own confession of failure was aggravated by this atmosphere of extreme uncertainty and misplaced hope.

The ministry managed the release of information in such a way as to convince political opinion of Byng's culpability. On 3 June, it had justified the admiral's recall by printing an account of his retreat to Gibraltar despite the fact that it had received no official notification. On 26 June, the day after it had privately determined to court martial Byng, the ministry published a

heavily censored version of his letter to Cleveland in the official government newspaper the *London Gazette*. References which reflected upon the ministry were suppressed, most notably Byng's statements concerning the relative inferiority of his fleet's armament and Gibraltar's decrepit dockyards. More significantly, passages describing Byng's efforts to establish contact with the besieged garrison, and his explanation that his withdrawal was necessitated by the damage and sickness suffered among the fleet, were erased in an attempt to make him appear guilty of negligence and cowardice. The fact that Byng's decision to retreat had received the unanimous approval of the Council of War was struck out in order to emphasise his personal responsibility. The most spiteful omission occurred in the final sentence, where the verb 'cover' was cut out, to make it seem as if Byng were flying in the face of the enemy rather than returning to protect a vulnerable naval base, 'I dispatch this to Sir Benjamin Keene, by way of Barcelona; and am making the best of my way to [cover] Gibraltar.'[21] Byng's editor was probably Fox, who notified a supporter on the Admiralty Board of the publication, 'You'll see in the Gazette an Abstract of Bing's Letter: He says He beat them; but they were stronger than Him; and some other Absurdities, which We leave out.'[22] Later he attempted to defend the censorship by arguing that it was intended to deny the enemy intelligence about the condition and movements of Byng's fleet, a specious claim contradicted by the earlier announcement of the admiral's retreat to Gibraltar, and by the report of casualties appended to his published letter.[23] The return of the killed and wounded was probably included to emphasise that Byng's flagship the *Ramillies* had suffered none, implying that a craven commander had failed to press home his attack. The total number of guns carried by the two combatants was printed to demonstrate that Byng's command was slightly more powerful than the French.

The ministry possibly even stooped to print outright lies in its propaganda offensive. The most notorious example was an anonymous article which appeared in the *Evening Advertiser* on 26 June and was widely reproduced.[24] It accused Byng of suspicious delays in his voyage to Minorca and in seeking out the enemy, which insinuated treason, cowardice or negligence. That the piece was written by someone within the ministry or 'leaked' to the press is apparent from its use of the Council of War against Byng, information first released in the admiral's letter to Cleveland which was published that very same day. The Pelhamite faction within the ministry probably was involved in the newspaper assault upon Byng. When the tide of opinion began to turn against the ministry in August, Hardwicke advised Newcastle that inserting short pieces in the daily papers was the most effective method of reaching the greatest number of people, and reversing the dangerous trend.[25] Hardwicke's eldest son, Lord Royston, was an MP with historical and literary interests, who closely followed the political press. He played a leading role in the

preparation of the ministry's defence during the parliamentary inquiry, and contributed newspaper articles vindicating the ministry and his brother-in-law Lord Anson. Royston had contacts with the *Evening Advertiser* through his friend the antiquary Thomas Birch, with whom he previously had arranged for the publication of attacks upon critics of the administration.[26] Royston's connection to the *Evening Advertiser*, and its emergence as one of Byng's earliest and most inveterate enemies, suggests that ministerial writers may have been active much earlier, and coordinated their campaign to reinforce the impression created by Byng's letter.

Minorca sparked one of the war's most prolonged, violent controversies, and each stage in its development was reflected in the unprecedented flood of political literature which it inspired. It emerged as one of the few great crises in the eighteenth century when popular agitation and political opinion profoundly influenced the course of national politics. An explosion of the more popular forms of political commentary – ballads, ephemeral verse, prose satire and prints – marked the extension of debate far beyond the boundaries of Parliament, Whitehall and the court. With official confirmation of Byng's retreat, public indignation finally erupted, at first flowing in the channel marked out by the ministry, and engulfing the admiral. The City merchant and patriot poet Richard Glover recorded the extraordinary popular wrath, 'Those who did not live at this period, cannot by any description conceive the excess of national resentment and rage against that Commander.'[27]

The extract of Byng's dispatch was extensively reprinted in the London and provincial, Scottish and Irish press, and its impact upon national political opinion can hardly be exaggerated.[28] A letter from a Reading innkeeper describing the reception of Byng's dispatch offers an excellent illustration of how political news was transmitted orally at coffee-houses and taverns, embracing an audience which extended far beyond the number of printed copies available. Upon the arrival of an early report of a British victory, the innkeeper had gathered a group of friends to celebrate, but their merriment was interrupted suddenly:

> On the letter from Barcelona great rejoicings were made at several places, on account of Admiral Byng's having drubb'd the French; . . . we were drinking the healths of our good King, the brave General Blakeney, and Admiral Byng, plough, loom, and sail; but in the midst of our joy, the post arrived, and the Gazette was called for. The oldest gentleman in company was desired to Read it: But alas! the alteration that appeared in every face was not to be described.[29]

Although Fox and the ministry later would come to regret the publication of Byng's censored dispatch as a two-edged sword which could easily be turned against them, initially it seemed to achieve its desired goal of concentrating

anger upon the admiral. In this they were assisted by Byng's writing style, which revealed the weaknesses that rendered him incapable of high command. The perception that Byng responded weakly to events rather than imposed his will upon them, was reinforced by a frequent use of passive constructions, most notably in the 4 May letter which so infuriated the ministry. His want of initiative was highlighted by phrases such as 'if I had been so happy', 'as it has unfortunately turned out', 'I am sorry to find', and 'it is to be apprehended'.[30] The tone of false modesty adopted by an intensely proud man contributed to the impression of timidity and indecisiveness.[31] Byng's combination of diffidence and self-satisfaction, and his at times confusing, inconsistent account of his actions, made his dispatch vulnerable to parody. Several 'versifications' or satirical poetic paraphrases were published, which mercilessly dissected his letter, twisting its contents to accuse the admiral of cowardice, treachery and negligence. The dissemination of these parodies demonstrates how literary propaganda achieved a remarkable circulation through the process of reproduction. Three separate versifications may be identified, with their own recensions, although it is difficult to trace the precise dates, places and formats of their original publication. 'A Letter' appeared in the *Evening Advertiser* on 3 July, and was included in that month's *Gentleman's Magazine*.[32] It was followed by 'To Mr. C[leveland]' in several newspapers and periodicals.[33] The latter illustrates the close relationship between literary and ideographic satire during this period, because it was united with one of the earliest anti-Byng prints *Cabin Council* (Plate 4). The third parody, the ballad *Admiral Byng's Letter to Secretary Cleveland, or Who Will Kick at a Coward* was printed in the *London Magazine*, and a political pamphlet combining prose analysis with several of the most stinging lampoons upon the admiral.[34] Not only were these mock letters widely available in the capital, but they were spread throughout the country by the London newspapers' far-reaching distribution system, and by the many provincial papers. During July, the versifications were copied into papers and magazines in Worcester, Bath, Ipswich, Northampton, York, Newcastle, Birmingham, Edinburgh, Belfast and other important centres.[35]

Acute booksellers, who were adept at identifying the public's hunger for news during controversies such as that provoked by Minorca, or publishers attempting to influence opinion, often assembled anthologies of the most extraordinary pieces of printed commentary. A collection designed to capitalise on Byng's notoriety was published on 12 August, its profit or political motive cynically concealed behind an appeal to exemplar history:

> the hero who has bravely fought in the cause of his country, and the patriot who
> has disinterestedly defended its liberty, are patterns of imitation; while on the
> contrary . . . the coward who has neglected, . . . and the traytor who has betray'd
> the interests it was his duty to serve, necessarily excite contempt and abhorrence.[36]

A Late EPISTLE to Mr. C————D.

The better Part of Valour is Discretion, in the which
better Part I have sav'd my Life.

FALSTAFF.

BUT timely Running's no small Part
Of Conduct in the Martial Art;
By that, some glorious Feats atchieve,
As Citizens by breaking, thrive.
It saves th' Expence of Time and Pains,
And dang'rous beating out of Brains,

For they that fly may fight again,
Which he can never do that's slain:
And they who run from th' Enemy,
Engage them equally to fly;
And when the Flight's become a Chace,
They win the Day that win the Race.

HUDIBRAS.

DEAR Sir, 'tis with Pleasure the following I write,
And hope you'll impute my Mistake to my Fright.
On the eighth Day of May we set sail for Mahon,
Where we fear'd we should get (as the Wind blew)
too soon;

I was not in Haste; for 'tis always my Way,
To be first at a Feast, and the last at a Fray.
On the nineteenth, at Noon, we discern'd the French Fleet,
And judg'd we must now either beat or be beat:
I was then to the Windward, and such was my Play,
That by shifting and shifting I spun out the Day;
On the twentieth again the French Fleet was in Sight,
And I found that in Spight of my Fear I must fight;
On comparing our Force, we had one Ship to spare,
And to take the Advantage I thought was unfair,
So I order'd the DEPTFORD to get to a Distance,
But not too far off should we want her Assistance.

Mr. W——ST, who loves fighting, behav'd like a Man,
Tho' he sail'd in the Rear, yet he fought in the Van;
If I fought, you'll believe the Engagement was hot,
But I wisely kept out of the Reach of their Shot.
Th' INTREPID, by Accident, losing her Mast,
Was a handsome Excuse for retreating at last.
A Council was call'd, and we all thought it best,
As they steer'd for the East, we should steer for the West.
This agreed; lest their Minds, when recover'd, should alter,
I am sailing as fast as I can to Gibraltar:
So have wrote this in Haste, as I thought it expected,
That News of such Moment should not be neglected.
Do your best to enhance my Deserts to the K——,
And in all Things (but fighting) believe me,
Your's,
B——G.

To be had at the *Golden Acorn* facing *Hungerford Market*, in the STRAND.

4 *Cabin council. A late epistle to Mr. C[levelan]d*

ARTS AND ARMS

It reprinted approximately twenty of the most powerful anti-Byng ballads, poems and epigrams, including 'A Letter' and 'To Mr. C[leveland]'. The parodies of Byng's dispatch demonstrate how political literature could attain a truly universal readership when transmitted by all the major forms of print culture: independent publication, newspaper, magazine, ballad, pamphlet, anthology and political print. Unfortunately, attempts to trace the authorship of the mock letters have been unsuccessful, although it is possible that Fox had a hand in instigating them, as his chaplain Philip Francis would later produce a verse parody of Pitt's letter of resignation in 1761.

Perhaps the most exasperating aspect of Byng's letter was its pompous, complacent tone. Clearly the author was satisfied that he had done all in his power, and seemed ignorant of the enormous discrepancy between his actions and public expectations. Byng began, 'I have the pleasure to desire you will acquaint their Lordships', as if he felt his actions merited praise, a phrase which only exacerbated his readers' disappointment. John Campbell probably expressed a common reaction of disgust when he wrote, 'how he could have any pleasure in giving such Account, I cannot possibly conceive'.[37] Byng's incongruous introduction was played upon by all three parodies and other critics as relief from escaping from the enemy, and from the burdens of command, for which he confessed himself unworthy.[38] A poem interpreted it as the product of a character so depraved that it lost the ability to distinguish between right and wrong:

> Curs'd be the wretch, that glories in his shame,
> Eternal infamy still brand his name
> His hated name, who basely dar'd repeat
> The tale with *pleasure* of his own defeat![39]

Many observers were suspicious of Byng's claim to victory, which appeared to be contradicted by his inexplicable retreat, and by Galissonière's report. Galissonière's dispatch was published, and was considered by many to be the truer account.[40] The belief that Byng was lying to conceal his cowardice was captured in a piercing epigram comparing his letter with Galissonière's:

> If you believe what Frenchmen say,
> B[YN]G came, was beat, and run away,
> Believe what B[YN]G himself has said;
> He fought, he conquer'd, and he fled.
> To fly, when beat, is no new thing;
> Thousands have don't, as well as B[YN]G;
> But no man did, before B[YN]G, say,
> He conquer'd, and then run away.[41]

Galissonière's letter was also used against Byng as evidence of treason.[42] It was claimed that he had been bribed by the French to stage a feigned battle

54

and deliver Blakeney's garrison to the invaders. Byng's refusal to take the battalion from Gibraltar, and his incomprehensible behaviour while he remained off Minorca for several days, but took no steps to land reinforcements or supplies, encouraged this idea.[43] It is most fully developed in *The Sham Fight*, which compared the commanders' suspicious reluctance to prolong the engagement to a popular fairground amusement, 'they ran like two Asses at a Race, one run one Way, and t'other the other.'[44] The charge of treason was propagated by a malicious falsehood which accused Byng of selling all his property out of the public funds before sailing.[45] It stated that Byng's family had sent him a warning not to return home for fear of punishment. This inspired an anti-Byng satirist to compose a counterfeit answer, which gained a great deal of attention. Byng shamelessly confesses his betrayal, but confides in his position, time, and the fickleness of the mob to save him from retribution:

> You tell me the nation is all in a flame,
> All murmur, and load with reproaches my name,
> They lash me in satire, and burn me in straw,
> And threaten the harshest of lashes, the law.
>
> The people of *England*, of all people living,
> Do murmur the most, yet are always forgiving.
> Their passions resemble the tides, you must know,
> The lower they ebb, then the higher they flow;
>
> Sage heroes like me, then, to get what we want,
> Abuse them, – as jilts, treat a love-sick gallant –
> Get bribes from abroad, and at home we get flags;
> 'Tis enough for the brave to get glory and – rags.[46]

A central point in the debate surrounding the fate of the relief expedition concerned the relative strength of the two fleets. From the beginning Fox was keen to forestall criticisms that the government was culpable for assigning Byng an inferior force.[47] Byng's decision not to take advantage of his numerical superiority, by leaving the *Deptford* out of his line of battle, was strongly condemned as proof of collusion, or evidence of criminal incompetence. His explanation that he wished to match his ships equally against Galissonière's, with the assumption that he felt confident of defeating the French without the *Deptford*, appeared to clash with his later explanation that the damage suffered by the *Intrepid* made a retreat imperative, 'whose loss would give the balance very greatly against us, if they attacked us next morning, as I expected'.[48] It also seemed to contradict Byng's claim that he had been sent out with an insufficient force. The inconsistency was pounced upon by several of Byng's sharpest satirists, who argued that the debate was irrelevant with a commander averse to engage the enemy under any condition:

> With thirteen ships to twelve, cries B[yn]g;
> It were a shame to meet 'em:
> And then with twelve to twelve, a thing
> Impossible to beat 'em.
>
> When *more*'s too many, *less* too few,
> And even still not right:
> Arithmetick must plainly shew
> 'Twere wrong in B[yn]g to fight.[49] (Plate 8)

The battle received an exhaustive scrutiny from armchair admirals. Byng's critics tore apart his report, simplifying and misinterpreting a long and at times detailed document in their efforts to disgrace him. Technical and tactical problems were ignored, and passages taken out of context to ridicule the admiral. The controversy over Byng's handling of the fleet was fuelled by maps and prints published to supplement those appearing in pamphlets and the press. The positions of the two divisions and of individual ships during various stages of the action were dictated by the bias of the designer, the vital dispute revolving around Byng's determination to support West, and how closely the *Ramillies* engaged the enemy.[50] A much-publicised imaginary trial held by a group of common sailors introduced most of the major criticisms of Byng's conduct, which would preoccupy the court martial.[51] In order to bring his line upon a parallel course with the French, Byng had tacked, which reversed the order of his fleet, placing West's division in the van. This tactical necessity was misrepresented as a deliberate evasion of his duty to assume the risk and honour of leading the fleet into battle (Plate 4):

> Mr. W[E]ST, who loves fighting, behav'd like a Man,
> Tho' he sail'd in the Rear, yet he fought in the Van;
> If I fought, you'll believe the Engagement was hot,
> But I wisely kept out of the Reach of their Shot.

Byng's earlier manoeuvres to secure the weather gage were dismissed as desperate procrastination:

> I was then to the Windward, and such was my Play,
> That by shifting and shifting I spun out the Day.[52]

The absence of any casualties aboard the *Ramillies* emerged as a damning reflection upon Byng's personal bravery, and evidence of a failure to support West.[53] This seemingly irrefutable evidence demonstrated the ministry's acumen in publishing the information. It enabled satirists to repudiate as a lie Byng's claim that the *Ramillies* closely engaged her immediate adversary, and drove her out of the French line.[54] The leading ship in the van, the *Defiance*, endured the severest punishment, and her captain George Andrews was killed. Captain Noel of the *Princess Louisa*, whose ship also suffered heavy casualties,

died from his wounds. The heroic self-sacrifice of the officers and the common sailors who died in action was contrasted to Byng's deceitful pusillanimity, particularly in the more popular ballads, which celebrated rugged, honest physical courage, the common Englishman's code of honour. In several of these works, the dead seamen rose from their watery graves to punish Byng for forsaking his comrades in battle, and permitting them to perish in vain.[55] West's gallant behaviour was commended in poetry and the press, and he was carried to court to receive the King's thanks. The ministry's opponents detected a political motive in these attentions, and the repetition of George II's alleged aside that he wished all had done their duty as devotedly as West.[56]

The damage suffered by the *Intrepid*, and its effect upon the ships in its wake, was the decisive incident in the battle. When the charges against Byng were drawn up, he was accused of two fundamental crimes: a failure to press home his attack and support West on 20 May, and to do everything in his power to aid Blakeney.[57] The delay of Byng's division in bearing down on the French centre was caused by the refusal of the ships immediately astern of the *Intrepid* to pass her for fear of breaking the integrity of the line of battle, and disobeying the Fighting Instructions. Temporary confusion or indecision in the heat of battle, and the restrictions of naval tactics, however, were disregarded by the admirals of Grub Street, who sought a simple explanation for the disappointing performance of the British fleet. In the eyes of Byng's accusers, the immobilisation of the *Intrepid* was nothing more than a shallow pretext to break off an action in which he had conceded defeat:

> And so Rude were the French, that egad Sir, at last,
> They crippled the Intrepid and brought down her Mast
> A ballance against us so great! and so clear!
> That Victory must have Declar'd for Monsieur.[58]

Byng's attempt to explain Galissonière's escape, how the cleaner sailing French were able to damage the British masts and rigging, and set a course to windward, which increased the distance the pursuers would have to cover, caused a great deal of confusion:

> I found the enemy edged away constantly; and as they went three feet to our one, they would never permit our closing with them, but took the advantage of destroying our rigging; for though I closed the Rear Admiral fast, I found that I could not gain close to the enemy.[59]

It was misconstrued as a claim that the French ships were endowed with supernatural speed, and scorned as the feeble excuse of a pathetic coward, or the ravings of a mind unbalanced by fear:

> The *French* most amazingly large to my Sight,
> Seem'd to wish to edge *off*, and declined the Fight
> Twas strange, yet Twas charming – and their Ships did run,
> (As good luck Wou'd have it) Three Feet to *Our* one.[60]

Byng's explanation of his motivations and actions was so awkward and inadequate in places that it gave the impression of grave ineptitude. Dodington thought the letter 'strange', while it encouraged Walpole to entertain a mean opinion of the admiral's intellect.[61] In an eighteenth-century context, councils of war were perceived as signs of weakness. Instead of vindicating his withdrawal, Byng's decision to call a council of war was interpreted as more glaring proof that he lacked the fortitude and independence to command:

> *In prudence I summon'd a Council of War,*
> *(That surest Asylum of dastardly Tar).*[62]

Initially, all who were thought to have signed the resolutions were dismissed as cowards.[63] Later, as the procedure of the council became known, Byng was vilified as the worst sort of coward: a sly, sneaking wretch who manipulated others to escape punishment for his treason. One portrayal of the council of war depicted brave officers who were manacled by a cunning, deceitful coward, and compelled to share his shame. They reluctantly acquiesced in withdrawal when convinced that nothing but total defeat could be expected from such a leader.[64] As part of its campaign to incite opinion against Byng, the ministry advertised the order for his arrest, which was relayed to all the channel ports.[65] Hume Campbell described the scene at Portsmouth on 26 July when Byng returned from the Mediterranean:

> Byng was in his barge coming to land when Osborne met him and carried him back in arrest. There was a vast mob got together to have tore him in pieces had he landed and I heard one man by being taken for him has been almost killed.[66]

Byng's immediate imprisonment was also publicised, a move which was interpreted as a sign of almost certain guilt, further aggravating fury against him.[67]

In its persecution of Byng, Grub Street ruthlessly pried into his private life. John Byng was the fifth son of Sir George Byng, who had been one of the great naval figures of the early eighteenth century. In 1718 at Cape Passaro he had defeated a Spanish fleet, and soon after was raised to the peerage as Viscount Torrington. He finished a distinguished career by attaining the highest honours within the naval hierarchy, as Admiral of the Fleet, and First Lord of the Admiralty in 1724. Byng's appointment stimulated the publication of biographical articles about Torrington.[68] Byng had been a participant in his father's victory, and felt a tremendous pressure to live up to his example. This tension may have contributed to the deep fear of failure which paralysed

his judgement during the campaign. Anticipation of a decisive victory over the French was raised when it was reported that Torrington's son had pressed for the command and was burning to emulate his glory. Some of the most malicious attacks upon Byng focused upon his admiration for his father, and his failure to repeat his success.[69] Byng's arrest provided the occasion for a mock biblical history of the campaign, which concluded with the spectacle of Torrington's son dragged home in chains.[70] The shade of Byng's father was resurrected, and made to disown his son for defiling the family honour. One poetic necromancer went further, and invoked Torrington as an avenging angel, the divine instrument chosen to seek justice for an injured God, king, country, and father:

> O'er the smooth surface of the deep
> A shade majestic glides;
> Darts through the caverns of the ship,
> Where *Britain's* coward rides.
>
> His eyes that flash'd with fiery beams
> His angry soul betray'd;
> Whilst from his hand, uplifted, gleams
> The visionary blade.[71]

In another poem, Torrington's harsh reproaches drive his conscience-racked son to suicide.[72] Richard Glover, a master of this genre, composed a sequel to his famous anti-Walpole ballad *Admiral Hosier's Ghost*, in which the peaceful repose of Torrington and other naval and military heroes in Elysium, was shattered by reports of Byng's infamy.[73] There appeared to be no limit to the viciousness of the abuse inflicted upon Byng. Immediately upon his arrival at Spithead, he had been visited by his severely ill brother Edward, who was worn down by anxiety and the fatigue of travelling, and by forcing his way through the mob of anti-Byng demonstrators. Edward died that night, and Byng's personal loss was ruthlessly exploited by his enemies in the press. He was tormented with the charge that a broken-hearted Edward had collapsed with shame when confronted with his brother's guilt and, 'died with grief for him, he could not love'.[74]

Byng's position as the wealthy son of a former First Lord and peer, and MP for the Admiralty borough of Rochester, led to accusations that he owed his advancement to favouritism and simony. His promotion to rear-admiral in 1745 at 41 had been rapid, though not unusual, for one with his length of service and connections. He had never commanded a warship or squadron in any major engagement, however. Byng was taken up as a glaring example by social commentators such as Dr John Brown, who argued that Britain's dismal defeats in the early stages of the war were caused by the moral bankruptcy of a selfish, effeminate, corrupt aristocracy, which had degenerated

from its forefathers.[75] The governing classes' sense of patriotic duty, and the moral and physical virtues essential for leadership in war, had been eroded by its pursuit of wealth, luxury, and empty honours. Victory could not be achieved until the nobility had recovered its Spartan purity of courage and self-sacrifice, and the armed forces were led by men of genuine ability:

> till her Fleet
> Is freed from the *right honourable* Thrall
> Of Cowards, petty Tyrants, Fops, and Fools:
> Till unbefriended Merit wins the Prize
> From suppliant Int'rest, and, the Bane of all,
> Destructive Luxury shall quit her Shores.[76]

Literary works contrasted the untainted natural bravery of the common seaman, who was burning to vindicate his country's rights, with the incompetent, pusillanimous sons of the privileged such as Byng, who encrusted the naval hierarchy like barnacles. These social tensions were emphasised by fears that Byng's rank, riches and political interest would enable him to escape retribution for his crimes. In one epigram a complacent Byng taunted his betrayed countrymen:

> Sudden death I abhor; while there's life, there is hope:
> Let me 'scape but the Gun, I can buy off the rope.[77]

In a satiric conversation piece, an enraged ship's mate, whose brother had lost a limb at Minorca, fulminated against the supposedly widespread venality within the Royal Navy. He quoted 'brave Johnny Gay's' famous reflection upon social and legal inequality in *The Beggar's Opera* in response to rumours that Byng's reprieve, secured by the intervention of his family and political allies, would lead to his escape from execution:

> Since laws they were made, in ev'ry degree,
> To curb vice in others, as well as in me,
> Wonder we ha'nt better company
> Upon Tyburn tree.[78]

Byng's deportment betrayed his pride in his position. He was stout in build, punctilious in dress and manner, and his features were distorted by a disdainful expression, exaggerated by his heavy-lidded eyes. Years earlier the Blue Stocking Frances Boscawen had recorded her first impression of Byng:

who seems to me a mixture of coxcomb and f[ool], if you'll allow a judgment upon an Admiral. He had an undressed frock, very richly embroidered with silver, which in my eyes is a strange dress, and his discourse and manner pleased me no better than his garb.[79]

Walpole described his carriage as 'haughty and disgusting'.[80] Byng had few friends within the service, and was known to be a harsh disciplinarian, and

overbearing towards his inferiors. A letter ostensibly written by a sailor testi-
fied to Byng's reputation for mercilessly flogging his crews, and observed
how tyranny, cruelty and cowardice were intimately related.[81] He was hyper-
sensitive to any perceived slight, and was branded as a bully for frequent
duels. Byng's alleged refusal to engage the French appeared to contradict
his reputation for picking quarrels, prompting regrets that he had not been
bred up as an attorney or parson, allowing him to indulge his penchant
while avoiding personal risk.[82] The mock-heroic poem *Hudibras* provided an
appropriate allusion for those who wished to strip away Byng's arrogant,
blustering exterior, and expose his true nature.[83] Shakespeare was another
invaluable source for satiric poets and printmakers. Byng was scorned as
a modern-day Falstaff, sharing the anti-hero's most famous maxim, *'The
better Part of Valour is Discretion, in the which better Part I have sav'd my Life'*
(Plate 4).

Byng had acquired a fortune in prize money, and spent it liberally to
maintain the style of living which he felt was due to his family and rank. The
admiral's fame as a gourmand prompted charges that he consumed precious
time in dining and drinking in Portsmouth and Gibraltar, when he should
have been delivering provisions to Blakeney's starving garrison:

> I was not in Haste, for 'tis always my Way,
> To be first at a Feast, and the last at a Fray.[84]

In 1741 he had commissioned the architect Isaac Ware to decorate his house
in Berkeley Square, which included a splendid replica of the wind dial in the
Board Room of the Admiralty. Later Ware designed a grandiose country house,
Wrotham Park, for an estate Byng purchased near Barnet, distinguished by an
imitation minaret tower and a huge portico.[85] Byng's conceited airs and ostenta-
tious display of wealth provoked deep hostility among the poor and humble:

> That B[yn]g is an Admiral, all the World knows
> Of Great Taste in Building, but bashful of Blows.
> Polite in Behaviour, and fond to Excess
> Can boast, much, Can swear much, Can fighting Profess.[86]

> Thou thought'st thyself as great as Caesar,
> But art brought as low as Neb'chadnezzar.[87]

Wrotham Park functioned as a lightening rod for the people's fury, a symbol
of a wealthy aristocrat who failed to deserve his privileges, or a traitor who
had sold his country for French gold. In July, soon after the publication of
his censored letter and the ensuing assaults in the press, Byng's house was
attacked by an enraged mob, and nearly burnt to the ground.[88]

Byng's refined manners, attention to dress, and enjoyment of material
comforts encouraged the assumption that his cowardice sprung from

effeminacy. Authors frequently adopted the affected, frivolous tone of the idiotic fop when making Byng speak and write in their fictitious dialogues and letters.[89] In one poem, after settling the details of their counterfeit battle, Byng and Galissonière kiss and retire to snore upon beds of down. Byng's condition as a confirmed middle-aged bachelor invited assertions that his behaviour more closely resembled that of a fussy, fretful spinster. He was depicted as more at home drinking tea in a drawing room than walking the quarterdeck of a man-of-war.[90] Other satirists went further insinuating that Byng's bachelorhood was caused by a dearth of sexual vigour. A print, which celebrated the popular image of the Jack Tar's closely-associated masculine courage and enthusiastic appreciation of women, found Byng's alleged lack of virility to be symptomatic of his cowardice.[91] The charge that the admiral possessed even less fortitude than a timorous old woman was bolstered by reports that he attempted to escape his imprisonment in Greenwich Hospital by dressing himself in the clothes of his sister Lady Sarah Osborne.[92] Printsellers capitalised upon such a ludicrous rumour. The alleged escape attempt lent further weight to the perception of his guilt.

Satirists who delved into Byng's private life discovered a hobby which could be utilised to corroborate their taunts of effeminacy and cowardice. The admiral was a noted porcelain connoisseur, and had amassed an impressive private collection. When this became known, print designers decorated Byng's cabin with examples of the most dainty, exquisite glass vases and china tea services.[93] It appeared as if the *Ramillies* had been converted into a floating porcelain gallery in order for the admiral to sail in comfort (Plate 4). Poets declared that it was the fear of damage to his priceless porcelain collection which motivated Byng to keep out of range of French fire:

> Our prudent Adm'ral held it wise,
> Not to expose the RAMELIES
> To the hard Blows of Iron Balls,
> Which would deface her Wooden Walls;
> Or might his Cabin Windows tare,
> And break his curious *China*Ware.[94]

It was the havoc wreaked among the precious cargo of West's ships, and not their dead and wounded seamen, which appalled Byng, and impelled him to break off the battle:

> Moreover 'twas plain,
> Three ships in the van,
> Had their glasses and china all broke;
> *And this gave the ballance,*
> In spite of great talents,
> *Against us:* – a damnable stroke![95]

Byng's reputation for effeminacy must have provoked the common people's contempt, accustomed as they were to blood and field sports – bear and bull-baiting, cock-fighting, cudgelling and bare-knuckle boxing.

Byng's lack of fighting spirit was rendered more odious by contrast with the stubborn resistance of Minorca's garrison commanded by the 82-year-old General William Blakeney. The course of the siege had been anxiously followed by the British press.[96] Eventually, the French succeeded in storming the outworks of St Philips, assisted by the fatigue of the defenders, and Blakeney surrendered on 29 June 1756.[97] Confirmation reached London on 15 July, dashing hopes that another relief attempt might raise the siege. Walpole described how the surrender rekindled ire against Byng, 'we are humbled, disgraced, angry'.[98] It seems ironic, that if the Minorca drama was distinguished by an admiral unjustly accused of cowardice and negligence, there should be a general endowed with an exaggerated reputation for bravery and activity. If Byng was the treasonous villain of Grub Street's Minorca tragedy, then Blakeney was cast in the role of tragic hero, and life was made to imitate art. This process was illustrated in a play dramatising the conquest of Minorca. A pair of patriotic Minorcan lovers assisting in Blakeney's defence were murdered by one of the couples' embittered rivals in a sentimental tragedy, whose domestic plot of greed and betrayal paralleled the international scene. The drama concludes with the surrender of the citadel, mourned by the disillusioned Blakeney as symbolic of the nation's degeneration:

If England to itself had been true,
'Twould ne'er have come to this.

Ev'n thus it is,
(If we compare the little with the great)
That nations rise and fall.[99]

Blakeney was represented as a forgotten old veteran, who had earned a peaceful retirement after an exhausting career of loyal service. When duty called, however, the grizzled soldier drew upon deep reserves of energy to become the life and soul of the defence. This is the portrait that emerges from a detailed verse narrative of the siege and other tributes.[100] Blakeney had gallantly rejected Richelieu's initial summons to surrender, inspiring an imitation biblical chronicle to depict him as an Israelite warrior-chieftain, defying an immense host of God's enemies.[101] Other panegyrists evoked sympathy for a weary old man, worn down by the strains of command and paternal care for Minorca's inhabitants. The patriot clergyman Dr John Free created the moving image of a martyr, vainly gazing out to sea for relief refused by a faithless comrade:

See yon good LEADER, mark'd with Age and Scars,
 Propping his feeble Footsteps with his Lance,
Wrapt in deep Thought, amidst the din of War,
 By *Moonlight*, tow'rds the gleaming Waves advance.
Why comes he? but some Succours to descry,
 For sore his Castle by the Foe is prest:
Yet ah! in vain he rolls his haggard Eye,
 His helpless State is not to be redress'd;
He sighs indignant, and in Grief returns,
 Tho' still his Thunders roar, and all the *Welkin* burns.[102]

It was reported that Blakeney reluctantly had accepted Richelieu's demand to surrender, not because he feared fighting to the bitter end himself, but to preserve Port Mahon's women and children from slaughter. Stretching poetic licence to its limits and beyond, Richard Glover consummated the hero's martyrdom, and transported him to Elysium after a valiant death in battle.[103]

Newspapers, magazines and literary works published biographical accounts and broadcast anecdotes, which greatly contributed to Blakeney's popularity. According to one report, he had sheltered three Minorcan young women, who had escaped imprisonment in a convent, and wanted to convert to Protestantism.[104] Blakeney's birthday on 7 September was celebrated nationally and, on 23 November 1756, he returned to a hero's welcome, greeted at Portsmouth by cheering crowds, bonfires, illuminated steeples and ringing bells.[105] The coincidence that he was carried by the *Deptford* stimulated further comparison at Byng's expense.[106] Blakeney appeared in at least ten prints and on the frontispiece of the November 1756 *Gentleman's Magazine*. In *The Sham Fight*, a merchant described the tumult caused by the exhibition of his portrait: 'O, Sir, the People adore him, there was above thirty Men and Women had got riding over one another to see a Print of him that's just publish'd, as I came by the *Change*.'[107]

One print depicted the mounted general's triumphant entry into London, his horse led by Byng, a modern parallel of the biblical Mordecai and Haman.[108] Blakeney received a knighthood of the Bath and a peerage, and the freedom of Dublin, but these rewards did not pass unchallenged. During most of the siege, Blakeney had in reality been confined to bed by gout.[109] Hervey criticised Blakeney for failing to prepare Port Mahon to endure a siege, and claimed that officers of the garrison complained that the surrender had been precipitate.[110] Walpole asserted that Blakeney's honours were ridiculed by some when his infirmity became known, and dismissed his lionisation at court as a ploy to fuel anger against Byng.[111] A satirical letter, ostensibly written by an old tar soliciting promotion, but attributed to Boscawen, gibed at Blakeney's undeserved laurels:

Sir, I had the honour to be at the taking of Port Mahon, for which one gentleman was made a Lord; I was also at the losing of Minorca, for which another gentleman has been made a Lord: each of those gentlemen performed but one of those services; surely I, who performed both ought to be made a lieutenant.[112]

Comparison with naval heroes of the past – Drake, Raleigh, Russell and Blake, but above all Sir Edward Vernon – emerged as another salient feature of the popular anti-Byng crusade.[113] Vernon was the champion of the common sailor, unafraid of offending the naval and political establishment in his campaigns for improvements in dockyard administration, and seamen's pay, provisioning, health, and living conditions. Vernon epitomised the patriotic, dedicated professional who spoke out against the evils of privilege and political intrigue. He was rough and direct in manner, and led by personal example, sharing the hazards and hardships of active service with his crews. Several ballads dramatising the conquest of Porto Bello employed sexual metaphors, casting an aura of powerful masculinity around the admiral.[114] He was known to despise the fashionable, foppish vices of the court, and refused to practice the arts of flattery and servility which guaranteed promotion. All of these qualities illustrate why Byng – the allegedly cowardly, effeminate, slothful, cruel, egotistical, privileged scion of the aristocracy – was represented as an anti-Vernon, the anti-type of the ideal naval commander.[115]

The violent popular animosity towards Byng revealed itself in the assault upon Wrotham Park, and the threatening behaviour of the vast crowds which gathered at Portsmouth, intending to wreak their own vengeance him. Byng was eventually escorted to Greenwich by a detachment of dragoons.[116] By hanging and burning Byng in effigy, the people expressed their indignation, and demanded that the government punish the traitor. This ritual occurred on a national scale in the summer of 1756, emphasising the magnitude of popular hostility. Byng was burnt in effigy before his estate in Barnet, and in Newgate, Tower Hill and Whitechapel in London. Similar ceremonies were staged in Birmingham, Newcastle, Gateshead, Sunderland, Leeds, Tynemouth, Dudley, Bewdley, South Shields, North Shields, Darlington, Higham Ferrars, York, Richmond, Cleveland, Market Harborough, Exeter, Devizes, Falmouth, Worcester, Hertford, Salisbury, Southampton, Gravesend, Bristol, the Isle of Wight, Dublin and other centres. An effigy of Byng was gibbeted in Covent Garden as part of the celebration of Blakeney's birthday, a fitting juxtaposition of hero and anti-hero. The comprehensive reporting of these performances of street theatre magnified the impression of universal condemnation.[117]

At Tower Hill on the evening of 26 August, an effigy of Byng, splendidly attired in the blue and gold of an admiral's full-dress uniform, was carried in an open sedan to the site of a 20-foot gallows. The procession had toured the streets, and was led by an honour guard of flying colours, beating drums, and

young men bearing arms. After conviction for treason in a mock trial, a chimney-sweep acted the role of clergyman and confessor before the effigy of Byng was strung up and exposed to the jeers and missiles flung at it by the crowd. Soon after the fire of tar-barrels, faggots and timber was ignited and consumed the image. Its head fell off, and was kicked about the hill by the demonstrators. As many as 10,000 people may have participated.[118] A dramatic reenactment of an effigy-burning provided the climax of *The Sham Fight*, in which Byng's execution was prefaced by a similar procession, the chanting of ballads, and a subversive mock trial.[119] Prints and ballads rejoiced in the symbolic execution of Byng.[120] Although many of the anti-Byng protests appear to have been popular initiatives, several were organised by members of the middling classes and the gentry, illustrating that indignation over the loss of Minorca was shared among the entire political nation. Newspapers reported that demonstrations were sponsored by persons of the highest station in Southampton, by an association of gentlemen in Cleveland, and by a group of master mariners in North Shields.[121]

Many of the images employed in literature and prints appeared in political demonstrations, emphasising the shared vocabulary and symbiotic relationship between the different forms of political expression. The iconography of street protests reflected a strong affinity with the symbolism of political prints. Effigies of Byng were often armed with wooden swords, sometimes pointing downwards, or broken admiral's staffs and tridents to emphasise his cowardice, rested upon comfortable cushions to suggest his effeminacy and luxuriousness, dressed in bag-wigs and gorgeous uniforms to demonstrate his pride, and adorned with French fashions and white cockades to illustrate his treason.[122] The written word also appeared as a central feature of the protests. Verse and prose inscriptions were written upon or hung from the breast, back and hats of the effigies, and upon banners. At Market Harborough, marchers accompanying Byng's dummy carried an elaborate monumental scroll, while in Southampton the effigy bore a paper upon its chest with a simple but striking confession of cowardice and treason, 'My heart grew on the wrong Side.'[123] In Richmond, a verse epitaph was carved upon the gallows built for Byng's mock execution.[124] In some cases, the influence of prints and literature in suggesting models for the stage designers and directors of these performances of political theatre was indicated even more directly by the repetition of identifiable ballad verses or print mottoes. In Newcastle for example, before being committed to the flames, the straw admiral led around the city on the back of an ass was preceded by a white standard bearing the motto of an anti-Byng print, 'Oh! back your Sails for G-d's Sake, a Shot may hit the Ship.'[125] The practice of illumination, like the torch-lit protest marches and nocturnal effigy-burnings, allowed visual political spectacle to achieve a truly impressive effect. A group of gentlemen who met to commemorate

Blakeney's birthday, demonstrated their fury against Byng by displaying portraits of the tragedy's main protagonists from their club-house windows. Richelieu the victor, adorned with laurels, appeared in the uppermost window; Blakeney the vanquished appeared in the window beneath; and Byng appeared in a third, hanging from a gibbet with an inscription printed beneath: 'Behold the Belier of his Birth: The Betrayer of his Country: The Scorn of every honest Man. Dishonour blasts the Name of every Coward.' It was as if the façade of the building had been fashioned into an enormous political print, a resemblance enhanced by a label, the device used to designate speech in graphic art, issuing from Blakeney's mouth which read, 'O lost Minorca! O Liberty! O Virtue! O my Country!'[126]

The performance of ballads during the anti-Byng processions, demonstrations and effigy-burnings highlights the integral vocal dimension of eighteenth-century political protests. The popular genre of 'goodnight ballads' or satiric last-dying speeches and confessions, inspired by the scaffold repentance of criminals at public hangings, often accompanied the public trial, sentencing and execution of Byng.[127] By joining together in song, individuals were transformed from passive spectators into active participants in a powerful form of collective political action. Ballads, chanted or sung, allowed demonstrators to articulate their opinions, and emphasise their solidarity. At the same time as balladeers and engravers may have inspired the organisers of demonstrations with ideas, slogans and images, they were also indebted to the political protesters themselves, whose public statements they recorded as chroniclers, and utilised to validate their own political positions. Writers and print makers must have drawn upon the imaginativeness of the demonstrators to enrich their own literary and graphic political symbolism. The Minorca demonstrations of late 1756 illustrate the existence of a vocally and visually rich tradition of extra-parliamentary political protest.

The extraordinary nature of the Minorca campaign, a defeat at sea and the conquest of a strategic naval base, provoked one of the war's most sustained political crises. There can be no doubting the intensity of national disappointment and fury, which manifested itself in the protests discussed above. Initially, Byng bore the brunt of condemnation, the immense circulation of his censored dispatch acting as a powerful catalyst. Its satiric versifications enjoyed an equally great dissemination, and emerged as the first and most compelling of a deluge of literary works and political prints accusing the admiral of treason, cowardice and negligence. The efficiency and persuasiveness of political poetry is emphasised by the parodies of Byng's letter, which reduced a complex series of political and strategic conditions, events, motivations and actions into a simple, direct, scathing personal attack upon Byng. Moreover, the charges levelled at Byng were reinforced and validated by an accurate, penetrating knowledge of the admiral's lifestyle and the flaws of

his character. When read by a poorly-informed nation in a climate of extreme uncertainty, anxiety, fear and disappointment, it is not surprising that the rumours, innuendoes, half-truths and blatant lies were at first widely accepted.

In addition to its rhetorical efficacy, literary propaganda had to be extensively disseminated in order to influence the political nation. To be effective, its message had to be repeatedly reinforced. The sheer volume of the anti-Byng material is striking. More than eighty independently published works of political literature were generated by the Minorca crisis during 1756–57, and as has been demonstrated, many went through several editions and were reprinted in other formats. Literary reviews and advertisements indicate that many others have not survived. The total becomes even greater when works written for newspapers, magazines and essay papers are included. More than fifty of these ballads, poems and prose satires were hostile to Byng. They were supplemented by at least eighty political prints alluding to Minorca; approximately fifty condemned Byng for the loss of the island. During the initial period of the controversy, which extended from late June through July and August, advertisements reveal that publications appeared upon a weekly basis. Their contribution in convincing the labouring and middling classes of Byng's guilt is suggested by the incredible level of popular agitation experienced during the summer of 1756.

Soon after the original shock of Minorca's fall had been absorbed, primarily by Byng, the focus of the controversy expanded. The ministry's critics, Byng's sympathisers, and objective observers began to question the speed and effectiveness of the administration's response to reports of French designs upon the island. They launched a forceful counterattack in the press, which turned the tide of opinion against the ministry. The Newcastle administration soon found itself in the position of the sorcerer's apprentice, threatened by a powerful demon it had helped to summon, but could not control.

NOTES

1 *Papers Relating to Minorca*, ed. H. Richmond (London, 1913); Dudley Pope, *At 12 Mr. Byng was Shot* (London, 1962), pp. 36–81.
2 Pope, pp. 82–95.
3 Augustu Hervey, *Augustus Hervey's Journal*, ed. David Erskine (London, 1953), pp. 204–7; Pope, 107–32.
4 Hervey, p. 208.
5 Dodington, p. 340.
6 Walpole, *Memoirs*, II. 141–9.
7 Byng to Cleveland, 4 May 1756, Yorke, II. 287.
8 Pope, p. 162.
9 Fox to Bedford, 4 June 1756, Bedford, II. 196.
10 Fox to Devonshire, 3 June 1756, Ilchester, *Fox*, I. 330; Newcastle to Hardwicke, 19 July 1756, Yorke, II. 306.

11 BL, Add. MSS 51,387 (Holland House Papers), fo. 26: Fox to Ellis, 26 June 1756.

12 Hervey to Fox, 24 May 1756, Hervey, p. 320.

13 Newcastle to Hardwicke, 19 July 1756, Yorke, II. 306.

14 *GM*, May 1756, 214–15.

15 Walpole to Mann, 14 June 1756, *Corr.*, XX. 561.

16 Walpole to Chute, 8 June 1756, *Corr.*, XXXV. 95.

17 *Gaz*, 24 June 1756.

18 Carlyle, p. 156.

19 Hume Campbell to the Earl of Marchmont, 21 June 1756, HMC, *Sixty-seventh Report*, V. 319; Walpole to Montague, 21 June 1756, *Corr.*, IX. 191.

20 *The Sham Fight*, 1756, pp. 28–30.

21 *LG*, 26 June 1756. The text of Byng's letter with the omissions italicised is reprinted in Pope, pp. 142–8.

22 BL, Add. MSS 51,387, fo. 26: Fox to Ellis, 26 June 1756.

23 Fox to George Digby, 20 Oct. 1756, HMC, *Eighth Report*, Pt. I. 221a.

24 *GM*, June 1756, 313.

25 BL, Add. MSS 32,867, fo. 146: Hardwicke to Newcastle, 29 Aug. 1756.

26 BL, Add. MSS 35,398, fo. 228, 241: Lord Royston to Thomas Birch, 15, 30 Oct. 1754.

27 Glover, *Memoirs*, p. 80.

28 *Gaz*, 28 June 1756. Byng's censored letter appeared in at least twenty other newspapers and periodicals during late June and July 1756.

29 *WEP*, 1 July 1756.

30 Byng to Cleveland, 4 May 1756, Yorke, II. 287–8.

31 Walpole, *Memoirs*, II. 206.

32 *GM*, July 1756, 354.

33 *BN*, 16 July 1756; *Gaz*, 6 July 1756; *LEP*, 6 July 1756; *RWJ*, 10 July 1756; *LiM*, July 1756, 152; *SM*, June 1756, 286; *UM*, July 1756, 324.

34 *Admiral Byng's Letter to Secretary Cleveland*, 1756; *LM*, July 1756, 352; *A Rueful Story or Britain in Tears*, 1756, p. 15.

35 *BWJ*, 8 July 1756; *BA*, 10 July 1756; *IJ*, 10 July 1756; *ABG*, 12 July 1756; *NM*, 12 July 1756; *YC*, 13 July 1756; *NJ*, 24 July 1756.

36 *Bungiana*, 1756, p. iii.

37 BL, Add. MSS. 51,423, fo. 11: Campbell to Fox, 6 July 1756.

38 *The Contrast*, BMC 3365; *The Eaters*, BMC 3545.

39 'On a Modern Character', *LM*, Sept. 1756, 445.

40 *GM*, June 1756, 313.

41 'On a Certain Most Admirable Admiral', *LEP*, 8 July 1756; *GM*, July 1756, 356; *LM*, July 1756, 352; *IJ*, 10 July 1756; *YC*, 13 July 1756; *NC*, 17 July 1756; *NM*, 2 Aug. 1756; *Bungiana*, p. 18.

42 'A Letter from Monsieur Le G[alis]s[onièr]e', *Gaz*, 21 July 1756; 'The Pacific Engagement', *EA*, 3 Aug. 1756, *Bungiana*, pp. 28, 35–7.

43 *The British Hero And Ignoble Poltroon Contrasted*, 1756, pp. 14–15; *A Rueful Story, Admiral B[yn]g's Glory*, 1756.

44 *Sham Fight*, p. 33.

45 *EA*, 29 June 1756.

46 'Admiral B[yn]g's Answer to his Friends', *EA*, 20 July, 1756; *BA*, 24 July; *A Rueful Story, or Britain in Tears*, p. 11; *Bungiana*, p. 27; *UM*, July 1756, 325.

47 Fox to Fowke, 5 June 1756, Ilchester, *Fox*, I. p. 331; Hervey, pp. 320–33.

48 Byng to Cleveland, 25 May 1756, Pope, p. 146.

49 'Naval Arithmetick', *BA*, 24 July 1756; *YC*, 3 Aug. 1756; *Bungiana*, p. 34; *The English Lion Dismembered*, BMC 3547.

50 *The New Art of War at Sea*, BMC 3353; *LiM*, Sept. 1756, 217; *LM*, Mar. 1757; Hervey, pp. 232, 323.

51 *The Hue and Cry After Admiral Bung*, 1756; reprinted in at least fifteen newspapers and periodicals.

52 'To Mr. C[leveland]', *Bungiana*, p. 17.

53 *A Rueful Story, Admiral B[yn]g's Glory*.

54 Byng to Cleveland, 25 May 1756, Pope, p. 145.

55 *Admiral Byng in Horrors*, 1756, reprinted *PA*, 14 July; *EA*, 15 July; *RWJ*, 17 July; *Bungiana*, pp. 20–1; *Capt. Andrew's Ghost*, 1756; *An Address from the Regions Below to A[dmira]l B[yn]g*, 1756; 'On the Death of Capt. Noel', 'On the Death of Capt. Andrews', *GAM*, Aug. 1756, 354.

56 Walpole, *Memoirs*, p. 164; Hervey, p. 230.

57 The charges are reprinted in Pope, p. 216.

58 *Admiral Byng's Letter*, *Bungiana*, p. 17; *The Hue and Cry after Admiral Bung*.

59 Byng to Cleveland, 25 May 1756, Pope, p. 145.

60 *Admiral Byng's Letter*; *Capt. Andrew's Ghost*; *Work for the Bellman*, BMC 3352.

61 Dodington, p. 344; Walpole, *Memoirs*, II. 201; *The Apparition*, BMC 3374.

62 *Admiral Byng's Letter*; *Cabin Council*, BMC 3358; *The Council of War in 1756*, BMC 3359.

63 'A Letter', 'To Mr. C[leveland]', *Bungiana*, pp. 15, 17; *The Wonder of Surrey! Or, Who Perswaded A[dmira]l B[yng] to Run Away?*, 1756; *Merit and Demerit*, BMC 3482.

64 *British Hero and Ignoble Poltroon*, p. 18.

65 *LG*, 24 July 1756.

66 Campbell to Marchmont, 29 July 1756, HMC, *Fifty-fifth Report*, VIII. 323.

67 *LG*, 27 July 1756.

68 *UM*, Mar. 1756, 97–106.

69 'Epigram', *LEP*, 10 July 1756; 'A Monumental Inscription', *LM*, Aug. 1756, 394; *British Hero and Ignoble Poltroon*, p. 11.

70 *The Chronicle of B[yn]g*, 1756. Two editions were published.

71 'T[or]r[ingto]n's Ghost', *GM*, Aug. 1756, 400; *B-n-g in Horrors*, BMC 3376.

72 *Admiral Byng in Horrors*.

73 Richard Glover, *A Sequel to Hosier's Ghost*, 1756. At least three editions were issued. Attributed to Glover upon the basis of a passage in his *Memoirs*, p. 88.

74 *Admiral Byng in Horrors*; *The Apparition*, BMC 3374.

75 John Brown, *Estimate of the Manners and Principles of the Times*, 1757.

76 Joseph Reed, *A British Philippic*, 1756, p. 17. A ropemaker by trade, Reed embarked upon an amateur literary career, enjoying most success as a comic dramatist.

77 *LEP*, 13 July 1756, *GM*, July 1756, 401; *LM*, July 1756, 352; *Bungiana*, p. 20.

78 *The Portsmouth Grand Humbug*, 1757.

79 *Admiral's Wife, Being the Life and Letters of the Hon. Mrs Edward Boscawen*, C. Aspinal-Oglander (ed.), (London, 1940), p. 136.

80 Walpole, *Memoirs*, II. 201.

81 *WEP*, 29 July 1756.

82 *British Hero and Ignoble Poltroon*, p. 12; *Orator Humbug to Admiral Bungy*, BMC 3388.

83 *The Council of War in 1756*, BMC 3359.

84 'A Letter', *Bungiana*, p. 17.

85 Pope, pp. 22–8.

86 *The Council of War in 1756*, BMC 3359.

87 'To J. B[yng], Esq', *WEP*, 29 July 1756.

88 Brian Tunstall, *Admiral Byng and the Loss of Minorca* (London, 1928), p. 165.

89 *Boh Peep-Peep Boh, or A[dmira]l Bing's Apology to the Fribbles*, 1756. Fables, fairy tales and children's games were frequent inspirations for poetic satire. In several, Byng and Galissonière were made to play hide and seek or Boh Peep.

90 'The Pacific Engagement', *EA*, 3 Aug. 1756, *Bungiana*, p. 39; *BA*, 24 July 1756.

91 *Cowardice Rewarded*, BMC 3484.

92 *A[dmira]l B[yn]g's Attempt*, BMC 3380; *Bungs Last Effort*, BMC 3381.

93 *At Home. Abroad*, BMC 3526; *Dedicated to the Captains Kirby, Constable, Warles*, 1756.

94 *British Hero and Ignoble Poltroon*, p. 16.

95 'A Letter', *Bungiana*, p. 16.

96 *GM*, June 1756, 311, July 1756, 319–21, 347.

97 Pope, p. 162.

98 Walpole to Mann, 24 July 1756, *Corr.*, XX. 578.

99 Henry Dell, *Minorca. A Tragedy*, 1756, p. 28. Dell was an impoverished bookseller, who had attempted acting and wrote four plays.

100 *British Hero and Ignoble Poltroon*, pp. 5–10, 18–23; 'On General Blakeney's Defence', *WEP*, 8 July 1756; 'On General Blakeney's Conduct', and 'Written under General Blakeney's Picture', *GM*, July 1756, 356; 'Epigram' and 'The Contrast', *LEP*, 1, 17 July 1756; 'An Ode in Honour of Brave Blakeney', *GAM*, Aug. 1756, 349; William Catton, *A Poem on Lord Blakeney's Bravery*, 1756; *A New Song*, 1756.

101 *Chronicle of B[yn]g*, pp. 4–6, 9–12.

102 John Free, *An Ode of Consolation upon the Loss of Minorca*, 1756, p. 6. Free was a virulent cultural and political patriot with a long-standing connection to Oxford.

103 Glover, *Sequel to Hosier's Ghost*, p. 4.

104 *GM*, Sept. 1756, 422.

105 'General Blakeney', *LM*, Sept. 1756, 445; *BN*, Sept.–Nov. 1757; *A New Song*.

106 *An Irregular Pindaric Ode. To His Majesty's Ship Deptford*, 1757; Edward Lamport, *An Ode Most Humbly Inscribed to the Right Hon. Lord Blakeney*, 1757.

107 *The Sham Fight*, p. 29.

108 *The Admirable Admiral B[yn]g*, BMC 3422.

109 Tunstall, p. 98.

110 Hervey, pp. 191–5, 228, 232.

111 Walpole, *Memoirs*, II. 192.

112 Walpole to Mann, 30 Jan. 1757, *Corr.*, XXI. 51. Minorca had been captured by General Stanhope in 1708.

113 G. Jordan and Nicholas Rogers, 'Admirals as Heroes: Patriotism and Liberty in Hanoverian England', *Journal of British Studies*, XXVIII (1988), 201–44; Kathleen Wilson, 'Empire, Trade and Popular Politics in Mid-Hanoverian Britain: The Case of Admiral Vernon', *Past and Present*, CXI (1988), 74–109.

114 *Admiral Vernon's Glory*, 1741; *The Conquest of Porto Bello*, 1741.

115 'An Ode to Edward Vernon', *PA*, 31 July 1756; Free, *Ode of Consolation*, p. 7; *Capt. Andrew's Ghost*; *The Sham Fight*, p. 29; *Admiral Vernon's Ghost*, 1758; *The Devil's Dance*, BMC 3373.

116 *LM*, Aug. 1756, 400.

117 *BN*, 20 July 1756; *BWJ*, 8 July, 5 Aug. 1756; *NM*, 12 July, 23 Aug. 1756; *NJ*, 31 July, 21 Aug., 11 Sept. 1756; *YC*, 3 Aug., 14 Sept. 1756; *DM*, 6 Aug., 10 Sept. 1756; *BA*, 21 Aug. 1756; *NC*, 11 Sept. 1756; *LEP*, 11 Sept. 1756; *Bungiana*, p. 8; *A Rueful Story, or Britain in Tears*, p. 12.

118 *GM*, Aug. 1756, 409.

119 *The Sham Fight*, pp. 36–8.
120 *The Apparition*, BMC 3374; *Cowardice Rewarded*, BMC 3484.
121 *SJ*, 2 Aug. 1756; *BWJ*, 5 Aug. 1756; *NC*, 11 Sept. 1756.
122 *NJ*, 21 Aug. 1756; *DM*, 10 Sept. 1756; *NC*, 11 Sept. 1756; *YC*, 14 Sept. 1756.
123 *DM*, 6 Aug., 10 Sept. 1756.
124 *NJ*, 21 Aug. 1756.
125 *The Eaters*, BMC 3545.
126 *NC*, 11 Sept. 1756.
127 *YC*, 14 Sept. 1756.

4

Minorca, the Newcastle ministry, and the failures of war

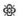

THE INITIAL shock of Minorca's fall was succeeded by an angry deter-
mination to look beyond Byng, and seek an explanation by re-examining
the ministry's handling of the crisis. This trend was encouraged by an
unabated flood of political literature which became increasingly hostile to
the Newcastle administration. It was accused of failing to act upon timely
warnings of French plans, by which a strategic catastrophe might have been
averted. Despite the government's efforts to pre-empt criticism by court
martialling Byng, it could not contain a rising swell of condemnation. Some
of the original attacks upon Byng had speculated that he was not the only
traitor, but merely the accomplice in a plot hatched by the leaders of the
ministry itself:

> But whether he his Country sold
> To *France*, for all-commanding Gold;
> Or, if he traitorously combin'd,
> With some Great Villains, yet behind
> The veiling Curtain, Time will shew –
> The Mystery now's too deep to know.[1]

As the inadequacy of the government's response became apparent, rumours
of a conspiracy multiplied. Poetry, ballads, drama and prints embraced the
allegations of ministerial treachery, and transmitted them to an extensive
audience in the late summer and autumn of 1756.

It was reported that just before leaving London, the French ambassador
Mirepoix had received an enormous sum of money from his government,
which was used to entice ministers to turn a blind eye to French aggression
in the Mediterranean.[2] One of the first and most influential expressions of
this theory was made by an inflammatory mock advertisement widely dis-
tributed around London in early August: 'Now selling by Auction; By Order

of Thomas Holles of Newcastle, Great Britain & the Dominions belonging thereunto. Gibraltar and Portmahon were disposed of the first Day, and the latter is already delivered.'

The information obtained from John Siswick, who was caught in the act of posting the broadside upon the walls of the courthouse on St Margaret's Hill, and carried before a Southwark magistrate, provides illuminating insight into the means by which this kind of political propaganda was disseminated. According to Siswick, he first became acquainted with the satire when a copy, either printed or in manuscript, was handed about during a club meeting at a tavern, The Swan with Two Necks, before being circulated more generally among the ale-house's other patrons, who were not members. Several including Siswick who were amused by 'the comical Paper' made their own copies to pass on for the entertainment of family, friends and colleagues. Other witnesses who were examined upon the provenance of the mock advertisement reported its being displayed in the Royal Exchange, and read aloud at a coffee-house. The importance of oral transmission was emphasised by a broker's clerk who, when asked for a copy by a friend of his master, replied that 'it was so short he could repeat it' and 'from his Memory wrote it when he went into his office'. The clerk reported showing the text to a bookseller, who speculated that the satire initially had been printed in a *Monitor Miscellany*.[3]

Siswick described the parody as 'a Skitt upon Some Body disaffected', but denied any seditious intent, claiming 'that it was to shew his Hand Writing that induced Him to put it up'.[4] The evidence is unclear as to whether Siswick's act was a spontaneous one, or whether he had been paid by anti-ministerial agitators to disperse their propaganda. In any event, the magistrate's attempt to track the manuscript broadside's paper trail to its original source illustrates the diverse channels of distribution, and the processes of multiplication, by which the ideas expressed in political literature reached such an wide audience. Wherever the mock advertisement initially was printed, in an essay-paper or independently, the episode justifies estimates by Joseph Addison and Samuel Johnson that there were at least 20–50 readers per printed copy of popular eighteenth-century publications. Furthermore, Siswick and the others' appreciation of the parody's humour emphasises the rhetorical effectiveness of literary satire. In the political club meeting, which was attended by the landlord, his brother a warehouse keeper, a clerk, a hosier and a tailor, the episode also offers a fine example of the increasing development of political awareness among the middling and labouring classes, and of the central role played by taverns and coffee-houses as forums for discussion. The auction metaphor was exploited by two prints, in which Newcastle was responsible for the sale of Minorca, Gibraltar, North America and the West Indies to the French and Spanish, while Great Britain and the monarchy were offered to

the Pretender.[5] William Hammond, MP for Southwark, who committed Siswick to goal, was so worried by the political consequences of the libel's great circulation, and so eager for its suppression, that he himself carried a copy to Newcastle.[6] The ministry's decision to prosecute indicates how deeply they shared his anxiety.[7] Siswick's arrest did not deter others, for several days later Hardwicke was warned of the dispersal at the Royal Exchange of a great number of copies of: 'a passionate, factious, violent & inflammatory Manifesto, addressed to the Citizens of London, exciting them to demand Justice from His Majesty upon the M[inister]s, who had basely betrayed their Country, & sold it to France for 300,000 £.'[8]

This reinterpretation of events did not necessarily lead to Byng's exoneration. Many writers portrayed him as the ministry's willing tool, persuaded to accept the command to indulge his vanity and claim a share of the spoils.[9] It was alleged that Byng had followed secret instructions, which explained his refusal to engage the French fleet and relieve Blakeney.[10] One ballad insisted that Byng's harsh treatment was provoked by Newcastle's fury that the bumbling admiral had exposed the plot by becoming entangled in an unnecessary, unconvincing naval battle. Byng pleaded for his friends at court to excuse him:

> I meant to follow (God well knows!)
> The Orders I receiv'd,
> And would have shunn'd my Country's Foes
> But was by them deceiv'd.
> 'Twas not my Fault we came so near,
> Let Mirepoix blame Galissionere.
>
> Now having told you (Fribbles dear)
> *The* Truth of all my Actions,
> I bid Adieu, and nothing fear
> From Clamour, Mobs, or Factions
> Since P[elham] in his Heart must own,
> I've done His Job and lost M[ahon].[11]

As leader of the government, Newcastle was the principal target of suspicion. In 1747–48 he had sponsored the international commission to resolve Franco-British territorial disputes in North America and the West Indies, and he had been blamed for not forcing the French to make concessions. As the border war in North America intensified during 1755–56 and opinion became more bellicose, his commitment to a vigorous military response was challenged.[12] Newcastle's reputed pacifism inspired a print satirist to depict him as a goose, a poor descendant of the guardians who had warned classical Rome of invasion.[13] The patriot Free indicted him for defeatism, utilising Minorcan history to strengthen the accusation. The island's magnificent

natural harbour had first been used as a naval base by the Carthaginians, given its name by Hannibal's brother Mago. Free compared Hannibal's failure to conquer Rome, and the final destruction of Carthage during the Punic Wars, with the fall of Minorca. In both cases, malevolent governments had starved their commanders of critical support. In a prophetic passage, Mago's ghost warns Blakeney of similar treachery:

> As now MINORCA, *Brutium* once was lost:
> For *Hanno's* Faction govern'd all at Home,
> Averse to Wars they drew him from his Post,
> And HANNIBAL by *Hanno* was 'ercome:
> To this the Fall of CARTHAGE we may place.[14]

Elsewhere in the poem, Free was more direct in his charge of ministerial perfidy:

> No! die the secret Authors of these Harms,
> These *civil* Traitors, worse than those *in Arms*.[15]

Parallels of betrayal were drawn from British history, with ballads and prints finding precedents in Calais, Dunkirk and Boulogne.[16]

The circumstances of Newcastle's private life were exploited to encourage this mistrust. He had inherited one of the greatest landed estates in Britain, which produced a net income of nearly £27,000, but he immediately began to squander his wealth by an opulent lifestyle. In 1715 Newcastle purchased the Surrey estate of Claremont from his friend Sir John Vanbrugh, and spent enormous sums expanding and enriching it under his direction. Newcastle also dissipated great sums to modernise his other country properties and his London house in Lincoln's Inn Fields. The duke became famous for his sumptuous hospitality, especially at Claremont, where he entertained the King, other members of the royal family, the foreign diplomatic corps, political allies and the leaders of English society. On 4 June 1761, £287 was spent upon a single dinner, which was concluded with an elaborate desert representing the citadel of the French island of Belleisle, then under siege by British forces. Newcastle's splendid collections of gold and silver plate provoked considerable comment, and the wonders of his extravagant feasts were often reported in the press. In 1731, the annual costs of maintaining a ducal lifestyle amounted to more than £15,000.[17] Political poetry and prints identified luxury as one of Newcastle's characteristic vices, and he was often depicted embezzling public funds to support it, as in the left foreground of Plate 5.

Newcastle's conspicuous consumption, the cost of maintaining his political interests, and his generous charitable contributions entangled him in a binding web of debt, which by 1738, had swollen to £158,193.[18] To place this huge sum in perspective, the drudge who scoured Newcastle House received

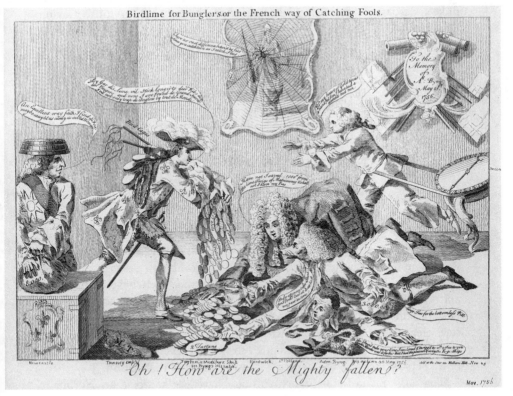

5 *Birdlime for bunglers*

an annual salary of £10 and the Claremont milkmaid £5. Repeated efforts at retrenchment failed because the duke lacked the willpower to amend.[19] Longstanding unpaid debts were destructive to Newcastle's reputation. In 1748, a tea and coffee merchant who was owed £170, and had not received payment for two years, complained, 'I assure your Grace I charge the same price in your Bill as I do all my ready money customers and therefore hope your Grace will be so good as to order Payment.' During the credit crisis of 1759, the mortgages on Claremont and Newcastle House were called in, and Newcastle was narrowly rescued from bankruptcy by Robert Clive.[20] Newcastle's insolvency was common knowledge among his peers and probably among the general public, as Walpole indicated when he dismissed claims made at the time of the duke's resignation in 1756, that his wealth had been expended in selfless public service.[21] A satirical biography of Newcastle insinuated the exact opposite, that his decision to embark upon public life was inspired by the urgent want of a lucrative place to repair his shattered finances.[22] According to one of the most scathing anti-Newcastle ballads, the

duke's desperate financial plight provided the motivation for betraying Minorca to the French:

> N[ewcastle] like Catiline, lives on the Spend,
> Is greedy of Pelf, his Fortune to mend.
>
> Thanks to his P[ee]r[a]ge, he rots not in jail
> While Free Air he breathes, his Tradesmen all Fail,
> Then stare not good Folks, at this wicked Thing.
> That a spendthrift and Knave shou'd sell country and King.
>
> To pay thy Duns off and replenish thy Chest,
> To wallow in Lux'ry, and feather thy Nest,
> If thy Country is ruin'd thou thinkst it no matter,
> So B[yng] to Minorca and slighted the latter.[23]

Newcastle's affluence allowed him to indulge his admiration of Gallic culture. One impressive chamber at Claremont was known as 'the Frenchman's Room', and French furnishings occupied a prominent position in all his homes. His libraries contained works by Racine, Fontenelle, Montaigne and Voltaire. Newcastle employed many French servants at Claremont and Halland, offending the patriotic sensibilities of neighbours such as the Sussex shopkeeper Thomas Turner: 'What seems very surprising to me in the Duke of Newcastle, is, that he countenances so many Frenchman, there being ten of his servants, cooks, &c., which was down there of that nation.'[24]

To gratify his taste for French cuisine, Newcastle had paid an exorbitant salary of £105 to procure one of France's most famous chefs, the celebrated Peter Cloué.[25] In one year he spent £1844 to stock his cellars with the finest French wines. In August 1759, Turner complained of the extravagance and impiety of a Sunday entertainment hosted by Newcastle:

> I think it a scene that loudly calls for the detestation of all serious and considerating people, to see the sabbath profaned, and turned into a day of luxury and debauchery; there being no less than ten cooks, four of which are French, and perhaps forty more, as busy as if it had been a rejoicing day.[26]

Newcastle's appetite for French food and wine inspired a Minorca print in which devils in the Great Hall of Pandemonium feast upon the carcasses of Newcastle, Fox and Byng. The gourmands drink goblets of the traitors' blood, and devour their hearts as entrees, while their bodies are dressed by a demonic chef who declares, 'Though Im no French Cook, I know Whats What as well as Cloe.'[27] The duke's francophilia led the North Briton and other satiric opponents to label him Chateauneuf.

Newcastle's admiration of French fashions, manners, dress, cooking, decor, literature and artistic models was typical of much of the mid-eighteenth-century British aristocracy. It has been argued that the nobility's

social exclusivity and authority, its domestic ascendancy, was founded upon claims to cultural superiority, derived from its adoption of a Gallic cosmopolitan culture. Aristocratic francophilia, however, clashed with the common people's deeply rooted fears of the hereditary Catholic enemy's threat to their political and religious liberties. Traditional hostility was sharpened by the increasingly bitter commercial and imperial conflicts of the 1740s and 1750s, which produced a sense of crisis, and encouraged the belief that the French were close to realising their enduring ambition of conquest and oppression.[28] In the 1750s a militant nationalism emerged, expressed by a group of bourgeoisie novelists, poets, playwrights, artists and moralists, who accused the aristocracy of cultural treason. They protested against the insidious moral, social, political and economic consequences of French influence, a disease which had infected the governing classes, and by the process of emulation, was poisoning the middling and lower orders. National identity, constitutional freedoms, inherent virtue, reformed religion, patriotic spirit and warlike valour were being contaminated. The aristocracy and their growing train of followers were seduced into a self-destructive obsession with riches, luxury, indulgence and social climbing. Labour, industry and commerce were neglected; national wealth and resources were fruitlessly consumed; selfishness, satiated effeminacy, and ennui were the result.[29] During the period of the Seven Years War, literature, and especially drama, functioned as influential media for the promotion of this anti-French, anti-aristocratic ideology.[30] Many of the attacks upon the 'fribble' Byng were informed by this sentiment.

Some of the most paranoid cultural patriots even went so far as to claim that the degeneration of British morals and manners represented the preparatory phase in a far-reaching French scheme of domination, which was so cunning and meticulous, as to be almost satanic. Like the venom of a snake paralysing its victim, the French cultural invasion would so enfeeble British resistance, as to make the final military invasion an almost bloodless occupation. In the 1740s, this grand design was attributed to Cardinal Fleury, the antigallicans' bête noire. A satiric dream vision attacking Walpole as his fellow conspirator was updated to refer to Minorca, and condemned Newcastle for promoting the plan's achievement.[31] The British ruling class was assailed as the conscious or unconscious accomplices of this internal cultural subversion. Even if they were not actively assisting the French, they had become so enslaved and degenerate that they had lost the will and power to resist. *The Sham Fight* weaves the related themes of a systematic French policy of conquest, and aristocratic cultural treason, into its explanation of the fall of Minorca. In a scene which provides the cultural context for the lethargic government reaction, a mob of French dancers, servants, tailors and barbers returns from England, boasting of how they have fleeced their credulous

employers. One emphasises the transformation of the English elite into a tainted, hybrid race, 'by Gar the bon Quality love de *French*, dey be half *French* themselves'.[32]

Indictments that the Newcastle administration was actively collaborating with the enemy, or that its Gallic sympathies restricted it from a vigorous resistance, received their most literal expression in graphic satire. Prints portraying the ministers repeatedly adorned their figures with fleur-de-lis, symbolic reflections of the evil within.[33] Images of bird catching and a gilded cage were employed to illustrate the cultural seduction of the ministry (see Plate 5). Many Minorca prints combined the associated ideas of political and cultural treason. In a notable example, the ministers were exhibited by a French fairground show-woman as the finest, newly-imported Parisian puppets, hung up by the neck in anticipation of their punishment.[34]

In literary and graphic satire, Henry Fox was frequently presented as Newcastle's confederate. Often because of his allegedly superior cunning, duplicity and penchant for intrigue, he was cast in the role of instigator. This is the interpretation developed in *The Sham Fight*, the most blatant accusation of ministerial perfidy. Fox – identified by the pseudonym Reynard, the wily, ravenous fox of fable, bestiary and fairy-tale – takes the initiative in plotting the betrayal of Minorca to the French. In an early expression of what came to be regarded as his ruling passion, unquenchable avarice was distinguished as the cause of Fox's treachery, which pours out in a frenzied monologue: 'Hail, glittering Ore! – Great *Baal* of the World, the Ch[ur]chman's G[o]d, the P[lacema]n's King, the Poet's Muse, the Astronomer's *Primum Mobile*, the Moralist's *Summum Bonum*; every Specie of human Creature adore thee.[35]

The passage echoes the introductory scene of Ben Jonson's comedy *Volpone*, when the Venetian miser throws open the doors of his treasure chamber, and ecstatically worships its contents. Other critics also associated Fox with the daring, impudent trickster Volpone.[36] Judging others by his own cynical materialism, understanding the power of money, and possessing an uncanny instinct to peer into the minds of men and discover the most insidious form of temptation, Fox becomes a master of political corruption. As a young man, Fox had developed a reputation for gambling, and it was rumoured that he had exhausted his patrimony.[37] Treason offered the means to continue fuelling an existence as luxurious as Newcastle's. Fox was also a noted devotee of Gallic culture, and this was taken as evidence of a predilection to aid and abet the enemy. When responding to a French diplomatic note in December 1755, he had replied in French, affronting a patriot writer by his subservience. Fox was reprimanded for disgracing national honour, and warned in future not 'to speak to the French court in any other language but plain English'.[38] A print adopting the form of a playing card depicted Fox as

the Knave of Hearts, or *Monsr. Surecard*, to denounce him for a scheming head and wicked heart. His figure is swathed in a flourishing fleur-de-lis, symbolising his Gallic proclivities.[39]

Hardwicke's position as a politically active Lord Chancellor, and Newcastle's intimate friend and adviser, led to his vilification as a fellow conspirator. He had risen from humble beginnings as a lawyer's clerk, through loyal service to the Old Corps, to become the head of the legal establishment. He had amassed a substantial fortune during his career, and exerted his influence to promote the interests of his family. His two elder sons had followed Lord Royston into Parliament. Sir Joseph Yorke held a colonel's commission, and was British minister at The Hague, and Charles had embarked upon a promising legal career. It was thought that Hardwicke's great ambition was to see Charles follow in his footsteps and become Lord Chancellor. It was alleged he jealously watched over his son's advancement, and damaged the prospects of potential rivals. When it appeared that the Old Corps might be driven from power, Hardwicke wrote of his satisfaction that he had seen his family securely settled in life, 'With thankfulness to the Divine Providence I see all my children well-provided for and (which is more) virtuous.'[40] He announced an important advance up the legal hierarchy for Charles, who had been made solicitor-general, and wrote of his efforts with the King to secure Joseph the colonelcy of a regiment of dragoons.

Hardwicke's political enemies accused him of a calculating, cruel acquisitiveness. The image of the vulture was chosen to symbolise Hardwicke's ruthless predatory instinct. Betraying Minorca to the French offered an irresistible opportunity further to feather his nest:

> Aquilas Can Nurse his Own,
> On other Birds he'll prey,
> Unhappy Country Cease your moan,
> 'Tis now the Usual Way.[41]

Perhaps the strongest indictment of Hardwicke's greed occurred in a print associating him with Judas Iscariot, who betrayed the Son of God for thirty pieces of silver.[42] Ballads traduced Hardwicke for grinding the poor, weak and vulnerable into the dust with legal sophistry and punitive fees:

> No griping Judge with Net of Law
> Shall fish for Gold and catch his Prey.
> But Maids and Orphans Justice find
> The clean contrary Way.[43]

Several of the most brutal attacks against Hardwicke glanced at his judicial record, interpreting his actions in the worst possible light. In 1754 the vehement Tory-patriot political writer Dr John Shebbeare had commenced

his turbulent career with a scathing fictional indictment of Hardwicke's Marriage Act. The novel inveighed against Hardwicke's reforms by dramatising their pernicious impact upon the lives of aspiring lovers, whose passions had been sanctioned by God, but were frustrated by tyrannical, self-serving parents, guardians and their legal minions.[44] As condemnation of the Whig ministry was stimulated by Minorca, the issue was resurrected by the Lord Chancellor's enemies.[45] They reviled him of a hatred of humanity, exemplified by miserliness as well as avarice. A print summarised the hostile perception of Hardwicke's character by maligning him as Gnaw Bowels, alias Misanthropos.[46]

Given Newcastle's reputation for muddled thinking, indecisiveness and panic, many viewed Hardwicke as the evil genius of the Whig administration.[47] A ballad portrayed him as the author of the ministry's plot to conceal its guilt by persecuting Byng. It accused the Lord Chancellor of manipulating the law to silence him by execution:

> N[ewcastle] hence soon in a pother,
> Hard Love-Gold did give him a Jog,
> 'Thy Bacon is safe, my dear Brother
> By the Laws we shall hang him a dog.'[48]

A source describing the deepening animosity towards the Whig ministry emphasised the wide currency of the charges levelled at Hardwicke: 'I spent yesterday in the City, where insanity is predominant. Their outrage at present is confined to the Chancellor. The D. of N. is said to be obsequious to his absolute direction.'[49] The commentator also reported how much of the indignation was caused by resentment of the Yorkes' inordinate wealth and influence. It was calculated that the total value of the family's acquired estates, offices and incomes exceeded those of the Duke of Marlborough at the pinnacle of his power.

Hardwicke's eldest daughter Elizabeth was married to Lord Anson, who had acquired a considerable fortune in prize money during the wars of the 1740s. The discrepancy between the couple's ages, and rumours of the admiral's inability to perform his conjugal duty, prompted insinuations that Hardwicke sacrificed his daughter to further aggrandise the family.[50] Many who accused Hardwicke of relentlessly pursuing Byng's destruction insisted that his relation to the First Lord acted as a powerful inspiration: 'Lord Hardwicke with great deliberation and sanctity sacrificed Admiral Byng to be shot, contrary to every rule of justice and of the best naval opinions, to stem the public clamour and save his son-in-law.'[51]

In a withering satiric poem depicting a meeting of the Newcastle cabinet council, Hardwicke pleads for Anson's exoneration, promising to practice every legal trick to vindicate the admiral and the ministry's naval strategy:

Indeed, if he has made a Flaw,
He is, my L[or]d, my S[o]n in L[aw],
And if you suffer in the N[av]y,
By fair and just D[e]cr[ee]s I'll save ye.
And all the Nation must agree,
How just I've been in Ch[an]c[er]y![52]

Hardwicke's own explanation of his fears for Anson's safety emerges as a telling commentary upon Byng's incrimination: 'Ill success will be worked up into mistakes, mistakes into neglects, and neglects into crimes, where, in my conscience, there is no crime at all.'[53] He could hardly have been unconscious of his own participation in the process.

In the atmosphere of hysteria stimulated by the capture of Minorca, the ministry's pacifism, francophilia, and Newcastle's notorious financial embarrassments, were seized upon as sufficient motivations for the betrayal of the island. The streets of London rang with ballads proclaiming the ministers' guilt as Thomas Potter related: 'This morning I heard the whole city of Westminster disturbed by the song of a hundred ballad-singers, the burthen of which was, "to the block with Newcastle, and the yard-arm with Byng".'[54]

Potter correctly identified the refrain from *The Block and Yard Arm* quoted above, a testimony to the power and clarity of the ballad singers' performance, and to the effectiveness of this type of propaganda. Subversive political ideas broadcast through the air as song escaped the government's provisions for the censorship of the press. A rough but accurate indication of the turn of opinion against the ministers is provided by the political prints. With ironic understatement, Walpole noted the transition from attacks focusing primarily upon Byng, 'The streets and shops swarmed with injurious ballads, libels and prints, in some of which was mingled a little justice on the ministers.'[55] During 1756–57 approximately 54 anti-ministerial Minorca prints were produced. Newcastle enjoyed the greatest notoriety, appearing in 52. Next to the duke, Fox possessed the highest profile, reflected in the 32 prints castigating him. Of the other ministers, Hardwicke was most often featured, included in 21 attacks. Newcastle, Hardwicke and Fox frequently were cast together by ballads or prints as an unholy triumvirate. One print compared the seditious ministers to Robert Damien, the doll maker who attempted to assassinate Louis XV with a knife on 6 January 1757.[56]

Accusations of ministerial malfeasance, widely disseminated by political literature and prints, had a significant impact upon popular opinion in the late summer and autumn of 1756. They were also encouraged by the parliamentary opposition: on at least two occasions, Pitt had openly accused the ministers of intentionally neglecting Minorca, so that its fall would justify their plans to make a disgraceful end to the war.[57] Evidence of literature's influence upon the citizens of London is provided by the events of

11 September 1756, when Newcastle was confronted by a large crowd of pro-
testers, who demanded that he be dragged to the Tower to await trial for
treason. Some of the most incensed demonstrators pelted the duke's carriage
with stones and rubbish, compelling him to seek refuge within Greenwich
Observatory.[58] This incident occurred about the time that Potter reported the
ballad singers chanting the violently anti-Newcastle *The Block and Yard Arm*,
an outstanding example of the power of the ballad in mobilising the people.
Some of the later effigy burnings were distinguished by anti-ministerial
overtones, as in Darlington where the image of Byng set ablaze bore the
inscription:

> A Curse on FRENCH GOLD, and GREAT MEN'S PROMISES;
> I have never done well since I took the ONE,
> And depended on the OTHER:
> But take Heed, my Countrymen,
> I AM NOT ALONE.[59]

In addition, the importance of political literature in shaping extra-
parliamentary opinion is suggested by the protest letters regularly received
by politicians. A fascinating example provoked by the Minorca controversy
is preserved among the Hardwicke Papers. Written by a semi-literate hand,
its author perhaps represents those members of the middling and poorer
stations of society most susceptible to proselytisation by popular literature.
Its recital of grievances against Hardwicke closely follows those elaborated
by ballads and broadsides such as Siswick's, indicating that they may have
been the sources of the writer's attitudes. The letter reviles the Lord Chan-
cellor for a vicious career of self-aggrandisement, notorious for the abuse
of his legal privileges and the victimisation of the poor: 'Pray good Mr.
Wickedness how many Widdows and Orphans have you Ruin[ed] to make
Wimp[o]le in the man[ner] it is in. Pray how many fellow Subjects has
been murder[e]d upon your and the Rest of y[ou]r Damnation C[l]an's
Acc[oun]t, purely that you might get money.' The author then accuses
Hardwicke of betraying Minorca to the French: 'Pray how much money
did you sell Port Mahon for. I wish y[ou]r Wicked Laws wo[ul]d give me
leave to speak to you face to face then I sho[ul]d see villainy in all its wicked
array.'[60]

While many of the early responses to Minorca concentrated upon allegations
of ministerial treason, later works subjected the ministry's management of
the crisis to a more rational, rigorous scrutiny. The government's opponents
and Byng's sympathisers criticised the inadequacy of its defensive measures,
and accused it of attempting to exonerate itself at the admiral's expense. It
was expected that the publication of Byng's instructions would resolve the

contentious issue of exactly who was responsible for the decision to withdraw from Minorca. A mock letter from a group of common sailors gathered to pass judgment upon Byng challenged him to publish his instructions and accept the consequences:

> let fly your ensign (orders) that we may descry them; and if . . . we find you have obeyed them, why we will stand by you as long as a plank is left to swim on . . .
>
> If the fair weather sparks of Whitehall have anchored in foul ground . . . Take out the tompkin of your mouth, and fire away as loud as thunder, that by the report all folk may hear that you have done your duty . . .
>
> If you find the storm so great as to disable you from carrying sail any longer . . . why fasten down your hatches, say a short prayer, and die like a man.[61]

Byng's defenders and the ministry's critics hoped that his orders would vindicate his behaviour and impeach an incompetent administration.[62]

Byng and his closest friends were alarmed by the success of the campaign to inflame political opinion against him, which might have affected the justice of his trial, and they were enraged by what they perceived to be the ministry's encouragement. Augustus Hervey denounced the:

> most infamous and shameful unheard-of treatment Admiral Byng had met with in England, all occasioned by a hired mob to insult him, and by papers being sent about everywhere to poison the minds of the people and prejudice them against him, in order to screen those wretches Newcastle, Anson and Fox.[63]

Byng and his allies were determined not to lose the struggle for the hearts and minds of the people, and hired a political writer to reply. Paul Whitehead, a former follower of Prince Frederick, who had made a name for himself as a patriot poet in opposition to Walpole, probably was the author selected to clear Byng's reputation.[64] He was responsible for some or all of a series of pamphlets published during early October, which castigated the ministry for acting too late to prevent a French invasion of Minorca, and dispatching Byng with a fleet too weak to relieve the island. The first major work reprinted the complete text of Byng's letter, exposing the ministry's tampering, and exploited the forgery as powerful support for accusations that it was persecuting Byng to conceal its own blunders.[65] The admiral's Gibraltar letter describing the lamentable condition of the base's dockyards, and the defects of his ships, was also reproduced to strengthen the impression of neglect. Two other pamphlets developed the theme of ministerial mismanagement by demonstrating the weakness of the British fleet in comparison to the French, and contending that ships which might have given Byng overwhelming superiority lay idly in port. They denounced the ministry for initiating a smear campaign against Byng, and instigating the effigy burnings, charging that the agent provocateur responsible for the disturbances at Whitechapel was a clerk of the Victualling Office.[66]

Either Byng or an enemy of the administration was prepared to invest heavily in the propaganda counter-offensive, for 10,000 copies of *An Appeal to the People* were distributed for free in London and Westminster coffee-houses and taverns. A pamphlet defence of the admiral was circulated without charge into the country with the direction, '*Pray disperse this amongst the middling sort of People.*'[67] The vindications of Byng received comprehensive treatment in the press. Periodicals and newspapers in London, provincial England, Scotland and Ireland reprinted Byng's dispatch with the deletions restored, and his critical report of 4 May.[68] They were reviewed by the Tory Samuel Johnson, who bestowed his contempt upon the Old Corps for its sordid behaviour.[69] Hervey was as an energetic pro-Byng polemicist, writing and arranging for the publication of numerous articles and broadsheets.[70]

The doctoring of Byng's dispatch was a short-sighted, rash act. Once the tampering became known, the ministry found itself hoist with its own petard. The uncorrupted text of Byng's letter achieved a distribution equal to the censored version. The manoeuvre was interpreted as a virtual confession of guilt for failing to protect Minorca, and irrefutable evidence of a conspiracy to transfer the blame to Byng. *The Sham Fight* accurately targeted Fox as the culprit. When confronted with the potentially fatal letter by an apprehensive Newcastle, Reynard contrives a ruse to divert attention onto Byng: 'Zounds, Sir, wou'd you publish this to the World; why, we shall have all the Battle Critics at it in a Moment, and our Conduct immediately stigmatiz'd; . . . it must be dockt here and there . . . I'll make it more plausible, and then, Sir, we may venture to publish it.'[71]

An anti-ministerial fable, which equated Minorca with the struggle of two animal kingdoms, narrated how the foxes, the advisers of the British lion, had colluded with the French monkey to betray a vital cave which divided their territories. Byng, the valiant Game-Cock who had been appointed to command the relief expedition, was hamstrung by an inadequate force. The extraction of 'cover' from Byng's letter, which transformed his return to safeguard Gibraltar into an apparent admission of cowardice, proved to be extremely damaging to the ministers. The fable throws it back into their faces as a vicious subterfuge concocted to disgrace an innocent man:

> but the base perfidious Foxes . . . not only filed off all his Claws, but also clipped his wings extremely short; which rendered this courageous *Cock* so much inferior to the Enemy, that it would have been Madness to contend with him; and, therefore, finding himself unable to scour or relieve this Cave, he prudently went to *cover* another equally important One.[72]

A ballad depicting a drunken cabinet council session described the hatching of the plot. Emboldened by freely flowing wine, the ministers bawl out their

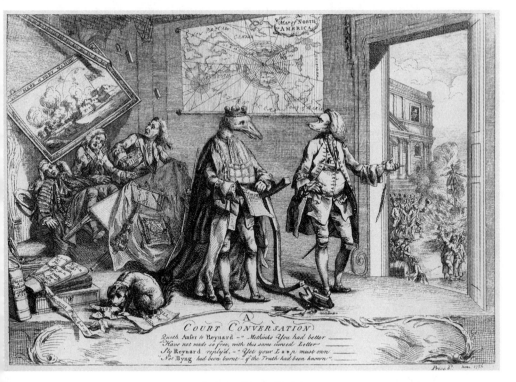

6 *A court conversation*

determination to cling to power by bringing Byng to the gallows.[73] Other
street songs attempted to endow the admiral's martyrdom with a popular
dimension.[74] A collection of pro-Byng pamphlet extracts, newspaper articles,
poems and epigrams was published, which proclaimed itself to be a riposte
to ministerial subterfuge, popular prejudice, and the 'abominable politics' of
Bungiana.[75]

Publications castigating the ministry for censoring Byng's letter identified
its central role in inciting popular antipathy against him. A print (Plate 6)
portrayed Anson, symbolically represented as a sea lion, and Fox smugly
watching Byng being burned in effigy: '*Quoth Anser to Reynard – "Methinks
you had better Have not made so free, with this same cursed Letter" Sly Reynard
reply'd "Yet your L[or]dship must own Not Byng had been burnt – if the Truth
had been known."*'

Occasionally, Anson also appeared as Byng's censor, most notably in a
print in which Byng is mounted upon the back of a sea-lion, chastising
it with a whip, shouting '*I'll flog ye Lyon for Contracting my Letter.*'[76] The

discovery of the tampering proved to be a grave blow to the credibility of the ministry, and to Fox personally: 'People here talk very much of . . . your curtailing Mr. Byngs letter, this they say is a very unjustifiable thing, & a great injury to him, as very material parts are left out, the D: of Bedford thinks this very unlucky, & that great handle will be made of it against you.'[77]

The defences of Byng motivated many to query the impetuous rush to condemn him, and to reassess the ministry's responsibility. The *Westminster Journal* employed the colloquial expression 'the cat is out of the bag' to capture the dramatic impact of their revelations. The metaphor was taken literally by a print which featured Byng as a little boy who had been mistreated by his elderly nurse, an alias commonly applied to Newcastle because of his allegedly timorous nature. In revenge, the abused child releases a ferocious cat upon his tormentor, symbolising the strength and effectiveness of Byng's literary counter-offensive:

> How varied are the turns of fickle Chance call'd fate,
> Bung was Obnoxious till he pamphleteer'd of late,
> And Now you plainly see he makes em Stir their stumps,
> By – Blowing up the train, You find which way Puss Jumps.[78]

Walpole described how reading Byng's justifications persuaded him to question the prevailing bias against the admiral, and converted him into a warm advocate.[79]

The efforts of Byng's allies and the ministry's opponents were assisted in varying degrees by the two literary journals, the *Critical* and the *Monthly*, which reviewed all the major contributions to the Minorca controversy. The treatment of Byng by the *Critical Review*, established in 1756 by Archibald Hamilton and Tobias Smollett, reflected the latter's hostility to the Whig regime. Smollett employed his editorial powers to condemn the ministry for the defeat, and for sacrificing Byng in a desperate scramble for self-preservation. Smollett was infuriated by what he perceived to be the government's irresponsible mobilisation of mob violence. He also feared that the prejudice against Byng in the press would pervert the course of justice. Smollett and the other reviewers railed against the 'maggoty booksellers' of Grub Street, and their unscrupulous scribblers, who feasted upon national misfortune and Byng's personal tragedy.[80] The *Monthly* shared the concern that the hostile press might deny Byng the right to a fair trial, and reviled the stream of scurrilous, semi-illiterate doggerel which flowed from the presses, manipulating the people's basest instincts.[81]

As the focus of the dispute shifted to the administration's naval strategy, Anson became embroiled in strident criticism. John Wilkes was supplying George Grenville with the latest publications of the political press, and wrote of the shift in opinion: 'The public indignation is rising very strong against

Lord Anson, and Byng has now everywhere some warm advocates ... *Poor Byng* is the phrase in every mouth, and then comes the hackneyed simile of the *Scapegoat*.'[82] Pitt emerged as one of the First Lord's harshest judges: 'Mr. Pitt ... charged the loss of Minorca upon Lord ANSON, and the Duke of NEWCASTLE; and added, with respect to Lord ANSON particularly, he was not fit to command a cock-boat on the river Thames.'[83]

Antagonism towards Anson was stimulated by the perception that Byng was suffering to conceal his deficiencies as a naval strategist.[84] Anson and the ministry were blamed for a lamentable misappreciation of intelligence derived from intercepted French diplomatic correspondence and spies at Versailles, which warned of the threat to Minorca:

> How quietly did they behold 'em
> Nor would believe what *Frenchmen* told 'em![85]

The Wisdom of Plutus included a merciless assault upon the admiral. Anson was nearly 60 years of age, and the poem charges that he lacked the mental and physical energy required to direct a global maritime conflict. It claimed that he owed his appointment to his personal connection to the Old Corps through marriage to Hardwicke's daughter Elizabeth, who ensured that he slavishly toed the political line.[86] Anson was repudiated as a decrepit old barnacle clinging to the sinking Pelhamite ship of state:

> Who dares dispute my sov'reign Right
> To rule the S[e]a, with parts so bright?
> Tho now at ease, my Sail be furl'd,
> I once have travell'd round the W[or]ld;
> Altho' perhaps I make no bustle,
> There may be Life yet in a Mustle;
> And by this lucky hit of Riches,
> I've gain'd a W[i]fe, she wears the Breeches;
> And any Thing with her must thrive,
> I'm yours, my L[or]d, whilst I'm alive.[87]

Anson was indicted for acquiescing in Newcastle's demands that politically influential officers receive promotions or ship assignments, to the detriment of service morale and efficiency.[88] Hervey charged that the First Lord favoured certain officers, usually his old comrades from the circumnavigation, with calamitous results in the ships and officers allocated for Minorca.[89]

Anson was a man of legendary taciturnity, which was interpreted as a sign of dull torpor, and he was mocked by the nickname 'Mute'. *The Wisdom of Plutus* makes Anson's obsession with a French invasion appear to be inspired by the fears of a timorous, senile old man, and sluggish comprehension, the latter ironically emphasised by Hardwicke's attempted justification of his son-in-law:

> Then rather let an A[nso]n rule,
> 'Tis wise sometimes to use a Fool;
> And sure 'tis safer for our Fl[eet],
> An Enemy to miss, than meet;
> Altho' we suffer in our Trade,
> By Peace, amends will soon be made;
> And Br[i]t[ai]n will recover soon,
> The woeful Loss of P[or]tm[aho]n;
> At S[pithead], then let him rule the Roast,
> He safely guarded B[ritai]n's Coast;
> Without equivocal evasion
> We've had, at least, no F[renc]h In[vasio]n.[90]

Anson was criticised for an appalling misapplication of British naval strength by tying down a large force to prevent an illusory invasion, and assigning other ships of the line to less strategically vital missions, such as attacking a convoy of merchantmen in Cherbourg.[91] The desperate attempt to reinforce Byng with five warships, which arrived too late to participate in the battle and relieve Minorca, made the failure to send them initially seem even more glaring. A poet challenged the ministry to answer the indictment which would become the central issue of the parliamentary inquiry:

> Had we not Ships enough in pay,
> That in our Ports at Anchor lay?
> The Cause is plain, none can excuse it,
> If we have Force, why don't we use it?[92]

A British Philippic chastised the ministry for its chaotic deployment of the fleet, which squandered the advantage of numerical superiority:

> Away this impolitic Defect!
> This Novelty in War, divided thus
> To parcel out your widely-scattered Fleet
> In scanty Destinations![93]

The accusation that the ministry had forfeited the strategic initiative to the enemy through indecision, and were always one step behind in their response, seemed to be corroborated by revived condemnation over Boscawen's failure to intercept the French fleet carrying reinforcements and military equipment to Canada in 1755.[94]

The invocation of chance in several satires was made to emphasise the apparently blind, random nature of British naval direction by playing upon Anson's notorious reputation as a gambler.[95] Anson was an avid patron of White's Club, where he won and lost considerable sums at all the fashionable games. The Wisdom of Plutus insinuated that the First Lord's intelligence

assessments, planning and deployment of the fleet were so erratic that he was guilty of recklessly gambling, not only with Britain's maritime and colonial fortunes, but also with national survival itself:

> Instead of Trident, it is plain,
> With Box of Dice, *he rul'd the Main.*[96]

Much of the antipathy towards Anson was instigated by prints: '... his incapacity grew the general topic of ridicule; and he was joined in all the satiric prints with his father-in-law, Newcastle and Fox'.[97] Anson appeared in approximately thirty-three hostile engravings during 1756–57, the majority linking him with Minorca and the ministerial conspiracy to scapegoat Byng. Many prints surrounded Anson with gambling paraphernalia to exemplify the charge that a grossly incompetent naval leader determined strategy as capriciously as the most abandoned gamester. The First Lord clutches cards and dice in his hands, and they overflow from his pockets.[98] One print envisaged Minorca as a valuable stake forfeited in an international game of dice.[99] In a second example (see Plate 5), Anson is bound to an E.O. table, and reveals the desperation of the compulsive gambler whose luck has run out. He demands more money, which will be squandered in a vain attempt to recover his initial losses, '*E.O. my heart of Gold tip us a handful for I have had a damn'd bad run*'. Often gambling symbols were incongruously juxtaposed with an anchor, an emblem associating the Admiralty and sea power with the virtues of trust, dedication, and stability.[100] As in the case of Byng, the anchor was often broken to emphasise Anson's unworthiness for his high position (see Plate 6).

Enemies seeking to discredit Anson seized upon the rumours of his impotence as crude metaphors for his feeble performance as a naval strategist. *The Wisdom of Plutus's* reference to Lady Anson wearing the breeches exploited Anson's alleged infirmity to scorn his political subservience to his Pelhamite masters. A print asserting the treasonous sale of Minorca included a declaration that Anson's marriage was invalid because of his inability to consummate it.[101] Walpole delighted in recounting this type of scurrilous gossip, which he featured in an epigram denouncing Anson for plotting Byng's destruction:

> Proud Anson, do you feel no conscience sting,
> While yours the errors, but the victim Byng?
> In you 'tis most unjust to hasten fate
> First multiply e'er you depopulate.[102]

In a broader context, patriot social critics cited Anson's gambling as confirmation of their charges that the early defeats of the war were caused by the moral bankruptcy of the Whig regime.

The Newcastle ministry's lack of strategic vision was underlined by comparison with Cromwell, a leader who understood the vital significance of sea power and oceanic trade. The Protectorate's naval successes in the commercial wars against arch-rivals Holland and Spain, and Cromwell's grandiose Western design of imperial expansion, were contrasted with Anson and Fox's aimless leadership, and neglect of the country's maritime aspirations.[103] The remarkable growth of the British economy during the eighteenth century, and the establishment of a thriving manufacturing industry, owed much to the development of overseas trade. British commerce had increased nearly threefold in the century before 1750, contributing to unprecedented levels of economic prosperity, and enhancing the quality of life enjoyed by all stations of society. The transatlantic economy had experienced the most vigorous development: by 1750 North American imports had quadrupled in value and the re-export of colonial products had tripled.[104] Britain was able to achieve an advantageous balance of trade by purchasing her European imports with re-exported colonial commodities, which were paid for by the export of domestic manufactures. The great wealth reaped by the sugar, tobacco, rice and indigo planters of the West Indies and the middle American colonies stimulated a growing demand for luxury goods imported from Britain. It was during the 1740s that the American consumer market for British pottery, glass, metal ware and other manufactured products rapidly accelerated. The New England merchants who supplied fish, grain and timber to the West Indies also spent much of their handsome profits upon British imports.[105]

British commercial expansion was distinguished not only by the development of a thriving merchant community, but also by the participation of those involved in the burgeoning wholesale, retail, service and manufacturing sectors of the economy. The benefits created by the free flow of trade were enjoyed by shopkeepers who supplied an astonishing variety of foreign luxury goods for domestic consumption, manufacturers who employed imported raw materials in production and exported their products to overseas markets, and those who engaged in maintaining the transportation networks by which goods were circulated. Geographically, the rewards were widely distributed among many regions and types of urban community. Ports such as London, Bristol and Liverpool, industrial centres in the Midlands, Yorkshire and the West Country, and market and county towns all profited from the transatlantic economy. In social terms, imperial and commercial growth accelerated the extension of the urban middling classes, providing the means which qualified many to participate in local and national politics. By mid-century, the conviction that imperial expansion, overseas trade, national wealth, and state power and prestige were inextricably linked, had become established as a central tenet of British political culture by the experience of the colonial wars with Spain and France during 1739–48.[106]

Contemporary literary works reflected the dominance of an economic vision, which asserted that national power rested upon achieving an advantageous balance of trade, and envisaged intense international rivalry to obtain resources and markets. As early as 1754, prints had registered fear caused by the spectre of French competition, and lamented the Whig ministry's refusal to promote British commerce more aggressively.[107] *The Block and Yard Arm* emphasised the widespread perception that trade and empire were the lifeblood of the British economy, and the ultimate source of that naval and military strength, which guaranteed national independence, and political and religious liberty. Furthermore, it adeptly expressed contemporary beliefs in the interdependency of commerce, industry, agriculture, and national wealth and personal prosperity, and painted a terrifying picture of the domino effect, which would be caused by the ruin of trade. The catastrophic repercussions would be felt by every sector of the economy and by every social class, devastating sailor, merchant, shopkeeper, tradesman, artisan, farmer, gentleman and aristocrat. It horrified its readers and hearers with a dire prophecy of poverty, conquest and oppression if the Newcastle administration's calamitous conduct of the war was allowed to continue:

> And you my brave Tars, who sail on the main,
> Bring Wealth to the Merchant; our Honour sustain,
> Must starve in our Ports, depriv'd of your Glory;
> Indeed my good Friends 'tis a very sad Story.
>
> Ye Merchants who now in your Coaches do ride
> Must lower your Grandure and bring down your Pride:
> Ye Shop-keepers too, who in plenty do live,
> Soon must ye now with sad Poverty Strive.
>
> Ye Farmers laborious who live by the Plough,
> Where to pay Rents, will you get money now?
> Ye Hinds and Mechanicks of each branch of Trade,
> Throw all your Tools down, and lay by the Spade.
>
> Ye Lords and ye Gentry, who make a great Show,
> Your Tenants can't pay, so down you must go,
> The Peer, the Beggar, and honest Jack Tar
> By B[yng] and N[ewcastle] brought on a Par.
>
> *Minorca* is lost; and America too
> Soon my good Folks, will be taken from you:
> And when to the French you've lost all your Trade,
> Soon to *French* Slaves Vile Slaves you'll be made.

The growing apprehension, recorded in political literature, that naval defeat would bring economic decline, is illustrated by the Minorca protests,

which were pronounced in regions of the country where people depended upon Mediterranean commerce for their livelihoods. The nightmare of economic privation threatened by the author of *The Block and Yard Arm* appeared to be becoming reality for many in the autumn of 1756. The textile and worsted industries of the south-west and East Anglia that relied upon the importation of Spanish wool and dyes for production were damaged by interruptions in supply. Many of the labouring poor who suffered as a result of the depression assigned their misery to Byng and the fiasco in the Mediterranean.[108] In Cornwall, it was reported that the disruption of the Mediterranean export trade caused 10,000 tinners to be thrown out of work, reducing many to 'a State of Desperation'. Economic hardship sharpened the violence of demonstrations against Byng and an ineffectual naval policy. At Falmouth, a crowd of approximately 15,000 jeered as an effigy of Byng was tied to a donkey's tail and dragged around the common. Written upon the straw admiral's chest was the curse 'the Friend of Monsieur Ragout and the Tinners' Scourge'.[109]

Charges that the French were refortifying Dunkirk, always a deeply emotional issue because of its strategic location, which made it an ideal base for privateers preying upon British shipping, emerged as another source of popular wrath. Joseph Reed abused Newcastle for a meek refusal to punish the French for violating their 1748 treaty obligation:

> Ask the proud Battlements in *Dunkirk* rais'd,
> In UNDEMOLISH'D *Dunkirk*, they will tell
> In what Contempt our dreadless Fleets are held,
> While Luxury and Avarice unman
> The native Spirit of our little Isle.'[110]

An examination of the contemporary press demonstrates how comprehensively North American affairs were reported.[111] During 1753–56, it was dominated by the two most important and intractable territorial disputes left unsettled by the Peace of Aix-la-Chapelle: the quarrel over the Acadian boundary, and the intensifying struggle for possession of the Ohio Valley.[112] Acadia had been ceded to Britain by the Treaty of Utrecht in 1713, but without any clear definition of its limits. In 1749, to prevent British movement westward, the French established a fort on the Missaguash River at Beauséjour. The British protested against the invasion of what they believed to be their territory, and built a fort of their own on the other bank of the river, leading to a tense stalemate along the frontier. Antagonism between the colonial powers was also stimulated by argument concerning how far the boundaries of Canada extended into the region south of Lake Ontario and the St Lawrence River. In 1749, France had also initiated plans to enforce her claim to the Mississippi basin – the heart of the North American continent – by expanding southward from Lake Erie, and joining together Canada and Louisiana by a series of

fortified posts. The British rejected France's right to annex the enormous territory and to monopolise trade with the region's native peoples. In the spring of 1754, Colonel George Washington had been dispatched by Virginia to defend the rival claims of the colony by constructing a fort at the forks of the Ohio River, the location of modern Pittsburgh. In April, Washington was expelled by a superior French force. The French began to construct a fort on the site named in honour of the Governor of Canada, Marquis Duquesne.[113]

During 1755–56, literature and graphic art recorded the conviction that war was justified to finally resolve the territorial and trade conflicts with France.[114] If the French were allowed to occupy the centre of the continent, the British colonies would be confined to a narrow tract of land along the Atlantic coast, and slowly strangled to death. In 1755, a print underscored Britain's mounting indignation at French treachery: Louis XV preaches compromise and pretends to negotiate while continuing to fortify the contested regions:

> Th' amusing Treaty he revives in vain,
> Whilst rising Forts extend th' insidious Chain.[115]

A neoclassical poem, in which Jupiter decreed a resounding victory for Britannia, identified the vindication of her peoples' imperial destiny in North America as the fundamental cause of the conflict:

> The vanquish'd Gaul for Peace shall humbly sue,
> And to the Britons for its Basis yield
> Acadia's fertile Soil, Ohio's Forts,
> And Dunkirk's lofty Battlements erase:
> She shall to them full Satisfaction make
> For Treaties broke, and on the briny Sea
> Shall own their Sovereign Pow'r, and Laws obey.[116]

Newcastle's most strident opponents accused him of sacrificing British maritime-colonial interests in North America by pandering to George II's partiality for Hanover. This indictment was expressed in a print (Plate 7) where a moose, symbolic of North America, is surrounded by the imperial monarchs of Europe, who are eager to lay claim to its resources. George II is portrayed as the most irresponsible imperial ruler, concerned only with short-term exploitation of the British colonies, whose riches are diverted for the aggrandisement of Hanover. He stands behind the moose holding up its tail, and beats it with a whip. The wealth generated by the tobacco, fur, salt, rum, indigo, and other colonial trades is rather incongruously depicted by the droppings of the moose, which fall into George II's crown, while the German-born king exclaims, 'I'm for de produce to enrich Hanover.' In contrast, Louis XV appears as the most far-sighted monarch, feeding the

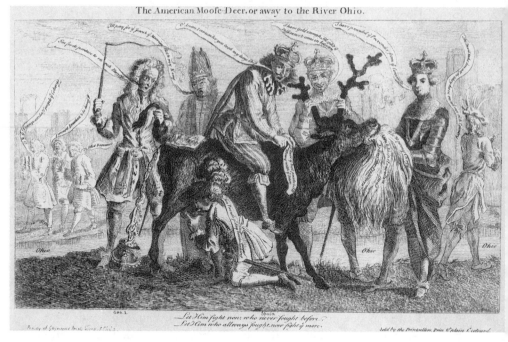

7 *The American moose-deer*

moose with fodder marked troops, arms and ships, representative of France's efforts to strengthen the military position of her colonies in preparation for their expansion. The print alludes to several controversial incidents in which British traders in the Ohio Valley had been arrested and imprisoned by the French. George II ignores the colonists' pleas for assistance, who are being driven away in chains, while the battlements of Fort Duquesne rise in the background.

John Shebbeare's second novel *Lydia* contains stinging criticism of New-castle for acquiescing in French encroachments in North America. The cap-tain of a Royal Navy warship in American waters, the dissolute, swaggering aristocrat Charles Bounce, is exposed as a coward for not retaliating against a French man of war. The patriotic crew burn to attack the enemy, but Bounce attempts to conceal his personal cowardice behind the political cowardice of Newcastle:

> you'll be broke by [Anson] I have Orders from the Duke of [Newcastle] not to offend the *French* on any Account; we are in no Condition to go to War . . . What a damned Scrape the brave Colonel *Wash[ing]ton* who so delighted with the whistling of Bullets, has brought upon the M[inistr]y.[117]

96 ❀

An Onondagan chief journeys to Britain to appeal for the redress of the sufferings of the Iroquois Confederacy. The Albany Conference of 1754, at which Britain's most powerful native allies had expressed their dissatisfaction over the crown's failure to address a host of grievances, had been extensively reported in Britain.[118] In a ludicrous encounter, Cannassatego is mistaken by Newcastle for the Young Pretender in disguise, who has infiltrated Britain to incite a Jacobite revolution. Newcastle rejects the pleas of the Iroquois, and Cannassatego returns to advise his nation to take revenge upon its false friends.[119]

The high hopes of the 1755–56 campaign were illustrated by two prints, which anticipated the immediate conquest of all of the ministry's objectives. In the first, the British lion plucks feathers marked Ohio, Beauséjour and Quebec from a fleeing Gallic cock, and in the second, the capture of Fort Niagara is presaged by a French canoe plunging over the Falls to its destruction.[120] Unfortunately, these expectations were to be bitterly disappointed. Braddock failed to secure the Ohio Valley for the westward expansion of the British colonies. A projected attack upon Fort Niagara ground to a halt. Another army raised at Lake George for an offensive into the Champlain-Hudson Valley barely repulsed a French counter-thrust. Britain's only unqualified success, the capture of Forts Beauséjour and Gaspereau on the Acadian frontier, was overshadowed by the other defeats.[121]

The near annihilation of Braddock's army before Fort Duquesne was a disheartening blow.[122] The debacle generated a prolonged controversy over its causes, which was renewed by the opposition in the wake of the ministry's embarrassment over Minorca. *One-Thousand, Seven-Hundred, and Fifty-Six* expressed two of the most frequent explanations for the disaster. First, the ministry was condemned for selecting Braddock for the command: an unimaginative officer, who had offended his native and colonial allies, was incapable of adapting European tactics to wilderness warfare, and whose blind, unthinking courage had precipitated the defeat and his own death.[123] Second, by mismanaging native affairs, the government had alienated the majority of the western native peoples. Many had fought against Braddock:

> But vile Oppression ev'ry where,
> Breeds Hate, Disdain, and mad Despair;
>
> What Means were taken to procure,
> A Friendship lasting and secure?
> Or did we use those *Indians* well,
> Who now against us do rebel?
> No, no, we slighted each Advance,
> So in Despair they joined with *France*.[124]

In the wake of the catastrophe, Fort Duquesne became the base for French and native raiding parties, which terrorised the frontier settlements of Pennsylvania, Virginia and Maryland. Lurid accounts of scalping, torture, captivities and burning farms were propagated by the British press and literature.[125] Typical was the republication of a poem by a Virginia clergyman, which revealed the intense hatred fuelled by imperial rivalry, religious bigotry, racism and mutual atrocity.[126] The settlers' sufferings highlighted the Newcastle ministry's tragic inability to protect Britain's North American colonies.

The news of Byng's retreat and Minorca's surrender inflicted another painful wound upon British martial pride, still open and bleeding after Braddock's debacle.[127] A poem exemplified the demoralisation caused by the two great defeats, which were unflinchingly juxtaposed in a single couplet:

> Disgrac'd her Glories on the Main;
> Her *Blakeney* beat, her *Braddock* slain.[128]

The nation was staggered by more bad news from America in the autumn of 1756. Taking advantage of British unpreparedness, the French seized the forts, naval base and fur trading post at Oswego on the south-eastern shore of Lake Ontario. The loss of Oswego confirmed French control of the Great Lakes, and deprived the British of their major trading connection to the native peoples of the north-west, who were further persuaded towards neutrality or active alliance with the French.[129] An elaborate hortatory poem, which pleaded with the nation and its leaders to shake off the enervating toils of luxury, and recover the warlike strength of their ancestors, chronicled its tragic consequences in the North American war:

> Behold a later scene, with ruin fresh
> And shameful ignominy; see the foe,
> Their ensigns streaming from Oswego's walls,[130]

The news of a further defeat at Oswego, which arrived in early October, when anti-ministerial outrage incited by Minorca had reached its zenith, destroyed whatever faith remained that the Newcastle ministry was capable of successfully conducting the war.[131] The collapse of its ambitious plan to drive the French out of the disputed territories in North America, and the fall of Minorca, appeared as irrefutable proof that it could not be trusted to defend British imperial and commercial interests. A print which emphasised the immense gulf between confident predictions of the plucking of the Gallic cock in 1755, and the harsh reality of 1756, portrayed a Frenchman chopping off the paws of the British lion. In the symbolic dismemberment of the British Empire, the first two strongholds to be amputated were labelled Minorca and Oswego[132] (see Plate 9).

NOTES

1 *British Hero and Ignoble Poltroon*, pp. 16–17.

2 *GM*, Dec. 1756, 572.

3 PRO, SP 36/135, fos 197–205.

4 *Ibid.*, 200.

5 *A (Letter) From an Auction(ear)*, BMC 3356; *The Auction*, BMC 3467.

6 BL, Add. MSS 35,594, fo. 148.

7 SP 44/134, fo. 379: Holdernesse to Murray, 20 Aug. 1756.

8 BL, Add. MSS 32,866, fo. 489: Dr Squires to Hardwicke, 19 Aug. 1756.

9 *Admiral B[yng]'s Catechism*, 1756; *Sham Fight*, p. 25.

10 *A Rueful Story, or Britain in Tears*, pp. 7–9; *B-n-g in Horrors*, BMC 3376; *The Discard*, BMC 3421.

11 *Boh Peep-Peep Boh*; 'A Farce', *LEP*, 27 Nov. 1756.

12 *The Observator of the Times*, 1756; *Half-Peace*, BMC 3334; *Half-War*, BMC 3335.

13 *A Goose of Old*, BMC 3330.

14 Free, *Ode of Consolation*, p. 6.

15 *Ibid.*, p. 4.

16 *Byng Return'd*, BMC 3367.

17 Kelch, pp. 69–93, 126–74.

18 *Ibid.*, pp. 1–13, pp. 211–17.

19 *Ibid.*, pp. 43, 85, 143.

20 *Ibid.*, pp. 118–25, 154.

21 Walpole, *Memoirs*, II. 190.

22 *The History of Tom Dunderhead*, 1755, p. 6.

23 *The Block and Yard Arm*, 1756.

24 Thomas Turner, *The Diary of a Georgian Shopkeeper*, ed. G. H. Jennings (Oxford 1979), p. 31.

25 Romney Sedgwick, 'The Duke of Newcastle's French Cook', *History Today*, V (1955), 308–16.

26 Turner, p. 40.

27 *A Scene in Hell*, BMC 3378.

28 Gerald Newman, *The Rise of English Nationalism* (London, 1987), pp. 12–47; R. Harris, *Politics*, pp. 4–5.

29 *Newman*, pp. 55–94.

30 Samuel Foote, *The Englishman in Paris*, 1753 and *The Englishman Return'd From Paris*, 1756; Louis de Boissy, *The Frenchman in London*, 1755; David Garrick, *Lilliput*, 1756; Arthur Murphy, *The Englishman From Paris*, 1757; and Henry Dell, *The Frenchify'd Lady Never in Paris*, 1757.

31 *A Dream Note*, 1756.

32 *Sham Fight*, p. 21.

33 *England Made Odious*, BMC 3543.

34 *Punch's Opera*, BMC 3394.

35 *Sham Fight*, pp. 6–7.

36 *The Court Cards*, BMC 3465.

37 Walpole, *Memoirs*, II. 62.

38 *LM*, Jan. 1756, 46.

39 *Monsr. Surecard*, BMC 3506.

40 Hardwicke to Joseph Yorke, 24 Oct. 1756, Yorke, II. 334.

41 *The Vulture*, BMC 3502; *The Devil Turned Drover*, BMC 3416.

42 *The Auction*, BMC 3467.
43 *The Ministry Chang'd*, 1756.
44 John Shebbeare, *The Marriage Act*, 1754. The novel went through three editions.
45 *Null Marriage*, BMC 3522; *Cannon Refus'd by Foreigners*, BMC 3490.
46 *The Bankrupts with Anecdotes*, BMC 3429.
47 Fox to Dodington, 19 Oct. 1756, HMC *Various Collections*, VI. 36.
48 *More Birds For the Tower*, 1756.
49 Rev. Henry Etough to Lord Walpole, 28 Aug. 1756, Yorke, II. 307.
50 Walpole reported a bon mot by Charles Townshend, who, upon being told that Lady Anson resembled a mermaid, replied 'Yes, she is a *mere maid*', Walpole to Mann, 3 Mar. 1757, *Corr.*, XX. 63.
51 Shelburne, I. 69.
52 *The Wisdom of Plutus*, 1757, p. 11. Newcastle was envisaged as Plutus, the God of Wealth, because of his apparently limitless riches or ability to borrow.
53 Hardwicke to Joseph Yorke, 24 Oct. 1756, Yorke, II. 334.
54 Potter to Grenville, 11 Sept. 1756, Smith, I. 173.
55 Walpole, *Memoirs*, II. 158.
56 *The Three Damiens*, BMC 3558.
57 Walpole, *Memoirs*, II. 143.
58 Potter to Grenville, 11 Sept. 1756, Smith, I. 173.
59 NC, 11 Sept. 1756; NJ, 11 Sept. 1756; *An Effigy of an Unpopular Minister*, BMC 3436.
60 Yorke, II. 309.
61 'A Letter From a Committee of Sailors', *Gaz*, 6 Aug. 1756; *LEP*, 7 Aug. 1756; *YC*, 10 Aug. 1756; *BWJ*, 12 Aug. 1756; *GM*, Aug. 1756, 398; *LM*, Aug. 1756, p. 393; *Bungiana*, p. 43.
62 *Byng Return'd*, BMC 3367.
63 Hervey, p. 226.
64 *Adml. Byng's Last Chance*, BMC 3569; Pope, p. 192.
65 *A Letter to a Member of Parliament . . . Relative to the Case of Admiral Byng*, 1756.
66 *An Appeal to the People: Containing, the Genuine and Entire Letter of Admiral Byng*, 1756; *Some Further Particulars in Relation to the Case of Admiral Byng*, 1756.
67 *WEP*, 12 Oct. 1756; *DM*, 5 Nov. 1756.
68 *GM*, Oct. 1756, 479–85 and many other publications.
69 *LiM*, Oct. 1756, 299–309.
70 Hervey, p. 311.
71 *Sham Fight*, p. 30.
72 *A Ray of Truth, Darting Thro' the Thick Clouds of Falsehood*, 1756, p. 6.
73 *The Merry Topers*, 1756.
74 *Admiral Byng's Complaint*, 1756.
75 *A Collection of Several Pamphlets . . . Relative to the Case of Admiral Byng*, 1756.
76 *Bi[n]g's Turn to Ride*, BMC 3370.
77 BL, Add. MSS 51,423, fo. 87: Digby to Fox, 18 Oct. 1756; *Admiral Byng Riding Mr. Fox*, BMC 3369.
78 *The Way the Cat Jumps*, BMC 3516.
79 Walpole, *Memoirs*, II. 201.
80 CR, Oct. 1756, 278–9, 286; Mar. 1757, 286.
81 Spector, *Literary Periodicals*, pp. 30–2.
82 Wilkes to Grenville, 16 Oct. 1756, Smith, I. 176.
83 John Almon, *Anecdotes of the Life of the Right Honourable William Pitt* (London, 1792), I. 230.

84 *The Merry Topers*.
85 *One-Thousand, Seven-Hundred, and Fifty-Six*, 1756, p. 31.
86 *The Discard*, BMC 3421.
87 *The Wisdom of Plutus*, pp. 13–14.
88 *Occasional Conformity*, BMC 3485.
89 Hervey, p. 213.
90 *The Wisdom of Plutus*, pp. 9–10.
91 *Some Further Particulars in Relation to the Case of Admiral Byng*, 1756, pp. 5–6.
92 *One-Thousand, Seven-Hundred, and Fifty-Six*, p. 32.
93 Reed, *A British Philippic*, p. 18.
94 *One-Thousand, Seven-Hundred, and Fifty-Six*, pp. 17–19.
95 Boscawen, p. 166.
96 *The Wisdom of Plutus*, p. 13.
97 Walpole, *Memoirs*, II. 164.
98 *Punch's Opera*, BMC 3394; *Britannia in Distress*, BMC 3524.
99 *The Rostrum*, BMC 3424.
100 *The Sea Lyon*, BMC 3493.
101 *Null Marriage*, BMC 3522.
102 Walpole to Mann, 3 Mar. 1757, *Corr.*, XXV. 64.
103 *Oliver Cromwell's Ghost*, 1756.
104 K. Morgan, in P. Mathias and J. A. Davis (eds), *Industrialisation, Trade and Economic Growth From the Eighteenth Century to the Present Day* (Oxford, 1996), pp. 1–14; R. P. Thomas and D. N. McCloskey, 'Overseas Trade and Empire', in Roderick Floud and D. N. McCloskey (eds), *The Economic History of England Since 1700* (Cambridge, 1981), I. pp. 90–2; John Rule, *The Vital Century: England's Developing Economy 1714–1815* (London, 1992), pp. 262–74.
105 T. H. Breen, 'An Empire of Goods: The Anglicisation of Colonial America, 1670–1776', *Journal of British Studies*, XXV (1986), 467–99.
106 Kathleen Wilson, *The Sense of the People: Politics, Culture and Imperialism in England, 1715–1785* (Cambridge, 1995), pp. 137–65; Brewer, *Sinews*, pp. 164–75; Rogers, *Whigs*, pp. 391–405.
107 *Foreign Trade and Domestic Compared*, BMC 3274.
108 *SJ*, 16, 23 Aug. 1756; *SMJ*, 11 Jan. 1757.
109 *LEP*, 14 Aug. 1756. Effigies of the admiral were also hung from pawnbrokers' signs.
110 *A British Philippic*, pp. 4–5.
111 D. E. Clark, 'News and Opinions Concerning America in English Newspapers, 1754–1763', *Pacific Historical Review*, X (1941), 75; *GM*, 1754–56.
112 T. C. Pease (ed.), *Anglo-French Boundary Disputes in the West, 1749–1763*, (Springfield, 1936); Max Savelle, *The Diplomatic History of the Canadian Boundary 1749–1763* (New Haven, 1940).
113 *GM*, July 1754, 399–400.
114 *Humorous and Diverting Dialogues*, 1755; *Britain, Strike Home*, 1756; *A Poem on the Declaration of War*, 1756; *The Royal Conference*, 1756.
115 *The Grand Monarch in a Fright*, BMC 3284.
116 Robert Averay, *Britannia and the Gods in Council*, 1756, p. 31.
117 John Shebbeare, *Lydia*, 1755, I. 211 (four editions printed). *Poor Old England*, BMC 3540; *Poor New England*, BMC 3541.
118 *GM*, June 1755, 252–6; Francis Jennings, *Empire of Fortune: Crowns, Colonies and Tribes in The Seven Years War in America* (New York, 1988), pp. 22–37, 80–108, 188–95.

119 Shebbeare, *Lydia*, III. 265–75, IV. 115–17.

120 *Britain's Rights Maintained*, BMC 3331; *British Resentment*, BMC 3332.

121 Guy Frégault, *Canada: The War of the Conquest*, trans. Margaret Cameron (Toronto, 1969), pp. 89–112.

122 *GM*, Aug., Sept. 1755, 378–80, 426–27; 'Verses', *LM*, Oct. 1755, 496.

123 *One-Thousand Seven-Hundred and Fifty-Six*, p. 30.

124 *Ibid.*, p. 29.

125 *GM*, Dec. 1755, 580; Mar., May 1756, 131, 227; *LEP*, 19 Feb., 24 July, 1756; *A British Philippic*, p. 4; *The British Hero and Ignoble Poltroon*, pp. 3–4; *The Patriot*, pp. 45–6.

126 Samuel Davies, 'On the Barbarities of the French and their Savage Allies', *GM*, Feb. 1757, 83. Ultimately, the European combatants' perceptions of the native peoples were dictated by their willingness to fight for British or French imperial interests. Consequently, in literature they were depicted in unrealistic extremes, either as idealised exemplars of natural virtue such as Cannassatego or the incarnation of barbarity.

127 Glover, *A Sequel to Hosier's Ghost*, p. 3.

128 'An Ode to Edward Vernon', *PA*, 31 July 1756.

129 *GM*, Nov. 1756, 508.

130 *Britain, A Poem*, 1757, pp. 15–16.

131 *The Speech of a Patriot Prince*, 1756, p. 8.

132 *The British Lion Dismembered*, BMC 3547.

5

Patriotism resurrected

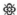

IN THE AUTUMN of 1756, the defeats at Minorca and in North America acted as powerful catalysts for the revival of a patriot opposition. Criticism of the ministry for failing to defend Britain's maritime-colonial interests was exacerbated by the deteriorating European situation. The Convention of Westminster, which had appeared to confirm the security of Hanover and the isolation of France, had in reality promoted a realignment of international alliances which had been developing since 1748. Conscious that France would be a far more effective ally than Britain for the recovery of Silesia from Frederick II, the Austrian court had pursued a policy of reconciliation. Apprehensive of being left without a major European ally, Louis XV concluded a defensive treaty with Austria in May 1756. Soon after, it became evident that the Russians would disregard their subsidy treaty with Britain, and join the coalition against Frederick II.[1] The Habsburg–Bourbon pact confirmed the Dutch republic's belief that its welfare would best be served by neutrality in any war between Britain and France.[2]

The shocking revelation of the Diplomatic Revolution – that Britain had been abandoned by its traditional allies for the restraint of French aggression on the continent – coincided with the extension of the war to Europe through the invasion of Minorca.[3] The British were confronted with the prospect of a full-scale continental war, and the political and military problems posed by the vulnerability of Hanover. It appeared as if all of Prussia's resources would be concentrated upon the struggle for survival in the east, leaving Hanover at the mercy of France. The strategic nightmare seemed inescapable when Frederick II launched a pre-emptive strike by invading Saxony in August 1756. The gloom caused by the outbreak of war in Europe, and Britain's almost inevitable involvement, was captured by Chesterfield: 'Here is a fire lighted up in Germany, which, I am persuaded, I shall not live to see extinguished, but of which the effects must, in the meantime, be dreadful to England.'[4]

Maria Theresa's betrayal of the 'old system', the Grand Alliance against France, provoked bitter charges of ingratitude. The Empress was reminded of how during the 1740s, when forsaken by others, Britain had vindicated her claim to her father's throne and possessions. Moreover, Britain's only important acquisition during the War of the Austrian Succession, the North Atlantic fortress of Louisbourg, had been surrendered to recover the occupied Austrian Netherlands from the French. *Britain* condemned Maria Theresa for faithlessness, and an insatiable, self-destructive thirst for vengeance, which would plunge all of Europe into war:

> The Empress queen, whom interest ever held,
> Not faith, or league, or solemn treaties seal'd;
> Her friendship venal, ever to be sold,
> By promises and powerful gold, had bound
> The faith of mighty monarchs to befriend
> Her guilty cause, and stand her brave resource,
> Should adverse fortune blast ambitious views;[5]

The strength of fury at the Habsburg defection was illustrated by the twenty hostile prints published during 1755–57, the most abusive being personal attacks upon Maria Theresa accusing her of prostitution to the French.[6]

Similar indignation was directed against the Dutch. Poets who wished to comment upon international affairs drew upon the rich tradition of animal symbolism in classical fables, medieval bestiaries and heraldry to represent national character, genius and political institutions. A verse fable of 1756, which followed the British and French diplomatic manoeuvres to persuade the States-General to espouse their causes, exemplified the violent ire sparked by the Dutch declaration of neutrality on 25 May. It allegorised the Franco-British struggle as a dispute between two of the most powerful beasts in the animal kingdom: the noble, magnanimous British lion, and his rival, the covetous, proud leopard. When the leopard's aggression leads to an open quarrel, both parties appeal to the badger republic for support, although the badgers are bound by treaty to sustain their 'old and natural Allies' the lions. The poem dramatises the respective ambassadors delivering a speech to the assembled States-General. Sir Joseph Yorke's leonine counterpart sways the badger deputies towards complying with justice and their word of honour, until they are addressed by the leopard's representative, who intimidates them with the threat of naked force:

> The timid BADGERS look like Spectres,
> Already think their State undone,
> And by the LEOPARDS over-run:
> For thus, like Optick Glasses, Fear
> Brings ev'ry distant Object near.
> The BADGERS tremble for their Lives,
> Next for their Money – then their Wives.[7]

The selection of such an ignoble creature to symbolise the Dutch character demonstrates the prevailing prejudice that a once vigorous, freedom-loving people had degenerated into a weak, low-minded, money-grubbing insularity. The French, who needed shipping to transport home the harvests of their West Indian sugar islands, and to provision their colonies, opened their colonial trade to neutral carriers. The Dutch were castigated as treacherous mercenaries, eager to profit from the distress of a former ally by taking over this traffic, and even more blatantly aiding and abetting the enemy by delivering naval stores to the French.[8] Prints fed the animosity towards the Dutch with stereotypical images of the crude, bloated, beer-swilling, tobacco-puffing merchant or burgher Nick Frog, who reaped immense profits by clandestinely doing business with both antagonists.[9] Much of the British rage must have been stimulated by commercial competition, and anxiety that the Dutch merchant marine's share of world trade would expand at their expense. As early as July 1756, Royal Navy cruisers and privateers began intercepting Dutch ships, and many were seized for carrying naval stores and other cargoes which might be construed as contraband. Dutch complaints over British violation of the freedom of the seas began immediately, inspiring a heated controversy over the relative rights of neutrals and belligerents, which reached its crisis during 1758–59.[10]

It is debatable whether the Newcastle ministry could have anticipated the Austro-French rapprochement, frustrated its achievement, or obtained a more favourable outcome for Britain than the Prussian alliance, considering the structural imperatives of the international situation, the foreign policy aims of individual states and their perceptions regarding the intentions of others, the climate of suspicion and uncertainty, and the fluidity of events.[11] The ministry's patriot critics in Parliament and the press reacted to the Prussian invasion of Saxony by accusing it of an incoherent, self-contradictory foreign policy, which had precipitated a continental war by treating with Maria Theresa's mortal enemy Frederick II, and driving her into the arms of France. In his influential series of *Letters to the People of England*, John Shebbeare fomented the resurgence of a patriotic opposition by attributing the disaster to the Hanoverian partiality of the Newcastle administration. An analysis of contemporary affairs was reinforced by a historical inquiry stretching back through the Hanoverians to William III, to demonstrate how the preference of alien monarchs for their Dutch and German homelands, connived in by sycophantic ministers, had embroiled Britain in a string of continental wars, which had sent thousands to perish in foreign graves, and crippled the country with a massive national debt.[12] The doctrine that Britain's welfare depended upon preserving a European balance of power was dismissed as a lie to conceal the neglect of the nation's maritime-colonial priorities. Shebbeare

pointed to the recent fate of Minorca and the defeats in North America as incontestable proof that Hanoverian ministers 'have fattened a spurious Race with your Heritage, and starved their legitimate Offspring'.[13] These arguments were propagated by all genres of political literature, and featured prominently in many of the ballads and poems focusing upon Minorca and North America discussed in Chapter 4. An anti-ministerial 'political catechism' recorded the bitter irony that the Prussian alliance seemed to instigate the very thing it had been intended to prevent: a French attack upon Hanover, when Frederick II was incapable of offering any assistance. Britain would be faced with two equally destructive alternatives: permit the French to occupy Hanover and hope to ransom it back at the peace by surrendering imperial conquests, or attempt by itself to oppose the mighty French armies on the exposed North German Plain of the electorate.[14]

Prints took up the patriotic anti-Hanoverian campaign as well. One engraving personified the looming imperial struggle as a duel, in which an Englishman attempts to draw his sword against his French adversary, but it is confined to its sheath by a lock inscribed with the White Horse of Hanover.[15] A second illustrated the consequences of a continental war by picturing the Gallic cock setting a flaming torch to one hemisphere of a globe marked Germany; on the other side of the world the blaze bursts out and engulfs America.[16] A Minorca print depicted Newcastle's violation of the constitution in embarking upon a continental war to shield Hanover in the form of a ministerial bulldog tearing apart the Act of Settlement (see Plate 6).

In late 1755, the political nation and Parliament had acquiesced in the Hessian and Russian treaties as initiatives designed to avert a continental war. Paying moderate subsidies to keep the peace in Europe while British military effort was concentrated upon North America was one thing; waging a full-scale continental war to protect Hanover was something entirely different. It appeared as if Britain would be committed, not only to offer financial assistance to Frederick II and Hanover, but also to hire an army of German mercenaries to assist in the defence of the electorate. The coincidental expiry in 1755–56 of four and six-year peacetime subsidy treaties with Saxony and Bavaria, undertaken as part of Newcastle's contentious Imperial Election Plan, made the ministry's European diplomacy seem even more irrational.[17]

It is not surprising that many within the political nation, who imperfectly comprehended the complexities of European diplomacy and the underlying causes of the diplomatic revolution, reacted to the threatening international upheaval with a sense of bewildered helplessness, fear and frustration. The violent attacks upon the Austrians and Dutch for their alleged betrayals were one result, symptomatic of the myopic, self-absorbed perspective which characterised general British attitudes towards European relations during the eighteenth century.[18] These developments which emphasised the uncertainty

and unreliability of European alliances, can only have encouraged the instinct-
ive impulse of many Britons to turn their backs upon the continent. Additional
insight into the causes of contemporary isolationism is provided by the
nation's state cobbler, who reminded his readers that as a trading empire,
Britain (if not Hanover) required no territorial expansion in Europe, only
free access to European markets. Furthermore, he declared that if British
rights to the interior of North America were asserted, the enormous continent
would accommodate any surplus population for the next three centuries,
and by developing the resources of the wilderness, these emigrants would
contribute to the wealth, prosperity and power of Old England.[19]

Under these circumstances, the appeal of the patriot blue-water strategy
must have been very compelling, because of its emphasis upon national self-
reliance and the exercise of sea power. A naval war was welcomed because
Britons believed they would be fighting upon their native element, and that
their numerical superiority gave them the strategic initiative, which could be
directed toward truly national objectives, without the interference of any
untrustworthy ally.[20] In this context, literary commentary emphasised the
importance patriots attached to control of the North American fishery, an
issue which would generate such heated controversy at the peace. When
writing of the fishery, patriots concentrated not only upon its significance as
an industry which produced great wealth, but also stressed its vital role in
fostering British sea power.[21] The interdependence or symbiotic relationship
of commerce and sea power, which was realised during peace by a thriving
merchant marine and fishing fleet, and during war by a powerful navy which
secured their unrestricted access to resources, trade routes and markets, and
eliminated foreign competition, was seen to operate most decisively in the
case of the fishery. A flourishing fishing fleet provided a pool of skilled seamen
who were essential for the manning of the wartime navy. For this reason a
poet celebrated the conquests of Newfoundland and Nova Scotia in 1713,
which gave Britain a commanding position in the North Atlantic cod and
halibut fisheries, as one of the most propitious events coinciding with George
I's accession:

> Now, chiefly, when their fishery's expand
> In such a manner, under such command,
> O fair possessions those! illustrious spoils!
> Well worthy of a prince t'adorn such toils![22]

Naval operations were perceived as being more cost effective than continen-
tal military campaigns, and their expenses more readily subject to careful
parliamentary scrutiny. Money would be spent at home in British dockyards
and to stimulate the industries which supported the fleet, and in paying
seamen. It would be circulated within the national economy, and not sent

abroad to be sunk in the courts of European princes. These economic arguments carried great weight with Parliament's frugal country gentlemen, who had just voted to double the land tax to four shillings, and with the urban bourgeoise engaged in international trade, who hoped to benefit from the elimination of French competition.[23] The republication of patriot calls to arms from the 1730s and 1740s indicates the continuity of mid-century maritime-colonial expansionism. The most significant examples involved the reprinting of Edward Young's A Sea-piece and Edward Philips' drama Britons, Strike Home. David Mallet rewrote the great patriot masque Alfred as Britannia: A Masque, which was performed at Drury Lane to rapturous applause during the spring of 1756, helping to incite calls for aggressive action against France.[24] In its account of the transformation of wood and metal into warships, Young's poem celebrating the virtues of sea power suggested the economic benefits derived from the encouragement of ship-building and iron-founding. It described the fleet's strategic reach in glowing terms:

> These Ministers of Fate fulfill
> On Empire's wide an Island's Will.[25]

A contemporary ballad opera, which reproduced lines from Alfred, also suggested how confidence in the strategic impact of sea power was deeply embedded in the popular mind:

> Britons, proceed, the subject Deep command,
> Awe with your Navies ev'ry hostile Land:
> In vain their Threats, their Armies all are vain,
> They rule the balanc'd World, who rule the Main.[26]

Patriot propagandists claimed that their faith in the efficacy of blue-water warfare had been vindicated by the capture of Louisbourg and the naval victories at Cape Finistère and Belleisle in 1747.[27] After ruminating upon these arguments, the political schoolboy clearly had learned his lesson that a naval war was the only legitimate alternative for Britain: 'That the shortest Follies are the best: disentangle from the Continent, provide for Home-security . . . and for Respect from Abroad, by throwing all the Force that can be spared into our Naval Armaments.'[28]

An incident in September 1756 involving a Hanoverian soldier at Maidstone occurred at the same time as the diplomatic crisis appeared to make a continental conflict seem inescapable. It incited a wave of popular anti-Hanoverianism, and punctuated criticism that the administration's international agenda was prejudiced in favour of the electorate. Since late May, when they had been brought over at British expense during the height of the invasion scare, twelve battalions of Hanoverian infantry and a contingent of

artillery had been encamped at Coxheath in Kent. The mercenaries had been well behaved and their services appreciated until a confrontation between the Hanoverian commanders and the English civilian authority was provoked when a private soldier named William Schroeder was imprisoned for theft on 13 September.[29] Schroeder had purchased four handkerchiefs at a local shop, but had accidentally carried away the entire piece of six, and the irate shop-keeper had him arrested and committed to gaol. The Hanoverian commander Count Kielmansegge protested to the Mayor of Maidstone, John Harris, that his soldiers were not subject to English law, and demanded his release so that he could be tried in a military court. Harris refused to surrender the felon until Kielmansegge's appeal to the ministry procured an order from the secretary of state, Holdernesse.[30]

The patriot press recognised the incident's potential as an issue certain to rouse the anti-Hanoverianism of the populace, which could be turned against the government. Newspapers, magazines and broadsides took up the cry that the balance of civil–military relations had been overthrown and that con-stitutional freedoms were in danger.[31] Satirists revelled in the opportunity to caricature Kielmansegge as a swaggering, dictatorial German autocrat, and distort his complaints into a declaration that his soldiers could commit any crime with impunity. One of the most diverting Maidstone poems was written from the perspective of Schroeder's imaginary English lover, a former serving wench and prostitute, who described her beloved's rescue:

> You stole a Handkerchief from out a Shop;
> And when you went to Prison for the Fact,
> Your Chief had like to have the Country sack't.
> Your great Commander fell into a Passion,
> He cock'd his Hat, and put his yellow Sash on:
> He call'd his Troops, and, in outlandish Words,
> He bid them charge their Guns and draw their Swords.
> But H[oldernes]se politely sent a Letter
> Commanding the good May'r to use you better:
> To rob, or kill, he said, was not a Cause
> To hang a *German* that defends our Laws.[32]

Prints contributed to the excitement by dramatising the encounter between the rule of law and naked force. An engraving portrayed the courageous Harris and the town councillors of Maidstone armed only with a copy of Magna Carta, confronting Kielmansegge, while he menaces them with a drawn sword (see Plate 9). Authors conjured up images of an army of barbaric Ger-man mercenaries run out of control, pillaging, murdering and raping at will. An inflammatory poem played upon husbands', fathers' and brothers' fears that their wives, daughters and sisters would be debauched by the soldiers, warning the 'puny linen-draper' Harris that even if he had discovered

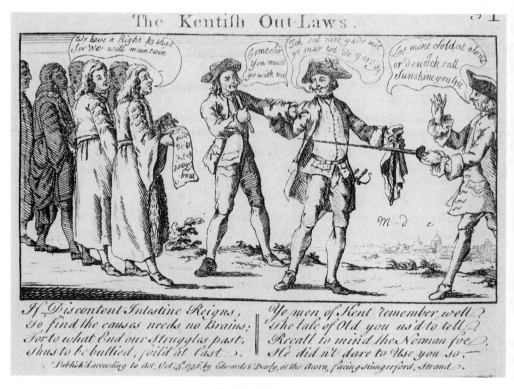

8 *The Kentish out-laws*

Schroeder ravishing his wife, he should have meekly submitted to the outrage rather than risk reprisal.[33] The immediate danger posed by the Hanoverians and Hessians was underlined by historical analogy. One ballad recalled the bitter experience of the South-Britons whose feeble King Vortigern had summoned Saxon mercenaries for their defence, only to be enslaved when the treacherous hirelings turned upon them.[34]

The hiring of George II's troops at what could be presented as exorbitant rates of pay and provisioning encouraged the revival of one of the most resented accusations against Hanover: that British wealth was poured into what Bolingbroke called 'the German gulf which cries "give, give" and is never satisfied'.[35] The popular prejudice that Hanover was transformed from a barren wasteland, whose inhabitants eked out a miserable existence upon turnips, into a luxurious land of plenty by secret payments and subsidies from the British Treasury, was repeated by a mock letter supposedly written by a Hanoverian officer, comparing the state of George II's two dominions. A flourishing Hanover was contrasted to an England oppressed by taxes levied to protect the electorate.[36] For his role in fostering the subsidies, a

satiric print depicted Newcastle as an unnatural nurse, neglecting Britain's legitimate offspring to pamper Hanoverian and Hessian changelings. He lulls them to sleep by crooning a famous old nursery rhyme:

> *Nurse*: Lulla-by Baby Bunting
> Why come you here a hunting?
>
> *Hess[ia]n*: To taak care of Honey
> And fatten vid Your Money.[37]

Another print portrayed the German mercenaries bleeding Britannia to death, while Hardwicke declares, '*If they kill her their own people shall try 'em*'.[38] Perhaps the primary cause of the anti-Hanoverianism which informed all levels of English society was the infuriating reflection that by dynastic accident England – an ancient monarchy with a model constitution and flourishing culture, and a wealthy imperial power whose ships and commerce dominated world trade – could be subordinated to a minor German state. In December 1742, Pitt had articulated the repugnance felt by many Britons when he raged against the humiliating association 'by which this great, this powerful, this formidable kingdom is considered only as a province of a despicable electorate'.[39] It was this universal assumption of superiority which made reliance upon the disdained Hanoverians for protection such a bitter pill for the nation to swallow in 1756. The stinging insult to British martial pride was aggravated by memory of the abuse which had been heaped upon the Hanoverians for cowardice following the controversial Battle of Dettingen in 1743. Poems which pretended to translate Hanoverian gloating over the release of Schroeder, and contempt for the degeneration of British warlike valour, touched a raw nerve, especially when they alluded to Byng. One of Kielmansegge's soldiers taunted the British with their tame submission to Hanoverian dictation, the consequence of shameful military dependence:

> Hence, shadows of what once you were,
> Learn *Han[overia]ns* to revere:
> Ye puny race of mortals, whence
> Proceeds this matchless impudence?
> Shall *Han[overia]ns*, who were born
> To guard your kingdom, bear your scorn?
> Shall an audacious may'r pretend,
> On petty theft to apprehend,
> Or clap our soldiers up in prison,
> Because two handkerchiefs are missing?[40]

Initially, George II was infuriated by the proposition that his troops were subject to English law, but as the anti-Hanoverian agitation escalated, King

and ministry were compelled to take steps to appease popular opinion. To demonstrate that the Hanoverian mercenaries would not be permitted to flout English law, Kielmansegge was sent home in disgrace, and the unfortunate Schroeder was sentenced to receive 300 lashes by a military tribunal.

The Maidstone affair encouraged demands for the reform of the militia, another central feature of patriot military strategy. The establishment of a body of civilian soldiers primarily responsible to Parliament was endorsed by those who feared a standing army as a potential menace to constitutional liberties, and as a source of patronage which enhanced the influence of the executive. In the Commons on 10 December 1755, George Townshend introduced a motion for a revival of the militia, and was seconded by Pitt, who outlined Townshend's plan.[41] To anticipate ministerial objections to the militia as at best an incompetent rabble, and at worst a potentially subversive mob, the drafters of the bill recommended a modest force drawn by lot from the general population, and devoted considerable care to their training. The selection of officers represented an attempt to free the militia from interference by the crown and its ministers. Any eligible gentlemen who met the property qualification was able to serve and make an important local contribution to the war effort, an opportunity which appealed to many Tories. Militia proponents stressed the economy of the plan when compared to the heavy expense of regular troops and hiring mercenaries.[42]

The movement for militia reform initially inspired extensive support because of its idealistic, emotional appeal, which tapped into the dynamic force of English nationalism awakened by the war.[43] Literary panegyrics upon the militia were informed by nationalistic consciousness of a historically unique land, people, culture, religion and political system, and the instinct to draw together and defend them. Enthusiasts proclaimed that it was the right and duty of every citizen to protect the extraordinary liberties they enjoyed under the most beneficent constitution in Europe. They argued that a militia representative of the entire people – nobility, gentry, men of moderate property and the labouring poor – would fight more valiantly against invaders than foreign mercenaries. The equation of citizenship with military service was reinforced by parallels with Greece and Rome. Proponents hoped to revive those military virtues and skills among the population, which had enabled their ancestors to win their liberties. Furthermore, the discipline, responsibility, self-respect and collective identity instilled by military instruction were promoted as a vehicle for the moral regeneration of the nation. In this context, advocates were probably inspired by the obsessive anxiety of 1756–57 that moral decline, and especially luxury and effeminacy, were the causes of military defeat. Edward Gibbon, who served as a captain in the Hampshire militia, demonstrated the ideological and moral attraction of the militia

when he valorised his own service as a formative experience of individual development and national initiation, 'my principal obligation to the militia was the making me an Englishmen, and a soldier.'[44] Few patriotic works published at this time failed to pay homage to these themes. They were glorified in a poem in which Britain's genius urged its sons to emulate their forefathers' heroic struggle for national freedom:

> O! how can vassals born to bear
> The galling weight of Slav'rys chain,
> A Patriot's noble ardor share,
> Or FREEDOM's sacred cause maintain?
> BRITONS, exert your own unconquer'd might,
> A Freeman best defends a Freeman's right.[45]

However much Pitt's advocacy was inspired by political expediency, there can be no doubt that the invasion threat encouraged comprehensive support for militia reform among the Tories, patriot Whigs, many members of the Old Corps, and the extended political nation.[46] The Commons' support appeared to be so overwhelming that the ministry's representatives declined to oppose it. Lyttelton 'compared a militia to the longitude, necessary, but hitherto sought in vain'.[47] It was approved without a division on 10 May 1756. George II and Cumberland, however, dismissed it as a poor substitute for an augmented professional army, and Newcastle and Hardwicke were worried by its political implications.[48] Newcastle's decision to stifle the bill in the Lords on 24 May shocked the political nation, especially after hopes had been raised when it was allowed to pass unchallenged through the lower house.[49] During the debate, Hardwicke, Granville and Newcastle distinguished themselves as the militia's leading opponents, while Temple, Bedford and Halifax supported it strenuously.[50]

When rumours of the ministry's determination to kill the bill began circulating, Horatio Walpole warned that its rejection would play into the hands of the patriots by furnishing them with a popular grievance against the government:

I apprehend it may occasion a great deal of ill humour and clamour, industriously fomented and propagated, not only by the pretended patriots in opposition, but even by the Tories ... as if there was a design to keep the foreign troops here longer than the defence of their country may require.[51]

He demonstrated equally impressive foresight when he predicted that Minorca would fall, and advised the ministry to avoid provoking any other controversy which might exacerbate the expected uproar.[52] Walpole's prediction proved to be all too accurate, and the indignation incited by the fall of Minorca was aggravated by discontent over the rejection of the Militia Bill. Much of this

fury was concentrated against Hardwicke for speaking so eloquently against it. Hardwicke based his opposition upon what he identified as two fundamental flaws in the bill. In the first he warned of its potential to upset the delicate balance of the constitution by increasing the power of the Commons.[53] Hardwicke also deplored the renewal of a warlike spirit among the people, by assigning the development of British economic and social progress to the demilitarisation of the state:

> I never was more convinced of any proposition in my life than of this, that a nation of merchants, manufacturers, artisans, and husbandsmen, defended by an army, is vastly preferable to a nation of soldiers.
>
> Since the reign of queen Elizabeth ... when military tenures were totally abolished, the people of this kingdom have been gradually weaned from arms, and formed, and habituated to trade, manufactures, and arts. From hence ... have flowed your commerce, your colonies, your riches, your real strength; which has enabled you ... to balance the power of your neighbours; some of whom have far outgone you in national military force.[54]

In this passage, Hardwicke repeated the socio-economic justification for the hiring of foreign troops, which preserved Britain's limited manpower resources for the creation of wealth through industry, commerce and agriculture. He confirmed his argument by holding up the warlike Scottish highlanders as the antithesis of a modern, enlightened, prosperous people.[55] Hardwicke also objected to the negative impact upon national piety by the plan to hold militia exercises on Sunday.[56] Support for the militia within the Commons was so widespread, however, that the ministry were unwilling to reject it outright, and Hardwicke pledged to consider an amended bill during the following session of Parliament.[57] This concession also reflected the ministry's awareness, articulated so forcefully by Walpole, of the great damage that hostility to the militia would inflict upon its reputation without doors. The strength of anger at the militia's rejection was suggested by a ballad demanding that Newcastle abandon his opposition:

> Trust no longer venal Faction,
> But yourself, your Country save
> Loose the nobles, ARM the *People*,
> Make 'em free, you'll find 'em BEAVE.[58]

The Militia Bill occasioned a memorable clash in the House of Lords, and the controversy offers another illustration of how the substance of parliamentary debates was quickly disseminated to the extra-parliamentary nation by political literature. The militia's most committed patriot supporters were infuriated by Hardwicke's leading role in the destruction of their cherished reform:

No one distinguished himself more in opposition to it than the Chancellor Lord Hardwicke, masking his own prostitution and servility under religious cant and hypocrisy by declaiming against the profanation of the Sabbath.[59]

The patriots assailed Hardwicke for his refusal to arm the nation, which was seen as an offensive reflection upon the loyalty, courage and warlike capacity of the English people. The anti-Byng campaign demonstrated how heavily the national self-image depended upon assumptions of military superiority, and celebration of the martial attributes of physical strength, bravery and mental toughness. The ministry's rejection of the Militia Bill was denounced as tantamount to a national slander of cowardice.[60] There was also an element of class consciousness in the Lord Chancellor's opposition, which was resented out of doors. One account of Hardwicke's speech reported that he condemned recruiting anyone from outside the ranks of the propertied, maligning the labouring classes as potential subversives by associating them with the slaves of Greece and Rome.[61] A balladeer twisted his allusion to the disaffected Scottish highlanders into a comparison with the English populace, accusing George II's devoted English subjects of Jacobitism.[62]

Patriots attacked Hardwicke for a contemptible reliance upon mercenaries and subsidy armies, which was a short-sighted, self-destructive foundation for national defence. A ballad ironically commended Hardwicke for being miserly with the lives of his countrymen:

> For Foreign Aid the Scheme is good
> Or else I'm much mistaken;
> By that we risque our Neighbours blood
> And save the *British* Bacon.[63]

This indictment was developed by John Free. The militia debate in Parliament and the press was dominated by appeals to historical precedent, and in Carthage, Free found a warning to the Newcastle ministry of the fate of a narrowly commercial empire-state, which allowed its native military traditions to decay. Mago's spirit reminded Blakeney how the Carthaginians were no match for the well-exercised, well-motivated citizen armies of Rome when deserted by the crass mercenaries they could no longer afford:

> Our *Tyrian* COLONIES were *Traders* all,
> In WAR they *purchas'd* AIDS; then *purchas'd* Peace,
> And thought the World would follow *Money's* Call:
> No *native* Troops, the while, their *Wealth* secur'd,
> Nor longer than they paid, their *sovereign* Strength endur'd.[64]

Free's condemnation of the ministry for throwing out the Militia Bill was founded upon an accurate knowledge of Hardwicke's speech, which he

refutes in a marginal note specifically aimed at the Lord Chancellor for his intervention in the Lords:

> I am sorry to find in some late Speeches the English have been considered as a People fitted for *Trade* only. One would be glad to know how they came so suddenly to degenerate from their Forefathers. This alteration can never be in the *Genius* of the People: it must rather proceed from the *Artiface* of some of the *pacific* Managers.[65]

Graphic art endorsed the militia during 1756–57, protesting against the humiliation and expense of maintaining a ravenous, indolent, fickle horde of mercenaries, while patriotic citizens were denied the opportunity to serve.[66]

The calls for a militia received impetus from renewed protest against the game laws, instigated by proposals for tighter regulation and enforcement brought before Parliament in the spring of 1756 by the National Association for the Preservation of Game.[67] Since 1671, legislation had restricted those entitled to hunt, and invested landlords with sweeping powers of enforcement, including the right to confiscate the arms of suspected poachers. This had been opposed as a violation of the traditional freedom to bear arms. The new Game Bill, which sought more narrowly to confine the privilege of hunting to the nobility and landed gentry, caused a backlash of popular protest, which fused patriotic libertarianism with more narrow self-interest among the many tenant farmers who were excluded.[68] Opposition also evoked sympathy among the urban middle classes, who resented the principle of aristocratic dominance that the game laws symbolised. Poetry and prints assailed the ministry for espousing the interests of the great.[69] The ropemaker-poet Joseph Reed reflected the element of social conflict when he lashed out against the country magnates' despotism:

> What is this
> But petty Tyranny, th'ambitious Child
> Of Luxury and Pride? If Heaven indulge
> A Right to kill, each free-born *Briton* sure
> May claim his Portion of the Carnage. All
> O'er Nature's Commoners, by Nature's Law,
> Plead equal Privilege:[70]

Reed chastised the landowners for neglecting their tenants' welfare, and warned that the compassionless enforcement of prerogative would alienate the commoner, upon whom the great ultimately depended for the protection of their estates in time of war.

Horatio Walpole's apprehension, that the suppression of the Militia Bill would lead to insinuations that the ministry harboured sinister motives

in retaining its German mercenaries, was also realised. These charges were intensified after the Maidstone affair demonstrated the ministry's apparent willingness to exempt them from legal restraint. Patriot incendiaries played upon popular xenophobia and anxiety by claiming that, rather than risk a public inquiry into their betrayal of Minorca, the treasonous ministers conspired to rule like corrupt Roman emperors, terrorising the people into submission with their Germanic Praetorian Guard.[71] Conspiracy theorists pretended to find proof not only in the refusal to recruit a loyal citizen militia to act as a democratic counterpoise to the regular army and mercenaries, but also exploited the Association, which they twisted into a malignant ploy to disarm the people upon pretence of protecting the game.[72] The nation's consequent vulnerability was vividly illustrated by a print (Plate 9) which portrayed country folk, armed only with pitchforks and rakes defiantly resisting the German soldiers. They lament 'Was it not for Hares & Partridges we could defend ourselves'.

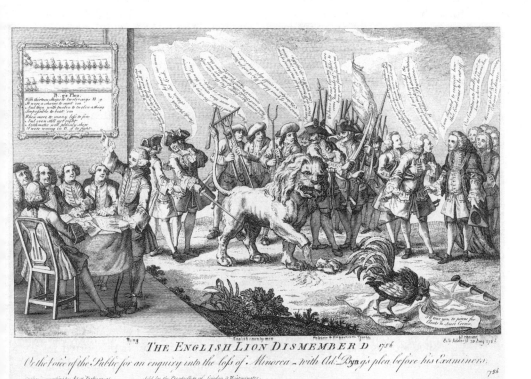

9 *The English lion dismember'd*

In the autumn of 1756, protest against the ministry's humiliating defeats at Minorca and in North America sparked a parallel condemnation of its domestic government. In their search for the fundamental causes of military failure, some patriot critics looked beyond foreign policy and strategy, to examine the health of the British body politic. Minorca acted as the catalyst for the revival of a fully-fledged patriot opposition, which assailed the Newcastle ministry for poisoning the political purity of the nation. A print published soon after news of Byng's retreat became known, emerged as one of its earliest expressions. Adopting the analogy between politics and medicine to comment upon the state of the constitution, it portrayed the Minorca crisis as the symptom of a diseased political system, taking its motto from Isaiah 1. 6, 'From the Sole of the Foot even unto the Head there is no Soundness in it but wounds and bruises and putrifying Sores.'[73] Patriots accused the Old Corps Whigs of insinuating themselves into royal favour by their subservience to Hanover, and then misappropriating the powers of the sovereign to impose a tyrannical stranglehold over Parliament, paralysing its ability to restrain the influence of the executive, and to defend the interests of the country. Under these circumstances, it was even more essential to maintain the autonomy of the Commons to combat the excesses of the court, but patriots feared that the Old Corps had so thoroughly polluted the electoral system through the bribery of voters, and enslaved the lower house by corrupting members with places and pensions, that constitutional government was threatened with imminent collapse.

A notable example of how demands for political reform attempted to exploit indignation over the loss of Minorca, involved an account of British political culture, allegedly written by a Minorcan gentlemen, contrasting the great benefits conferred upon the island by its new French masters with former British maladministration. The Minorcan observer, who concentrates upon the importance of the electoral system as the foundation of English liberty, paints a portrait of a nation whose voters have been taught to emulate the callous self-interest of their superiors, and sell themselves to the highest bidder.[74] Blakeney disappointed the opposition by not becoming a vocal anti-ministerial critic, a second patriot hero such as Vernon, but there were attempts to capitalise upon his popularity, as in a broadside which made him demand a complete programme of reform including triennial parliaments, place bills, and reductions in the civil list.[75]

Patriot ideology received a classic restatement in a political allegory published during the height of the anti-ministerial frenzy. It purported to be the translation of a speech by a Japanese emperor, who repudiated his wicked advisers at a time of national crisis when: 'Japan's being engaged in an expensive, burthensome, unsuccessful, and most shamefully mis-conducted

War with *China* was but a trifle, if compared to a Complication of intestine Maladies that preyed upon her Vitals, and threatened her with Ruin irretrievable.'[76]

The Japanese monarch proves to be the incarnation of the patriot king whom Bolingbroke and his followers longed to see ascend the British throne, and of whom some contemporary patriots were already anticipating in the future George III. This passage provides a concise summary of the inexorable programme of interrelated moral and political enslavement that patriots claimed was being imposed upon the British people by decades of Whig oligarchy. A party of men long entrusted with Japan's government had been:

> embezzling and mis-applying the Treasures of the Empire; in draining the Pockets, debauching the Principles, and debasing the Minds of our faithful Subjects . . . in effacing the very Idea, of Liberty amongst them; and in avowedly erecting the infernal Maxims of Bribery and Corruption . . . into a standing System to carry on their Administration[77]

These themes also received a comprehensive treatment in graphic art.[78] Perhaps the most famous anti-ministerial print of the period was George Townshend's *The Pillars of the State*, which integrated ridicule of the strategic mismanagement which led to the loss of Minorca, with accusations of rampant political corruption by allusion to *The Beggar's Opera*. Newcastle and Fox were compared to Peachum and Lockit, the notorious partners in crime, who abused their positions as gaoler and pawnbroker to manage a gang of thieves and traffic in stolen goods in Gay's allegorical ballad opera.[79] Walpole reported how Townshend's visual propaganda was disseminated by his brother Charles, who adorned 'the shutters, walls, and napkins of every tavern in Pall Mall with caricatures of the Duke and Sir George Lyttelton, the Duke of Newcastle and Mr. Fox', and his wife, who wrote all her messages upon the back of *The Pillars of the State* and other caricatura cards, which were so much in vogue.[80]

Poems and prints pointed to specific examples to justify allegations that Newcastle maintained his grasp upon Parliament by a Machiavellian manipulation of place and pension. To bolster the debating prowess of the ministry's Commons front bench for the critical subsidy treaty debates during December 1755, Newcastle entered into negotiations with the barrister Hume Campbell, who agreed to defend them when made Lord Register of Scotland with an augmented salary of £1000 for life.[81] At the same time, patriots charged that the respected Old Corps elder statesman Horatio Walpole was reconciled to the subsidies by the bribe of a barony:

> Old H[o]r[ac]e too believes, or dreams,
> 'Tis right to forward Treaty Schemes,
> Converted by a Peerage.[82]

Newcastle's management of ecclesiastical patronage was another source of discontent, prompting charges that preferments were determined not by the candidates' piety, but as rewards for unquestioning devotion to the Old Corps. A satire described the spectacle afforded by the obsequious office seekers, both lay and religious, who flocked to Newcastle's weekly levees:

> Lords' Sons and Kinsmen, members' Cousins
> And Borough-In'trest men by Dozens,
> Archdeacons, Prebendaries, Deans
> In spite of idleness found Means
> Once every Week to show their Faces
> And lodge Pretensions at his Grace's.[83]

Preparation for hostilities necessitated great increases in the strength of the army and navy, and arrangements for their logistical support. The awarding of these lucrative contracts enhanced the scope of the executive's patronage, and patriots feared the ministry's abuse of these powers for political ends.[84] An early example of the opposition's charges that contracts were peddled to creatures of the court involved the Pelhamite MP, Alderman and merchant William Baker. Baker was granted a £110,000 contract for victualling the British troops in North America, which was later attacked by Charles Townshend for its allegedly crooked terms.[85]

In addition, patriots harboured apprehensions of the presence of considerable numbers of military and naval officers in Parliament. Between 1754 and 1790 they comprised the largest, most recognisable group in the Commons, upon average approximately 15 per cent of membership. Soldiers were viewed with graver suspicion because of their historically greater menace to constitutional government, and the belief that they were more directly susceptible to royal pressure.[86] Political influence did contribute to promote the careers of many soldiers and sailors, but its impact was exaggerated. The court's occasionally arbitrary exercise of military patronage, however, encouraged its patriot antagonists to caricature soldiers as the most well-disciplined of the ministry's parliamentary mercenaries. A novel inspired by Minorca, describing how the career of a patriot-soldier was frustrated by the abuse of military patronage, attempted to expose unbridled corruption within the army establishment. The protagonist was a gentleman who had been disowned for defying his family and enlisting as a volunteer. Despite mastering all the theoretical and practical branches of the art of war, the impoverished corporal was denied a lieutenant's commission for casting his freehold election vote in favour of the patriot interest. Tristram Bates discovered that clientage and political interference operated at all levels of the army hierarchy.[87] A crippled veteran, who had lost both legs in battle, shocked Bates

with the revelation that venality even descended to govern the allocation of places at Chelsea Hospital:

> the ears of *Bates* were stunned with Tales of filthy *Party* and private *Interest* – how such a Man was only a General Officer's House Porter, and yet enjoyed the Benefit so many poor Fellows *languish* after, and even *starve* for want of: How a *Butcher*, with a long Arrear to [Newcastle], was glad to accept that or nothing; 'We have *Taylors, Glaziers, Bakers, &c.* all on the same Interest. An unpaid Bill, or a Vote is a better *Right* than my two *Tuscan Pillars* here.'[88]

The novel's indictments of political corruption were aimed primarily at Newcastle and Fox, and probably referred to contemporary disputes concerning army affairs. Bates's punishment for supporting the patriotic baronet Lt Colonel Spontoon against a court candidate may have been inspired by the example of Sir Henry Erskine. In late 1755, Lt Colonel Erskine, an MP and friend of Bute, had joined Pitt in opposition, and sought to foster his alliance with Leicester House. He spoke and voted against the subsidy treaties, and the patriots charged that his subsequent dismissal from his regimental command and captaincy in January 1756 was a callous act of political retribution.[89] Erskine became something of a patriot martyr, recalling Pitt's own persecution by Walpole, who had deprived him of his cornet's commission.[90] Opposition writers hostile to Cumberland pretended that, with Fox's connivance, he plotted to seize absolute power should his father die before Prince George reached his majority. A patriot balladeer asserted that the defence of Fort Mahon was crippled because its garrison's regimental commanders had been ordered to abandon their posts so that they could fight their chief's political battles in the Commons:

> Say by what rule it does appear,
> And suit thy *Prussian* System,
> To keep *three Colonels* voting here,
> When poor old *Blakeney* mist 'em.

> To hold the Sword ar't not content,
> 'Tis more than thy proportion;
> To have also the *P[arliament]*,
> And all at thy devotion.
> See *France* our *Colonies* still rends,
> With slaughter and distraction,
> While each *Red* Senator attends
> At West[minste]r *thy* F[a]ct[io]n.[91]

Patriots were the kingdom's most begrudging taxpayers, and the country gentlemen especially considered it their duty to act as watchdogs to ensure that public finance was conducted as economically as possible. They redoubled their vigilance following the outbreak of war, suspicious of the greater

opportunities for corruption its financing placed in the hands of the central government. They were also dismayed by the baleful necessity of greater taxation. Critics were furious that unprecedented sums of tax revenue had been raised, yet the ministry had nothing to show for it but ignominious defeat. Outrage over the ministry's mismanagement of war finance was reflected in two dramas published during 1756–57. The first, written by the patriot Oxfordshire clergyman Dr Phanuel Bacon, deplored the proliferation of taxes. Bacon's comedy begins with a grand protest march by the personifications of thirty-four commodities already oppressed by taxes, or punished with additional duties, led by Mead, Hop, Malt, Window and Salt who laments: 'I look'd upon myself to have a natural exemption from any *fresh impositions* . . . unless it is because I am so remarkably fix'd in the *Country Interest*; or rather because I am look'd upon by the Courtiers – to be tooth and nail an enemy from the very soul of me to all *Corruption*.'[92]

The second drama, which lamented the atrophy of virtue in public life, transmitted a similar message of a people ground into poverty by their vicious governors. It is a moral allegory which 'Discovers Avarice in the Character of a Prime Minister'. Opponents of ministerial tax policy inveighed against the window and glass excises as particular hardships, and maligned them as blasphemous appropriations of God's greatest blessing – light – the source of life.[93] The prime minister, however, proposed an even more sacrilegious extortion by imposing a tax upon life itself: 'All in the land who enjoy the benefit of good health for one year, shall be liable for a tax of five shillings for every month after so great a blessing, and in proportion on their children.[94]

The parents of children who survived beyond one year of age were compelled to pay a monthly rate for their offspring. Demonstrating a ruthless efficiency, the First Lord of the Treasury was careful to close a potential loophole in the 'life-tax', which gave a miserly parent the incentive to murder a son or daughter, by instituting an annual penalty for the expenses they would save by not having to raise the child, thus extending the reach of the tax-gatherer beyond the grave. This in fact occurred in a 'death-tax' conceived to mulct widowers, 'Every man who buries his wife will pay so much per year for being rid of the plague.'[95]

Patriots were horrified by the prospect of reckless borrowing leading to a massive expansion of the national debt. The nightmare of bankruptcy haunted many eighteenth-century patriots, and again particularly the country gentleman, whose fears were stimulated by their uncertainty regarding the complexities of deficit finance. Agonised speculation concerning the levels of indebtedness the country was able to endure commenced almost immediately, as the political schoolboy revealed when asked for a definition of public credit. He described it as, 'A Fiddle-string; which will bear playing on, to a certain Pitch; Screw it up too high, and it snaps.'[96] Many thought it suicidal

to entrust national finance to Newcastle, a man whose own chronic financial irresponsibility repeatedly had brought him to the brink of ruin:

> Discharge thy French cooks, disengage thy estate,
> When that thou canst do, undertake Britain's fate.[97]

A Minorca print speculated upon the damage the defeat would inflict upon the confidence of investors when it depicted public credit as a broken column 'Prov'd Rotten by Monseurs Touch'.[98] Architectural images had become well-established metaphors for commentaries upon the health of national finance, as illustrated by an elaborate print dating from the autumn of 1756, which predicted ruin if the Newcastle ministry's maladministration was suffered to continue. A portico representing the state, formerly supported by sturdy columns labelled trade and public credit, appears to be upon the verge of crumbling beneath the immense burden of taxes and borrowing loaded upon it by ministerial corruption, and a disastrously misconducted war. Its fall threatens to crush Britannia who shelters beneath, while Newcastle, Hardwicke, Anson and Fox accelerate its collapse by pulling upon ropes marked 'Min[or]ca Lost, Am[eri]ca Neglected, Tr[a]de not Protected'.[99] For those who assessed the economic consequences of military defeat, it appeared as if internal collapse through bankruptcy might bring the nation to its knees even before victorious French arms dictated a disgraceful peace.

NOTES

1 K. W. Schweizer, 'The Seven Years' War', in J. Black (ed.), Origins of War in Early Modern Europe (Edinburgh, 1987), pp. 242–60.
2 A. Carter, The Dutch Republic in Europe in the Seven Years War (London, 1971), pp. 31–66.
3 GM, June 1756, 268–71.
4 Chesterfield to Dayrolles, 19 Sept. 1756, P. D. Stanhope, The Letters of Philip Dormer Stanhope, 4th Earl Chesterfield, ed. B. Dobrée (London, 1932), V. 2199.
5 Britain, p. 29.
6 Nell Gw(eye)nn 2 the Hungary (Hare)lot, BMC 3362.
7 The Lyon, the Leopard and the Badger, 1756, p. 17.
8 Observator of the Times; Carter, pp. 64–5.
9 The Egotist, BMC 3464; The European Equilibrist, BMC 3486; The Devil Turnd Fisherman, BMC 3609; Atherton, pp. 104–5.
10 The Devil the Dutch the King of France, n.d.; The D[u]t[c]h Alliance, 1759; Carter, pp. 97–102.
11 D. B. Horn, 'The Duke of Newcastle and the Origins of the Diplomatic Revolution', in J. H. Elliott (ed.), Diversity of History (London, 1970), pp. 245–69; Pares, p. 433; Schweizer, 'The Seven Years War', pp. 246–52; Baugh, p. 48; Clayton, p. 603; S. B. Baxter, 'The Conduct of the Seven Years' War', in S. B. Baxter (ed.), England's Rise to Greatness (Berkeley, 1983), pp. 335–44; Clark, 'Introduction', Clark, Waldegrave, pp. 64–71.

12 John Shebbeare, *A Second Letter*, 1756, pp. 25–55; *A Third Letter*, 1756, pp. 19–56. Four editions of each letter were printed, and a collected issue of the first three.

13 Shebbeare, *A Fourth Letter*, 1756, p. 93.

14 *The School-Boy in Politics*, 1756, p. 10.

15 *Half Peace*, BMC 3334.

16 *The Slough*, BMC 3471.

17 Clark, *Waldegrave*, p. 166.

18 J. S. Bromley, 'Britain and Europe in the Eighteenth Century' *History*, LXVI (1981), 407–9; Pares, 437–9.

19 *A Letter From a Cobler*, p. 17.

20 Baugh, pp. 33–47.

21 *GM*, May 1755, 217.

22 'The Ocean', *State Poems*, p. 10.

23 Baugh, pp. 33–47.

24 *Britannia: A Masque*, 1755; *LM*, May 1756, 246–7; Tobias Smollett's comedy *The Reprisal*, written during 1755, although not performed until 1757, expressed a similar message.

25 Edward Young, 'The British Sailor's Exultation', *A Sea-piece . . . Occasion'd by the Rumour of War*, 1755, p. 6.

26 *The Press-gang*, 1755, p. 17; Reed, *British Philippic*, pp. 18–19.

27 R. Harris, *Patriot Press*, 221–57.

28 *The School-Boy*, p. 22; 'The Sailor's Prayer Before Engagement', *A Sea-piece*, pp. 13–14.

29 Walpole, *Memoirs*, II. 176.

30 BL, Add. MSS 35,594, fo. 107: Holdernesse to Harris, 17 Sept. 1756; *Ibid.*, fo. 203: Harris to Holdernesse 18 Sept. 1756. For his subservience, Holdernesse was caricatured as *The Patriot of Patriots*, BMC 3529.

31 *LEP*, 28 Sept. 1756; *GM*, Sept. 1756, 448, Oct. 475; *The Hanoverian Treaty*, 1757.

32 *A Lamentation for the Departure of the Hanoverians*, 1757, pp. 5–6.

33 *Four Hundred and Forty Six Verses, Containing Harsh Truths*, 1757, p. 15.

34 *England's Alarum Bell*, 1756; *German Cruelty*, 1756.

35 Quoted in U. Dann, *Hanover and Great Britain 1740–1760* (London, 1991) p. 128.

36 *England's Warning*, 1756, pp. 3–4; 'A Ballad', *LM*, Aug. 1756, 399.

37 *A Nurse for the Hessians*, BMC 3478.

38 *Hengist & Horsa*, BMC 3346.

39 Cobbett, XII. 1035.

40 *Harsh Truths*, pp. 12–13.

41 Walpole, *Memoirs*, II. 91–3.

42 J. Western, *The English Militia in the Eighteenth Century* (London, 1965) pp. 128–31.

43 English as opposed to British nationalism is the correct term to apply in relation to militia reform during the Seven Years War. The Whigs were not prepared to countenance the raising of a militia in Scotland, provoking the formation of the famous Poker Club to lobby for its extension. As well as David Hume, Adam Smith, William Robertson, Robert Adam and Adam Ferguson, the political club 'Consisted of all the Literati of Edinburgh and its Neighbourhood', Carlyle, p. 214.

44 Edward Gibbon, *Memoirs of My Life*, ed. G. Bonnard (New York, 1969), p. 117.

45 John Cooper, *The Genius of Britain*, 1756, p. 11; *Britain*, pp. 75–84; *A Pathetick Address*, pp. 4–6; *Ode on the Present Times*, 1756, pp. 4–8; *One-Thousand, Seven-Hundred, and Fifty-Six*, pp. 21–2.

46 Horatio Walpole to Hardwicke, 4 Apr. 1756, Coxe, *Walpole*, II. 424; Walpole, *Memoirs*, II. 143.

47 Walpole, *Memoirs*, II. 93; Ilchester, *Fox*, I. 342.

48 BL, Add. MSS 32,864, fo. 204: Newcastle to Devonshire, 10 Apr. 1756.
49 Ilchester, *Fox*, I. 342.
50 Cobbett, XV. 706–69; Walpole, *Memoirs*, II. 149; Gilbert Elliot to Grenville, 25, 27 May, Smith, I. 160–2.
51 Horatio Walpole to Hardwicke, 16 Apr. 1756, Coxe, *Walpole*, II. 424.
52 Horatio Walpole to Hardwicke, 26 Apr. 1756, *Ibid.*, 428.
53 Cobbett, XV. 731.
54 *Ibid.*, 734.
55 *Ibid.*, 735–6.
56 *Ibid.*, 738–9.
57 *Ibid.*, 740; Campbell to Marchmont, 14 Oct. 1756, HMC, *Fifty-fifth Report*, VIII. 326.
58 *The Wonder of Surry! The Wonder of Surry!* 1756.
59 Glover, *Memoirs*, 74.
60 *Harsh Truths*, p. 16.
61 Cobbett, XV. 714.
62 *The Freeholder's Ditty*, 1756.
63 *Wonder Upon Wonder: or the Cocoa Tree's Answer to the Surrey Oak*, 1756.
64 Free, *Ode of Consolation*, pp. 7–8.
65 *Ibid.*, p. 8.
66 *In Neat Silver Coin 50,000£*, BMC 3344; *The 2 H, H, 's*, BMC 3342; *An Hieroglyphic Epistle*, BMC 3479.
67 P. Munsche, *Gentlemen and Poachers: The English Game Laws 1671–1831* (Cambridge, 1981), p. 113.
68 *GM*, Apr., Aug. 1756, 176–80, 384.
69 *The Association 1756*, BMC 3348.
70 Reed, *British Philippic*, pp. 14–15.
71 Shebbeare, *Third Letter*, pp. 12–22; *England's Warning*, p. 5.
72 *A Dream Note*; *The Ministry Chang'd*.
73 *A Grand Consultation of Physitians*, BMC 3443.
74 *A True Portrait of the E[nglish] N[ation]*, 1757, p. 6.
75 *General B[lakene]y's Account*, 1756.
76 *Patriot Prince*, p. 5.
77 *Ibid.*, pp. 11–12.
78 *Effigy of an Unpopular Minister*, BMC 3436; *Byng Return'd*, BMC 3367; *Poor Robin's Prophecy*, BMC 3383.
79 *The Pillars of the State*, BMC 3371; Atherton, pp. 51–60.
80 Walpole to Conway, 4 Mar. and 2 Sept. 1756, *Corr.*, XXXVII. 444, 473.
81 Campbell's venality provoked Pitt's harshest invective during the subsidy exchanges, 'he is the slave; and the shame of this doctrine will stick to him as long as his gown sticks to his back', Walpole, *Memoirs*, II. 100.
82 *The Converts*, p. 6.
83 Benjamin Newton, *The Levee*, 1756, p. 4.
84 *The Similie*, BMC 3432.
85 Walpole, *Memoirs*, II. 209.
86 Sedgwick, I. 141–44; Brewer, *Sinews*, p. 45.
87 *The Life and Memoirs of Mr. Epigram Tristram Bates*, 1756, pp. 39, 58, 199, 220, 224. The novel almost certainly influenced Sterne's composition of *Tristram Shandy*, and probably suggested models for the Quixotic soldiers Uncle Toby and Corporal Trim. H. Hughes, 'A Precursor to *Tristram Shandy*', *Journal of English and Germanic Philology*, XVII (1918), 227–51.

88 *Ibid.*, p. 203.

89 Sir Lewis Namier and John Brooke, *The History of Parliament. The House of Commons 1754–1790* (London, 1971), I. 403.

90 Walpole, *Memoirs*, II. 123.

91 *Freeholder's Ditty.*

92 Phanuel Bacon, *The Taxes*, 1757, p. 3. Bacon was vicar of a Sussex parish, and rector of Balden, where he died in 1783. In 1757, he published four other plays attempting to rekindle patriot ideals of integrity, austerity and public service, which were published together the following year as *Humorous Ethics*, 1758.

93 *The Fall of Public Spirit*, 1757, p. 6.

94 *Ibid.*, p. 22.

95 *Ibid.*, p. 23.

96 *The School-Boy*, p. 21.

97 *British Worthies*, p. 16.

98 *Merit and Demerit*, BMC 3482.

99 *Britannia in Distress*, BMC 3424.

6

The collapse of the Newcastle ministry

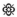

THE CORRESPONDENCE of the ministers reveals their deep apprehension and dismay at the scale and virulence of criticism levelled at them follow-ing the conquest of Minorca.[1] Sensitivity to the impact of the literary world and the press upon opinion, and the application of legal powers to regulate it, had been a pronounced characteristic of Newcastle's political career.[2] Hardwicke shared Newcastle's respect for the power of the press and political opinion, which he revealed in acknowledgement of their contribution in toppling Walpole from office.[3] From his entry into politics, Fox displayed an eager interest in the propaganda potential of the press, and became one of the Walpolean Whigs' leading defenders in their print wars with the opposition. He and Lord Hervey gathered a circle of politicians and writers, who shared their taste for satire, and encouraged their composition of attacks upon the Walpole and Pelham administrations' adversaries. Charles Hanbury Williams, perhaps the most influential political poet between the time of Pope and Charles Churchill, became one of Fox's closest allies and collaborators. During the early 1740s they developed an intimate working relationship, which mater-ially assisted the Old Corps, particularly in their struggle against Bath and Granville. Fox played a major role in the genesis of Hanbury Williams's polit-ical poems, often suggesting their themes, refining their treatment of issues and individuals, and coordinating the timing of their publication to maximise their impact. Hanbury Williams himself described his debt to his friend's initiative and inspiration: 'One morning, after an Evening's conversation with you at Holland House would infallibly produce something, For you know that I us'd to be able to write whenever you bid and instructed me.'[4]

Henry Pelham's promotion of Hanbury Williams's poems, achieved through Fox's mediation, offers testimony to the influence exercised by polit-ical literature at court and among the parliamentary classes during this period. When Hanbury Williams's work was first brought to his notice, Pelham 'expressed the utmost surprise at the excellence of the verses which Fox gave

him to read'. Once Pelham had recognised the value of Hanbury Williams's poems, he often passed on confidential information regarding international or domestic affairs to sharpen the point of his satiric pen. Hanbury Williams's poems were often submitted for Pelham's approval before publication.[5]

In the autumn of 1756, Newcastle, Hardwicke and Fox monitored political opinion and attempted to combat efforts made by opponents in the press to expose the ministry's responsibility for the conquests of Minorca and Oswego, and to capitalise upon the controversies generated by the militia, Maidstone, and the looming continental war. Fox's correspondence illustrates his anxiety to gauge the flow of opinion immediately after Byng's defeat by an exhaustive examination of all species of commentary. He reported the results of his survey of the political press to Welbore Ellis, offering to supply any publications which his ally on the Admiralty Board had not yet read, 'I suppose you have order'd all Pamphlets and Ballads that get into print sent to you, so I don't send them, and I know of none in manuscript.'[6] Given Fox's long-standing involvement in the composition of political poetry, and his confidence in its capacity to shape the attitudes of its readers, it is not surprising to find that he carefully analysed the ballads, and attempted to identify those written or patronised by other politicians. Evidence of the opposition's participation in the hostile literary campaign is provided by a ballad Fox passed on to Ellis, which his contacts in Grub Street assured him had been written by Charles Townshend. At the same time, it appears that he sent a print which may have been George Townshend's cutting satire *The Pillars of the State.*[7] Fox also sent Ellis a packet of Minorca ballads, whose provenance is unknown. It is possible that these were not ballads that Fox had collected, but were works that he himself had written or commissioned, which he was submitting to Ellis for his opinion before publishing.[8]

As criticism of the ministry over Minorca and its persecution of Byng snowballed, Newcastle sought to stifle further condemnation by legal retaliation. The scurrilous attacks in the press clearly caused him considerable personal anguish and injury.[9] He was incensed by the writings of John Shebbeare, who had already been taken up after the publication of *The Marriage Act.*[10] In 1755–56 however, Shebbeare published *Lydia* and *Letters on the English Nation*, a two-volume epistolary fiction, which developed a sweeping analysis of the alleged decline of the English constitution, religion, morals, culture and power under the corrupt rule of the Whigs. It denounced Newcastle for failing to resist French encroachments in North America.[11] Thomas Birch recorded how Shebbeare's Tory polemic encouraged that party to promote it, 'the Flatteries to the Tories . . . have brib'd them to support the Sale of a Book, which an Englishman and a Protestant must detest'.[12] *Letters on the English Nation* was examined by the attorney general for possible prosecution.[13]

On 4 August 1756, Shebbeare published a *Fourth Letter to the People of England*, which condemned the ministry for pandering to George II's partiality to Hanover, forfeiting imperial interests in North America, rejecting the militia, and neglecting Minorca. The influential pamphlet went through at least six editions, and was widely excerpted in the press. Newcastle submitted a copy to the Clerk of the Privy Council, William Sharpe, demanding whether Shebbeare could be prosecuted for seditious libel. Sharpe had no qualms about pronouncing the work to be illegal, but he deterred Newcastle from proceeding, because the flood of anti-ministerial literature had so completely saturated political opinion that a conviction would be impossible to obtain:

> considering also the surprising and unaccountable Spirit which at this time almost universally influences the Minds of the People upon these very Topicks, I can by no means presume to advise your Grace to direct a Prosecution ... it would from the Poison that is gone forth amongst the People end in an Acquittal, as it will be hardly possible to get a Jury whose prepositions will not lead them to that way of thinking.[14]

Newcastle received a similar verdict upon a series of hostile articles in the *London Evening Post* by 'Britannicus', whom Birch had identified as 'no other than that pious and exemplary man, Paul Whitehead'.[15] Sharpe regretted, 'The temper of the times ... is in too inflamed and convulsed a State to advise any Prosecution of this kind.' Newcastle was also dissuaded by Hardwicke, who warned that 'this Ferment of the People' would make legal action futile.[16] Murray commented upon the practical importance of the seemingly inexhaustible variety of allegorical disguises invented by the fertile imaginations of political writers to intrigue and amuse their readers. By concealing the political text within the literal, these rhetorical devices provided a thick enough cloak to confound the crown's efforts to prosecute. Murray admitted that although he considered one satire 'seditious and libelous and therefore highly criminal', he was discouraged from proceeding because, 'it is conveyed in so obscure a manner, that it will be difficult so to explain the many allusions and innuendoes as to expect a jury will find libelous'.

The Crown's messengers of the press were occupied in gathering evidence concerning other offensive or influential publications. A search was undertaken to discover the author of *Tristram Bates*, and inquiries were made concerning *Byng Return'd or the Council of Expedients*, which portrayed the admiral confronting the culpable ministers with his censored letter.[17] The Admiralty consulted the Solicitor General, Sir Robert Henley, about indicting the *Gazetteer* for a vicious slander on 19 October 1756. Henley agreed that the article was libellous, but confessed that the ministry was powerless to contain the unprecedented scale and freedom of hostile publication.[18]

Even successful prosecutions often proved to be Pyrrhic victories, as the consequent notoriety could vastly publicise the work of the ministry's critics. So significant was government action in attracting popular curiosity and stimulating sales, that the *Grub Street Journal* wrote that among booksellers and authors, a spell in the pillory, 'is so universally esteemed, that he, who has had the honour to mount that rostrum, is always looked upon amongst them, as a graduate of his profession.'[19] Misuse of powers of search, seizure and arrest could generate embarrassing libertarian issues, exemplified by John Wilkes and John Entick's later challenges of the legality of general warrants.[20] Ministerial intervention also prompted accusations of the tyrannical suppression of free speech. Sharpe and Hardwicke's cautions reflected the growing conviction that an informed, independent and critical press acted as a safeguard to constitutional freedom, and as a means of enforcing ministerial accountability.[21] Joseph Reed appealed to a firm belief in the liberty of expression, and to the poet's time-honoured, sacred role as the conscience of the nation, when he asserted his freedom to examine into the ministry's conduct as, 'My Birthright as a Briton, and a Bard'.[22]

Although prosecution was too hazardous, Hardwicke suggested an expedient alternative, harassing the worst instigators of discontent, 'In some glaring Instances it may be prudent to take up the Persons, tho' you don't intend to proceed to Trial'.[23] The disruption in publication caused by arrest and confinement, and the expense of bail and sureties, often ruined financially insecure publishers and printers, or intimidated them into moderating their attacks upon government. To win back the hearts and the minds of the political nation, Hardwicke urged that the ministry intensify the dissemination of its own counter-propaganda, especially in the newspapers, whose frequent publication and wide circulation captured the greatest audience:

> One thing I am sure ought to be done, and set about immediately; – I mean printing *Short Papers*, in some of the Daily New's Papers ... I really believe these short diurnal Libels do more harm than the larger Pamphlets, because they are more read, and spread amongst the common People.[24]

Lord Royston took a leading role in this initiative.

Newcastle also sought to turn back the tide of condemnation by encouraging the assistance of the ministry's literary friends and political writers. An intriguing letter to Newcastle from the Whig clergyman and poet Thomas Newcomb indicates that the Duke patronised the composition of satiric verse aimed at his enemies. In requesting financial assistance, Newcomb reminded Newcastle of a political poem he had written upon his behalf, a service which had been considered so important that it earned a valuable reward: 'I was honoured with a share of your regard and friendship; and re[ceive]d a most

signal instance of your Grace's generous favour, for a little humorous ode I address'd to you.'[25] The title of the poem is not given, but it probably was *The State Farce*, which ridiculed Pitt and the patriot opposition of 1755–56. Newcastle must have appreciated Newcomb's cutting parody of Pitt's Rhône and Saône speech as a well-deserved retaliation for the abuse he had suffered in the Commons.

As the Minorca storm cloud gathered in June, the poet, dramatist and ministerial writer David Mallet composed a pamphlet vindicating the administration.[26] He had been a prominent contributor to the patriot literary opposition of the 1730s and 1740s under the patronage of Lyttelton and Prince Frederick. In 1740 Mallet collaborated with Thomson and Arne to compose the pastoral masque *Alfred*. In 1749 he fell out with Prince Frederick and Lyttelton, and was recruited for the ministry when offered a pension by Pelham.[27] Hardwicke instructed Mallet in what the ministry required: a thorough statement of the many demands upon the Royal Navy's limited resources and manpower, which rendered it impossible to dispatch Byng at an earlier date and with a more powerful fleet.[28] Anson arranged for Mallet to have access to any Admiralty papers which would assist in strengthening his defence. Mallet attempted to demonstrate that responsibility for the relief expedition's miscarriage rested squarely upon Byng's shoulders. His draft was carefully studied by Hardwicke, who insisted upon several revisions, directing Mallet to absolve the ministry from the charge of issuing secret instructions to Byng. Hardwicke also instructed Mallet to reinforce his justification of the censorship of Byng's letter, submitting a rationalisation of each deleted passage.[29] Hardwicke reminded Anson to have Mallet's corrected draft written out by the Admiralty secretary, explaining this as a precaution to prevent it becoming known that the Lord Chancellor of England had collaborated with a mercenary political writer in composing an attack upon Byng: 'My reason (which I will tell your Lordship) for taking this method is that I am not fond of giving a handle to be named as a joint author with this gentleman.'[30]

On 9 November 1756, Mallet was paid with money taken out of the Secret Service budget. He received £300 for penning the pamphlet and to cover the production of 3000 copies, an exceptional print-run, demonstrating the ministry's determination to challenge the opposition's domination of the press, and combat its effect upon political opinion.[31] Mallet had relied upon his identity being kept secret, and complained of damage to his personal and literary reputation when it was divulged.[32] Mallet's authorship was known to Samuel Johnson, which explains the ferocity of his review.[33] Johnson later declared: 'he was ready to do any dirty job: that he had written against Byng at the instigation of the ministry, and was equally ready to write for him, provided he found his account in it'.[34] Mallet probably was the author of a

pamphlet justifying Byng's execution, *Observations on the Twelfth Article of War.*

To the political nation, the government's reluctance to retaliate against its critics in the press may have been interpreted as a tacit confession of guilt. This is how many writers interpreted their licence. Modelled upon Pope's famous satiric dialogues, *One-Thousand Seven-Hundred and Fifty-Six* defied the ministry to refute its allegations. The poem describes the attempts of an apologist for the Newcastle ministry to dissuade a patriot poet from exposing its crimes. The courtier first threatens prosecution and the pillory to intimidate, and when coercion fails, he dangles a pension before the patriot, who refuses to prostitute his pen with righteous indignation:

> B. O dread that vile, ill-fated Place,
> Where many a Wit has shewn his Face!
> Where Eggs, and Mud, drown'd Dogs, and Cats,
> Corrupted Fruit and stinking Sprats,
> Fly in perpetual Vollies round,
> And sometimes stain, and sometimes wound:
> A. Pensions! Confusion! name them not,
> To flatter – I abhor the Thought!
> Truth is the Word hence Dangers fly,
> For Truth I could a Martyr die![35]

Another important manifestation of political opinion, closely related to the press, and sharing its insistence upon the accountability of government to the people, was the addresses and instructions submitted to the King and Parliament during the latter half of 1756. These appeals demanded ministerial respect because the right to petition was sanctioned by the constitution, and because they represented the voice of important sections of the propertied classes. While the freedom of constituents to urge their MPs to lay their grievances before Parliament, and to advise them upon how to vote, was generally accepted, the view still prevailed that, after election, MPs became independent representatives of the entire nation, and were not compelled to follow the dictates of their electors. Nevertheless, during times of violent political controversy, addresses and instructions, instigated on a large scale by the patriot opposition to Walpole's 1733 Excise Bill and his appeasement of Spain, were powerful instruments of extra-parliamentary protest. They warned the government of the magnitude of antipathy incited by its actions, and exerted pressure upon individual MPs, above all in the larger, more open constituencies, to conform to the will of the voters, or risk defeat at the next election. The Pelham ministry's deference to the power of popular opinion was emphasised by its repeal of the Jewish Naturalisation Act immediately before the 1754 general election, when confronted by violent opposition manifested in public demonstrations, the press, and an effective petitioning offensive.[36]

Leadership was often assumed by the City of London, which claimed to speak for the entire country. This pre-eminence was encouraged by its status as national capital and its proximity to court and Parliament, its vital interest in finance and international trade, and its relatively democratic system of government. Moreover, London's lead was confirmed by its domination of national print culture. A mature political press with an efficient, comprehensive distribution network, skilfully utilised by the patriot opposition, was an essential prerequisite for the mobilisation and coordination of campaigns of popular protest. London newspapers enjoyed a virtually unchallenged monopoly on the reporting of international and national events, a supremacy emphasised by the provincial papers' dependence upon them as sources for their own news.[37]

Although Parliament was in recess when the report of Minorca's capture was received, petitions to the Crown provided a forceful channel for the expression of dissatisfaction with the ministry. The first addresses and instructions emanated from the counties, assembled for the August assizes, followed soon after by London, which presented an Address to the King on 20 August 1756. The October quarter sessions, and the reconvening of Parliament, inspired a second wave of addresses and instructions during the autumn. Between August and December, the Minorca crisis precipitated approximately forty addresses and instructions, representing thirty-six constituencies. Some undoubtedly were instigated by the Tories and Pitt's patriot allies. Recent examinations of the petitioning campaign, however, pointing to the participation of all regions of the country, which included the south-west and East Anglia as well as the ports and industrial towns engaged in transatlantic trade, have emphasised their fundamentally bipartisan and spontaneous nature. The impact of the addresses and instructions was magnified by their systematic publication in the London and provincial press, which promoted their demands and stressed their legitimacy. A parliamentary inquiry into the fall of Minorca, the foundation of a militia, the dismissal of foreign mercenaries, isolation from the continent, and greater exertions in the defence of the North American colonies and for the protection of trade, emerged as the fundamental demands. A significant number of later petitions broadened their parameters to insist that the tide of defeat could be turned only by national moral regeneration, achieved through a programme of patriotic political reform. This call for political renewal was stimulated by the City of London, whose aggressive October Instructions advocating the purification of Parliament through a strict auditing of public funds, restrictions on placemen and pensioners, and the restoration of triennial elections, encouraged a similar response from several other major cities.[38]

The Newcastle ministry was aware of the damage the addresses and instructions inflicted upon public confidence.[39] Newcastle's determination

to silence Shebbeare and Whitehead, and Hardwicke's concern that the ministry launch a counter-attack in the newspapers, were based upon a belief in the responsibility of the press in helping to foment the addresses. The administration attempted to pre-empt petitions, or at least moderate their language.[40] Through the intervention of his City ally, Alderman Sir John Barnard, Newcastle sought to forestall the London Address.[41] When Barnard's efforts failed, the ministry hoped to diffuse the crisis by giving in to demands for a rigorous inquiry into Minorca, and Hardwicke drafted a temperate reply, in which George II was made to promise, 'I will not fail to do justice upon any persons who have been wanting in their duty to me, and their country.'[42] Elsewhere, a conciliatory response was considered essential to placate discontented constituents. The Pelhamite MP for Bristol, Robert Nugent, urged Newcastle to persuade George II to offer a pledge that the city's expectations would not be disappointed when he presented its petitions, 'I hope the King will say something when I present the Addresses that will tell well at Bristol.'[43] Horatio Walpole had been unable to halt an address in Norfolk, but he was more successful in Norwich after composing a memorial discrediting the petitioners' motives and questioning the constitutional propriety of addressing the Crown. Hardwicke urged Walpole to print his pamphlet, which had been circulated anonymously among the corporation members. Walpole refused publicly to acknowledge his authorship, however, for fear that it would damage his son's electoral interest in the city, another illustration of how the petitioning campaign embodied the dissatisfaction of significant elements of the political nation, and had placed the ministry upon the defensive.[44]

The addresses and instructions received a nearly universal commendation from political poetry and prints, which by expressing the same concerns, had done much to inspire them. They endorsed the people's right to scrutinise their leaders' actions and to protest if they wavered in their public duty, a safeguard especially important during war. A poetic address declared, 'the Eyes of *Britain* on our Senate are', while a print (see Plate 8) dramatised the presentation of a petition by the Lord Mayor and Aldermen of London, who confront the creatures of the court, demanding an explanation for the loss of Minorca and Oswego, '*Our Constituents loudly insist to know where the blame lies*'.[45] Exponents of the addresses and instructions were careful to avoid countercharges of factionalism or disaffection by emphasising their devotion to the Hanoverian dynasty. This was achieved by portraying George II as the isolated victim of tyrannical ministers, who had sealed off the institutional avenues of political communication so completely, that his faithful subjects had no other means of exposing their crimes than by appealing directly to the throne.[46] In the Japanese political allegory, a repentant emperor thanks his people for opening his eyes to the incompetence and perfidy of his advisers.[47] In graphic art, the people's intervention was celebrated metaphorically as the

liberation of the British lion from the chains or sedatives with which treasonous courtiers had suppressed him.[48]

The diversity of the works which promoted the petitions offers insight into the wide range of opinion they articulated. The aggressively populist tone of *The Block and the Yard Arm*, with its emphasis upon commerce and the North American colonies, suggests an affinity with the City's merchants and tradesmen, who supported its address drafted by the Tory Alderman, MP, and West Indian merchant William Beckford and other patriots.[49] A print alluding to the addresses from Bristol and Norfolk, in which Justice demanded an inquiry on *'behalf of London and all the Trading Cities & Towns of Great Britain'*, suggested that these priorities were shared by their counterparts in other major ports and industrial centres.[50] Many literary works which extended their mandate to advocate parliamentary reform, testify to the sentiments embodied in the later addresses and instructions. *The Speech of a Patriot Prince* endorsed the call for constitutional change, even going so far as to sanction the call for the City MPs to refuse supply until its demands had been met.[51] Some members of the political nation, however, appear to have regretted the extremity of the City Instructions' tone. A *Pathetick Address* refused to condone inflammatory demands for supplies to be withheld, perhaps representing the views of those more moderate patriot critics, who suspected that the motivation behind the instructions was tainted by party politics.

There is evidence of conservative distrust of the protest movement in a satire parodying the Minorca addresses, which envisaged them as dangerous intrusions of the people into the political arena and a threat to the established order. Through the presentation of a semi-literate mock-address from the canaille of St Giles, the author disparages the social status and political pretensions of the participants in the petitioning campaign, who are:

> the Lamp-Lighters, Link-Boys, Dustmen, Chimney-Sweepers, Cinder-Sifters, Carmen, Porters, Shoe-Cleaners, Hackney-coachmen and (late) Bruisers of the ancient Corporation and County of the Town Palatinate of St *Giles's*, in the common Highway assembled (having no common Hall, like other Bodies Politic).[52]

The ignorant, impulsive rabble complain of the economic hardships and oppressive taxation caused by an unsuccessful war, *'tis Cozz of Minny-Orkey'*, presume to dictate solutions for complex problems they do not understand, and threaten to storm St James's and Westminster if their demands are not met.[53] The satire's ironic tone makes its ultimate message difficult to assess, however, for while on the one hand, it caricatures the populism of the addresses, on the other, its treatment of Minorca, the militia and Maidstone by no means exculpates the ministry. It may almost be read as a caricature of

the addresses' reactionary opponents themselves. Ultimately, the work is best interpreted as a non-partisan commentary upon the political chaos created by an incompetent ministry, which threatens to descend into mob violence. Several poems and prints taunted the ministry for its embarrassment over the petitions, which were taken as telling admissions of its weakness and unpopularity. An engraving alluded to the presentation of the City of Chester's Address on 2 October 1756. The intimidated ministers sit around the council table determining how to respond, and their helplessness is emphasised by Anson, who lamely suggests, 'Let's Rub out as we did in Bungs Letter.'[54]

The vociferous, sustained extra-parliamentary condemnation of the administration, by exacerbating internal divisions among the ministers, significantly contributed to its collapse in November 1756. Despite the appearance of unity between Fox, Newcastle and Hardwicke fostered by the successful parliamentary session of 1755–56, Fox's promotion to secretary of state did not resolve the deep-seated, long-standing suspicion and hostility which separated the three men. Fox had entered politics as a disciple of Walpole. Although he transferred his loyalty to Pelham, the conviction that the Old Corps had deserted Walpole prevented him from developing a close relationship with his successors. Fox's developing ties with Cumberland during the 1740s had alienated Newcastle, who feared the captain general's political influence. The perceived threat from Cumberland was intensified by the drift into war, which increased his involvement in all aspects of decision making.[55] Personal animosity had also contributed to sour the relations between Fox and the Old Corps leadership. Fox's opposition to the Marriage Act propelled him into a fierce personal attack upon Hardwicke, which had been returned with equal vigour, and subsequent attempts at reconciliation had failed.[56] Hardwicke assigned Fox's behaviour to political ambition, which he was determined to frustrate.[57] Mistrust of Fox, the potential parliamentary leader of a Cumberland ministry, had inspired Newcastle and Hardwicke to deny him the unrestricted lead of the Commons following Pelham's death, a right of succession which Fox believed he had earned by a career of loyal service. Fox's conviction that Newcastle and Hardwicke were determined to monopolise political power, and his belief in their fundamental dishonesty, seemed to be confirmed by the misunderstanding regarding the offer of the full management of the Commons, which Fox maintained had been offered to him, but later retracted.

Considering its unstable foundation of unresolved conflict, unsatisfied ambition and mutual suspicion, cracks in the façade of ministerial unity appeared almost immediately upons new of the invasion of Minorca. Anticipating the political outcry which the island's fall would inspire, Newcastle and Fox manoeuvred to avoid being held personally accountable. Newcastle renounced the idea that his status as first minister endowed him with any

ultimate authority for the cabinet's decisions or for the prosecution of the war. He maintained that Anson's professional advice concerning the deployment of the fleet had been accepted by the entire Cabinet, for which he shared no greater responsibility than Fox or any other member.[58] Their uneasy ministerial partnership was subjected to immense strain, because as his deputy in the Commons, Newcastle expected Fox to defend him and the rest of the Cabinet from censure. Yet Fox refused to bear this very public and individual burden of responsibility, claiming that his advice to reinforce the Royal Navy's strength in the Mediterranean had been rejected by Newcastle and the Pelhamite majority in the Cabinet: 'Fear of an invasion, and *landing in Sussex prevented*. Lord Anson assur'd him, and took it upon himself, that Byng's squadron would beat anything the French had, or could have, in the Mediterranean.'[59]

To distance himself even further from blame, Fox argued that the ultimate cause of Minorca's peril lay in the ministry's failure to mobilise the army quickly enough for home defence, an oversight which required an otherwise unnecessarily large number ships to be retained to guard against invasion. This argument provided the most complete self-justification for Fox, who had not been a member of the Cabinet when the neglect occurred, and could therefore wash his hands of the consequences.[60]

In the Commons, the opposition played upon ministerial discord by appearing to absolve Anson and Fox while concentrating their accusations of neglect and incompetence upon a defenceless Newcastle. The tactic's success is illustrated by Newcastle's outraged reaction to Pitt's attacks of 7 May 1756: 'Mr. Pitt laid everything that was blamed upon me . . . I am not able to bear this weight, especially for measures where others have the principal, if not the sole direction.'[61]

Five days later Pitt and Grenville repeated the ploy.[62] On both occasions, as Fox was not directly implicated, he declined to vindicate Newcastle, and in an equivocal response to another acquittal of Anson, even appeared to confirm their indictments.[63] Fox's sardonic excuse of his behaviour to Newcastle, 'I answered as well as I could, but the loss of Minorca is a weight that it is not easy to debate under', only increased the duke's fury at his dereliction.[64] An indignant Newcastle reminded Fox of his obligation to defend the ministry's naval dispositions according to the plan agreed to by the Cabinet, that Britain's vulnerability to invasion prevented the earlier dispatch of a more powerful fleet.[65] Newcastle confided his growing suspicion to Hardwicke that Fox would exonerate himself by betraying his colleagues.[66] Eager to justify himself, on 14 May, Newcastle compelled Fox to read a statement to the Commons elicited from Anson, in which the First Lord denied rumours that Newcastle had prevented him from assigning additional warships to Byng.

Newcastle and Fox's anxiety to evade personal responsibility for Minorca's plight led to a remarkable spectacle over dinner at Holland House, which emphasised the great importance each attached to maintaining the confidence of Parliament and the wider political nation. The beleaguered ministers compared the reports of their own coffee-house spies and parliamentary observers. Upon the basis of reports from Garraways, Newcastle asserted that Fox's declaration had reassured the City that he was innocent of vetoing proposals for a more powerful naval reinforcement.[67] Fox challenged Newcastle's evaluation of City opinion, claiming that as head of the administration, he bore the greatest share of blame. When Newcastle maintained the truth of reports which vindicated him, this time from the Commons, he was again contradicted by Fox, who claimed to be in closer touch with the sympathies of members: 'it appear'd plain to him, that when Mr. Pitt charg'd the loss of Minorca upon his Grace ... all friends hung their heads. That he defended him in everything he could defend him; in *one thing*, he never could, which was, in not believing it must be war, and not arming sooner.'[68]

Fox concluded the dispute by persisting in reports of his own absolution. This acrimonious exchange highlights the incompatibility of the two men's positions regarding the division of responsibility over Minorca, and the fragility of their ministerial partnership, which would be brought to the breaking point by the accumulated weight of tension produced by the island's fall, and a number of other adverse political developments.

During the summer of 1756, Newcastle was preoccupied with the arrangement of an independent establishment for the Prince of Wales, who came of age on 4 June. Prince George's insistence that Lord Bute be appointed Groom of the Stole threatened to cause a rupture within the royal family. If not conciliated, Newcastle feared that Leicester House would openly espouse the patriot opposition in the Commons. By early October, the King had been persuaded that Bute's elevation would ensure a quieter session in the Commons, although the concession had been offered in such a manner that Leicester House remained alienated from the ministry.[69] Fox had been excluded from the negotiations, which contributed to his deteriorating relationship with Newcastle. Fox suspected from George II's growing resentment that Newcastle and Hardwicke had accused him of intriguing with Leicester House, and refusing to conduct business in the Commons unless Bute were gratified.[70]

Newcastle and Hardwicke interpreted Fox's attempts to dissociate himself from blame over Minorca, and his insistence that the ministry's problems in the Commons could be resolved only by an understanding with Pitt, as indications that he was contemplating an alliance with the opposition. Both men, like Fox, followed trends in literature as indicative of the aims of

competing politicians, who exploited the press to advance their interests. They seemed to find confirmation of their rival's treachery in works which suggested that Fox and Pitt replace the discredited Old Corps administration. Newcastle attributed one pro-Fox pamphlet advocating such an alternative to Beckford.[71] The importance of the political press to the ministers was demonstrated by its tactical application as a means of gauging George II's disposition towards Fox. On 20 August 1756, Hardwicke showed the King an editorial letter in the *Evening Advertiser*, which proposed the formation of a Fox–Pitt ministry. George II's dismissal of the scheme reassured Hardwicke of his confidence in the Old Corps, and the letter offered an opportunity for him to insinuate that Fox was plotting to desert to the opposition.[72]

The stability of the administration was further undermined by the death of the Lord Chief Justice, Sir Dudley Ryder, on 25 May 1756. The Attorney General, William Murray, claimed the promotion and a peerage. This development could not have occurred at a worse time for Newcastle, who had relied so heavily upon Murray to defend the ministry in the Commons during the tumultuous parliamentary session of 1755–56. The controversy incited by Minorca and the concession of a parliamentary inquiry made Murray's presence seem even more imperative, 'I dread to think of the Attorney General being out of the House of Commons (as he must be), when this question comes on.'[73] Newcastle's personal dependence upon Murray was reinforced by the abuse he had endured in Parliament and the political press over Minorca, and by Fox's refusal to defend him. He appealed to Murray to accept alternative offices and honours which would keep him in the Commons, or at least to delay his removal until the Minorca storm had been weathered, 'nobody but yourself will or can support me . . . against such a formed opposition, and in such a critical conjuncture'.[74] *Patriot Policy* emphasised how Murray's well-reasoned justifications of government policy had been instrumental in refuting the opposition, and how they had complemented Fox's more pragmatic skills as a debater. No one was more conscious of the grave implications of Murray's removal to the House of Lords than Fox, who recognised how greatly his own success in debate had depended upon their partnership, 'I shall miss him in the House of Commons, and indeed find an essential want of him. We were made for one another there.'[75]

Despite his long-standing ambition for legal promotion, it is probable that Murray's demands for immediate elevation to the Chief Justiceship and the Lords were encouraged by a reluctance to vindicate the ministry's naval strategy in the Commons. Murray's enemies accused him of cowardice – of running away from the approaching war of words with Pitt.[76] *The Wisdom of Plutus* compared Murray's prudent, timely withdrawal to a migrating bird's instinct for self-preservation:

> So passage Birds take wing and fly,
> When wintry Frost approaches nigh,
> Sagaciously avoid the Times
> Of Storms, and seek for warmer Climes;
> Thus he, by wise foreseeing Skill,
> Soars, like a Woodcock, on his *Quill,*[77]

An astute political print prophesied that Murray's departure from the Commons would cause the collapse of the Newcastle ministry. A lion casts the guilty triumvirate of Newcastle, Hardwicke and Fox, who are consumed by mutual recrimination over Minorca, into a bottomless pit. Murray stands upon steps from which the ministers have fallen, celebrating his escape from their fate by playing a folk tune upon a fiddle (Plate 10).

Murray's promotion dealt a crippling blow to Newcastle's management of the Commons. Newcastle and Hardwicke were confronted, this time in a seemingly inescapable form, with the dilemma which had haunted them

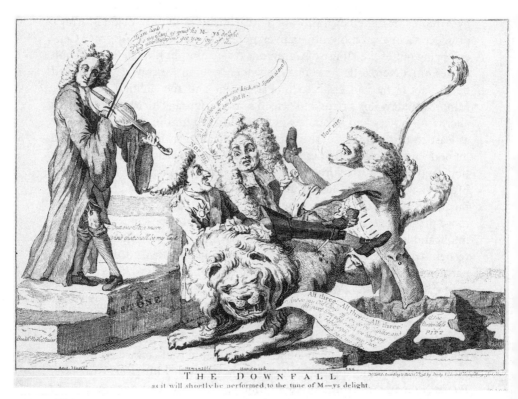

10 *The downfall*

since Pelham's death. It had become essential to entrust the leadership of the Commons to a colleague, who would be admitted into an equal share of ministerial confidence. Newcastle's anxiety that Fox would exploit his supremacy in the Commons to launch a bid for control of the ministry was too acute to permit the experiment. Fox's distrust was aggravated by Newcastle's appeals to Murray to defer his promotion, which he interpreted as a sign of the duke's determination to avoid relinquishing any real power to him.[78]

Since the ministry's reconstruction in 1754, critics charged that it was racked by an increasingly bitter struggle for power between Fox and the Old Corps, which prevented it from pursuing a coherent, vigorous response to French aggression. This indictment became a persistent theme in anti-ministerial literature and prints. Fox's inclusion in the cabinet council in December 1754 had been followed by reports of internecine strife. *An Excellent Historical Ballad* represented Hardwicke poisoning the King's mind against Fox. It portrayed his promotion as a ruse by Newcastle to trick him into perpetuating the Old Corps hegemony by renouncing Pitt and opposition, while being denied admission into the innermost circle of the ministry:

> There we may safely let him sit
> For that I see no hurt in
> I have another Cabinet
> That sits behind the Curtain.[79]

It was alleged that the next victory in the battle for political supremacy was won by Fox, who took advantage of the subsidy issue to extort the secretary's seals and a more commanding position in the Commons. In commenting upon the inveterate Fox–Hardwicke vendetta, *The Converts* voiced disillusionment with ministers who were driven by self-aggrandisement rather than a desire to cooperate for the good of the nation:

> Now, whether F[o]x to H[ar]d[wic]k grave,
> Or he to F[o]x, is turn'd a Slave,
> Let that still rest a Doubt:
> Both hate each other, yet agree,
> 'Tis better far, *in* Place to be,
> On *any* Terms, than *out*.[80]

The internal dissension instigated by Minorca was brought into high relief by the ministers' increasingly overt struggle to evade responsibility for its fall. Chesterfield voiced the belief, which must have been shared by many, that the crisis ultimately was caused by the ministerial divisions it so blatantly exposed: 'One of the chief causes of this unfortunate situation is, that we have now in truth no minister; but the administration is a mere Republic,

and carried on by the Cabinet Council, the individuals of which think only how to get the better of each other.'[81]

Puppet shows and simple, humorous dramatic performances known as 'drolls' formed an integral part of fairground entertainment, and often became influential vehicles for the propagation of political ideas among the common people. One engraving alluding to this tradition conveyed the charge of self-destructive inter-ministerial strife by caricaturing Fox and Newcastle as Punch and Judy, too obsessed with their own squabbles to unite against the common enemy France.[82] Patriots portrayed the conflict between Newcastle, Hardwicke and Fox as a struggle to plunder the Crown of its profitable places. Satirists played upon the zoomorphic significance of Fox's surname, and the well-established image of the goose to symbolise Newcastle, to express the same message. Print makers condemned the secretary of state's voracious appetite for riches, and his craft in pilfering these prizes away from his rivals, by depicting him as the fox which ran away with the golden goose (Plate 11). *The Wisdom of Plutus* recorded Newcastle's fear that Fox was plotting to subvert the ministry from within, by reference to the folk tale

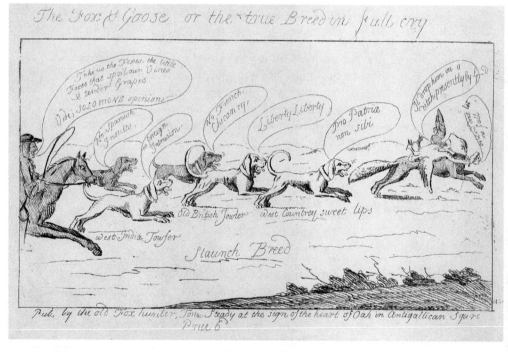

11 *The fox & goose*

of the gullible goose, which was first deceived and then devoured by his mortal enemy:

> A Goose most strange! like highland pack,
> Takes up a F[o]x upon his Back.[83]

Through the analogy of a travelling coach, the poem also identified Fox's paramount grievance against Newcastle: that he was denied what he believed was his proper share of ministerial influence and royal favour. Fox's resentment at his exclusion from policy making and the distribution of patronage was reflected in his subservient status as an outside passenger, while Newcastle and Hardwicke, the real wielders of power, enjoy comfortable seats inside the coach:

> But note, my Lord, 'tis not a Sin,
> Who drove without, should ride within.[84]

In addition, presenting Fox as the driver, exposed to the severity of the weather, neatly expressed his unwillingness to take on the punishing, thankless task of steering the ministerial coach through a House of Commons indignant over Minorca's fall.

One of the most powerful denunciations of ministerial discord, which created a vacuum of national leadership and paralysed the prosecution of the war, was made by a ballad portraying Newcastle and Fox as a hare and a fox, pursued for their neglect by a pack of patriotic bloodhounds. When finally run to ground by the avengers of a betrayed people, each attempts to save himself by betraying his comrade:

> For deceiv'd by each other, each other deceiving,
> No Business advancing no Project succeeding,
> The Nation in Factions and Partys is tost,
> Its Treasure exhausted, its Honour quite lost.[85]

A print vividly warned of the catastrophic consequences of entrusting national defence to a government torn apart by the self-serving intrigues of its members through images of the murder and dismemberment of Britannia. Its prophecy was hammered home by the caption 'A House divided against it self can never stand.'[86]

As the reconvening of Parliament approached, Fox's relationship with Newcastle had deteriorated to a state where all meaningful communication ceased. He was frustrated by Newcastle's refusal to admit him into a more equal partnership and alleviate the displeasure of the King. Fox was pessimistic about the ministry's ability to prepare a creditable defence for the impending Commons inquiry, and dreaded enduring the assaults of the opposition unassisted by Murray: 'But when Parliament meets, the scene of

action will be the H. of Commons, and I, being the only figure of a Minister there, shall of course draw all the odium on me.'[87]

Fox was suspicious of Newcastle's continued support for him as secretary of state, fearing that he might be scapegoated for the fall of Minorca, or dismissed as the price of an alliance with Leicester House.[88] He was also despondent about the future conduct of the war under Newcastle, and doubted his fitness to serve as secretary of state, for which he was unqualified by experience or aptitude. He did not share Pitt's obsessive desire to assert British maritime, commercial and imperial supremacy in confrontation with France, and lacked the personal strength, determination and strategic vision necessary to take the lead in a wartime crisis.[89] On 13 October 1756 Fox re-signed, and conveyed his decision and an explanation to George II by letter.[90]

Although Newcastle retained a majority in the Commons, he searched in vain for a replacement with the authority to lead the ministry in debate. Newcastle explained to the King 'tho we did not want Numbers, we wanted Hands, & Tongues, in the House of Commons', while Waldegrave emphas-ised the threat to the conduct of government business posed by Pitt, 'standing without a Rival, no Orator to oppose him who had Courage even to look him in the Face'.[91] Once Newcastle and Hardwicke had persuaded George II that the vacuum of leadership in the Commons could be filled only by Pitt, they were authorised to offer him the secretary's seals if he would join the ministry. Pitt refused to serve with Newcastle upon any terms, however, and unable to devise an alternative system for the management of the Commons, Newcastle offered his own resignation on 26 October 1756.[92]

During the summer and autumn of 1756, the Newcastle ministry was engulfed in a blaze of condemnation inspired by the defeats at Minorca and Oswego, the rejection of the Militia Bill, its alleged subservience to Hanover, and accusations of moral and political corruption. The sudden, sharp in-crease in the production of prints after Minorca is a rough but accurate barometer registering the renewal of fierce political controversy. During the relative calm of 1754–55 approximately twelve prints were published, but this number increased by ten times to more than one hundred and twenty during 1756. Political literature acted as a powerful catalyst in the development and dissemination of anti-ministerial sentiment, achieving a national audience through independent publication, circulation within the newspaper and periodical press, and by being broadcast through the air as song. More than forty ballads, poems, novels, prose satires and plays hostile to the Newcastle ministry were published between August and November 1756, and their criti-cism was reinforced by no fewer than ninety political prints.

The addresses and instructions indicated pervasive discontent among important elements of the propertied classes with the ministry's conduct of

the war, an expression of opinion paralleled by the effigy burnings, crowd demonstrations and the mobbing of Newcastle, which offered scope for the common people to communicate their dissatisfaction. A comparison of literary text and image with the petitions, and the grievances articulated during the popular protests, reveals a close correspondence in the substance of the criticisms levelled at the ministry, and in the patriot vocabulary adopted to express them. Such a strong correlation suggests that literary works exercised considerable influence in fostering anti-ministerial animosity. Convincing evidence that literature helped to shape the formation of opinion is also provided by the clear belief among contemporary politicians that a connection existed. Newcastle's patronage of Newcomb and desire to silence Shebbeare, Hardwicke's collaboration with Mallet and advocacy of a newspaper counter-offensive, Fox's manipulation of the press to scapegoat Byng, and Anson's desire to prosecute the *Gazetteer*, were all predicated upon the conviction that literary propaganda affected the hearts and minds of readers. Each accepted that it was partly responsible for turning the political nation against them, and this idea was confirmed by the testimony of the administration's legal advisers, Sharpe and Henley.

After discussing the salient role played by literature in fomenting criticism of the ministry, its interaction with other channels for the expression of opinion, and the broadly-based support its message commanded within the political nation, it is necessary briefly to consider its contribution to the fall of the Newcastle ministry. Perhaps the most challenging problem confronting the historian, who seeks to evaluate the significance of eighteenth-century literature and its relation to political opinion, is to determine their impact upon the innermost circle of ministers, in this case Newcastle, Hardwicke and Fox, who wielded power by virtue of the confidence of the King, the support they enjoyed in Parliament, and from predominance in the House of Commons.

Newcastle and the other Whig ministers recognised that government rested upon consent, an important restriction upon political leaders' freedom of action at all times, but of even more vital significance during periods of armed conflict. Only with the united, enthusiastic cooperation of the entire political nation could the economic and human resources of the state be mobilised against the enemy. Acuteness to shifts in political opinion was a defining feature of Newcastle's career in public life, and in part explained his remarkable longevity in office. Newcastle was apprehensive of the extra-parliamentary unrest instigated by Minorca, which coincided from mid-August 1756 with the development of one of eighteenth-century Britain's most severe outbursts of food rioting.[93] The ministry feared that popular fury over food shortages might merge with discontent over the fall of Minorca, and erupt in more prolonged and intense outbursts of violence, constituting

a grave challenge to their capacity to maintain civil order and prosecute the war. Newcastle was also anxious about widespread alienation among the propertied, enfranchised members of the political nation, whose voice was heard through the addresses and instructions from sixteen counties and nineteen boroughs. Newcastle's correspondence with Barnard and James West, secretary to the Treasury and the regular employment of informants to assess the mood of coffee-houses such as Garraways, demonstrate his interest to remain in close contact with the political temper of the City of London.[94] The City's opposition was damaging because its example was frequently emulated by the rest of the country, and because the cooperation of its financial and commercial sectors was imperative in raising the unprecedented sums demanded to wage the war.[95] Newcastle was apprehensive of the impact of these hostile forces upon MPs when Parliament reconvened:

> I could have wished in this time of difficulty, danger and almost universal uneasiness and discontent throughout the whole kingdom (of which I receive fresh accounts from all quarters and from undoubted hands), that your Lordship could have suggested some adequate expedient from stemming the torrent and effect of this ill-humour in the House of Commons.[96]

After Minorca, Newcastle attempted to pre-empt condemnation of the ministry by diverting the blame upon Byng, and resorting to the familiar Pelhamite tactic of compromise and conciliation. It was the importance of maintaining the confidence of the parliamentary classes, the City of London, and the extended political nation, which motivated the two major concessions Newcastle surrendered to the ministry's critics: militia reform and a parliamentary inquiry into the conduct of the war. When these manoeuvres failed to diffuse the crisis, Newcastle's refusal to continue in office, and to run the risk of attempting to manage the Commons without either Fox or Pitt, must have been influenced by consideration of the disruptive effect of extra-parliamentary hostility upon the stability of his administration, and its prospects of surviving in the Commons: 'It is impossible for Things to go on as they are, the Violence without Doors, will soon come within, and the Parliament, I mean the House of Commons, may be a Scene of great Confusion.'[97]

The most complete understanding of political literature's contribution to the fall of the Newcastle ministry is achieved when it is remembered that the ministerial crisis was precipitated by Fox who, more than any other politician, was intimidated by the violent onslaught of the political press and the popular agitation it helped to incite. After Byng's defeat, he had attempted to dictate the development of political reaction by releasing information in such a manner as to exonerate the ministry from responsibility for the debacle. By a careful evaluation of the political press, the crowd demonstrations, the

consensus of the coffee-houses, and the addresses and instructions, Fox recognised the failure of his attempt at crisis management. As early as 12 August, Fox conceded that Minorca's surrender had shattered the political nation's faith in the ministry – a crisis of confidence so acute that he felt compelled to resign: 'For this administration has, I think, lost the good will and good opinion of their country, (which they six months ago enjoyed to a great degree) and without them who can wish to be in administration.'[98]

Fox collected many of the anti-ministerial ballads, poems, plays, pamphlets, essay-papers and prints, and read how savagely they denounced him for greed, deceit, corruption, incompetence and treason. He had been exposed as the instigator of a conspiracy to scapegoat Byng – to murder an innocent man in order to cover up his own criminal neglect. If there was a failure of nerve upon the part of any politician during the Minorca crisis, it was by Fox, who after enduring nearly three months of vicious slander in the press, could not contemplate running the gauntlet of parliamentary censure alone and unassisted by Murray.[99] Fox regarded the stream of hostile literary publications and prints as his own Sibylline Leaves – accurate forewarnings of the accusations which would be showered upon him by Pitt and the opposition, and for which he believed the ministry had no adequate defence:

> You may collect what a time I am likely to have the next session, by the torrent of abuse I share in now. Now, I have only a share, and not a great one. But then, being the only person who can be attacked in the House of Commons, the whole storm will fall on me.[100]

With the immediate approach of the new parliamentary session, Fox's forebodings multiplied, and in explaining the impossibility of his continuing to lead the Commons as Newcastle's lieutenant, he emphasised the prospect of humiliating defeat, made inevitable by the crumbling of the ministry's support beneath the combined weight of extra-parliamentary pressure, and a patriot opposition championed by Pitt: 'Pitt will be with popular clamour against both. Whom must the Numbers look to, Who must combine and direct the Majority? and my God! upon what Points! My Dear Lord, If utter Confusion happens remember it was not my fault.'[101]

NOTES

1 Lyttelton to William Lyttelton, 8 Aug. 1756, Phillimore, II. 522.
2 Reed Browning, *The Duke of Newcastle* (New Haven, 1975), p. 15; L. Hanson, *Government and the Press 1695–1763* (London, 1967), pp. 36–82; Harris, *London Newspapers*, p. 136; Atherton, p. 70.
3 W. Coxe, *Memoirs of the Administration of the Right Honourable Henry Pelham* (London, 1829), I. 203.
4 BL, Add. MSS 51,393, fo. 186: Hanbury Williams to Fox, 26 Apr. 1757.

5 Ilchester, *Hanbury Williams*, p. 68.

6 BL, Add. MSS 51,387, fo. 28: Fox to Ellis, 1 July 1756.

7 *Ibid.*, fo. 34: Fox to Ellis, 12 July 1756.

8 *Ibid.*, fo. 32: Fox to Ellis, 5 July 1756.

9 BL, Add. MSS 32,867, fo. 148: Hardwicke to Newcastle, 29 Aug. 1756.

10 BL, Add. MSS 35,398, fo. 242: Birch to Royston, 2 Nov. 1755.

11 John Shebbeare, *Letters on the English Nation*, 1756, pp. viii–xlviii. The work went through several editions during 1755–56, and was reissued in 1763.

12 BL, Add. MSS 35,398, fo. 255: Birch to Royston, 5 July 1755.

13 SP 44/85, fo. 440: Robinson to Attorney General, 28 May 1755.

14 BL, Add. MSS 32,867, fo. 135–6: William Sharpe to Newcastle, 20 Aug. 1756.

15 BL, Add. MSS 35,398, fo. 230: Birch to Royston, 10 Oct. 1754. Whitehead's employment on the paper would explain its frequent publication of political poetry.

16 BL, Add. MSS 32,867, fo. 146: Hardwicke to Newcastle, 29 Aug. 1756 Hanson, p. 56.

17 *LEP*, 31 Aug. 1756; *Gaz*, 20 Aug. 1756.

18 BL, Add. MSS 32,867, fo. 46: Henley to Cleveland, 22 Oct. 1756.

19 Hanson, p. 58.

20 *Ibid.*, pp. 30–2.

21 H. T. Dickinson, 'Popular Politics in the Age of Walpole', in J. Black (ed.), *Britain in the Age of Walpole* (London, 1984), pp. 47, 64; Rogers, *Whigs*, pp. 1–6, 391–405; Harris, *Patriot Press*, p. 32.

22 Reed, *A British Philippic*, p. 4.

23 BL, Add. MSS 32,867, fo. 146: Hardwicke to Newcastle, 29 Aug. 1756.

24 *Ibid.*, fo. 146.

25 BL, Add. MSS 32,948, fo. 381: Newcomb to Newcastle, 25 May 1763.

26 BL, Add. MSS 32,867, fo. 115: Mallet to Newcastle, 10 June 1756.

27 Goldgar, pp. 178–88.

28 David Mallet, *The Conduct of the Ministry Impartially Examined*, 1756.

29 BL, Add. MSS 35,593, fo. 236: Mallet to Hardwicke, 3 Oct. 1756; fo. 254: Hardwicke to Mallet, 9 Oct. 1756.

30 *Ibid.*, fo. 254: Hardwicke to Anson, 10 Oct. 1756.

31 Namier, *Structure*, II. 536.

32 BL, Add. MSS 32,868, fo. 591: Mallet to Newcastle, 8 Nov. 1756.

33 *LiM*, 15 Nov. 1756, 336–40.

34 James Boswell, *Life of Johnson* (Oxford, 1980), p. 444.

35 *One-Thousand, Seven-Hundred, and Fifty-Six*, pp. 25–6.

36 Rogers, *Whigs*, pp. 240–8; Dickinson, *Politics of the People*, pp. 36–40.

37 M. Harris, 'Print and Politics', pp. 189–210.

38 Rogers, *Whigs*, pp. 93–104; Peters, *Pitt*, pp. 50–7; Wilson, *Sense of the People*, pp. 183–4; *The Voice of the People: a Collection of Addresses to His Majesty and Instructions to Members of Parliament*, 1756.

39 BL, Add. MSS 32,867, fos 175–6: Newcastle to Hardwicke, 2 Sept. 1756.

40 Rogers, *Whigs*, pp. 97–100; Lucy Sutherland, 'City of London and the Devonshire-Pitt Administration, 1756–57', *Proceedings of the British Academy*, XLVI (1960), 153–7.

41 BL, Add. MSS 35,398 fos 317–18: Birch to Royston, 20 Aug. 1756. Anti-ministerial ire was so pervasive that the idea of promoting a Pelhamite counter-address was abandoned.

42 *GM*, Aug. 1756, 408.

43 Claud Nugent (ed.), *Memoir of Robert, Earl Nugent* (London, 1898), p. 219.

44 Coxe, *Walpole*, pp. 437–45.

45 *A Pathetick Address*, 1756, p. 7.

46 *The Freeholder's Ditty*.

47 *Speech of a Patriot Prince*, pp. 10–13.

48 *Britannia's Revival*, BMC 3377; *The Mirrour*, BMC 3487.

49 BL, Add. MSS 35,398, fos 317–18: Birch to Royston, 20 Aug. 1756.

50 *The Vision*, BMC 3476.

51 *Speech of a Patriot Prince*, p. 15.

52 *Two Very Singular Addresses*, 1757, p. 4.

53 *Ibid.*, p. 9.

54 *The Western Address*, BMC 3392.

55 Peter A. Luff, 'Henry Fox, the Duke of Cumberland, and Pelhamite Politics, 1748–57' (Oxford Univ. DPhil thesis 1981), pp. 19–102.

56 Cobbett, XV. 1–86; Walpole, *Memoirs*, I. 225–33.

57 Ilchester, I. 186–197; Yorke, II. 60–71.

58 BL, Add. MSS 51,379, fo. 26: Newcastle to Fox, 8 May 1756; BL, Add. MSS 35,415, fo. 231: Newcastle to Hardwicke, 19 July 1756.

59 Dodington, p. 340.

60 BL, Add. MSS 51,387, fo. 32: Fox to Ellis, 5 July 1756.

61 Newcastle to Hardwicke, 8 May 1756, Yorke, II. 289.

62 Walpole, *Memoirs*, II. 146.

63 BL, Add. MSS 35,375, fo. 134: John Yorke to Royston, 13 May 1756.

64 Yorke, II. 290.

65 BL, Add. MSS 51,379, fo. 26: Newcastle to Fox, 8 May 1756.

66 Newcastle to Hardwicke, 8 May 1756, Yorke, II. 289–90.

67 Garraways was an important coffee-house near the Royal Exchange, listed as the business address of many prominent City merchants, stockbrokers, bank directors and directors of the chartered trading companies, Bryant Lillywhite, *London Coffee Houses: A Reference Book of Coffee Houses of the Seventeenth, Eighteenth and Nineteenth Centuries* (London, 1963), p. 221.

68 Dodington, p. 341.

69 Hardwicke to Newcastle, 7 Oct. 1756, Yorke II. 316; Clark, *Waldegrave*, pp. 176–83.

70 Fox to Devonshire, 7 Sept. 1756, Narrative for Lord Kildare, Ilchester, I. 347–8.

71 BL, Add. MSS 32,867, fo. 111: Newcastle to Hardwicke, 28 Aug. 1756.

72 *EA*, 18 Aug. 1756; BL, Add. MSS 32,866, fo. 492: Hardwicke to Newcastle, 20 Aug. 1756.

73 Newcastle to Hardwicke, 19 July 1756, Yorke, II. 306.

74 BL, Add. MSS 32,865, fo. 143: Newcastle to Murray, 30 May 1756; Campbell to Marchmont, 21 June 1756, HMC, *Fifty-fifth Report*, VIII. 319.

75 BL, Add. MSS 69,093, fo. 12: Fox to Hanbury Williams, 29 May 1756.

76 Glover, *Memoirs*, p. 82.

77 *Wisdom of Plutus*, p. 17.

78 BL, Add. MSS 69,093, fo. 12: Fox to Hanbury Williams, 29 May 1756.

79 *Historical Ballad*.

80 *The Converts*, p. 6.

81 Chesterfield to Dayrolles, 17 June 1756, Chesterfield, V. 2191.

82 *Punch's Opera*, BMC 3394.

83 *Wisdom of Plutus*, p. 6.

84 *Ibid.*, p. 6.

85 *The Old British Foxhunter's Cry*, 1756.

86 *A View of the Assassination of the Lady of John Bull Esq.*, BMC 3548.

87 Fox to Devonshire, 31 July 1756, Ilchester, II. 335.

88 Dodington, p. 341.
89 Fox to Edward Digby, 12 Mar. 1754, HMC, *Eighth Report*, Pt. I. 220a.
90 Reprinted in Yorke, II. 319.
91 BL, Add. MSS 32,867, fo. 177: Newcastle to Hardwicke, 2 Sept. 1756; Clark, *Waldegrave*, p. 184.
92 Hardwicke to Newcastle, 19 Oct. 1756, Yorke, II. 326; Conference with Mr. Pitt, 24 Oct. 1756, *Ibid.*, 277–9.
93 Nicholas Rogers, *Crowds, Culture, and Politics in Georgian Britain* (Oxford, 1998), pp. 64–85.
94 BL, Add. MSS 32,868, fo. 390: West to Newcastle, 23 Oct. 1756.
95 Sutherland, *City of London*, p. 164.
96 Newcastle to Hardwicke, 2 Sept. 1756, Yorke, II. 311.
97 BL, Add. MSS 32,867, fo. 111: Newcastle to Hardwicke, 28 Aug. 1756; Hardwicke to Joseph Yorke, 31 Oct. 1756, Yorke, II. 330.
98 Fox to Hanbury Williams, 12 Aug. 1756, quoted in Black, *Pitt*, p. 122.
99 Shelburne, I. 78, 64.
100 Fox to Hanbury Williams, 7 Aug. 1756; Fox to Devonshire, 31 July, 1756, Ilchester, I. 341, 335.
101 Fox to Lord Digby, Oct. 1756, HMC, *Eighth Report*, Pt. I. 221a; Clark, *Waldegrave*, p. 184; Walpole, *Memoirs*, II. 177.

7

The rise of Pitt

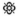

NEWCASTLE's resignation was followed by a period of intense activity upon the part of those politicians who hoped to succeed him. George II commissioned Fox to form an administration, who pursued an alliance with Pitt. Pitt rejected any partnership, fearing that Fox's and Cumberland's monopoly of royal confidence would relegate him to a subordinate position.[1] On 30 October 1756, George II offered the Treasury to the Duke of Devonshire, a widely respected Whig, amenable to the Old Corps, around whom it was hoped that Pitt and Fox might unify to form a stable government. Earlier, Pitt had submitted a proposal for his own ministry to the King, with Devonshire at the Treasury, and he leading the Commons as secretary of state. Devonshire's participation was essential to Pitt to secure the Old Corps' toleration of the new ministry, because Newcastle retained his majority in the Commons. An agreement between Pitt and Devonshire was achieved on 12 November 1756.[2] Pitt's success in forcing his way into office independently of either Newcastle or Fox may be explained by a combination of factors, of which his standing in the Commons, strengthened by Murray's removal, emerged as the most fundamental. In pressing George II to sanction an approach to Pitt before his resignation, Newcastle emphasised how the military crisis had made his cooperation vital for the smooth transaction of wartime government. Pitt's position was bolstered by the support of Leicester House and the heir to the throne. In addition, Pitt's defiance of his two rivals was assisted by the extra-parliamentary political forces, which had contributed so dramatically to undermine the Newcastle ministry.

Assessing the impact of literature and extra-parliamentary support in promoting Pitt's bid for power involves the examination of several related problems, including the traditional assumption that political opinion decisively turned to him during the Minorca controversy. Pitt was not the only politician whose immediate fortune, and future career, were determined in great measure by perceptions of his political reputation and personal character.

Before considering the resurrection of Pitt's patriot image, it is necessary to examine the genesis of his great rival Fox's unpopularity, which affected the outcome of the struggle to form a new ministry as profoundly as did Pitt's popularity. Fox's role in the turbulent events of 1756–57 provoked overwhelming condemnation, shattering his reputation for political integrity and effectively destroying his career. Literary evidence provides illuminating insight into the causes and process by which Fox became stigmatised as one of the eighteenth century's most infamous statesmen.

There appears to be no indication that Fox suffered any permanent damage to his standing with either the parliamentary classes or the wider political nation before Pelham's death. His opposition to the Marriage Act as a measure designed to entrench aristocratic power had won him a temporary popularity, emphasised by the crowds who dragged his carriage through the streets. It was the Minorca controversy and Fox's manipulation of the press to scapegoat Byng, which prompted the first sustained assaults upon him. Fox was aware that his resignation would expose him to accusations of exploiting the triumphs of the nation's enemy to satisfy his desire for supreme power.[3] Newcastle and the Old Corps Whigs believed that they had been betrayed: 'he makes use of this opportunity of distress to put the knife to our throats to get his own terms and all the power he wants'.[4] Fox's immediate involvement in negotiations to form a new ministry, in which it was rumoured that he coveted the premiership, reinforced this impression. His resignation fuelled the campaign of character assassination mounted by political enemies and their literary allies, who raked up unsavoury incidents from his past, and combined them with the opportunities provided by his behaviour during the bitter factional struggles of 1756–57, to brand him as an adventurer possessed of limitless ambition and insatiable avarice.

One satiric poem in particular, a Horatian ode in imitation of Pope, inflicted irreparable damage upon his reputation. Its fundamental accusation that Fox craved political power as a means of self-aggrandisement, and that he promoted it by the most nefarious methods, was validated by the circumstances of his birth and political education. The Fox family had risen from modest Wiltshire yeomen to prominence through political service, and Henry's pursuit of status, titles and honours was seen as an attempt to conceal shame at the lowness of his origin:

> Meanness and Pride betray thy Birth,
> The Peasant's Hovel whence you sprung,
> A noxious Vapour from the Earth;
> Tho' like a Comet o'er us hung![5]

The poet alludes to Fox's tuition under Walpole, from whom he learned to practice the art of political corruption, and the notoriety of his friends, to

demonstrate the perversion of his personal and political morality. Fox's association with Hervey and Sir Thomas Winnington, a Tory who converted to Walpolean Whiggery for the rewards of office, had also shaped impressions of his character: '. . . educated under Sir Robert Walpole and brought up in all the principles of that school, or rather in a still worse, that of Lord Hervey and Mr. Winnington, men remarkable for their profligacy, their debauchery . . . and their total contempt and disregard of all principle'.[6] The poem ironically praises Fox for following these exemplars:

> Nurtur'd in W[inningto]n's chaste School,
> Renown'd for Probity and Truth!
> That nice and rigid moral Rule,
> Adorns thy Age which form'd thy Youth.[7]

The young Fox embraced aristocratic fashion, and made a name for himself as a man of pleasure. In 1743, he was elected to White's, London's most exclusive gentlemen's club. Fox became infamous for gambling and high play, and it was alleged that he had exhausted his inheritance at the gaming table. At one time he was forced to flee the country because of debt. Rumours circulated that while at the War Office, Fox had commenced an illegal trade in army promotions and commissions to repair his shattered fortunes, with the aid of John Calcraft the regimental agent, who was rumoured to be his illegitimate son.[8] The satirist asserts that Fox's political venality was inspired by the depravity of his private life. It was feared that his elevation to the leadership of the Commons in November 1755 would enable him to implement upon a national scale the crimes he had perpetrated at the War Office:

> Hid under C[alcraf]t's borrow'd Name
> Red'ning she views her servile Bands
> (Her Glory once, but now her Shame)
> Giv'n up to your rapacious Hands.[9]

The derisive use of the word 'conduct' in the satire's title alludes to an indiscretion committed by Fox when drafting the circular letters sent by the ministry's leader of the Commons to its supporters at the opening of the parliamentary session: 'The King has declared his intention to make me Secretary of State, and I (unworthy as I fear I am of such an undertaking) must take upon me the conduct of the House of Commons.' The accepted form was 'the conduct of His Majesty's House of Commons', and Fox's opponents seized upon the replacement of the King's name with his own. George Townshend read a copy of Fox's letter aloud in the Commons, declaring that it exposed his venal aspirations to usurp royal power, a charge repeated by the satirist:

> When list'ning to Corruptions's Lore,
> Obedient to her fell Commands
> Is this your promis'd Conduct o'er
> The S[enate]'s mercenary Bands?[10]

This allusion offers another illustration of political poets' familiarity with the details of parliamentary conflict, and how they relied upon a sophisticated readership to share their understanding.

Fox's mastery of patronage and parliamentary management, displayed when cementing the majority required to secure the passage of the subsidy treaties, which allegedly he had described as tickling of the palm, provoked accusations of unbridled corruption. He was warned however, that the country would not long tolerate such abuse:

> Think'st thou she'll see herself a Prey
> To Foxes, Vultures, Wolves, and Kites,
> Her Wealth and Honours dealt away
> Amongst th' abandon'd Gang at *White's!*
>
> Will she not shake the guilty Dome,
> Which Freedom and which Virtue Leaves,
> By your insidious Arts become
> A Sink of Slaves and Den of Thieves.[11]

A Fifteenth Ode's application of nautical imagery to vilify Fox for sordid self-interest probably echoed the political testament of one of his most infamous allies, the place hunter Dodington, who expounded his mercenary philosophy in a poem entitled *Shorten Sail:*

> Love thy country, wish it well
> Not with too intense a care;
> 'Tis enough that when it fell
> Thou its ruin did not share.
>
> Void of strong desire and fear
> Life's wide ocean trust no more:
> Strive thy little bark to steer
> With the tide, but near the shore.[12]

Fox's adversaries maintained that he joined the ministry in 1754 with a design to overthrow Newcastle. Minorca offered the opportunity to realise his covert ambition. Once he had fastened blame upon Newcastle, Fox expected to consummate the duke's ruin and his own vindication by an opportune resignation. The consequent political chaos would leave George II with little option but to throw everything into his hands.[13] The idea that Fox had engineered the ruin of Newcastle was masterfully conveyed by graphic satire.[14] In *The Fox and Goose* (Plate 11), when pursued by a pack of avenging

blood hounds, symbolic of the impending parliamentary inquiry, the fleeing fox ignores the pleas of the goose he is carrying, which bears Newcastle's features, and saves himself by throwing his prey to the dogs, '*I'l drop him in a ditch*'.

When the images employed by politicians and literary satirists to express the debasement of Fox's private and public character are compared, a striking similarity is revealed. Metaphors of darkness and blackness emphasised the reputation for ambition, avarice, corruption and intrigue that Fox derived from the part he played in the ministerial upheavals of 1756–57, and from the behind-the-scenes manoeuvres at court that he utilised to attain his ends. One of the earliest examples of the demonisation of Fox came from Hardwicke during the Marriage Act debates, who maligned him as 'a dark, gloomy and insidious genius'.[15] When fulminating against Fox for his ungratefulness and ambition, George II exclaimed, 'He is black; I know him, tho' I don't show it.'[16] For his cold-blooded persecution of Byng, Hervey reviled Fox as 'that infernal black demon'.[17] Pitt described Fox as, 'the blackest man that ever lived'.[18] Satiric poets also depicted Fox as a sinister arch-plotter:

> Beneath that sullen gloomy Brow
> Your black malignant Heart appears;
> With Insolence elated now,
> Now sunk in base and abject Fears.[19]

> Of *meanest* Birth, by vilest tricks
> *Stole up* to highest Station,
> Of dark design, black Politicks,
> See Fox conduct the Nation;[20]

Satiric prints contributed a striking visual dimension to the eclipse of Fox's reputation. A compelling symbolic treatment of Fox's dangerous ambition was achieved by the engraver who refashioned part of Samuel Ward's famous print '*The Destruction of the Spanish Armada*'. Fox is portrayed as Guy Fawkes, the architect of the Gunpowder Plot. In the shadows of night, the reincarnation of the demonic conspirator, concealed beneath a long black cloak and large hat, approaches Parliament, intent upon similar mischief, only to be revealed by rays of light beaming from the vengeful Eye of Providence.[21]

The extent to which literary villifications of Fox permeated political consciousness may be measured by *A Fifteenth Ode*, which was one of the most popular and effective poems published during the war. The satire ran through at least four editions during the final months of 1756. It represented only one of approximately twenty anti-Fox poems, ballads and dramas independently printed during this period. Political prints made a major contribution to the blackening of the former secretary of state's good name. Over seventy engravings condemned Fox during 1756–57, and during the latter year, he appeared

in twice as many hostile prints as any other politician. The contamination of Fox's personal and political reputation in late 1756 was confirmed by observers such as Chesterfield.[22] Fox was acutely aware of his own unpopularity, and attempted to counter its spread by turning to the press. In early November, he sponsored a weekly essay paper, the *Test*, to vindicate his conduct while a member of the Newcastle ministry and to undermine Pitt's administration. It was written by the playwright Arthur Murphy.[23] Fox also cooperated with Horace Walpole to publish a defence of his character.[24]

The backlash of political opinion against Fox, in part fomented by the press, affected the outcome of the high political manoeuvres to form a new government in the autumn of 1756. Fox's recognition of his unpopularity was an important motive in deterring him from taking the Treasury after Pitt had refused his overtures. The same fear of braving violent hostility in the Commons, without doors, and in the press, which had inspired Fox's resignation, deterred him from taking the great risk of assuming personal control of affairs. Fox confessed that he would rather accept a secure, lucrative minor office than: '. . . being Prime Minister (which I may be) with Leicester House, Pitt, etc., opposing, the clamour of all England directed at me in my first year as much as at Sr Robt Walpole in his last'.[25]

Fox was also discouraged from taking the premiership by Newcastle's majority in the Commons, but the animosity of voters discouraged him from calling an election.[26] Consciousness of the widespread hostility towards Fox among the parliamentary classes and the people influenced Devonshire during the negotiations to form his own ministry. Since Pelham's death, it had become obvious that any stable government must include either Pitt or Fox as leader of the Commons. Despite his friendship with Fox, when Pitt's intransigence forced Devonshire to choose, he preferred Pitt: 'not because he liked him better, but because he had the Nation on his side, and consequently had the means of doing most Service, to his King & Country.'[27]

It is now necessary to discuss the impact of literature, patriotism and popular opinion in assisting Pitt's bid to succeed Newcastle and Fox.[28] A survey of ballads, poetry, prose and prints published immediately before Newcastle's resignation offers only qualified support for the traditional assumption that political opinion embraced Pitt during the autumn of 1756.[29] Literature inspired by Minorca's fall was defined by enmity towards Byng, Newcastle and Fox. Few works specifically praised Pitt or identified him as the disgraced administration's natural successor before the ministerial crisis of October 1756. Support for Pitt was limited to a few works and prints, which contrasted the leading figures of the opposition with the ministry.[30] It may be more accurate to state that Pitt turned to political opinion rather than that political opinion turned to Pitt, or that Pitt expropriated the extra-parliamentary clamour

against Newcastle and Fox to justify his refusal to cooperate with either of his rivals. Although it appears plausible that Pitt's patriotic campaign during the 1755–56 parliamentary session should have distinguished him as the logical figure to profit from the anti-ministerial hostility, there is no clear indication that popular opinion coalesced around him before Fox triggered the ministerial crisis. The sources of popular indignation – Minorca, Maidstone, aversion to continental entanglements and demands for patriotic reform – occurred after Parliament had been prorogued, denying Pitt the opportunity to follow up his criticisms. The protest movement without doors had developed without his direct involvement, and Pitt's adoption of its major demands in the autumn of 1756 represented an attempt to capture its leadership, and exploit it for his own political purposes.

Pitt's repudiation of Newcastle's overtures to replace Fox confirms one of Shelburne's most perceptive assessments of his political acumen, 'He had an extraordinary quick eye, which enabled him to judge mankind en masse, what would do and not do.'[31] Furthermore, he recorded Pitt's admission of how consciously he manipulated political opinion to advance his aims, 'Lord Chatham told me that he could never be sure of the Publick passions, that all that he could do was to watch, and be the first to follow them.'[32] Pitt's meetings with Hardwicke demonstrate how effectively he took advantage of the popular uproar to vindicate his determination to drive Newcastle from power: 'he was surprized that it should be thought possible for him to come into an employment to serve with the Duke of Newcastle, under whose administration the things he had so much blamed had happened, and against which the sense of the nation so strongly appeared'.[33]

The measures which Pitt claimed he was compelled to promote, and which made it imperative for him to exclude Newcastle, corresponded with the major demands of the extra-parliamentary opposition campaign: a strict inquiry into the defeats of the war, a Militia Bill, and the punishment of Holdernesse for exempting Schroeder from the jurisdiction of the civilian authorities. The great importance Pitt attached to the Maidstone controversy, which was perhaps the most alarming to George II and his advisers, because the anti-Hanoverianism it instigated would increase the difficulty of pushing aid for the electorate through the Commons, reinforces the idea that Pitt embraced the patriot agenda as a means of establishing himself as leader of the popular opposition, and strengthening his negotiating position. At this time Pitt renewed his contacts with the City patriot and poet Richard Glover, who wrote that the Maidstone affair: 'raised a clamour which had echoed throughout the Kingdom, promoted by no one more than Mr. Pitt, who talked in a very high strain to Lord Hardwicke on the subject'.[34] Additional evidence of Pitt's tactical application of popular hostility to provide the moral authority to demand Newcastle's withdrawal from power is offered by

Lyttelton, who recorded his assertions that 'to *reassure and reanimate the people of England*, another head of the Administration was absolutely necessary'.[35]

It was during the negotiations to form a new administration that the attention of the press and the political nation increasingly focused upon Pitt. The petitions and the patriot press had called for new men and measures to reverse the disastrous course of the war. Pitt's advocacy of the major demands of the extra-parliamentary opposition enabled him to portray himself as its champion. The revival of Pitt's patriot image was also reinforced by the way in which perceptions of his character and political reputation could be manipulated to justify his claim to be the only leader capable of rescuing national fortunes. Literary works written to promote Pitt's rise to power illustrate these two foundations of his developing political popularity.

The theme of his character will be discussed first. Pitt's past offered opportunities for panegyrists to present him as an exemplar of patriot virtue. Independence and disdain for the acquisition of wealth and honours formed the cornerstone of Pitt's patriot reputation. Born outside the innermost circles of the social and political elite, Pitt did not inherit the wealth, parliamentary interest and influence at court enjoyed by the great Whig aristocrats. His political significance depended upon his status as a speaker in the Commons, and his relative isolation owed much to his personality and to conscious choice. Temperamentally he was too proud and too strong willed to accept the compromises required by cooperation. Politically, Pitt's refusal to curry royal favour, to court the protection of powerful patrons, or to accept the leadership of the Old Corps Whigs proved to be sound strategy, for it preserved his freedom of action. His outspoken independence in the Commons allowed him to appear as the quintessential patriot, who transcended party and self-interest to follow the dictates of conscience. Pitt's individuality appealed to those in the parliamentary classes and the wider political nation, who felt excluded by the Old Corps oligarchy, and disapproved of the politics of patronage.[36]

Pitt's willingness to risk the loss of his place as Paymaster General by opposing the government seemed to confirm his independence. His behaviour while in office since 1746 was held up as proof of his altruism. The paymaster was responsible for the payment of the troops and the contractors hired for the logistical support of the army. It was the most coveted of all government offices, especially during wartime, because of its opportunities for personal enrichment. The money voted by Parliament was deposited directly into the paymaster's account. Surpluses from each year remained in the paymaster's hands, and would not be returned until his accounts had been audited, a process not usually completed until years after he had

left office. It was accepted practice for the paymaster privately to invest the grants and surpluses, pocketing the profits himself.[37] Pitt refused to exploit any funds for his own benefit in sharp contrast to his predecessor Winnington, and when his accounts were audited in 1767, a surplus of £90,000 was found, which he had declined to invest in his own name. Pitt also renounced another perquisite, a commission upon subsidies paid to foreign allies, which was an extremely lucrative benefit when Britain was at war. The King of Sardinia, hearing of Pitt's refusal to accept a commission upon his subsidy of £200,000, sent him a gift as a reward for his generosity, only to have it returned.[38] Other examples of Pitt's extraordinary magnanimity appeared in the press, such as his refusal to deduct the customary 2.5 per cent commission from the pensions of Chelsea Hospital veterans.[39] Newspapers published a promise that the new secretary of state would even forgo his salary if the other members of the administration would emulate him, thereby saving the nation's taxpayers £100,000.[40] Accounts of Pitt's apparent disregard for ministerial powers of patronage in his negotiations with Devonshire appeared to confirm his determination to renounce the corrupt politics of the past.

Pitt's political career was driven by a high sense of national duty, as emphasised by his letters to his nephew Thomas, urging him to answer a similar call to: '. . . manly, honourable and virtuous action upon the stage of the world, both in private and public life, as a gentleman, . . . who is to answer for all he does to the laws of his country, to his own breast and conscience, and at the tribunal of honour and good fame'.[41]

Of a grave, earnest, and remote nature, Pitt shunned St James's and aristocratic society, whose manners, amusements and morals he disdained in sharp contrast to Fox. His intentional detachment from this world was highlighted by his refusal during this period to put himself forward for election to White's. Pitt did not conceal his distaste for and abstinence from the fashionable vices, once sanctimoniously proclaiming to the Commons that 'He never went to the place where so many bets were made.'[42] Pitt was perhaps most happy when visiting the country houses of friends and relations, or at his own estate, Hayes Place in Kent. At Hayes, Pitt expanded the estate, improved the house, and pursued his passion for landscape gardening. Hayes offered a refuge where he could withdraw from the pressures of politics, and from the social milieu of the court and fashionable circles, where he felt undervalued and out of place.

The significance of Pitt's fame for stoical austerity, sobriety, honesty and a high-minded dedication to public service was underlined by its prominence in political debate. Attacks upon the sincerity of Pitt's patriot pretensions by the *Test* inspired the publication of an essay paper to defend him entitled the *Con-test*.[43] In their bitter debate over whether Pitt or Fox were most fit

to lead their country, the subject of the two rivals' characters emerged as a dominant theme. Realising the immense reinforcement to Pitt's credibility that a comparison would produce, the issue was strenuously pursued by the *Con-test*. It declared that 'His character ought to undergo a strict examination, who stands candidate for one of the highest posts in government' and identified stainless honour and integrity as the criteria for judgement, 'MORALS, are essentially requisite for a minister'.[44] The essay paper asserted that '*political* and *moral* virtue are the same', and in Pitt discovered the rare union of the two.[45] A sustained comparison between Pitt and Fox identified the latter to be a 'pernicious monster' gorged on 'the poisonous delicacies of high fed luxury' and the supreme warning of how 'an indolent, luxurious, and immoral man, will make a careless, rapacious, and corrupt minister'. The inquiry into who was most suited to govern judged the patriotic Pitt to be the better man and politician.[46]

Ballads and poetry functioned as crucial mechanisms in the construction of Pitt's patriot identity, because of their wide transmission among the parliamentary classes and the common people. Panegyrics marking the advent of his ministry celebrated his fame for virtue, altruism and political independence. A poet seeking to animate Britons to revive the values of their ancestors selected Pitt as his muse:

> Whose breast (O never let the flame expire!)
> Glows ardent with the Patriot's sacred fire;
> Who far from Courts maintains superior state,
> And thinks that to be free is to be great.
> Careless of Pride's imperial smile or frown,
> A Friend to all mankind, but Slave to none.
> Above temptation, and unaw'd by pow'r,
> Pleas'd with his present lot, nor wishes more,
> Save that kind Heaven would give his warm desire,
> What Kings can't grant, nor Courtiers oft require,
> From each low view of selfish faction free,
> To think, to speak, to live, O PITT, like thee.[47]

Prints extolling Pitt's ethical approach to politics, often in direct contrast to his rivals, also promulgated a favourable impression. In one engraving, Pitt is represented by the image of a fiery volcano named honour, which erupts with columns of smoke labelled zeal. Bolts of lightening burst from the clouds striking down Pitt's adversaries, who vainly struggle to reach his heights of patriotism. The bolts symbolise essential virtues that Pitt possesses and they lack, thus Fox is struck down by public spirit, Hardwicke by generosity, and Newcastle by wisdom.[48]

The origins of Pitt's fame as a war leader may be traced to literature inspired by his first ministry. He was cast in a heroic mould as one ordained

by Providence to rescue a country upon the brink of humiliating defeat. One of the earliest poetic examples envisaged Pitt as Britain's saviour, summoned from a virtuous life of retirement at Hayes:

> As late Corruption overflow'd the Land,
> And *Britain's* Fate, impending, was at Hand;
> When those, who should defend, her Cause betray'd,
> Nor *Head*, or *Heart*, employ'd to yield her Aid.
> When one Defeat was follow'd by a worse,
> And Debts, immense, still added to our Curse;
>
> You, mighty Sir, with gen'rous Ardor fir'd,
> By all that's good, – by all that's great inspir'd;
> By just Compassion drawn, dar'd interpose,
> And to your *bleeding Country's* Succour rose.[49]

This is the role that Pitt aspired to play in the dramatic events of 1756. His heroic self-conception was suggested by the playwright Samuel Foote, who recorded Pitt's delight in reading epic works of English history and literature aloud to family and friends:

> Shakespeare was one of his favourite authors; whom he occasionally read to his family and private companies, with great power of voice and manner. He generally selected the heroic characters; such as *Hotspur, Henry V, Coriolanus,* &c; assigning the comic parts to some of his relations.[50]

It was the image of a guardian of British liberty and national power that Pitt sought to project, most notably through his speeches in the Commons, and admiration of his oratory emerged as a dominant feature of literature published to applaud his attainment of office. Pitt's outspoken opposition to Newcastle and Fox in the Commons during 1755–56 laid the foundation for the revival of his patriot reputation. As Chapter 2 has demonstrated, when first made, Pitt's assaults upon Newcastle for mismanaging foreign affairs evoked only modest support either within the Commons or out of doors. In his final speeches of the session, however, the threat to Minorca had given him the opening to launch a forceful criticism of the ministry: '*that we had provoked before we could defend, and neglected after provocation; that we were inferior to France in every quarter* . . . He prayed to God that His Majesty might not have Minorca, like Calais, written upon his heart.'[51] Eulogies of Pitt suggest that after Minorca he was endowed with the status of an unheeded prophet, his earlier parliamentary opposition apparently vindicating his claim to be the only statesman possessing the vision and energy to rally a demoralised people and reverse the tide of defeat.

Pitt's great speeches against political venality also came to be seen as prescient by the powerful strain of opinion, exemplified by John Brown, that

ascribed Britain's defeats to the moral degradation of the nation and its aristocratic leaders. This sentiment was reflected in the attacks upon Byng, Newcastle, Fox, Hardwicke and Anson for avarice, luxury, effeminacy and placing self above country. The significance of this demand for a reformation in the private and public morals of Britain's governing classes was emphasised by the many patriotic publications that developed the theme. Many displayed a religious character, and argued that Britain's military and naval humiliations were a divine punishment for the abandonment of the nation's traditional moral purity, civic virtue, and Protestant piety.[52] Pitt's reputation for honour, integrity and public spirit distinguished him as the politician most likely to profit from this growing condemnation of the morality and methods of government practised by the Old Corps Whig oligarchy.

Literary sources demonstrate that Pitt's lofty philippics urging patriotic self-sacrifice in the vigorous prosecution of the war contributed to the establishment of his reputation as a great orator. They were also important in fostering his political popularity. While Pitt's impassioned patriot rhetoric may have had a limited effect upon Newcastle's majority in the Commons during 1755–56, its style and substance were more suited to appeal to an extra-parliamentary audience. Commentators upon Pitt's public speaking stressed its emotive power, which was most compelling when exerted in defence of Britain's threatened national liberty, honour and interest. Horace Walpole observed that 'the grace and force of words was so natural to him' and wrote of the 'commanding impetuosity' of his rhetoric.[53] Poets and print designers frequently employed images of torrential storms or lightening to convey the inspiring energy of Pitt's eloquence:

> When P[it]t inspir'd does all inspire,
> Shrinking beneath his awful Brow,
> Dreadst thou not that celestial Fire?
> The flaming Bolt that's hurl'd at you.
>
> Resistless as the Torrents roll,
> Down the stupendous Mountain's Height
> He seizes on the raptur'd Soul,
> And bears it with him in his Flight.[54]

The publication of ballads and poems supporting Pitt suggests that his passionate appeals for the reassertion of England's power and glory enjoyed a wide resonance among the political nation. The frequent comparison of Pitt to Cicero and Demosthenes emphasised the degree to which he was perceived as a modern incarnation of the patriotic heroes of classical epic and history, one destined to unify a divided nation and lead it to victory:

> O THOU, ordain'd at length by pitying Fate
> To save from ruin a declining State;
> Adorn'd with all the scientific stores
> Which bloom'd on ROMAN or ATHENIAN shores;
> At whose command our Passions rise or fall,
> Obedient to the magic of thy call;[55]

Literature celebrating the new ministry's inauguration reflected the expectations of political change it had helped to arouse. Pitt's most enthusiastic literary champions heralded the dawn of a patriot millennium. It was widely believed that he had committed himself to the punishment of Holdernesse for his role in the Maidstone affair, the dismissal of the German mercenaries, militia reform and the rejection of continental subsidies and alliances. On the home front, it was hoped that Pitt would implement a sweeping programme of patriot political reform.[56] Many looked to Pitt to usher in a new age of civic virtue by his personal example. A popular patriotic ballad captured the mood of optimism and the anticipation of change:

> The Fox outwitted by the Goose,
> The Patriots now shall bear the Sway,
> And *Britain's* Good alone pursue
> The clean contrary Way.
>
> Now Sense and Virtue near the Throne
> [Shall] not fade and wither in a Day,
> And Patriot *Tully* speak and act
> The clean contrary Way.[57]

Graphic art also emphasised the revolutionary nature of the ministerial upheaval, which saw the Old Corps finally driven from office.[58]

The authorship and political bias of some pro-Pitt publications offer insight into the nature of the new administration's support. Evidence of dissident Whig sympathy may be found in the ballad *The Freeholder's Ditty*, which denounced Newcastle for betraying the traditional principles of the Whigs:

> What Parts, what Principle has he,
> But *Name* of *whig* to boast Sir?
> O *Name*, defil'd by foulest Dirt!
> By basest Prostitution!
> By ev'ry Sin that could subvert
> The *British* Constitution!

Pitt's devotion to a maritime-colonial war appealed to the commercial interests within the City and other ports and towns involved in transatlantic trade. The City's growing commitment to Pitt was highlighted by declarations

of support from William Beckford and the merchant and poet Richard Glover. Glover was an important link with popular patriot forces and a valuable literary ally. In describing the renewal of his contacts with Pitt and his allies, Glover claimed that they had embraced the patriot sentiments he had committed to verse in *A Sequel to Hosier's Ghost*: 'They saluted me with repeating some stanzas of my own, lately published without a name, which they in compliment ascribed to no one but me, and whose sentiments they professed to adopt.'[59]

Establishing an alliance with the Tories was important for Pitt, given the numerical inferiority of his parliamentary party, which consisted of his own followers and the adherents of Leicester House. Beckford's support was significant for his growing influence upon Tory and commercial opinion in the City of London, and his connections to the Tory country gentlemen.[60] Beckford was closely associated with the Tory essay paper the *Monitor*, which would become an enthusiastic champion of the new ministry.[61] George Townshend became a vital mediator with the Tory country gentlemen. Many factors explain the reconciliation of the Tories to Pitt, not least of which was their elation at seeing the Old Corps finally fall from power, and their antipathy to Fox. Tory hopes of being welcomed at court in the next reign may have contributed to their decision to back the new administration.[62] Tory support for Pitt is suggested by *The Taxes*, whose characters represent the diverse social profile of those who were united in their allegiance to the new ministry: the country gentleman Sir Jonathan Jolley, and the London merchants Jack Hearty and Tom Tradewell.

The Tories were receptive to Pitt's advocacy of a patriot 'blue-water' strategy and his opposition to European commitments. Tory support for Pitt was encouraged by John Shebbeare, who appealed to the Tories' deep distrust of the Hanoverian partiality of the Old Corps. He eulogised Pitt as the one leader who could be trusted to place British national interests at the centre of policy: 'On this Man then turn all your Eyes, from Him expect Redress, by Him urge your Remonstrances, believe Him sent for your Preservation; lest, like the *Messiah* to the *Jews*, he preach Salvation to an ungrateful People, and ye are lost for ever.'[63]

The parliamentary inquiry was another major issue that absorbed Tory attention. The strength of feeling it aroused was illustrated by a complex political allegory, *The History of Reynard the Fox*, which from a Tory perspective, surveyed Whig government from its establishment earlier in the century to the Minorca crisis. Although one is at first tempted to associate the animal kingdom of Numidia's evil prime minister Reynard with Henry Fox, he is best described as a composite figure of Walpole, Pelham, Newcastle and Fox, a symbol of all the evils perpetrated by generations of Whig tyranny. Reynard's long career of oppression and corruption is brought to an end by his betrayal

of an important island fortress. The Tories are identified with the kingdom's most loyal subjects, the blue-coated rams, who rise up to cast off Reynard's yoke. Reynard is forced to stand trial for his crimes, and the Tory bias of the fable is revealed in the articles of impeachment. His conviction of high treason reflects Tory hopes of the outcome of an inquiry directed by Pitt. The disgraced prime minister is sentenced to death, and makes a full confession of his abuses of power before his right paw is cut off, and he is hanged and beheaded.[64]

Reynard the Fox's party bias is identified even more precisely by its allusion to City politics and the Maidstone controversy. It endorsed Tory attempts to contest the election of the Pelhamite senior alderman, Marshe Dickinson, as Lord Mayor in September 1756, because he had voted for the address requesting George II to employ the German mercenaries.[65] The allegory's condemnation of Holdernesse for granting immunity to Schroeder, 'tho' he were guilty of *rapes, robberies, or even murder*', highlights the Tories' insistence that the secretary of state be held accountable for his unlawful act.[66] The determination of the Tories to press the inquiry was also emphasised by graphic satire. *The Fox and Goose* applied the appropriate metaphor of the foxhunt to demand the punishment of Newcastle and Fox for their criminal neglect. It displayed a huntsman and a pack of hounds of the patriotic '*Staunch Breed*' in full pursuit of a fleeing fox and goose. The expectation that Pitt would take a leading role in the inquiry is indicated by his identification with the leading hound, which is named '*West Countrey sweet lips*' and exclaims '*Pro Patriae non sibi*' (see Plate 11).

Once in office, Pitt revealed a realistic appreciation of the weakness of his political position. His freedom of action was restricted by the lack of royal confidence and a parliamentary majority, and the need to avoid moves that might unite Newcastle and Fox against him. Pitt's ability to alter the strategic direction of the war was limited by the Prussian alliance and the prospect of a French invasion of Hanover. Compromise upon the issues of the inquiry and the continent would be essential if Pitt were to have any hope of securing the acquiescence of the Old Corps and overcoming the hostility of the King. The challenge confronting Pitt was how to reconcile patriot opinion to the concessions without compromising his reputation. He responded with considerable political skill to bridge the gap between what was expected and what was possible. He drafted the King's Speech, which was delivered to Parliament in early December 1756, to appeal to a popular audience, emphasising policies that would win the approbation of his supporters.[67] Relief was promised to alleviate the sufferings of the poor caused by a shortage of corn. Victory in the imperial struggle in America was identified as the administration's principal war aim.[68]

During the debate on the Address in Reply, Pitt discreetly dealt with the delicate subject of the ministry's continental policy and its potential expense. He cautiously prepared the ground for assistance to Frederick II and Hanover, but insisted that this would only be considered after adequate resources had been committed to the maritime-colonial struggle and home defence. Patriotic initiatives, such as the return of the German mercenaries and the promise of a militia bill, were highlighted in an effort to disguise Pitt's modification of his earlier opposition to the treaty with Prussia. Pitt dwelt upon the unpropitious strategic situation to reduce pressure on the ministry to achieve a sudden reversal of fortune. He also adopted a temperate tone when speaking of the inquiry, from which, now that he was in office, he had little to gain and much to lose.

The wide dissemination around London of a spurious speech from the throne, printed on 2 December 1756, the day that the authentic one was delivered to Parliament, reminded Pitt of the strong popular desire for an inquiry. The text Pitt had written made no explicit reference to the inquiry, but the fictitious one made George II declare: 'I am determined not to screen any that on a due examination shall be found Guilty the loss of Oswego and Minorca ... and the punishment of whoever occasion'd them will be the greatest satisfaction to me.'[69]

On 3 December, the forgery was denounced in the House of Lords as an infamous libel, an insult to the dignity of the Crown, and a violation of parliamentary privilege. The Lords were alarmed by the work's influence in: '... tending to poison the minds of the people, and to create and foment jealousies and animosities amongst his majesty's good subjects in this time of common danger'.[70]

The Long Acre bookseller George King was taken into custody and tried before the Lords for writing and publishing the broadsheet, but its printer James Howe absconded. King was convicted on 15 December and sentenced to serve six months in Newgate and pay a fine of 50 guineas. The spurious speech was publicly burnt by the common hangman at Westminster and the Royal Exchange. Evidence collected by the Westminster magistrate Sir John Fielding, who examined Howe's maid and pressman, and the hawker who purchased the broadsheets and organised their distribution, offers fascinating insight into the production of this kind of seditious literature.[71] George II, who had complained of the excessive length and florid nature of Pitt's writing as secretary of state, also read the forgery, and commented: '... he hoped the Man's Punishment would not be very severe, for that he had read both, and, as far as he understood either of them he liked the Spurious Speech better than his own'.[72]

The dilemma that the inquiry caused Pitt was revealed in a confidential conversation with Hardwicke. When warned that the probable consequences

of an aggressive inquiry would be a reunification of the Old Corps and Fox, and dismissal by the King, Pitt denied any intention of pursuing a self-destructive vendetta against the former ministers. He admitted, however, that he was compelled by his previous rhetoric and his supporters' expectations to allow some form of inquiry to proceed. The Maidstone affair placed Pitt in a similar predicament. When Hardwicke cautioned, 'That nothing could tend more to entangle and embarrass him at Court', Pitt acknowledged how unwilling he was to see the question taken up in the Commons.[73] In early December, Pitt was incapacitated by gout, and repeated bouts over the next few months would prevent regular attendance at Parliament and slow the progress of the ministry's measures. Given Pitt's reluctance to launch an inquiry, illness offered a convenient pretext for delay. It was decided to postpone any move until after the outcome of Byng's court martial, which was convened on 28 December 1756. Byng's acquittal of blame for Minorca's fall would reinforce charges that the old ministry was culpable. The initiative was assumed by the Townshends, Glover, and others outside the ministry.[74] On 8 February 1757, George Townshend moved for the submission of documents relating to Minorca, indicating that it had been decided to limit the inquiry's scope to the loss of the island. Despite apparently being in good health, Pitt did not appear in the House to take part. The repeated deferral of the inquiry and its restriction to Minorca suggest that Pitt's allies had come to appreciate the danger of its driving his enemies together.[75] The Maidstone affair, the subject of so much controversy, was quietly dropped.

The new ministry was able to make progress in fulfilling two of its patriotic pledges. The Hanoverian troops were repatriated before the end of the year, although it was considered necessary to retain the Hessians for several months longer. On 26 January 1757 George Townshend introduced a new militia bill. Due to Newcastle and Hardwicke's hostility, the bill occasioned considerable debate, and was not approved by the Commons until 25 March.[76] Support for the militia inspired a poem by a female author, who suggested its continued popularity. She dramatised a parade by the City militia to commend the commercial classes for their contribution to national wealth and for their courage in taking up arms:

> Go on brave Souls, may you successful prove,
> At Home, Abroad, in Traffick, War, and Love:
> And you, bright Nymphs, do Justice to your Charms,
> Each take a TRADING HERO to her Arms.[77]

Pitt became widely associated with the militia by opinion out of doors. *The Departure of the Hanoverians* praised Pitt for honouring his promises to send home the mercenaries and promote the militia. The Hanoverian Schroeder's English sweetheart blamed Pitt for separating the two lovers:

> FROM Beef and Pudding you at length depart,
> And bear away an *English* Maiden's Heart:
> Ah! cruel *Pitt!* to send my Love away!
> Ah cruel Love! his Orders to obey![78]

National finance was another area where the ministry attempted to implement patriotic policies. Newcastle had resigned before completing plans for raising the next year's supplies, which would have to include significant borrowing. He had followed Pelham's practice of relying primarily upon a small circle of wealthy financiers and institutions to raise loans through private negotiation. This method and the financiers who lent the money were the objects of suspicion and animosity among popular elements in the City and among Tory country gentlemen. The system was perceived as being complicated, secretive, and open to abuse by Old Corps' politicians and their notorious allies, who enriched themselves at the country's expense. Aversion to the intricacies of deficit finance and related speculation on the stock market was recorded in a contemporary ballad, which compared it to a form of Satanic black magic:

> 'Tis a Nuisance illegal, a d[am]nable Cheat,
> To make rich men poor, and designing Knaves great:
> Its Mystery so dark, and unfathom'd as Hell,
> Which none but the Devil and Jobbers can tell.[79]

In *The Taxes*, Tory anxiety of an unholy alliance between the moneyed interest and the Old Corps was illustrated in the conspiracy of bankers, company directors and stock jobbers, who plot to prevent Lord Worthy's advice of fiscal reform being accepted by Britannia. One of the great financiers confesses how the people have determined to throw off such parasites:

> We're compared,
> To flies, that bask, and fatten on corruption –
> Nay, what is worse, (the foul mouth'd scandal, rising
> still to a higher pitch) we're called, the feeders
> of bloated bribery, sellers of state poison.[80]

The drama also reflects Tory calls for the economical administration of public finance, and fear of a growing national debt. Britannia's patriotic subjects cheerfully contribute their taxes and subscribe to loans when promised that the money will not be diverted from its use in vindicating the country's imperial and commercial rights.[81] On 21 January and 11 March 1757, Legge, the Chancellor of the Exchequer, introduced budgetary measures to raise the supplies without relying upon the closed subscription system of the past. They were intended to appeal to many of the smaller, independent commercial

interests in the City, who resented the predominance of the great financiers. Legge's scheme included a £1,050,000 lottery, and an attempt to raise £2.5 million by the issue of annuities. The measures would avoid a permanent increase to the national debt, and the books would be laid open giving any individual the opportunity to participate. It was hoped that the small denomination of the lottery tickets would encourage the middling sort to take part. The closing date for the subscriptions was to be 14 April.[82]

On 17 February 1757, Pitt submitted a request to the Commons for a grant to mobilise an army in Germany to defend Hanover and protect Frederick II's western frontier against France. An army of 60,000 men would be formed, composed of 24,000 Hessians and Prussians, and 36,000 Hanoverians. Pitt asked Parliament for £200,000 to cover the cost of the Hessians and Prussians, but stressed the relative economy of the measure by observing that, in contrast to the last war, George II and not Britain would pay for the Hanoverians. He warned that £300,000 more would probably be needed to muster an additional 12,000 Hessians.[83] For Pitt, this commitment to the war on the continent represented a startling volte-face. He justified himself by qualifying his previous opposition, arguing that he adhered to the spirit if not to the letter of previous declarations: 'That he did not insist upon being litterally & nominally consistent as long as He thought He was substantially so; that He never was against granting moderate Sums of money to the Support of a continent War as long as we did not squander it away by Millions'.[84]

To make the grant more acceptable to his audience within the Commons and without doors, Pitt astutely portrayed it as support for Frederick II, tapping into the Prussian king's widespread popularity. During its early years, personal veneration of Frederick II sustained the Prussian alliance. Frederick II's reputation as a Protestant hero and victorious ally was enhanced by a wide variety of literary genres, which were disseminated throughout all ranks of society. For those who viewed the war as much more than a territorial or commercial conflict – as a momentous struggle between Protestantism and Catholicism in Europe and North America – Frederick II was ordained by God to protect the reformed faith. Literary examples illustrate the strength of feeling aroused by the war's religious dimension in their vehement denunciation of Catholicism:

> The sons of rapine, cruelty, and blood,
> Tyrannic pride and arbitrary sway,
> Enthusiasm, and bigotted Rome,
> Known by her halter, tortures, racks, and fire,
> Her inquisition's black infernal court,[85]

Appeals for assistance to Prussia and Hanover based upon religious fraternity were visualised in prints.[86]

The military value of the Prussian alliance seemed vindicated by the success of Frederick II's campaign in Saxony, which demonstrated his brilliance as a strategist and commander. Ballads and elaborate panegyrics glorified his exploits on the battlefield, and sympathised with his stoic endurance of dramatic reversals of fortune.[87] Frederick II's fame as a beneficent, enlightened ruler encouraged claims that he was a defender of European liberty against the tyranny of France, Austria and Russia. The Prussian king's interests in poetry, philosophy, history and music were warmly acknowledged, and he was extolled as a master of the arts of culture as well as the arts of war:

> In vain we trace the stretch of time,
> To find a genius so sublime;
>> A monarch so complete;
> No age, or nation can produce
> A mind so noble so diffuse,
> A prodigy so great.[88]

Frederick II's attack upon Saxony had alienated Voltaire, one of his most famous friends among the world of letters. In a verse letter to Frederick II, Voltaire condemned him for abandoning his alliance with France and plunging Europe into war in order to gratify his pride and ambition.[89] Frederick II replied in a poetic epistle of his own, which was translated, and circulated widely. He asserted that his reluctant recourse to hostilities was motivated by self-defence:

> And, tho' a Prince and Poet born,
> Vain blandishments of Glory scorn.[90]

Voltaire's attack upon England's ally was resented by cultural patriots, and can only have increased Frederick II's popularity.

In his speech on the Address, Pitt had admitted that 'you must go as far as the interests of this country were combined with those of the Powers on the continent, for combined they were'.[91] Advocates of the Prussian alliance also argued the need to maintain a favourable European balance of power. If French expansion were not checked in Europe, she would turn upon an isolated Britain with an overwhelmingly superior force. Thus it was imperative to combat the growth of French power in every sphere of the globe, not only in the New World.[92] A print literally illustrated how Frederick II's victories had tipped the European balance of power in Britain's favour (Plate 12). In January 1759, a grand musical entertainment or serenata, *Il Tempio della Gloria*, patronised by the court, was staged at the King's Theatre, Haymarket, to celebrate 'the glorious alliance between Great Britain and Prussia; and the happy effects which are naturally expected to accrue ... to the liberties of Europe'.[93]

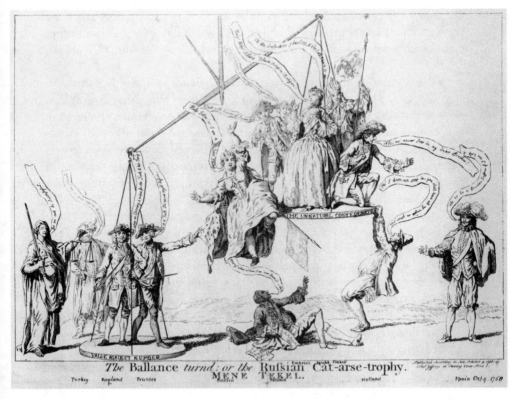

The Ballance *turnd;* or the Russian Cat-arse-trophy.

MENE TEKEL.

Turkey England Prussia Russia Poland Holland Spain Oct.4. 1758

12 *The ballance*

Between 1757–60, at least twenty-five literary works were published supporting Frederick II and the Prussian alliance. Many more occasional pieces were printed in the periodical press. Biographies of Frederick II and translations of his works were published. Sermons interpreted his victories as signs of divine favour for the Protestant cause.[94] The political nation's adulation of its Prussian ally was also stimulated by the production of sixteen prints. The demand for likeness of Frederick II was satisfied by the sale of portraits, and by periodicals such as the *Gentleman's Magazine*, which published an image of the Prussian king on its frontispiece for the year 1756. The enthusiastic celebration of Frederick II's birthday on 24 February 1758 highlighted the sweeping popularity that literature had done so much to excite: 'All England has kept his birthday; it has taken its place in our calender next to Admiral Vernon's and my Lord Blakeney's ... We had bonfires and processions, illuminations and French horns playing out of windows all night.'[95]

Walpole also observed how even the poorest members of the political nation paid homage to Frederick II, a fact which probably reflected the influence of

the ballad: 'It is incredible how popular he is here ... the lowest of the people are perfectly acquainted with him: as I was walking by the river t'other night, a bargeman asked me for something to drink to the King of Prussia's health.'[96]

In the Commons on 18 February 1757, Fox took advantage of Pitt's request of assistance for Hanover and Prussia to accuse him of hypocrisy. To emphasise that Pitt was now advocating measures he had so vehemently opposed, Fox turned his own words against him. He alluded to a colourful simile employed by Pitt when he had condemned his predecessor as secretary of state: 'He had been told indeed that the German measures of last year would be a millstone about the neck of the minister. He hoped this German measure would be an ornament about the minister's neck!'[97]

Glover reported some misgivings about the measure among Pitt's allies, but claimed that he convinced George Townshend to overcome his own doubts and mediate with the Tories. The subsidy was approved, and the behaviour of Beckford and other speakers confirmed that the Tories and Pitt's other patriot supporters shared the general approbation, 'the whole vote was universally approved of as being just the happy medium in which we ought to steer'.[98] The Tories' acceptance of the subsidy reflected the strength of their alliance with Pitt, and the modesty of the sum involved. Pitt again stressed the economy of the subsidy during discussion of the budget on 11 March. He contrasted the restricted extent of his continental connection with the extravagant subsidy policy that he claimed would be pursued by Fox. He declared that a millstone of four pounds would sink a man while two-pound one would not.[99] The beginning of Pitt's advocacy of the Prussian alliance, and of his personal identification with Frederick II, was marked by a print expressing the Prussian king's confidence in the newly appointed secretary of state.[100]

Byng's court martial concluded hearing evidence on 19 January 1757. Avid interest had been stimulated by the widespread publication of accounts of the trial.[101] On 27 January, it found Byng guilty of not doing his utmost to engage the French fleet and to relieve Port Mahon. He was sentenced to the mandatory penalty of death. At the same time, the court martial acquitted Byng of cowardice and disaffection, and submitted a plea to the Admiralty for a pardon. It seems that in condemning Byng, the court martial had confused an error of judgement of which they believed him guilty, with negligence.[102] The confusing and contradictory decision ignited a fierce controversy. The verdict and the petition were extensively distributed in the press.[103] Frustration with the naval officers' failure to provide a decisive resolution was captured in a parody in which they advocate placing Byng in a kind of suspended animation between life and death:

We found him guilty, and we found him not,
We wish'd him sav'd and wou'd have him shot,

Spare him, great Sir, your Royal Mercy shew;
Shoot him dead Sir, let Royal Justice flow.
Regard your Subjects with a pitying eye;
Contrive the man may – neither live nor die.[104]

A print also mocked the court martial's moral cowardice by depicting it as a tribunal of women of questionable reputation, who have assembled to pass judgement upon a friend accused of an amorous indiscretion. The female court martial refuse to condemn their guilty sister, who demonstrated no 'fear in her Countenance, nor backwardness to Engage', lest they one day share her punishment. They advocate mercy after finding 'Her guilty of Neglect according to ye 12th Article of not burning, & Destroying certain mischevious Letters which it was her duty to burn & Destroy'.[105]

George II believed Byng to be guilty, and refused the plea for clemency. Further action was delayed until doubts over the legality of the sentence had been resolved by a panel of judges on 15 February 1756. On 17 February, the controversy was introduced into the Commons, leading to discussions of the verdict's justice and Byng's right to a pardon. On 25 February, several members of the court martial requested an act of parliament to release them from their oath of secrecy so that they could explain their verdict to the King, and produce more material reasons vindicating their appeal for mercy. The bill passed the Commons, but was thrown out by the Lords on 2 March, when only a minority of those members who appeared for examination asked to be absolved from their oath, and even these seemed to have nothing significant to add to their petition.[106] Byng was shot on 14 March, impressing many by the dignity and bravery of his death. Further censure of the court martial was inspired by its members' failure to press for the bill they had requested. Spurious versions of the tribunal's oath were printed in two newspapers provoking the Lords to take legal action against the publishers, who were released when they agreed to pay the cost of their confinement and beg for forgiveness, although Rigby was convinced that Augustus Hervey had been responsible.[107]

Many literary works applauded Byng's conviction and execution, demonstrating an inflexible belief in his guilt. He was determined to exonerate himself and prevent his execution being made an opportunity for further slander by writing a final declaration of his innocence. On the morning of his execution, Byng handed a copy to the Admiralty marshal to authenticate to stop 'anything spurious being published that might tend to defame me'.[108] The printing of Byng's self-defence did not thwart attempts by Grub Street to capitalise upon his death, which a produced a stream of sensational forged

'good-night ballads' and 'last dying speeches and confessions' in the best Tyburn tradition. Typical was a verse broadside dramatising Byng's last moments, in which he confesses that Minorca's fall was due to his terror of the French.[109] In other poems, Byng described his descent into hell and eternal punishment.[110] The first full account of Byng's trial was published for the Admiralty in late February[111] and provided the foundation for a satiric versification of evidence hostile to him.[112] Prints also endorsed Byng's conviction and welcomed his execution as a punishment appropriate to the gravity of his crime.[113]

Those who viewed Byng as a victim of ministerial persecution were outraged by the court martial's verdict. The accusation that he had been scapegoated was industriously propagated by Augustus Hervey, who launched a bitter assault upon Newcastle, Hardwicke, Anson and Fox for orchestrating the judicial murder of the admiral.[114] Hervey had written an extreme indictment of the former ministers for Byng to authenticate as his final declaration. When Byng replaced Hervey's paper with a more moderate one, Hervey printed his own version.[115] Hervey also published an account of Byng's execution, which portrayed him as a political martyr.[116] The minutes of the trial as recorded by Byng's secretary Thomas Cook were published together with the admiral's defence.[117] Horace Walpole participated in the campaign to save the admiral by encouraging members of the court martial to speak out about their misgivings. He also contributed to the offensive in the press, portraying Byng's trial as a miscarriage of justice in 'Queries: Addressed to Every Englishman's Own Feelings', which Hervey arranged to be published anonymously.[118]

Byng received unexpected assistance from Voltaire, who requested a testimony of the gallantry of his behaviour in battle from Richelieu, and forwarded it to the admiral, probably for presentation during his trial. It was opened at the Lombard Street post office on 19 January 1757, and sent to Holdernesse, who took copies and showed them to the King. Anson was also given a copy, and he advised Holdernesse to 'sink them' lest 'they would do harm at the court martial'.[119] The letter was delivered to the president of the court martial, Thomas Smith, who sent it back to the Admiralty, and it was read by Pitt. Pitt disapproved of the letter's interception, and returned it to Smith. It is not certain that Byng ever received the letter, but it may have reached him on 23 January, four days after the trial had finished. It was published soon after.[120] Reaction to Voltaire's interference appeared to be hostile, as reflected in a poem which rebuked Byng for soliciting propaganda from the enemy:

> But what Sort of Defence is it now you advance!
> Our Isle won't suffice, you'll have Witness from *France*:
> We must be convinc'd by such Evidence rare,
> Produc'd by the decent, unspotted *Voltaire*.[121]

Byng's execution provoked a final wave of literary assaults upon Newcastle, Hardwicke, Fox and Anson. It was seen as the consummation of their conspiracy to escape justice by turning the King, the press, Parliament and political opinion against him. Much of the bitterness of these attacks stemmed from the leading role taken by Hardwicke and Newcastle's protégé Mansfield in stifling the bill to free the court martial from its oath so that its members could speak out more strongly in Byng's favour. Hardwicke and Mansfield organised and conducted the examination of the naval officers before the House of Lords. Many thought the formality of the procedure was calculated to intimidate the sailors from insisting upon their right to convey their doubts directly to the King.[122] Walpole denounced Hardwicke as 'a shrewd old lawyer . . . weakly or audaciously betraying his own dark purposes in so solemn an assembly'.[123] As this represented Byng's last chance of a reprieve, the killing of the bill in the Lords by Newcastle and Hardwicke was regarded as driving the final nail into his coffin. Byng's ghost was summoned up by satirists to torment those who had sacrificed him to appease the wrath of a deluded nation. One of the most popular of these works of political Gothic dramatised the materialisation of Byng's bloodstained corpse in Newcastle's bedchamber, threatening to haunt the duke until he confesses his crime:

> Else, I will, ceaseless, sting your Soul;
> Till you repent, and clear the Whole
> To a Deluded [King];
> Each Night, in Person, I'll appear!
> Each Day, I'll Thunder in your Ear
> The Name of MURDER'D BYNG.[124]

An impressive print depicted the admiral's spectre breaking in upon the midnight rejoicing of Newcastle, Hardwicke and Anson, who congratulate themselves upon engineering their victim's destruction. Byng is wrapped in a funeral shroud and points to five bullet wounds in his side, emphasising his martyrdom by allusion to the traditional iconography of Christ's crucifixion and resurrection.[125]

The court martial's verdict placed Pitt in another difficult position. It was not in his interest to allow Byng's conviction to pass unchallenged since it appeared to exonerate the former ministers, and clear the way for their return to office. Any overt attempt to question the verdict, however, would put Pitt on a collision course with George II, and jeopardise his popular support:

> Pitt and Lord Temple were very desirous to save him . . . because making him less Criminal, would throw greater Blame on the late Administration. At the same time, to avoid the Odium of protecting a Man who had been hanged in Effigy in almost every Town in England, they wanted the King to pardon him without their seeming to interfere.[126]

Pitt had attempted to avoid an open advocacy of Byng in the Commons, facilitating the bill to enable the court martial to appeal to George II, but at the same time insisting that clemency could only come from the throne. He was thwarted by Fox, who took every opportunity of fastening the responsibility for petitioning upon Pitt and the Admiralty. Pitt condemned the decision of the court martial, and asserted that justice, compassion, and the good of the service demanded that Byng be pardoned. Fox's tactic of exploiting Byng's fate to undermine Pitt's standing with George II and among extra-parliamentary opinion outraged the admiral's friends. Walpole charged that Fox 'turned mercy itself into an engine of faction'.[127]

Pitt twice pleaded with George II to pardon Byng. On the second attempt, when claiming that the Commons endorsed his petition, Pitt received a sharp rebuke from the King, who justified his rejection by an ironic appeal to Pitt's own popular mandate, 'Sir, *you* have taught me to look for the sense of my subjects in another place than in the House of Commons'.[128] Temple, the new First Lord of the Admiralty, seconded Pitt's efforts. George II's fury at their persistence was aggravated by the Temple's obstinacy:

> ... his Majesty persevered, and told his lordship flatly he thought him guilty of cowardice in the action, and therefore could not break his word they had forced him to give to his people, – to pardon no delinquents. His lordship walked up to his nose, and, sans autre ceremonie, said, what shall you think if he dies courageously? His Majesty stifled his anger, and made him no reply. I think I never heard of such insolence.[129]

The identification of Pitt with the campaign to save Byng was encouraged by reports that he was behind an attempt by Tory aldermen to initiate an City address requesting a reprieve.[130]

Literary commentary upon Byng's trial bears out indications from other sources, that the general trend of popular opinion remained convinced of Byng's guilt, and believed his sentence to be just. A seditious verse broadsheet was posted upon the walls of the Royal Exchange threatening vengeance if the admiral were pardoned, 'Shoot Byng, or take care of your King.'[131] Intimidating letters and printed literature were sent directly to George II. Pitt's efforts to secure clemency for Byng provoked a backlash against him, as he feared when he confessed to the Commons, 'that he should probably smart for it'.[132] The *Test* encouraged this trend, complementing Fox's campaign in Parliament. It censured Pitt for misrepresenting royal justice as cruelty, usurping the crown's prerogative of mercy, defying the wishes of the people, and with reference to the Minorca inquiry, of 'screening delinquency from justice, while he is pretending to be a ministerial *thief-taker* himself'.[133] The *Con-test*'s tentative defences of Pitt's conduct as a humane stand against unthinking prejudice revealed its consciousness of striving against the most

powerful current of popular opinion. Pitt's vulnerability to charges of partiality to Byng was emphasised by its insistence that the admiral's noble birth, naval rank, wealth and parliamentary privileges had won him no favours.[134] Pitt received anonymous threatening letters, and he warned MPs of the need to resolve Byng's affair quickly, lest discontent over the delay in carrying out the sentence spark rioting. Glover recorded the damage done to Pitt's popular reputation by his attempts to save Byng from punishment which: 'at once threw down the public adoration, polluted and defaced by the despicable hands which raised it: Pitt became hateful to the people of Great Britain, like Anson, Fox, or Byng'.[135]

Rigby reported that many in the City were offended by his exertions upon Byng's behalf.[136] A cutting satiric print (Plate 13) published soon after Byng's execution exemplified the largely hostile popular reaction to Pitt's endeavours to pardon the admiral. A member of the Admiralty Board, perhaps Temple, attempts to blow the kiss of life into Byng's corpse through a tube inserted into its backside, while Pitt pictured on the extreme right shouts encouragement, *'Save him, or we perish, he's purg'd of all Criminality'*.

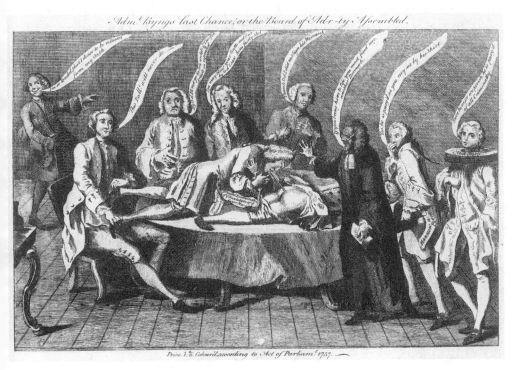

13 *Adml. Byng's last chance*

Confidence in the ministry had been eroded by Pitt's frequent relapses of gout, which gave the impression that the prosecution of the war and domestic administration were paralysed by his illness. A significant reinforcement of troops had been sent to North America, where an offensive was planned, but because operations were not possible until late spring, the ministry could not expect its position to be bolstered by early reports of success. A satiric poem expressed growing impatience with the secretary of state's incapacity:

> The land to rescue from impending fate,
> P[itt] rose; the smooth-tongu'd *Nestor* of the state.
> Swift from young Paris flew a whizzing spear,
> Stopt the stern hero in full career;
> Quick gliding, thro' the foot an entrance found,
> And nail'd the bleeding warriour to the ground.[137]

The ministry was embarrassed by the failure of its attempts to raise the supplies.[138] The lottery's popularity was undermined by the high level of risk involved. Investors in the annuity scheme were discouraged by its intricacy and low rates of interest. Pitt was also condemned for failing to honour his real or alleged promises of patriot reform. The possibility of an election and a return to triennial parliaments had been abandoned. No action was taken to satisfy expectations that Pitt would wage war upon corruption until 18 March 1757, when Legge introduced a modest plan to abolish the Wine Licence Office.[139] Pitt's failure to commence political renewal provoked accusations of mock patriotism from the *Test*, most notably in a Lilliputian allegory in which he was identified with Reldresal, who 'hath been known . . . to cut a tolerable Summerset, and hath *leaped* over, and *crept* under the *Stick* very much to his own advantage'.[140] Pitt's conversion to support for a continental war also inspired criticism. *Adml. Byng's Last Chance* echoed Fox's ridicule of Pitt's recantation regarding Hanover and Prussia by portraying him with a millstone hanging about his neck (see Plate 13).

The new ministry enjoyed little success in recruiting supporters in the Commons. Pitt's aloofness and frequent absence due to illness hindered him from fostering a stronger parliamentary following. Party hostility also contributed to the failure to attract new allies: the great majority of the Whigs would not join a ministry tainted by its association with the Tories. A cogent poem written from an Old Corps perspective sheds light into why the Whig parliamentary party remained hostile to Pitt. The author contrasted Newcastle, Hardwicke, Fox and Anson's experience with the incompetence of their successors, who had attained office, not by merit, ability and public spirit, but by manipulation of the mob. Pitt was accused of playing upon the ignorance and prejudices of the most vulgar elements of the political nation, and relying upon mock patriotism, feigned illness, and procrastination to

conceal the bankruptcy of his foreign and domestic policies. He was only able to cling to power because the majority of both Houses of Parliament, who were not taken in by his patriot demagoguery, refused to bring down the ministry out of concern for public tranquillity. The final stanza emphasised the disapproval felt by many members of the propertied classes and the political elite with Pitt's recourse to extra-parliamentary agitation:

> Assist, when they their Downfall meet,
> Some Deity in Charity!
> Catch them ye Nymphs of River *Fleet*;
> Recline 'em in your oozy Seat,
> That Couch of Popularity.[141]

Immediately before the Pitt–Devonshire ministry's formation and during its existence, literature acted as a significant force in restoring Pitt's reputation for patriotism. Literary evidence offers illuminating insight into the problems confronting the new ministry, and into the nature of its support. Its analysis contributes to an understanding of why specific political interests and parties, such as commercial opinion within the City of London and the Tories, responded to Pitt's appeal. Ballads, poetry, drama, fiction and prints conveyed the impression of his widespread popularity among the extended political nation. The importance of this perception is revealed in its acceptance by George II and other politicians, and its effect can be measured by its prominence in their assessments of Pitt's political strength.

It was political necessity that had forced George II to surrender the secretary's seals to Pitt, and the King had resented the tactics with which he had been compelled to accept the new ministry. Pitt's critics denounced him for storming the closet, and adopting an insolent, autocratic tone in his relations with the King.[142] Whatever progress Pitt made in overcoming the King's long-standing antipathy by his willingness to aid Hanover was shattered by their conflict over Byng. In late February 1757, George II's dissatisfaction burst out, 'I do not look upon myself as King, whilst I am in the hands of these Scoundrels.'[143] The impact of Pitt's popularity upon high political manoeuvre is most clearly visible in the consequences of his controversial defence of Byng. Many politicians interpreted the backlash against Pitt in the press and in other media of political communication as signs of the alienation of his extra-parliamentary support, which seriously undermined his hold upon power. Holdernesse predicted: 'I think we are at the Verge of another Ministerial Revolution; the Conduct of my Colleagues in the Affair of *Byng* has greatly lowered their Popularity, & so exasperated the King that I think they cannot long keep in the Saddle.'[144]

Henry Digby also shared the view that Pitt's 'tricks & contrivances to save Byng' had, by compromising his reputation without doors, made him

politically vulnerable, 'he has not his popularity which was the thing that raised him'.[145] The antagonism of the City was seen as especially significant. While Pitt enjoyed its confidence, he had been sustained by the belief that a ministry without him would be unable to raise the supplies.

The apparent loss of Pitt's extra-parliamentary mandate probably helped to convince George II that he could be safely dismissed. An anonymous paper sent to the King condemning Pitt's attempts to mitigate Byng's sentence declared that he: 'has lost by this factious job all that he had acquired with the City. If he presumes again, Sir, discard him; your people will stand by you.'[146]

George II contacted first Newcastle and then Fox about preparing a new administration.[147] Newcastle refused to take office before the inquiry had been held and the supplies had been raised. In early April, Cumberland was to assume command of the Army of Observation in Hanover, but he was reluctant to take up the position unless he was backed by a more sympathetic government. Cumberland supported Fox's efforts to form his own ministry once Newcastle had declined to cooperate. An assessment of the damage that Pitt's sympathy for Byng and his conversion to continental measures had inflicted upon his extra-parliamentary reputation influenced Fox's conduct. He advised the King to dismiss Pitt and his allies immediately, 'when by their late Behaviour, they had lost their popularity'.[148] Pressure from Cumberland also encouraged George II to make the change. Temple was removed on 5 April 1757, and when Pitt's anticipated resignation did not follow, he was dismissed on the following day.

NOTES

1 Fox to Bedford, 30 Oct. 1756, Bedford, II. 205.
2 Walpole, *Memoirs*, II. 184–90; Clark, *Waldegrave*, pp. 186–7; Clark, *Dynamics*, pp. 283–95.
3 Narrative for Lord Kildare, Ilchester, I. 357.
4 Newcastle to Hardwicke, 13 Oct. 1756, Yorke, II. 318.
5 *The Fifteenth Ode of the First Book of Horace Imitated, and Applied to Mr. F[ox]* 1756, pp. 3–4; Ilchester, I. 3–7.
6 Shelburne, I. 42.
7 *Fifteenth Ode*, p. 5.
8 Walpole, *Memoirs*, II. 62; *The Eaters*, BMC 3545.
9 *Fifteenth Ode*, pp. 3–4.
10 *Ibid.*, p. 7; Walpole, *Memoirs*, II. 75.
11 *Fifteenth Ode*, pp. 3–4.
12 Williams, I. 210.
13 *The Mirrour*, BMC 3487; *The Rostrum*, BMC 3424; *The Fox Unkennel'd*, BMC 3542.
14 *An Odd Sight Sometime Hence*, BMC 3435; *The Still Birth*, BMC 3385.
15 Ilchester, I. 192.
16 Newcastle to Hardwicke, 8 July, Yorke, II. 304.

17 Hervey, p. 239.
18 Shelburne, I. 61.
19 *Fifteenth Ode*, p. 4.
20 *The Freeholder's Ditty*.
21 *Guy Vaux the 2nd*, BMC 3439.
22 Chesterfield to Huntingdon, 6 Nov. 1756, Chesterfield, V. 2207.
23 R. D. Spector, *Arthur Murphy* (Boston, 1979), pp. 32–6. Fox's chaplain Philip Francis also contributed.
24 *World Extraordinary*, 4 Jan. 1757; Walpole to Fox, 20 Dec. 1756, *Corr.*, XXX. 131.
25 Fox to Digby, 30 Oct. 1756, Ilchester, II. 5.
26 Walpole, *Memoirs*, II. 186.
27 In another version of his *Memoirs*, Waldegrave wrote, 'because it was more safe to be united with him who had the Nation of his Side, than with the Man who was the most unpopular. A Reason which will have its proper Weight with most Ministers', p. 187.
28 The development of Pitt's patriot reputation and its political influence during the Seven Years War have been the subjects of a valuable study by Marie Peters, *Pitt and Popularity: The Patriot Minister and London Opinion during the Seven Years' War* (Oxford, 1980).
29 Sutherland, 'Devonshire-Pitt', p. 150.
30 *Patriot Prince*, p. 16; *Byng Return'd*, BMC 3367.
31 Shelburne, I. 60.
32 *Ibid.*, 36.
33 Relation of my Conference with Mr. Pitt, 24 Oct. 1756, Yorke, II. 279; Pitt to Grenville, 17 Oct. 1756, Smith, I. 178; Hardwicke to Royston, 21 Oct. 1756, Yorke, II. 328.
34 Glover, *Memoirs*, p. 89.
35 Lyttelton to William Lyttelton, 25 Nov. 1756, Phillimore, II. 534.
36 Williams, I. 28–59, 190–217.
37 *Ibid.*, 151–2.
38 *Ibid.*, 154.
39 *NM*, 13 Nov. 1756; *YC*, 16 Nov. 1756.
40 *YC*, 9 Nov. 1756; *FFBJ*, 13 Nov. 1756.
41 Pitt to Thomas Pitt, 13 July 1755, Chatham, I. 140.
42 Walpole, *Memoirs*, II. 78.
43 The journal was probably written by the lawyer and pamphleteer Owen Ruffhead.
44 *Con-test*, 2 July 1757.
45 *Ibid.*, 14 Dec. 1756.
46 *Ibid.*, 12 Feb. 1756.
47 *The Genius of Britain*, pp. 3–4; 'The Machine', *GM*, Jan. 1757, 34.
48 *The Burning Pitt*, BMC 3462; *Magna est Veritas et Proevalebit*, BMC 3390.
49 *A Poetical Epistle, Occasioned by the Late Change in the Administration*, 1757, pp. 3–5. At least two editions were published.
50 Samuel Foote, *Memoirs of Samuel Foote*, ed. William Cooke (London, 1805), II. 206.
51 Walpole, *Memoirs*, II. 145.
52 *The Prayer; or the Muse on Her Knees for Britannia*, 1757, pp. 1–9, 12–25; *The Patriot, or a Call to Glory*, 1757, pp. 15–23, 56–79; *Britain*, pp. 63–84.
53 Walpole, *Memoirs*, II. 116; Carlyle, p. 172.
54 *Fifteenth Ode*, p. 6.
55 *The Genius of Britain*, p. 3.
56 Lyttelton to W. Lyttelton, 25 Nov. 1756, Phillimore, II. 536.

57 *The Ministry Chang'd*. The second stanza alludes to parliamentary exchanges between Pitt and Fox, provoked by Pitt's alleged declaration that while Newcastle and Fox governed, there was '*no sense and virtue near the throne*', Walpole, *Memoirs*, II. 78.

58 *Exit Unworthies. Enter Worthies*, BMC 3427; *The Revolving State*, BMC 3431.

59 Glover, *Memoirs*, p. 87.

60 Beckford to Pitt, 6 Nov. 1756, Chatham, I. 185.

61 Peters, *Pitt*, p. 13.

62 Walpole, *Memoirs*, II. 193. For Pitt's relations with the Tories see, Linda Colley, *In Defence of Oligarchy: The Tory Party 1714–1760* (Cambridge, 1982), pp. 268–79.

63 Shebbeare, *Third Letter*, pp. 62–4.

64 *The History of Reynard the Fox*, 1756, pp. 101–60.

65 *GM*, Oct. 1756, 475.

66 *History of Reynard*, p. 152.

67 Pitt to Devonshire, 15 Nov. 1756, Torrens, II. 342.

68 Debrett, III. 269.

69 *His Majesty's Most Gracious Speech*, 1756.

70 Cobbett, XV. 779.

71 SP 36/136, fos 91–107.

72 Waldegrave, p. 187. On 4 April 1757, King was released from prison and the fine remitted when he appeared at the bar of the Lords, and on his hands and knees, begged for forgiveness and mercy.

73 Hardwicke to Newcastle, 6 Dec. 1756, Yorke II. 377.

74 Glover, *Memoirs*, p. 107.

75 Walpole to Mann, 13 Feb. 1757, *Corr.*, XXI. 55; Rigby to Bedford, 20 Jan. 1756, Bedford, II. 223.

76 Western, pp. 135–40.

77 *A Poem. Occasioned by the Militia Bill*, 1757, p. 8.

78 *Departure of the Hanoverians*, p. 3.

79 *Pandemonium College; The Stocks*.

80 Bacon, *The Taxes*, p. 27.

81 *Ibid.*, p. 37.

82 Sutherland, 'City of London', pp. 164–6.

83 Cobbett, XV. 782–802; Schweizer, *Frederick the Great*, pp. 1–63.

84 BL, Add. MSS 51,341, fo. 142: H. Digby to Ilchester, 1 Mar. 1757.

85 *The Prayer*, pp. 8–9.

86 *The Indulgent Care of the Roman Eagle Display'd*, BMC 3607; *Protestantism & Liberty*, BMC 3612.

87 William Dobson, *The Prussian Campaign*, 1758; Alexander Gordon, *The Prussiad*, 1759.

88 *The Eulogy of Frederick*, 1757, p. 14.

89 *An Epistle from M. Voltaire to the King of Prussia*, 1757.

90 *An Epistle from the King of Prussia, to Monsieur Voltaire*, 1757, p. 7.

91 H. Digby to Lord Digby, 7 Dec. 1756, HMC, *Eighth Report*, Pt. I. 223.

92 *Britain*, p. 30.

93 Walpole to Conway, 19 Jan. 1759, *Corr.*, XXXVIII. 1.

94 The Bibliography documents the extent of literary publication. At least fifty works sympathetic to the Prussian alliance were printed during 1756–59, Wellenreuther, p. 63.

95 Walpole to Mann, 9 Feb. 1758, *Corr.*, XXI. 171. Seventeen provincial celebrations were reported, as well as rejoicing in Ireland and Scotland.

96 Walpole to Mann, 9 Sept. 1758, *Ibid.*, 238.

97 Walpole, *Memoirs*, II. 214; BL, Add. MSS 51,341, fo. 43: H. Digby to Ilchester, 1 Mar. 1757.

98 Charles Jenkinson to Sanderson Miller, 19 Feb. 1756, *An Eighteenth-Century Correspondence*, ed. Lilian Dickins (London, 1911), pp. 353–4.

99 Williams, I. 305.

100 *(King) of Prussia's S(peach) (toe) (Britannia) 1756*, BMC 3425.

101 *GM*, Dec. 1756, 599–602; Jan., Feb. 1757, 30–2, 51–6.

102 Pope, p. 255.

103 *LEP*, 29 Jan. 1757.

104 *The Court-Martial's Address to His Majesty*, 1757; *A Letter from the C[our]t M[artia]l*, 1757.

105 *The Female Court Martial*, BMC 3568.

106 Walpole, *Memoirs*, II. 211–37; Hervey, pp. 232–42.

107 *LEP* 26 Feb. 1757; *PA*, 2 Mar. 1757; Rigby to Bedford, 3 Mar. 1757, Bedford, II. 239; Hervey, p. 31.

108 *A Copy of a Paper Delivered by the Honourable Admiral Byng Immediately Before His Death*, 1757.

109 *The Sorrowful Lamentation and Last Farewell to the World, of A[dmiral] B[yn]g*, 1757; *The Case of the Hon. Admiral Byng Ingenuously Represented*, 1757, p. 63.

110 *A Poetical Epistle from Admiral Byng, in the Infernal Shades*, 1757; *Admiral Byng in the Elysian Shades*, 1757.

111 Charles Ferne, *The Trial of the Honourable Admiral John Byng*, 1757.

112 *A Poem for the Better Success of His Majesty's Arms Against the French this Spring, with Byng's Tryal Versyfied*, 1757.

113 *The Monument*, BMC 3562; *The Court-Martial's Sentence*, BMC 3566.

114 Hervey, pp. 311–12.

115 Augustus Hervey, *The Speech of the Honble. Admiral Byng, Intended to Have Been Spoken . . . at the Time of his Execution*, 1757.

116 Augustus Hervey, *A Letter to a Gentleman Giving an Authentic Account of the Death of Admiral Byng*, 1757.

117 Thomas Cook, *The Trial of the Honourable Admiral Byng*, 1757.

118 *LC*, 8 Feb. 1757.

119 Quoted in Pope, p. 248.

120 *LC*, 1 Feb. 1757.

121 'On Sight of Mr. Voltaire's Epistle', *A Too Hasty Censure*, p. 4; Walpole to Mann, 30 Jan. 1757, *Corr.*, XXI. 51.

122 Edward Owen to James Porter, 5 Mar. 1757, HMC, *Tenth Report*, Pt. I. 312.

123 Walpole, *Memoirs*, II. 236.

124 *Past Twelve O'Clock*, 1757, pp. 4–7. At least three editions were published.

125 *Byng's Ghost to the Triumvirate*, BMC 3570.

126 Clark, *Waldegrave*, p. 189.

127 Walpole, II. 212.

128 *Ibid.*, 223.

129 Rigby to Bedford, 3 Mar. 1757, Bedford, II. 239.

130 Walpole, *Memoirs*, II. 242.

131 Walpole to Mann, 3 Mar. 1757, *Corr.*, XXI. 66.

132 Walpole, *Memoirs*, II. 222.

133 *Test*, 26 Feb. 1757.

134 *Con-test*, 5 Mar, 1757.

135 Glover, *Memoirs*, p. 121.
136 Rigby to Bedford, 3 Mar. 1757, Bedford, II. 239.
137 'On the Honourable Mr. P[itt]'s Indisposition', *GM*, Feb. 1757, 81; 'On Mr. Pitt's Being Indisposed', *LEP*, 8 Feb. 1757.
138 *Test*, 12 Feb., 12 Mar. 1757.
139 Walpole, *Memoirs*, II. 245.
140 *Test*, 4 Dec. 1756.
141 *The Times*, 1757.
142 *Condescension and Humility*, 1756.
143 Clark, *Waldegrave*, p. 191.
144 BL, Eg. 3460, fo. 193: Holdernesse to Mitchell, 4 Mar. 1757.
145 BL, Add. MSS 51,341, fo. 48: H. Digby to Ilchester, 1 Mar. 1757.
146 Quoted in Williams, I. 308.
147 Clark, *Dynamics*, pp. 335–57.
148 BL, Add. MSS 35,416, fo. 178: Newcastle to Hardwicke, 5 Mar. 1757.

8

The Pitt–Newcastle ministry

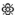

I F GEORGE II and Fox reckoned that the ostensible erosion of Pitt's popular-
ity meant that he could be readily discarded, extra-parliamentary reaction
appeared to prove how badly they had miscalculated. On 15 April 1757,
London's Common Council expressed approbation of Pitt's behaviour while
in office and outrage at his dismissal by granting him its freedom, enclosing
the certificate in a box of gold. London's striking endorsement was repeated by
eleven other cities and towns including several important commercial centres
such as Bristol and Norwich. The presentation of the honours and Pitt's letters
of thanks were extensively reported in the London and provincial press. Al-
though virtually all of the boroughs and corporations involved were dominated
by Pitt's allies or the Tories, the patriot press magnified the political signific-
ance of the campaign, portraying it as a spontaneous act of national consensus.[1]

Pitt's dismissal triggered an acute political crisis, and literature protesting
against his removal made a prominent contribution to the controversy.
Authors sympathetic to Pitt impressed his indispensability upon George II and
his rivals during the ensuing struggle for power. They were instrumental in
disseminating favourable perceptions of the causes of Pitt's expulsion, his con-
duct as a minister, and the achievements of his administration. Pittite writers
were aided in their efforts to portray his ministry in the most auspicious light
by the circumstances of its end: his decision to await dismissal rather than
resign was a shrewd one. He could be cast in the role of a patriot martyr, who
was discarded because he was too noble to compromise his political principles
and personal integrity.

A mock-biblical chronicle asserted that Pitt was commanded to resign
after refusing to countenance additional diversions of money and manpower
for the defence of Hanover. Pitt demonstrated his supreme independence in
surrendering the secretary's seals rather than sacrifice the maritime-colonial
interests of the nation and his honour, 'which was dearer to him than Life'.
Remaining loyal to his popular following, Pitt declared to an enraged King,

'nor do I desire to keep a Place in the M[inistr]y any longer than while I can assure myself of the People's good Wishes'.[2] The allegory reflects the perspective of patriot London opinion so closely that it concludes with a reproduction of the speech made by James Hodges, who introduced the motion to bestow the City's freedom upon Pitt.[3] The former ministers were accused of engineering Pitt's downfall to protect themselves from the parliamentary inquiry, and to frustrate his intention to cleanse the political system of corruption. The 'old faction' conduct a malicious campaign of character assassination, deluding George II with lies of Pitt's ambition to usurp royal power:

> Th' impious clan observe th' impending storm,
> And all combine a wicked scheme to form;
> While P[IT]T remains they cry death hovers round,
> Not one of us is safe on *England's* ground;
>
> Foul declamations swell their croaking notes,
> And jealousies distend their husty throats;
> Insinuations dark disturb their sov'reign's ear,
> Their clamour still encreasing with their fear;[4]

Poetry vindicating Pitt emphasised how the outcome could be interpreted in a way which cultivated his fame for political idealism. An eloquent ode claimed that Pitt fell victim to the intrigues of his enemies because he was too noble to descend to their level:

> Ye vers'd in ministerial Springs
> Studious of Statesmen and of Kings,
> Say, was he too sincere?
> Perhaps he bore too good a Heart;
> A little Vice, a little Art,
> Had kept him in his Sphere.[5]

Once returned to a private station, Pitt finds consolation in having followed the dictates of his conscience and earning the gratitude of the people:

> Pride wou'd lost Dignity bewail; –
> The Statesman light in virtue's Scale,
> May Pomp and Glare require:
> Heav'n gave You dignity of Soul,
> That Fate itself can ne'er controul,
> Nor grandeur render higher.
>
> What Joys in each reflecting Hour,
> (When Anguish stings Corruption's Pow'r)
> Life's Journey must improve!
> While Mem'ry tells thy Stoic Mind,
> How nationally bright it shin'd,
> And won *Augusta's* Love.[6]

Pitt's dismissal was fortuitous because the outrage and sympathy it incited diverted attention away from his compromises over Hanover, the inquiry, and Byng. At the same time, it offered a justification. In the Commons, Pitt had sought to distance himself from controversial measures, such as the Army of Observation, by describing himself as '*a nominal minister without a grain of power*'.[7] Pitt's apologists adopted his plea of restricted freedom of action to excuse the slow progress of his expected programme of constitutional reform. Its defeat in his removal was blamed upon the former ministers' entrenched opposition. The reforms that had been attempted, particularly Legge's fiscal innovations, were celebrated as the first steps toward Pitt's goal of national regeneration. The City's granting of its freedom to Legge highlights how efforts to shake off the parasitic 'moneyed interest' had been appreciated by popular opinion.[8] The significance of other initiatives, such as the abolition of the Wine Licences Office, was exaggerated to strengthen the impression of the dawn of a new era of political liberty and economy, 'Placemen and Pensioners, Jobbers and Agents, the corrupt Sons of a bad Administration, hung down their Heads, snarled and retired into Corners.'[9] In its domestic policy, Pitt's ministry was presented as the frustrated return to a golden age of patriotism:

> Oh Friend, whose Virtues, sweetly bright,
> Conspicuous through Corruption's Night,
> Three sinking Realms adore,
> You knew us wrong'd! – You sought redress!
> A venal Statesman had done less;
> No *Briton* could do more.
>
> Thy great retrieving Plan, was drawn;
> Success, progressive, eak'd; – the Dawn
> Beam'd clear through Error's Shade:
> But, – what our Sons shall blush to say,
> Before it brighten'd into Day,
> The Kingdom lost thy Aid.[10]

Eulogists employed the same combination of exaggeration and prophecy to magnify Pitt's performance as a war leader. They maintained that he had brought an unprecedented strategic clarity and energy to the direction of the war, concentrating British effort against the naval and colonial power of France, while relegating the continental theatre of war to its proper subordinate position. The efficient mobilisation of wartime finance, the formation of a militia, the deployment of naval squadrons to protect British interests in India and Jamaica, and the despatch of a fleet and reinforcements to North America were cited as proof that, if given the opportunity to bring his plans to fruition, Pitt would have emerged as Britain's victorious champion:

> The mighty genius of our land began
> To stem destruction, what a glorious plan!
> Curtail'd Expense, discarded foreign force,
> For our defence to *England* had recourse;
>
> Who station'd ships along the *Indian* shore?
> Who sav'd *Jamaica* from oppressive pow'r?
> Whose care so provident in wafting o'er
> Speedy supplies to the *American* shore?[11]

Grim accounts of the bleak strategic situation, the decayed state of the armed forces, and the demoralised nation Pitt inherited from his predecessors made his alleged feat of turning the tide of defeat seem even more magnificent. Tragically, however, the loss of Pitt shattered the visions of martial glory and imperial expansion promised by poets.[12]

Graphic art also offers insight into why Pitt retained his allies in the City, in other commercial centres, and among the Tories. Prints applauded Pitt's disinterested conduct and his struggle to free the country from the tyranny of the venal faction, which had dominated government for so long.[13] Pitt was distinguished as the champion of the middling merchant or tradesman, the small freeholder and the labouring classes against the aristocracy and their creatures in court, Parliament and the City. Portraits of Pitt were surrounded with images, emblems, inscriptions and verses extolling his moral virtue, altruism, independence and veneration for liberty and justice.[14] The engravings also highlighted the growing belief among the citizens of London and of other ports and towns engaged in commercial enterprise, that Pitt was sympathetic to their concerns and eager to promote their prosperity. All of these patriot themes were illustrated in a print dramatising the City's presentation of its freedom to Pitt (Plate 14).

Literary comment upon Pitt's dismissal is interesting for its assessments of George II's behaviour, and its intervention into the debate over the constitutional propriety of the gold box campaign. One print at least maintained the convention that the King could do no wrong, blaming the dismissal upon the cabal of former ministers who held him in thrall. The remorseful George II sends a note to Pitt commending his attempt at reformation, which he could not sustain, 'Sir I have Seen your Intentions but cannot prevail against Vice in Power.'[15] The right of the City to acknowledge and thank Pitt for his services was asserted by the mock-biblical chronicle, paraphrasing Hodges's motion.[16] Most works of literature were hostile to George II and expressed their disapprobation with considerable freedom. One patriot poet openly condemned his attempt to replace the people's champion Pitt with Fox, by which he:

> Repeal'd th' invested Power his Wisdom gave,
> And sunk his royal Self to raise a Slave.[17]

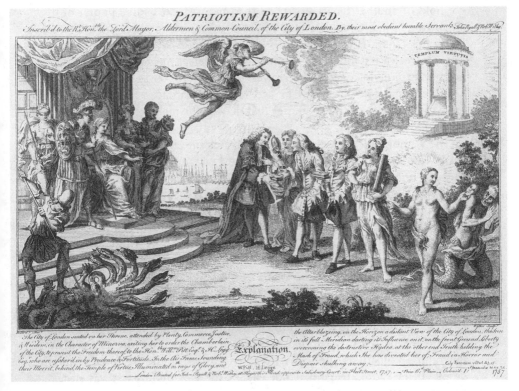

14 *Patriotism rewarded*

Despite the predominance of tributes to Pitt, a small number of publications expressed dissatisfaction with his conduct as minister. These works attempted to expose the reality of inactivity, failure and broken promises which had been denied or concealed. A fictitious speech that Pitt had allegedly delivered to Parliament upon his dismissal accused him of arrogance, arbitrariness, inconsistency and insincerity.[18] It ridiculed Pitt's pretence to altruism and public spirit with the admission that virtually all of government's most lucrative offices had been divided among a narrow faction composed of his family and political connections, 'My Brothers, Cousins, and namesakes'. It queried the honesty of Pitt's conversion to support for Hanover and Prussia, reminding the reader of his previous opposition with the declaration, 'The Germans are now our natural Enemies: I hate them and I always shall, though I complied with immediate and accidental Interest.' Pitt's sympathy for Byng was condemned by allusion to the fact that the bachelor Pitt's sister Mary had kept house for him until his recent marriage. Pitt explains that he struggled to save the admiral 'because I live in a sister's House, and imagined I had

189

got hold of another Dowager'. The broadsheet attacked Pitt's populism by portraying him as a rabble-rousing Roman tribune, who raises the militia to storm the Closet. It concludes with an assault upon Pitt's selfish opportunism. The retreating minister prays for another defeat such as Minorca, which he may exploit in a return to power: 'I shall now retire to Mutton and Turnips again; to Spleen and malice, and Opposition ... and pray most fervently for some dreadful disaster that may be the making of me, though it may undo my Country.'

The author's ideas, style and imagery resemble those of the *Test*, which strove to disparage Pitt's administration and his popular reputation. Arthur Murphy, the essay paper's principal author, was a gifted comic dramatist, which explains the frequent employment of literary techniques to sharpen its satire. One of Murphy's most stinging attacks was a parody of Shakespeare's *Richard III*, which indicted Pitt for overweening ambition and unscrupulous manipulation of the Prince of Wales by comparison to the ruthless usurper. Murphy attempted to reveal the narrowly partisan nature of the gold box campaign, and argued that the City's freedom had been contrived by Pitt's incendiaries Beckford and Hodges. The charge was developed in a satiric parallel, which echoed Richard III's success in duping the Lord Mayor and citizens of London into proclaiming him King. To highlight Pitt's hypocrisy, when receiving the City deputation who have come to bestow its freedom, the future William IV pretends to be engrossed in the Minorca inquiry despite being racked by gout. To be eligible for the honour, Pitt was elected freeman of the Grocers' Company, which allowed Murphy to pour scorn upon his sham patriotism and disgraceful popularity with the mob. Like Richard III's refusal to accept the crown, Pitt feigns reluctance to accept the gold box: 'Alas! Why will you heap this acre on me: I am unfit for figs and raisins, nor deserve now to be made a grocer.'

The City's act was denounced as an insolent attempt to infringe upon the King's prerogative to select his ministerial servants. Murphy maintained that Pitt's claim to be the country's chosen saviour was pure fiction, conjured out of nothing by the chimeric effect of his speeches and a mirage of national consensus. Pitt admits this to Beckford when instructing him to circulate more lies embellishing his heroic status: 'Tell' em, that when my mother went with child of me, She dreamt she was deliver'd of a trope, That saved this sinking land'.[19] Pitt and Legge were depicted as Don Quixote and Sancho Panza by a print commenting upon the grant of the City's freedom, which satirised the lunacy and charlatanism of their policies.[20]

Another important piece of adverse commentary expressed the indictment of mock patriotism through an ingenuous parody of the works of John Bunyan.[21] Pitt is envisaged as Mr. Badman, a political pilgrim whose goal is to attain the summit of Greatness Hill, but he is animated by the impure

motives of ambition, pride and avarice. Too impatient to follow the steep and rugged path set out by Truth, Badman makes more rapid progress upon Vice Road. He swears allegiance to Queen Vice, who equips him with all the arts and arms that an aspiring politician will require. A parchment revealing the secrets of intrigue, and powerful weapons including the Cap of Assurance, the Shield of Craftiness, and a Golden Spear enable him to triumph over Justice and the Dragon of Conscience. After wallowing in the Pelhamite Slough of Preferment doing the dirty work of his superiors, and enriching himself and his family, Badman reaches the peak of ministerial power. He imposes pernicious policies upon the people, compelling them to swallow bitter pills harmful to their constitutions. The dream vision concludes with the sick and angry people rising up against Badman, and an attempt to throw down his statue which has been set up in the City.[22]

The exact nature of the grievances against Badman is never indicated, although the financing of an army of German mercenaries for the defence of Hanover may be the nauseous pill the nation finds so difficult to stomach. The satire focuses upon the fundamental question of Pitt's reputation for patriotic integrity, which is shattered by his violation of the people's trust. The 'great number of pretty flowry Things called *Golden Promises*' given to Badman by Queen Vice correspond to Pitt's abandoned pledges over constitutional change, disengagement from the continent, Maidstone, and the inquiry. The satire's acrid tone and City bias suggest that its author may have been a disillusioned patriot supporter, one who could not accept Pitt's compromises. Additional evidence of disappointment with Pitt's failure to fulfil the expectations of patriot opinion was provided by a paper posted upon the gates of St James's, which contained a mock advertisement for his replacement, 'A Secretary of State much wanted; honesty not necessary; no principles will be treated with.'[23]

The prevalent tone of the literary response to Pitt's dismissal, however, was one of regret and indignation. These sentiments were mirrored in the prints: approximately twelve engravings vindicated Pitt, while only one expressed clear condemnation. Literature and prints illustrate the transitory nature of the hostility inspired by Pitt's leniency towards Byng, and how it and the other causes of dissatisfaction were eclipsed by the shock of his removal. Most of the few adverse reactions, such as the *Test* and *The Speech of William IV* (which may also have been written by Murphy), embodied the views of his inveterate enemy Fox. Only one work, *The Fall of the City of Eutopia*, appeared to represent a feeling of betrayal from one who had supported Pitt. Literary sources when combined with the wider trend of the press, and the gold box campaign, suggest that there was no crisis of confidence among those Tory and popular adherents already committed to Pitt. By taking advantage of his dismissal to augment his reputation for

patriot virtue, and to broadcast a message of enthusiastic national adulation, Pitt's literary advocates contributed to the development of his political popularity.

George II's dismissal of Pitt precipitated a protracted ministerial crisis, during which Fox, Newcastle and Pitt manoeuvred for positions of the greatest possible power and influence in a new administration. The negotiations were conducted against the background of the demonstrations of extra-parliamentary support for Pitt. Before considering their impact upon the outcome, it is necessary to assess the effect of Pitt's dismissal upon the political fortunes of Fox. Chapter 7 established the importance of literature and prints in recording and disseminating Fox's political unpopularity in the wake of Minorca. Fox's reputation was further tarnished by his behaviour during the Pitt–Devonshire ministry. He was accused of mounting a clandestine campaign to embroil Pitt in conflict with George II and to compromise his popular support, by exploiting issues such as Hanover and Byng. Fox's underhanded obstruction of the Commons' efforts to extend mercy to Byng were damaging, prompting a contemptuous dismissal from Pitt, '*He should have been ashamed to run away basely and timidly, and hide his head, as if he had murdered somebody under a hedge*'.[24] Fox's intrigues were explained by unceasing ambition and jealousy at the success of his high-minded rival. He was tainted as much by the tactics he adopted to secure his aims, as by perceptions of the objectives themselves. Viewed with hostility by the people, and ostracised by the Old Corps, Fox relied primarily upon Cumberland and his influence with George II to maintain his political significance. It was during this period, after subverting Newcastle, and when he was attempting to undermine Pitt, that Fox's reputation for self-interest, deceit and treachery was consolidated. Denunciations of Fox's political immorality were punctuated by claims that he based his conduct upon the teachings of the most infamous philosophers: Machiavelli, Hobbes and Mandeville.[25]

Much of Fox's growing notoriety was derived from his association with Cumberland, whose popularity after Culloden had been compromised by his brutal suppression of Jacobitism.[26] Those hostile to the captain general worried that his influence over George II would be increased by the extension of the war to the continent, and his responsibility for the protection of Hanover. The dismissal of Pitt, reputedly instigated by Cumberland, encouraged allegations that the captain general plotted with Fox to impose a military dictatorship and interrupt the succession. These rumours received encouragement from Leceister House and Pitt, who recognised their propaganda value.[27] George II's failure immediately to appoint a new ministry or fill all of the offices which had been occupied by Pitt and his supporters stimulated this anxiety. The apparent suspension of constitutional government aroused suspicions

that 'Cumberland held England in commendium and left Mr. Fox his Viceroy to command in his absence'.[28]

Literature and prints transmitted these rumours and allegations to a wide audience during the spring of 1757.[29] The *Con-test* replied to the *Test*'s dramatic parody with one of its own, a pastiche of Shakespeare and Jonson which described Fox's jubilation at the success of his schemes, despite the patriotic resistance of Pitt and the City:

> Thus far my fortune, keeps an upward course;
> I've worked the downfall of the people's darling;
> And am supreme dictator. – To be thus, is nothing –
> But to be safely thus – Ay! That were great.
> My fears in William,
> Stick deep; and in his dignity of nature,
> Reigns that, which would be feared –
> Ay! there's the rub.[30]

Fox's attempts to launch an administration inspired one of George Townshend's most popular prints (Plate 15), in which he appears as the duke's recruiting officer exclaiming, '*All Gentlemen Volunteers willing to serve under Military Government let' em repair to my Standard and they Shall be Kindly Receiv'd*'. Fox could only drum up a rag-tag band of feeble, morally bankrupt mercenaries, including Dodington, Ellis and Sandwich, who march

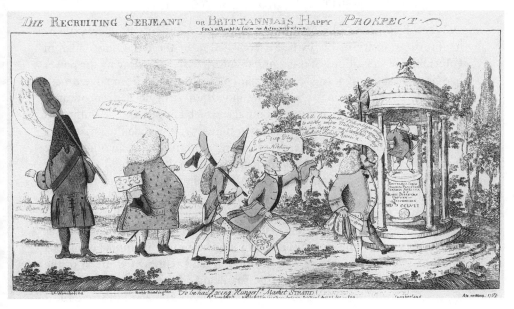

15 *The recruiting serjeant*

toward the statue of a grossly corpulent Cumberland cast in a mock-heroic attitude, enthroned in a temple of fame. The satire also charged that the conceited, incompetent captain general was determined to embroil Britain in a European war in a futile effort to win the military glory that had so far eluded him.[31]

Fox's character also suffered from his continued pursuit of profitable places and honours. His departure from office left him in a precarious financial situation, since he had little hope of favour from the old King's successor. Some of Fox's anxiety was relieved when he secured the reversion to Dodington's Clerkship of the Pells in Ireland for his own life and the lives of his two eldest sons, worth approximately £2500 a year.[32] His request for a peerage for his wife was refused. Without doors, Fox's sinecure was reviled as his price for conniving in the disposal of Pitt. An engraving portrayed a fearful Dodington subjected to the hungry stares of Fox and his two eldest sons, reminding the viewer of vultures circling their prey.[33] This fresh demonstration of Fox's cupidity was more glaring by comparison with Pitt's refusal to solicit favours for himself while minister.[34] An epigram alluding to the 'rain' of gold boxes emphasised popular opinion's contrasting perceptions of the two men's ruling passions:

> The two great Rivals *London* might content,
> If what He values most, to each She sent:
> Ill was the Franchise coupled with the Box;
> Give PITT the *Freedom*, and the *Gold* to F[ox].[35]

When Fox failed in his attempts to achieve a coalition with Newcastle or to form a ministry of his own, his consolation in the Pay Office left him vulnerable to accusations of indulging his avarice when his craving for power had been disappointed. In October 1756, Fox's withdrawal from government at a critical moment in Britain's life and death struggle had encouraged doubts of his patriotism and moral courage, which appeared to be confirmed by his acceptance of the paymastership in June 1757. It was claimed that Fox's nerve failed again, and he preferred the shame of retreating to an office of the second rank, where he could accumulate an enormous fortune. Fox himself described it as a step 'that in many people's opinions is a disgrace'.[36] Fox's personal and Pay Office accounts reveal how thoroughly he fed upon the public purse during his eight-year tenure, and until all of his balances were finally repaid. It has been calculated that from the time Fox became paymaster until within a few months of his death in 1783, he earned an annual unofficial profit of £23,657. The £193,366 he invested in land represented much of the wealth he had hoarded up from the financing of a war of extraordinary expense.[37] The immensity of the fortune Fox amassed made Pitt's refusal to take advantage of the paymastership seem even more remarkable.

The income from the Pay Office permitted Fox to live upon a grand scale at his Kensington mansion Holland House. He paid dearly for his pursuit of material wealth, and the moral degradation he suffered was emphasised by Shelburne, who accused him of abusing his position to maximise his gain: 'Mr. Fox was content all this time to sit in the dark, making money by applying the publick moneys in his hands to various uses, particularly stock-jobbing, and devoting his interest and arts to get as large a balance as possible.'[38] Walpole claimed that Fox had forsaken honour for aggrandisement:

He had neither the patriotism which forms a virtuous character, nor the love of fame which composes a shining one . . . His natural bent was love of power . . . but growing a fond father, he became a provident father – and from a provident father to a rapacious man, the transition was but too easy.[39]

The stain upon Fox's character was aggravated by the levity with which he sometimes spoke of his prize, 'Upon the whole I shall drink my Spa Water very cheerfully I believe in the Pay Office during this Reign.'[40] Fox's apparently cynical self-seeking inspired a scathing poetic satire. It ironically contrasted Fox's retreat to the renumerative obscurity of the Pay Office and the excesses of Holland House – the renunciation of duty, integrity and dignity – with the retirement of a religious pilgrim or a pious Roman patriot, who returned to simple, virtuous existences after lifetimes exhausted in the service of God or the state:

Here lives the CATO of his days!
Who touch'd by some seraphic wing!
Forsook all titles, honours, praise;
Rather to serve his G[o]d than K[in]g.[41]

Antipathy towards Fox was stimulated by his recourse to the press to promote his political interests. Despite Fox's denials of any association with the *Test*, he was widely regarded as its patron. Fox's requests to his old literary collaborator Hanbury Williams, then ambassador in Russia, 'to send me a Teste or two', indicated his ability to influence its tone and contents.[42] Hanbury Williams agreed, but was worried that detachment from the political scene rendered his task difficult, there is 'no painting faces by description'. The lack of the encouragement of Fox's imagination was another hindrance, 'I am too far absent from my Genius, and the Sun, & every Thing that inspires wither Wit or humour or Poetry.'[43] That Fox may have edited the *Test* is suggested by his reassurance not to worry about being out of touch with developments, 'I'll alter where you mistake.'[44] Despite a sustained effort, however, Hanbury Williams could produce nothing suitable for publication. Fox was censured for the extremity of the *Test*'s satire, which its victims claimed sank to unprecedented depths of virulence, maliciousness and calumny.[45] Moderate opinion may have been offended by its personal

abuse of Pitt and its ridicule of his ill health. The *Test* and the *Con-test* enjoyed a wide readership in popular and high political circles. As the oracle of its patron, the *Test* was carefully scrutinised by Newcastle, Hardwicke and Pitt for indications of Fox's political intentions and tactics. Newcastle and Hardwicke were so disturbed by the *Test*'s attacks upon the Old Corps, that Hardwicke initiated inquiries into the essay paper's publication, perhaps with a view to prosecution.[46] This information was passed on to the King. Newcastle considered replying with an essay paper of his own.[47] Newcastle and Hardwicke also focused attention upon the *Con-test*, which they interpreted as a reliable guide to the political disposition of Pitt.[48]

Fox was alarmed by the turn of the press against him during the inter-ministerium. George Townshend's satiric prints had rankled. In a heated exchange in the Commons, Fox replied to Townshend's complaints about the abuse heaped upon Pitt in the *Test* with a condemnation of Townshend's own assaults upon him.[49] Townshend's *Recruiting Serjeant* was answered by a caustic political pamphlet, *An Essay on Political Lying*, probably written by Fox's chaplain, Francis.[50] Fox's reprisal may have been counter-productive, as its virulence brought down more censure upon his head for mud-slinging.[51] The virtually unanimous hostility of political prints encouraged Fox to attempt to redress the imbalance. An etching was published in June 1757 warning New-castle against the shame and ingratitude of forsaking George II for an alliance with Pitt, Bute and Leicester House.[52] The print provoked a great scandal due to the representation of a figure referred to by the verse 'See a blue ribbon'd, silly, proud, son of a W[hore]', who was not precisely identified. Although Newcastle's nephew Lord Lincoln was thought to be the individual, many believed that the Prince of Wales was the target. This connection was ren-dered more probable by allusions to slanderous rumours that Lord Bute and the prince's mother were lovers, 'See a Strutting Scotch Peer, of whom I could say more'. Walpole recorded Fox's association with the satire and the sensation it created.[53] The ostensible reflection upon the Prince of Wales was exploited by Fox's enemies to reinforce their charges of his treasonous deal-ings with Cumberland. This time the *Con-test* drew a parallel between Fox's insinuations of the illegitimacy of the heir apparent and Richard III, who had propagated similar lies before usurping the throne.[54] A second impression of the print was published denying that any insult to the prince had been intended. To unmistakably identify the controversial figure as Lord Lincoln, a devil was inserted hovering in the air above him with the explanatory couplet:

> As sure as I look over L[incol]n,
> That shall not happen which these think on.

Unfortunately for Fox, this amendment appeared to be more of a guilty retraction than an expression of innocence.[55]

Cumberland's assumption of the command in Germany, and Pitt's apparent dismissal at his bidding, concentrated attention upon the continental war. These developments heightened fears that any ministry headed by Fox would direct military resources away from North America and the maritime-colonial conflict. Apprehension that Fox intended to engage the country in a self-destructive military adventure in Germany was fuelled by rumours that Pitt had been discarded for refusing to condone the dispatch of British troops to Hanover.[56] Political literature and prints appealed to anti-Hanoverian emotion when warning of the threat of a Fox ministry, and the extravagant continental subsidy policy it would entail. A drama summoned Walpole's ghost, who pleads with Fox not to make George II's favouritism for Hanover the cornerstone of his ministry if he wished to avoid eternal damnation: 'I hear the bankrupt's groans, the widow's and the orphan's sighs, they all ascend to heaven, their tears are catch'd in the vials divine, laid up for witnesses against me. I was the cause of this, for why? for what? only to protect that million curs'd country called England's ruin.[57]

The *Con-test*'s 'State Farce' included a scene in which Fox strikes a bargain with the moneyed interest, who prop him up at the Treasury by lending the supplies at extortionate rates of interest. Fox confesses that much of the money will be diverted to Hanover, bankrupting the nation:

> But I forget, my noble friends abroad!
> Whom patriot William would have gladly starv'd . . .
> For how can I, to greater 'vantage use,
> The heap to secret services consign'd
> Than to express, the greatness of my love,[58]

The theme that Fox had sold himself to Hanoverian counsels was pursued in Townshend's *Recruiting Serjeant*, which elevated Cumberland upon a pedestal bearing the inscription '*Britannia Subacta America prostrata Germania asserta*'. Other prints reinforced the accusation that Fox would give free reign to George II's Hanoverian bias. In one engraving, Fox reviews an army of mercenaries hired for the defence of Hanover.[59] In another, George II, Fox and Cumberland plunder the apple orchards of England in a vain effort to encourage the crab trees of Hanover to bear more fruit.[60] Perhaps the most shocking image portrayed the Hanoverian white horse devouring the British lion.[61]

The power of political literature in generating hostility towards Fox during 1756–57 is emphasised by the extraordinary success of the two most telling attacks upon him, *A Fifteenth Ode* and *A Tenth Ode*. To satisfy intense public demand, four impressions of each poem were published. The run of the political prints against Fox received fresh impetus from his part in provoking Pitt's fall and his attempts to profit from the subsequent political

chaos. Approximately thirty engravings hostile to Fox were published during 1757, marking him out as the most abhorred politician whose image was exposed for sale in the print shops.

Horace Walpole's Chinese letter satirising the interministerium characterised the crisis as a struggle for power between three factions led by Newcastle, Fox and Pitt.[62] It was resolved in June 1757 by a coalition between Newcastle and Pitt. Newcastle replaced Devonshire as First Lord of the Treasury and Pitt returned to office as Southern Secretary of State, while Fox, who was excluded from executive authority, was accommodated with the Pay Office. In explaining the outcome, a combination of factors must be assessed, including the wishes of George II, the personal interrelationships of the key figures, the balance of forces in the House of Commons, and the attitude of Leicester House.[63] In addition, the influence that political opinion, and perceptions of opinion, exercised upon the small circle of pre-eminent politicians who determined the composition and policies of the new ministry must also be considered.

Newcastle's possession of a majority in both Houses of Parliament placed him in the strongest political position. His freedom of action, however, was restricted by the intractable problem of establishing a stable system for the leadership of the Commons independently of Fox or Pitt.[64] Fox offered to support Newcastle in the Commons if he resumed office, surrendering any share in decision making or parliamentary management. Doubts about Fox's commitment and his renunciation of ambition made it difficult for Newcastle to trust the former colleague who had abandoned him. Leicester House's backing of Pitt had persuaded Newcastle that unity within the royal family was another important prerequisite for any lasting settlement. Although much of Fox's favour with George II was derived from his connection to Cumberland, it proved to be a mixed blessing, for it antagonised the junior court. Early in the negotiations, jealousy of Cumberland inspired Princess Augusta and Bute to reject Fox's overtures of reconciliation.[65] Given George II's advanced age, few politicians were rash enough to incur the displeasure of his youthful heir by joining with Fox. For Newcastle, an alliance with Pitt provided the best possible outcome by resolving his problems in the Commons, and achieving a rapprochement between the two courts. It also seemed to entail the most favourable balance of power within any partnership. Newcastle felt threatened by Fox's credit with George II and Cumberland, which, when combined with his skills as a political manager and his leading role in the Commons, might enable him to challenge Newcastle's dominance within any joint ministry. In contrast, Pitt's strained relationship with the King, political isolation, and apparent willingness to relinquish control over patronage, appeared to guarantee Newcastle's supremacy in the closet, and superior influence within any coalition.

In explaining why the crisis culminated in an alliance between Newcastle and Pitt, the significance of political opinion, both within parliamentary circles and among the extended political nation, must not be neglected. The acute unpopularity that Fox had acquired by April 1757 was a great liability. The diverse nature of the anti-Fox literature, which included high political works such as the two Horatian odes, as well as ballads and ephemeral verse, reflected the widespread diffusion of hostility towards him at Westminster and the court, in the City, and among the extra-parliamentary classes. Many politicians testified to the extent of Fox's unpopularity and its consequences, which literature had documented and done much to promote. The City's enmity was reported to Halifax, President of the Board of Trade, by his contacts among its financiers, who declared their refusal to lend support to a Fox administration.[66] Holdernesse argued that Fox's conduct had alienated so many potential allies in Parliament and without doors that he lacked the strength to form a ministry of his own: 'the people in general of all ranks and denominations except a few of his creatures are so averse to him that it is impossible for him to undertake the management of affairs'.[67] Holdernesse's assessment was confirmed by Lord Mansfield, who asserted that Fox's attempts were doomed to fail, 'with a majority in the H of Commons & the cry of the people violent against him'.[68]

Newcastle was aware that Fox had forfeited the trust of Parliament and of popular forces in the City.[69] His resolution to ally himself with Pitt, despite George II's preference for Fox, was affected by a conviction of the damaging impact of the latter's unpopularity.[70] He recognised the backlash of opinion against him that would occur if he joined what was regarded as a Cumberland–Fox ministry or even supported an administration in which Fox occupied a prominent position.[71] Like Devonshire before him, Newcastle was deterred from any association with Fox by the prospect of unrelenting attacks in the Commons and a campaign of extra-parliamentary protest fomented by a hostile press. His determination to repudiate Fox was reinforced by the outrage incited by the rumour of a partnership, which: 'has created such a flame, that I have been given to understand, that I am to expect a more violent opposition against *me*, than ever was against Sir Robert Walpole'.[72]

Ultimately, it was the alienation of Whig opinion in Parliament and at court which dealt the critical blow to Fox's final effort to form a government independently of Newcastle. Fox confessed the truth of George II's reproach that his desertion of Newcastle after Minorca had 'lost him the hearts of the Whiggs'.[73] The causes of Fox's ostracism from the Old Corps were vividly illustrated by the literary assaults, which had circulated among his peers and encouraged their censure. Fox's desperate bid to launch an administration with Waldegrave was defeated by the opposition of his fellow Whigs in Parliament and the Royal Household, who threatened to resign if he were rash

enough to go ahead with the scheme. Calling an election was not an option, because Fox judged that there was little hope of improving his position in the Commons.[74]

The negotiations' political climate was influenced by the displays of extra-parliamentary support for Pitt manifested in the 'rain' of gold boxes and the acclaim of the press. The impression they conveyed of a virtually unanimous demand of popular opinion for the restoration of Pitt was accepted by George II, Newcastle, Hardwicke and Fox. In warning George II of the inevitable failure of his projected ministry with Fox, Waldegrave declared that 'the popular Cry without doors was violent in Favor of Mr. Pitt'.[75] Newcastle too was convinced of Pitt's command of extra-parliamentary opinion, a belief reinforced by his sources in the City of London, and the views of Hardwicke and other trusted advisers.[76] George Stone, the Primate of Ireland, who acted as a mediator, asserted that the pro-Pitt national consensus made it imperative for Newcastle to reach an agreement with the patriot leader.[77]

The analysis of the central figures was also affected by the unpropitious state of the war, and by the dire plight of Hanover, which was in danger of being overrun by the French. Necessity demanded additional aid for Hanover and more material assistance for Frederick II. Any further support for the electorate appeared certain to ignite a controversy, and it was in this context that Pitt's apparent mastery of extra-parliamentary opinion, especially in the City, seemed of such importance. The championship of British interests against those of Hanover was a significant source of Pitt's patriot reputation, and provided an issue which he could exploit as Maidstone had illustrated, if he were not satisfied in any ministerial settlement. Waldegrave emphasised this danger when urging George II to overcome his aversion to Pitt: 'That the whole Weight of Opposition rested on a single Point, his Majesty's supposed Partiality to his Electoral subjects, which would at any time set the Nation in a Flame; and that being thought an Enemy to Hanover, was the solid Foundation of Pitt's Popularity.'[78]

Pitt's success in steering the potentially contentious grant of money for the Army of Observation thorough the Commons had demonstrated how essential his assistance would be for the approval of future requests. Hardwicke confessed that it would have been impossible for the Newcastle ministry to have pushed a similar measure through the Commons when confronted by Pitt's outspoken condemnation: 'Here is a great deal of extensive and expensive work cut out for the new Ministry, more I am sure than we could have gone through under the weight from bad successes and their opposition.'[79] Furthermore, in the spring of 1757 it was feared that Pitt alone could win the City's consent to raise the money required, not only for Hanover, but to sustain all military operations.

During the height of the negotiations, Pitt took advantage of a request made to Parliament for £1 million to cover the costs of the war, to highlight his capacity to disrupt further attempts to finance the fighting in Germany. Sensitivity to the adverse reaction to a plea for more money for Hanover had already caused the measure to be presented in general terms as a vote of credit. During the 18 May 1757 debate, Pitt declared his disapproval that any of the money should be devoted to the electorate, and insinuated that the true cause of his dismissal had been his determination to limit the amount of aid squandered upon it. He contrasted George II's miserliness as elector with the magnanimity of Frederick II, who solicited no subsidy. He asserted that 'the people had lost all confidence, seeing how surreptitiously their money was taken and given'. Pitt's threat of opposition if his ministerial aspirations were frustrated was aimed at Newcastle and George II. He reinforced it by emphasising his extra-parliamentary mandate and the backing of the Tories, 'He added some hints on his own popularity, and on the independence of the country gentlemen who favoured him.' Even as Pitt menaced however, he signalled a willingness to compromise. He highlighted his success in reconciling opinion in the Commons and without doors to Hanoverian measures by depicting them as assistance to Frederick II, whom he eulogised as the ally, 'who saw all, did all, knew all, did everything, was everything!'[80] Pitt's realistic attitude towards continental involvement had been indicated by his behaviour as secretary of state. In urging George II to accept Pitt, Waldegrave recognised that his anti-Hanoverian rhetoric was essentially a tactic to stress his indispensability: 'Nor would his former Violence against Hanover be any Kind of Obstacle, as he had given frequent Proofs that he could change Sides whenever he found it necessary, and could deny his own words with an unembarrass'd Countenance.'[81]

Newcastle's determination to accommodate Pitt was increased by the demoralising military prospect. Pitt was certain to exploit any defeat to launch a scathing attack upon the ministry and its Commons spokesmen, with a potentially critical impact upon its ability to manage the lower house. The Minorca crisis had subjected the individual members of the Newcastle ministry to immense pressure, leading to its collapse beneath the weight of mutual recrimination and distrust. Newcastle had learnt not to return to power without a resolute, effective leader in the Commons. Holdernesse's resignation when the formation of a Fox–Waldegrave ministry appeared imminent accentuated the refusal of Newcastle to expose himself to criticism in the Commons without the support of a committed ministerial colleague.[82] Newcastle like Holdernesse was unwilling to trust Fox to defend him, and he had no ally in the Commons to reply to Pitt, should his ministry be shaken by military disaster. Newcastle's anxiety of Pitt's ability to capitalise upon military failure was enhanced by the probability that any anti-ministerial rhetoric

he uttered in the Commons would be echoed without doors, reinforcing his opposition with a formidable extra-parliamentary dimension. Hardwicke, whose mediation secured the final settlement, was also swayed by this consideration. An alliance with Pitt would remove the threat of opposition in the Commons and secure the ministry's popular base.[83]

Although Newcastle and Fox professed satisfaction with the settlement, Pitt was discouraged by what he called 'a mutilated, enfeebled, half-formed system, which is every hour blown upon and brought into discredit'.[84] Pitt was anxious about the reaction of his patriot supporters to an alliance with Newcastle, which included a lucrative place for Fox and the return of Anson to the Admiralty. Lyttelton's indictment of Pitt for joining the former ministers he had bitterly opposed, and so recently repudiated, emphasised how vulnerable the coalition made him to allegations of hypocrisy and opportunism.[85] Pitt had adopted a moderate attitude during the parliamentary inquiry into Minorca to facilitate a coalition with Newcastle.[86] Several of his supporters were dismayed by his acquiescence in its findings, which exonerated the former ministers from charges of neglect.[87] When the new ministry was announced, some of Pitt's closest allies including the Townshends and Glover expressed disappointment that he had withdrawn from his undertaking never to serve with Newcastle or Fox.[88] The restoration of Anson was unpopular among commercial opinion in the City of London.[89]

Political literature sheds light upon the initial response of surprise, disbelief and disapproval evoked by Pitt's coalition with Newcastle. A poem accused Pitt of mock patriotism in making the compromise immediately after accepting the freedom of so many cities, which had praised his independence:

> Fye Billy, so Naughtily thus to behave,
> What just Dub'd a Free man, and List for a Slave
> With P[el]h[a]m and A[n]s[o]n those true Pack horse Peers,
> And Fox the Train'd War-Horse, to draw in the Geer's?[90]

It is difficult to assess the gravity of the political fallout stimulated by Pitt's alliance with Newcastle. Some evidence of the alienation of extra-parliamentary opinion is provided by reports that Chester had instructed its MP to recall the gift of its freedom to Pitt and Legge.[91] Pitt feared that the coalition might compromise his reputation in the City, for soon after it was announced, he clarified his motives and intentions to James Hodges.[92] Pitt's use of Hodges to mediate with his patriot allies in the City emphasises how highly he valued popular support, and the pains he took to cultivate it.

Literary sources suggest that Pitt's detractors may have exaggerated the depth and the extent of the controversy. There was relatively little adverse comment, while several works vindicating the coalition and welcoming his

return to power were printed. The *Con-test* remained loyal to its idol. The strategy it adopted to defend Pitt from charges of mock patriotism suggests why he was able to weather the political storm and emerge with his credibility intact. The journal implored its readers to place their trust in Pitt's unquestioned reputation for honour in private life, which was presented as a pledge of his future unfailing devotion to the public good. The strength of the plea to avoid impulsive, unjustified condemnation lay in an appeal to the hitherto unbroken harmony of Pitt and Legge's personal and political virtue:

> MORALITY, is the only criterion by which we can determine the sincerity of professed patriotism … And till by a series of administration, they have had opportunity of convincing mankind of the integrity of their *political* principles, we can only found our confidence on their *moral* character.[93]

The writer reversed the argument to defend Pitt from accusations of inconsistency in joining a ministry, which it was believed would make greater efforts to aid Hanover. The *Con-test* declared that even if Pitt were compelled to increase Britain's role in the continental sphere, it would remain subordinate and complementary to his vision of realising her imperial interests: '… there is a wide difference, between our moral and political conduct. In the one, we may preserve uniformity in the means as well as the end; in the other, the means will often appear to be inconsistent though the end is uniform'.[94]

A patriotic play voiced optimism that the new minister would remain true to his principles. Pitt's exemplary character, when combined with the influence he wielded as a result of his status in the Commons, would give him the opportunity to do great things for his country, '… it is in your power, to make yourself particular, because the greatest rarity in this world is – an Honest Orator'.[95] The dramatist warned of the trials awaiting Pitt, including the opposition of colleagues, who might attempt to frustrate his patriot policies. He was also cautioned against the temptations of the court, which had beguiled so many former patriot leaders. The epic nature of the struggle was emphasised by the exhortation to follow the example of God's champion Abdiel in *Paradise Lost*, who would be Pitt's guide and guardian angel:

> So spake the seraph Abdiel faithful found
> Among the faithless, faithful only he;
> Among innumerable false, unmov'd,
> Unshaken, unseduc'd, unterrify'd
> His loyalty he kept, his love, his zeal;
> Nor number, nor example with him wrought
> To swerve from truth, or change his constant mind.[96]

An updated version of an anti-Walpole political fable was printed, which endorsed Pitt's resumption of power with no misgivings about his partnership

with Newcastle. When the ants, the great patriots of the insect nation, are summoned to serve their monarch, they promise to follow the noble example of George II's new minister:

> From *Prussia's* King, the soldier's pride!
> Or *Pit*, the *English* senate's guide!
> We'll copy to be brave, and wise,
> To conquer foes, encounter vice.[97]

The poet's coupling of Frederick II and Pitt offers another illustration of how far the latter had been able to pacify popular aversion to European connections by associating them with the popular King of Prussia. Pitt's identification with Frederick II, combined with his previous success in restricting the scope of Britain's engagement in Hanover's defence, may indicate that patriotic opinion did not recoil against his alliance with Newcastle as a retreat from his promise to limit Britain's participation in the continental conflict. The poem's emphasis upon Pitt's energetic wartime leadership suggests that his popular supporters accepted the necessity of his return to government, even in partnership with unwelcome colleagues, if the revitalised military effort he had introduced was to continue.[98] This is the justification for the coalition in a naval allegory, which depicted Pitt as a pilot who responds to the desperate pleas of his captain to resume command of the ship of state, when it is threatened with destruction by a hurricane and enemy attack. Pitt agrees to rescue the directionless vessel, and even to serve with its former commanders Newcastle, Anson and Fox, provided they do not interfere with his running of the ship. The poem's publication in leading Pittite papers suggests that the argument of dire necessity was effective in conciliating patriot opinion.[99]

Members of all parties – Whig and Tory, Pelhamite, Pittite and Foxite – must have been persuaded to accept the coalition as an end to the self-destructive factional conflict, which had paralysed government and the prosecution of the war for nearly three months. The damaging consequences were strikingly illustrated by a print entitled *Without*. In addition to a visual design, it contained a complementary verbal description, which assisted the spectator in interpreting the images by applying the title to fill in the gaps. Thus the picture of French and Indian war parties burning the homes of British North Americans is supplemented by the caption 'Colonies [Without] Protection', and an engraving of a begging sailor by 'Seamen [Without] Encouragement'. The print's depiction of the effects of the vacuum of political leadership is emphasised by other captions which read, 'Manufactories [Without] Trade', 'Parading Fleets [Without] Fighting', 'Great Armies [Without] Use', 'The Common People [Without] Money', and 'The Poor [Without] Bread'. The ultimate causes of this damaging chaos were the factional struggles

succeeding Pitt's dismissal, which left the country in the hands of 'Supreme Majesty [Without] Power' and 'Counsellors [Without] Abilities'.[100]

A pro-Pitt reply to Walpole's Chinese letter, by refuting some of his attacks upon Pitt and Newcastle, reflected the willingness to compromise which brought the two politicians together. Lien Chi resolved the contentious issue of the Minorca inquiry in a manner which exonerated Newcastle and Anson from responsibility. At the same time, he insisted that Pitt had conscientiously examined into the facts, and had not colluded in the acquittal of guilty former ministers as the price of an alliance.[101] The author's handling of the question appears designed to remove one of the major obstacles to patriot opinion's acquiescence in the coalition, especially in the City. A poem urging Newcastle to ally himself with Pitt also suggests why opinion without doors accepted the coalition. The satire dramatises a meeting of Newcastle's party with his former partner Fox, who attempt to dissuade him from reaching an agreement with Pitt, motivated by jealousy, factious love of power and fear of losing their lucrative places. Revolted by their venality and incompetence, Newcastle takes refuge in Pitt, the only politician with the wisdom, courage, and integrity to lead Britain out of her demoralising military plight:

> But Plutus chose a Place more fit,
> He waited at the Nodd of [Pitt]
> Lighting at first, surprised to find,
> Mars and Minerva there combin'd.[102]

The popular mood of the poem is illustrated by Newcastle's confession of the significance of commerce in stimulating national wealth, which encourages him to approach Pitt, the acknowledged spokesman of mercantile opinion.

The *Wisdom of Plutus*'s advocacy of a partnership between Pitt and Newcastle should be set in the context of the entire press debate during the interministerium, which was largely defined in terms of the inveterate rivalry between Pitt and Fox. Its overall tone was anti-Fox. It was Fox's insatiable ambition which had precipitated Pitt's fall, and he was portrayed as the sinister figure lurking behind the throne, seeking to dominate affairs through Cumberland. There were critical references to Newcastle in literature and graphic art, usually associated with Minorca or expressing fear of his Hanoverian sympathies. They were relatively few in number when compared to the onslaught against Fox, perhaps reflecting an intention upon the part of those sympathetic to Pitt not to damage his prospects of a rapprochement with Newcastle. Pitt's allies Leicester House and the Tories were united with the Old Corps in their hostility to Fox, which provided a powerful incentive for the two parties to cooperate in his exclusion. Pittite literature seemed to regard Fox as the most dangerous threat. This attitude helps to explain how and why Pitt's patriot supporters were resigned to an alliance with Newcastle

as the lesser of three evils, when the alternatives would have been a Cumberland–Fox ministry or an administration composed entirely of the Old Corps. Although Pitt's allies remained suspicious of Newcastle, the coalition appeared to give Pitt the only opportunity to positively influence the conduct of the war.

NOTES

1 Paul Langford, 'William Pitt and Public Opinion, 1757', *English Historical Review*, 1973, LXXXVIII. 54–80.
2 *The Chronicle of the Short Reign of Honesty*, 1757, pp. 14–15.
3 *Ibid.*, pp. 19–21. Hodges, a bookseller, emerged as one of Pitt's staunchest supporters in the City, where he was elected Town Clerk on 10 May 1757.
4 *Britannia in Tears*, 1757, pp. 10–11; two editions were printed. 'On Mr. Pitt's Dismission', *LEP*, 19 Apr. 1757.
5 *For Our Country*, p. 12; 'On the Freedom of the City of London', *LEP*, 14 July 1757.
6 *For Our Country*, pp. 13–15.
7 Glover, *Memoirs*, p. 111; Walpole, *Memoirs*, II. 214.
8 'Acrostick', *LEP*, 9 July 1757.
9 *Short Reign of Honesty*, p. 20; *Harsh Truths*, p. 10.
10 *For Our Country*, pp. 10–12; 'On a Late Change', *LEP*, 7 May 1757.
11 *Britannia in Tears*, pp. 10–11.
12 *Ibid.*, pp. 14–15; *The Voice of Britain*, 1757, p. 14.
13 *Epigram 3rd of the 1st Book of Martial*, BMC 3571; *Oliver Cromwell to Honest Will Pat.*, BMC 3596.
14 *The True Patriot*, BMC 3599; *The Patriot Minister*, BMC 3600.
15 *The True Contrast*, BMC 3595.
16 *Short Reign of Honesty*, p. 21.
17 *The Voice of Britain*, p. 13; *Britannia in Tears*, p. 13.
18 *The Speech of William the Fourth*, 1757.
19 'The City Farce', *Test*, 23 Apr. 1757.
20 *Will Quixote*, BMC 3598.
21 *The Father of the City of Eutopia*, 1757.
22 *Ibid.*, pp. 2–20.
23 Walpole, *Memoirs*, II. 251.
24 *Ibid.*, 224.
25 *The True Contrast*, BMC 3595; *The Cato: of 1757*, BMC 3584.
26 Clark, *Waldegrave*, p. 155.
27 Fox to Devonshire, 22 May 1757, Ilchester, II. 49.
28 Hardwicke to Newcastle, 9 Apr. 1757, Yorke, II. 390.
29 *Wonder upon Wonder; The Wonder of Surry; The Freeholder's Ditty; Harsh Truths*, p. 10.
30 *Con-test*, 30 Apr. 1757.
31 Walpole to Mann, 20 Apr. 1757, *Corr.*, XXI. 77. Newcastle also appreciated the satire, BL, Add. MSS 33,075, fo. 122: Newcastle to Duchess, 10 Apr. 1757.
32 Ilchester, II. 43.
33 *The Sturdy Beggar*, BMC 3579; *An Ass Loaded with Trifles & Preferments*, BMC 3659.
34 *The Voice of Britain*, p. 14; *Harsh Truths*, p. 10.

35 *LEP*, 30 Apr. 1757.
36 Fox to Devonshire, June 1757, Ilchester, II. 51.
37 Lucy Sutherland, 'Henry Fox as Paymaster General of the Forces', *English Historical Review*, LXX (1955), 222–57.
38 Shelburne, I. 70. In 1761 and 1762, Fox's probable use of insider information about the prospects of peace to make profitable speculations on the stock exchange caused scandal; *Pandemonium College*, 1762.
39 Walpole, *Memoirs*, II. 156.
40 BL, Add. MSS 51,387, fo. 68: Fox to Ellis, 30 May 1757.
41 *An Allusion to the Tenth Ode of the Second Book of Horace*, 1757, pp. 1–8. Four editions were printed.
42 BL, Add. MSS 69,093, fo. 14: Fox to Hanbury Williams, n.d.
43 BL, Add. MSS 51,423, fo. 186: Hanbury Williams to Fox, 26 Apr. 1757.
44 BL, Add. MSS 69,093, fo. 14: Fox to Hanbury Williams, n.d.
45 *Late Change in the Administration*, p. 7; *Britannia in Tears*, p. 11.
46 BL, Add. MSS 35,416, fo. 158.
47 BL, Add. MSS 32,869, fo. 400: Newcastle to John Roberts, 26 Dec. 1756.
48 BL, Add. MSS 35,416, fo. 143: Newcastle to Hardwicke, 23 Nov. 1756; Hardwicke to Newcastle, 6 Dec. 1756, Yorke, II. 375; BL, Add. MSS 32,869, fo. 402: Newcastle to Robinson, 27 Dec. 1756.
49 Walpole, *Memoirs*, II. 248–9.
50 Walpole to Mann, 20 Apr. 1757, *Corr.*, XXI. 77.
51 *The Lying Hydra*, BMC 3633; *Court Manners*, BMC 3602.
52 *The Treaty*, BMC 3608.
53 Walpole to Mann, 1 June 1757, *Corr.*, XXI. 93.
54 *Con-test*, 11 June 1757.
55 *Ibid.*, 18 June 1757.
56 *Test*, 23 Apr. 1757.
57 *Court and Country* [1757], p. 22.
58 *Con-test*, 30 Apr. 1757.
59 *The Lying Hydra*, BMC 3633.
60 *The Crab Tree*, BMC 3592.
61 *The Temple and Pitt*, BMC 3652.
62 Horace Walpole, *A Letter from Xo Ho*, 1757, p. 2. Walpole's popular work produced five editions. A notable example of verse graffiti allegedly written upon the walls of a great house in the West End, and copied into the press, advocated an alliance between Pitt and Fox, Gee, p. 174.
63 Clark, *Dynamics*, pp. 354–447.
64 Hardwicke to Newcastle, 1 June 1757, Yorke, II. 396.
65 Walpole, *Memoirs*, II. 252.
66 BL, Add. MSS 32,870, fo. 372: Halifax to Newcastle, 7 Apr. 1757.
67 BL, Add. MSS 6832, fo. 152: Holdernesse to Mitchell, 27 May 1757.
68 Henry Digby to Lord Digby, 11 June 1757, HMC *Eighth Report*, Pt. I. 224.
69 BL, Add. MSS 35,416, fo. 182: Newcastle to Hardwicke, 8 Apr. 1757.
70 Walpole to Mann, 20 Apr. 1757, *Corr.*, XXV. 76.
71 BL, Add. MSS 35,416, fo. 182: Newcastle to Hardwicke, 8 Apr. 1757.
72 Newcastle to Devonshire, 2 June 1757, quoted in Clark, *Dynamics*, p. 404.
73 Ilchester to Lord Digby, [13 June 1757?], HMC *Eighth Report*, Pt. I. 225.
74 Walpole, *Memoirs*, II. 264.
75 Clark, *Waldegrave*, p. 205.

76 Walpole to Mann, 5 May 1757, *Corr.*, XXV. 87.
77 BL, Add. MSS 32,871, fo. 62: Stone to Newcastle, 12 May 1757.
78 Clark, *Waldegrave*, p. 206.
79 Hardwicke to Newcastle, 12 Dec. 1756, Yorke, II. 379.
80 Walpole, *Memoirs*, II. 257–8.
81 Clark, *Waldegrave*, p. 206.
82 BL, Eg. 3481, fos 64–5: Holdernesse to Bentinck, 12 July 1757.
83 Hardwicke to Lyttelton, 4 July 1757, Yorke, II. 410–11.
84 Pitt to Hardwicke, 22 June, 1757, *Ibid.*, 406.
85 Lyttelton to William Lyttelton, 23 Jan. 1757, [June 1757], Phillimore, II. 601.
86 Cobbett, XV. 822–7.
87 Glover, *Memoirs*, p. 133.
88 *Ibid.*, pp. 126–53; Walpole to Fox, 18 June 1757, *Corr.*, XXX. 134–5; Rigby to Bedford, 18 June 1757, Bedford, II. 252.
89 Walpole, *Memoirs*, II. 267.
90 BL, Add. MSS 35,398, fo. 338: Birch to Royston, 23 July 1757.
91 Walpole, *Memoirs*, II. 267.
92 BL, Add. MSS 35,398, fo. 345: Birch to Royston, 6 Aug. 1757.
93 *Con-Test*, 2 July 1757.
94 *Ibid.*
95 *Court and Country*, p. 4.
96 *Ibid.*, pp. 4–5.
97 *The Insects Chuse a Minister*, 1757, pp. 19–20.
98 'On the Return of the Right Hon. Mr. Pitt', *LEP*, 7 July 1757.
99 Reprinted from *Monitor* in *LEP*, 30 Aug. 1757; *FFBJ*, 3 Sept. 1757.
100 *Without*, BMC, 3605.
101 *An Answer from Lien Chi*, 1757, p. 8.
102 *Widsom of Plutus*, p. 27.

9

North America and Germany

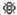

THE NEW MINISTRY was confronted with a bleak strategic situation in Europe. The conquest of Hanover appeared imminent. No help could be expected from Frederick II, who had been defeated at Kolin on 18 June 1757, and faced attack by France, Russia and Sweden. Pitt recognised the urgency of assistance to Cumberland and Prussia, but he was wary of its effect upon his patriot supporters. His freedom of action was limited by recent declarations against additional financial aid for Hanover and the deployment of British troops to reinforce Cumberland. Frederick II's requests that Britain commit troops to Germany were refused primarily because of Pitt's opposition.[1] He embraced Fredrick II's suggestion that Britain relieve pressure upon Hanover and Prussia's western flank by amphibious operations against the French coast, compelling the enemy to retain large numbers of troops at home, which would have been deployed in Germany. Rochefort was selected as the most vulnerable target. Pitt's enthusiasm was not shared by Newcastle and Hardwicke, and the ministry's military and naval commanders, who were sceptical of the strategic utility of the policy and warned of the problems posed by combined operations.[2] In urging the adoption of the coastal expedition, Pitt was influenced by its political advantages. It could be presented to patriot opinion as a measure, which by striking at French shipping and naval bases, was consistent with British commercial and imperial interests. Sir John Mordaunt was placed in command of the expedition's military forces, and Sir Edward Hawke was to lead the fleet.

Even before the expedition weighed anchor, the French defeated Cumberland at Hastenbeck on 26 July 1757, and pursued him into Hanover. On 8 September, he surrendered at Klosterseven. The terms of the Convention included the dissolution of the Army of Observation and the occupation of Hanover.[3] The expedition arrived off the Basque Roads on 20 September. The small island of Aix was captured, but further progress was hampered by

a lack of reliable intelligence concerning the French defences. The expedition was paralysed by a failure of initiative on the part of Mordaunt and poor cooperation with the naval commanders. After indecisive councils of war, the attempt was abandoned, and the expedition returned to Portsmouth on 3 October.[4]

Excitement surrounding what popularly became known as the 'secret expedition' had been stimulated by widespread speculation in the press about its destination, strength, expense and the wonders it would perform.[5] The expedition's ignominious failure ignited a fierce controversy, and the flames of discontent were fanned by literature and prints: 'The inglorious Return of our Land-forces from the Coast of France is the present Subject of Invective and Ridicule . . . in prints in prose and in Verse; and our Streets and Alleys eccho with the Ballads already compos'd upon it.'[6]

The most immediate, extreme reaction adopted a conspiratorial anti-Hanoverian theory, and accused the ministry of striking a deal with the French to recall the expedition in order to obtain more lenient terms for the electorate during the negotiations at Klosterseven. The fact that this inflammatory charge was propagated by many works, and initially attained a wide acceptance, reveals the strength of popular hostility towards Hanover.

The absence of sympathy for Hanover's plight had been suggested by the response to Hastenbeck. It had been invaded by the French, purely because of its dynastic connection to Britain, yet not only were many indifferent to its fate but, 'some even seem to exult upon the unfortunate Situation of the Electorate . . . and to wish that it may never be recover'd'.[7] George II's grief at the ravaging of his homeland was ridiculed in a mock-biblical satire, which associated it with the Old Testament humiliations of Israel. The Hanoverians' former pride and affluence 'when her Sovereigns were Emperors and when the Treasure of E[ngland] was spent among them' were contrasted with their present degradation.[8] Some of the King's most vehement critics blamed the electorate's demise upon his miserliness. It was alleged that Hanover could have been saved had George II hired sufficient mercenaries and called out its militia, rather than wait for Britain to pay for its defence.[9]

The description of the expedition as 'secret' took on a sinister meaning when it was rumoured that the assault upon Rochefort had been abandoned because George II feared reprisals against Hanover. It was claimed that a sloop was dispatched immediately after news of Klosterseven arrived, carrying confidential orders for Mordaunt to spare the French. A popular poem assigned the retreat to political interference:

> There was an old Man had a House,
> A very fine House had he;
> As fine a Place, as ever was,
> Or is in G[erman]y.

Some scurvy Frenchmen came that Way,
Who full of Wrath and Ire;
Declared they'd plunder all his Land,
And set his House on Fire.[10]

A satirical farce also blamed the frustration of the expedition upon the machinations of George II and his ministers, making it one of the articles inserted into the Convention. The author resurrected the ghost of the patriot martyr Admiral Hosier, who had reputedly died from shame when his imminent attack upon the Spanish fleet had been thwarted by secret orders from Walpole. Hosier's shade inquires, '*Does Treachery in* England *yet abound?*'[11] In a literal treatment of the indictment that the descent upon Rochefort was abandoned to appease Hanover's conquerors, a print portrayed a panic-stricken George II shouting across the channel to the British landing craft, '*Zouns call 'em back I shall not have a Turnip left.*'[12] Another engraving included the sloop, aptly named the *Viper,* which carried the orders recalling the expedition, whose captain declares, '*Venom to thy work*'.[13]

The ministry was alarmed by the political controversy instigated by the Rochefort affair. Walpole reported the fury of the City of London, whose members: 'talk very treason, and, connecting the suspension at Stade with this disappointment, cry out, that the General had positive orders to do nothing, in order to obtain gentler treatment of Hanover.'[14] In late October 1757, Beckford and Wilkes warned Pitt that the City was considering an address demanding an examination into the disaster.[15] Pitt's ally Potter reported the growth of popular discontent in Bristol and Bath which, 'rises to a degree, and points to a place which makes me tremble'.[16] The spread of popular animosity and the prospect of a petitioning campaign was disturbing to Pitt, since it threatened to alienate his support without doors, which he relied upon to maintain his political weight and independence within the ministry. To quash the rumours of secret instructions and a Hanoverian conspiracy, Pitt arranged for the printing of the only orders dispatched to the expedition after it had sailed, which authorised Mordaunt and Hawke to delay their return if necessary.[17] Charles Jenkinson reported the success of Pitt's damage control exercise.[18] Although Pitt's recourse to the press allayed fears of a Hanoverian intrigue, a burning desire to discover the causes of the debacle remained unsatisfied. Indignation was aggravated by the contrast between what was expected and what was achieved. Instead of the destruction of a French naval base, the ambitious expedition, which was rumoured to have cost as much as £2 million, returned with no greater triumph than the conquest of an insignificant island and its vineyards, which one poet described as 'about as big as St Paul's Church-yard'. The capture of its garrison of six hundred soldiers was dismissed as at best a burden, and at worst, further encouragement of the French cultural invasion:

> Some say that no *Service* can come of this *Prize*,
> But lest any one think, do they talk very wise?
> *Useless mouths*! No such thing, for they're surely of *Use*,
> To eat up our *Bread*, Sir, and *French* introduce.[19]

The author of a feigned letter from Louis XV suggested the employment of the prisoners as domestic servants for Britain's francophile aristocrats.[20]

Queries regarding the expedition's strategic utility and the thoroughness of its planning represented another danger to Pitt, who was identified as its promoter.[21] Devonshire suggested that the attempt upon Rochefort had been undertaken 'with very slender information of the real strength of the place, or the nature of the coast'.[22] Literary evidence illustrates a strain of opinion which held Pitt responsible for the miscarriage. The attack was portrayed as a Quixotic enterprise, doomed by its tactical impracticality and poor preparation. These allegations threatened to undermine confidence in Pitt's abilities as a war leader, but perhaps the most damaging charge levelled against him was political. Critics sought to expose the selfish political calculations that lay behind a strategy, which was designed, not to further important national interests, but enhance his reputation among his patriot supporters. This attack is reflected in two poems, which adopted the mock-heroic mode to satirise the expedition's inglorious conclusion. The first gibed at Pitt's pretensions to classical virtue and a popular mandate by comparing the expedition to a gladiatorial show staged by an unscrupulous Roman tribune or emperor to beguile the fickle mob. If it had been adopted:

> (in Imitation of the Romans of old, who you seem to emulate in all your other Actions) to amuse the People with a naval Show, upon your Entrance on your new Employment; methinks it would have better tally'd with a true magnificent Spirit, to have built an Amphitheatre on purpose.[23]

The second poem accused Pitt of exploiting the expedition to divert the attention of his patriot allies away from his coalition with Newcastle, and his deepening commitment to the continental war. It alluded to contemporary predictions of the return of Halley's comet to claim that Pitt's primary goal was to conceal his compromises beneath a dazzling, but futile display of maritime power:

> The wonder both of friends and foes,
> The project, like a meteor rose,
> That gleams athwart the night;
> France to th' alarm; all England gaz'd;
> The patriots plum'd; the people prais'd,
> With ignorant delight.[24]

The authorship of the poem was assigned to Chesterfield, an attribution supported by his use of the comet metaphor around the time of its publication, 'the tail of the Hanoverian neutrality, like the comet, extended itself to Richelieu'. Chesterfield denied the rumours, but praised the ode as a masterful stroke of satire.[25] Criticism of Pitt was reinforced by a print, which depicted him receiving a gold box from the citizens of Rochefort, in gratitude for the preservation of their city, harbour and ships.[26]

Pitt reacted to halt the spread of condemnation in the same way that Newcastle, Hardwicke, Fox and Anson had attempted to evade blame for Minorca – by scapegoating the expedition's commander. Newcastle reported: 'He told me yesterday, that *he,* or Sir John Mordaunt must be tried . . . thinking . . . that the measure would greatly increase his popularity, when it should appear that it failed purely from the behaviour of the land officers.'[27]

Pitt may have been encouraged to prosecute Mordaunt by the disastrous outcome of the campaign in North America, which also threatened to inspire doubts of his competence as a military planner. Lord Loudoun, commander of the assault upon Louisbourg, had abandoned the attempt in the face of French naval superiority. While British forces were concentrated in the east, the French destroyed Fort William Henry on Lake George, which defended northern New York. The significance of the fort's destruction was magnified by reports of the massacre, which occurred after its surrender.[28] Pitt sought to deny responsibility for the defeat by blaming Loudoun, who was relieved of his command. To pre-empt further criticism over Rochefort, on 1 November an inquiry was set up to examine the behaviour of Mordaunt and the other military officers. Its political motivation was revealed by the notification that Pitt sent to the Lord Mayor of London. Pitt's almost unprecedented action, which highlights the great value he placed upon the support of the City, appeased those who had threatened an address. Pitt's pandering to popular opinion was resented by many of his colleagues and conservatives among the parliamentary classes, who regarded it as an undignified and dangerous concession.[29] The inquiry's report was critical enough of Mordaunt for a formal court martial to be convened on 14 December 1757.[30]

The prevailing tone of literary reaction to the expedition's failure had been hostile to Mordaunt. It was promoted by Pitt's denial of the rumours that the ministry had recalled the fleet, and the court martial, which appeared to distinguish him as the one primarily accountable. George II's contempt for Mordaunt also prejudiced opinion against him.[31] Wilkes reported, 'The truth is now generally known, and the saddle laid on the right Ass.'[32] Mordaunt was abused as a coward in terms reminiscent of the onslaught against Byng.[33] The comparison was encouraged by his summoning several councils of war

to assess the risk of a landing, which revealed his reluctance to take personal responsibility:

> But, Thanks to our Stars, we had *Councils* of *War*,
> And *Councils* of *War*, Sir, are now very far
> From *Fighting* at all: Sir, they're only design'd
> To keep our *Bones* whole, tho' your *Eyes* they may blind.[34]

Mordaunt's reasons for calling off the attack, including the strength of the French fortifications and the great number of defenders, were ridiculed as signs of fearfulness, credulity and a devious attempt to palliate his negligence. He was condemned for accepting a French volunteer's report that an assault would be rendered futile by a formidable water-filled ditch:

> And we'll have Rochfort by and by,
> As soon as that damn'd Ditch is dry.[35]

The charge that Mordaunt seized upon this difficulty as a pretext to vindicate his retreat was pressed home in a ballad, whose performance interrupted Charles Jenkinson's composition of a letter, 'While I was writing my ears were saluted with the Cry of a ballad on the Ditch of Rochfort, which I send you.'[36] The general was also accused of magnifying the number of French troops mobilised to repel the landing. George Townshend published a print portraying Mordaunt peering through his telescope at a ragged rank of Frenchwomen drawn up on the beach to oppose him. His fear transforms them into an intimidating force of Swiss Guards.[37] Widespread popular enmity towards Mordaunt, which the assaults in ballads, poetry, drama and prints had helped to promote, was illustrated by effigy burnings of the unsuccessful general.[38]

When giving evidence at Mordaunt's court martial, Pitt defended the feasibility of the expedition, and suggested that its miscarriage was caused by the negligence of the military commanders. He also condemned their conduct in Parliament. The trial of Mordaunt did not silence Pitt's most determined critics, who accused him of persecuting an innocent man to salvage his reputation:

> Yet still support the great design,
> For eloquence, perchance, like thine,
> May prove it wise and great;
> Say *Hawke* and *Mordaunt* were afraid,
> Let them, like *Fowke*, be victims made,
> 'Tis a mystery of state.[39]

Mordaunt's acquittal was a potentially damaging outcome for Pitt, since it reflected upon the practicality of the expedition. The general literary response,

however, did not follow up the implicit criticism, but condemned the soldiers who tried Mordaunt for shielding a guilty comrade:

> Acquitted with honour – it can't be denied –
> Yet remember brave soldier, by whom thou wert tried.
> That *par pari gaudet*, old saws often tell us,
> 'Quit me, I'll 'quit you, we are all gallant fellows.[40]

A print also denounced the court martial for its alleged partiality towards a brother officer.[41] The majority of works demonstrate the success of Pitt's efforts to shift censure for the expedition's failure away from faults in its planning and on to Mordaunt:

> Now Pitt who should Blame,
> For he fail'd in his Scheme,
> Would Act like a Jew or a Turk-man;
> What Knaves or what Fools,
> The fault of the Tools,
> Would lay to the Charge of the Workman.[42]

The conclusion that the Rochefort crisis did not undermine the faith of Pitt's supporters is strengthened by other evidence. During the Lord Mayor's pageant in the autumn of 1757, there was an extraordinary expression of the London citizens' unshaken adoration: 'The Popularity of Mr. Pitt is still so high that the Mob almost broke the new Lord Mayor's Coach on Wednesday from their Impatience to see the Secretary of State.'[43]

The loss of Hanover had potentially damaging consequences for Britain, and would have to be recovered at the conclusion of the war, ransomed by the surrender of conquests in North America or elsewhere. Its occupation encouraged George II's inclination to accept a treaty of neutrality. Hanover's withdrawal from the war would expose Frederick II to attack by the undivided force of the French army, perhaps leading to his negotiation of a separate peace, the isolation of Britain, and the triumph of France upon the continent.[44] Frederick II's indignant reaction to the Convention was anticipated in a print by George Townshend (Plate 16), which employed a turnip farm as a symbolic representation of Hanover. Cumberland drags Britain's abandoned ally behind a turnip cart, who exclaims, *'is it for this I have Sustain'd the heat of the battle Alone, & now be to deserted, Shame! Vengeance!'*.

In October 1757, George II renounced the Convention, encouraged by Pitt's proposal that Britain would take over the pay of the remobilised electoral forces.[45] Although expensive, and politically contentious, this decision would allow Britain to exercise greater strategic control over the army's operations. The army returned to the field on 28 November, under the

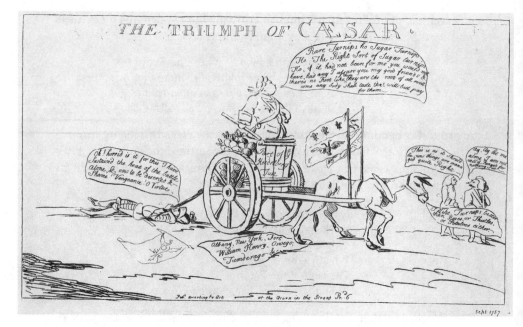

16 *The triumph of Caesar*

command of Prince Ferdinand of Brunswick, whose appointment had been recommended by Frederick II. It was hoped that the repudiation of the Convention and the offer of a subsidy would cement the alliance with Frederick II. These initiatives threatened to place immense strain upon Pitt's relations with his patriot allies. Klosterseven and Rochefort revealed the depth of hostility towards Hanover and Britain's involvement in the continental war. *The Triumph of Caesar* had denounced the ministry for sacrificing British imperial interests in favour of the electorate by portraying Cumberland riding his turnip cart over a scroll engraved with some of the most important sites of the war in North America, which included Fort William Henry. Its protest against Hanover's distortion of British military policy lay in the description of the turnip *'as the root of all evil'* (see Plate 16).

Pressured by the crisis in Germany, which demanded a more active policy on the one hand, and the expectations of his supporters on the other, Pitt was forced to walk a very narrow political tightrope. Pitt's success in resolving the conflicting tensions without alienating either George II and Newcastle, or patriotic opinion, illustrates his political importance and provides a testimony to his skill. Pitt devoted considerable energy to justifying the new measures to the Grenvilles, Legge and Bute. Thomas Potter mediated with the Tories and other allies.[46] At the same time, Pitt made clever use of the

advantages inherent in his unique political position. He exploited the ministry's dependence upon him to act as its advocate in the Commons and its link with political forces without doors. Hardwicke stressed Pitt's indispensability when conceding that controversial decisions such as an emergency grant to Hanover and financial aid to Hesse would never have received parliamentary and popular approval without his assistance.[47] Pitt's more sympathetic attitude towards the electorate gratified his colleagues, and improved his relations with George II. In exchange, Pitt pressed George II and Newcastle to accept patriot initiatives such as the coastal expeditions and the militia, which preserved his credibility in the City, with the Tories, and among the wider political nation.

In the constant struggle over policy, Pitt frequently resorted to threats and exaggerated allegations to achieve his aims. To Newcastle he charged that the failure at Rochefort was caused by the poisonous influence of Cumberland and the King, who calculated that it would leave the ministry with no option but to engage all available British forces in the defence of Hanover. He also claimed that Loudoun's inactivity was part of the conspiracy to discredit him. Pitt threatened to withdraw his support for Hanover and even resign if the coastal expeditions did not receive more wholehearted backing in the future.[48] To his patriot allies, however, he portrayed his compromises over Hanover as faits accomplis dictated by the Pelhamite faction, who dominated the Cabinet and the court. Literature commenting upon the crisis illustrates how Pitt achieved such a dexterous balancing act, and distanced himself from the ministry's most controversial measures. Authors sympathetic to Pitt accepted his disavowals of responsibility, and threw the blame for growing entanglement in the continental conflict upon his colleagues. Pitt's charges that Cumberland was abusing his authority to promote greater involvement in the German war were echoed in poetry, plays and prints. It was alleged that Cumberland's lieutenant Fox plotted to take advantage of the Hanoverian crisis to regain his waning influence at court. Responsibility for the pro-Hanoverian bias of British policy was also assigned to Newcastle.[49] The popular belief that the Cabinet was divided over the issue of Hanover, and that Pitt vigorously fought to champion the national interest against the superior power of the Pelhams, was strikingly dramatised in the *State Farce*. During a violent altercation over whether to preserve Hanover by recalling the Rochefort expedition, Pitt and Anson draw swords upon one another, and a fatal encounter is only prevented by the intervention of Legge and Fox.[50]

Hanover's fall was fortuitous in that Pitt's hold upon power was reinforced by Cumberland's disgrace. George II bitterly condemned his son for offering little resistance to the French, and even accused him of cowardice.[51] In repudiating the Convention, the King attempted to save face by claiming that Cumberland had negotiated it without his authority. Cumberland

attempted to exonerate himself by resigning as captain-general and surrendering all of his other military offices and honours. Many anti-Hanoverian poems and prints had condemned Cumberland as a blustering martinet, whose want of leadership, courage and skill was woefully exposed at Hastenbeck.[52] Critics charged that he had owed his position to the misplaced affection of his father, and several prints depicted him as a spoiled child playing at soldier, who was punished with a stiff caning by his vanquisher Marshal d'Estrées.[53] With the exception of an engraving castigating the Hanoverian ministers for compelling Cumberland to accept the Convention, and a ballad ostensibly voicing the army's regret at his loss, the duke's retirement inspired little expression of sympathy in literature or prints.[54] To make Cumberland's retreat irrevocable, Pitt and Newcastle convinced George II to appoint the veteran soldier Sir John Ligonier commander-in-chief, whose role would be limited to offering the Cabinet advice upon military matters.[55] Pro-Pitt publications welcomed Cumberland's fall as signalling the eclipse of his enemy Fox:

> And thou on a common, great commoner bred,
> With a bosom corrupt and a deep-scheming-head,
> With plans fraught with ruin, no longer oppress us,
> But thy patron disgrac'd, soon retire and bless us.[56]

During the autumn of 1757, Pitt was also threatened by opposition to the militia. Efforts to carry out the census of men liable to serve provoked violent popular resistance. Protestors sought to halt the execution of the act by seizing the lists from the local officials responsible for compiling them. The rioters were primarily composed of rural labourers, colliers and weavers, but numbers of tenant farmers also participated. The rioting was most heavily concentrated in the eastern counties and Yorkshire, although there were also incidents in the Midlands and the West Country.[57] Hostility towards the militia was aroused by a belief in the basic inequality of the scheme, which disproportionately placed the financial burden and the obligation to serve upon the labouring poor. There was anxiety that militia men would receive no pay. Probably the greatest fear of potential recruits was that they might be draughted into the regular army and compelled to serve abroad.[58] This rumour had been stimulated by the treatment of men raised by Lord Digby as part of the plan whereby the nobility and gentry had helped to raise volunteers for the army. Despite assurances to the contrary, many of the recruits were forced to fight overseas. The violation of this promise, popularly known as 'Digbying', became notorious, and many men who were eligible to be drawn in the militia ballot dreaded a similar fate.[59] A ballad recorded the sense of injustice which informed the anti-militia riots, and the protestors' apprehensions of being taken from their families and homes, perhaps to die in a foreign land:

> Though many do laugh at the Militia Men,
> And say to Old England we never shall come again,
> And are to be draughted to cross the raging Seas,
> While such as do encourage us do live at home in Ease.

The balladeer, who claimed to be a militiaman himself, concluded with a stark warning to the government:

> But if we are transported out of our Native land,
> Upon our Friends in England we'll turn with Sword in Hand.[60]

The implementation of the Militia Act was also delayed by hostile lord lieutenants, and the unwillingness of many of the gentry to serve as officers. The causes of this reluctance to support the militia were suggested by literary works, which ridiculed the scheme as the product of absurdly extravagant notions of patriotism. A novel written by the lawyer Edward Long, narrating the misfortunes inflicted upon the family of a Kentish country squire by his belligerent patriotism, emerges as an excellent example.[61] Harry Cobham had been elected president of an association dedicated to oppose the expansion of French economic, cultural and military power, which in reality was composed of cunning sharpers, who prey upon his naivety to rob him of his fortune. During the '45 Cobham had raised a regiment of dragoons at his own expense, and embarked upon a desperate attempt to infiltrate the Jacobite army, and assassinate the Pretender. He was abandoned by his comrades, captured by a loyalist mob, and narrowly escaped execution as a rebel himself. During the invasion scare, Cobham was duped into fortifying his country house by the conspirators, who attempted to murder him and abscond with the funds he had advanced for the purchase of arms and military stores. In his blind obsession to raise the money, Cobham was willing to sacrifice his family and fortune, and engaged his beautiful young daughter to the villainous old Jacobite lawyer Tripartite, who offers a loan, with Cobham's estate as security. Cobham's narrow escape from self-destruction, thanks to the exposure of the mock-patriot society, and a philanthropic young baronet who falls in love with his daughter, opens his eyes to his folly. The Kentish squire abandons taking up arms himself, and consoles himself by drilling his servants in the military exercise. Cobham finds a wiser outlet for his patriotic zeal in an association to encourage the enlistment of soldiers through the offer of a generous bounty.

The militia was dismissed as a poor substitute for a professional army. It was derided as an incompetent rabble, officered by a set of bellicose country bumpkins and shopkeepers, whose vanity was indulged by the prospect of a commission and the opportunity to parade about in a military uniform. Samuel Foote reflected this caricature of the militia through the misadventures

of the mock-heroic fishmonger turned officer Major Sturgeon and his comrades in a farce written soon after the conclusion of the war.[62]

The poet Dr Mark Akenside appealed to Britain's lords and gentry to embrace their role as the militia's natural leaders, reminding them of the responsibilities as well as of the privileges inherent in their position:

> Why are ye tardy? What inglorious care
> Detains you from their head, your native post?
> Who most their country's fame and fortune share,
> 'Tis theirs to share her toils, her perils most.
> Each man his task in social life sustains.[63]

The apathy of the country gentlemen towards defending British religious, as well as political freedom, was symbolised in a print, which portrayed a militia chaplain preaching to a snoring major.[64] Akenside's poem was written in response to the disturbing militia riots, but its reproach against Britain's landowners for neglecting their patriotic duty adopted a broader perspective, including other sources of popular discontent, such as widespread hunger caused by shortages of grain.[65] Akenside argued that the traditional ties binding together the rural community had been weakened by the failure of the governing elite to quickly alleviate the sufferings of the rural poor. The charitable response of landlords had been inadequate, and the emergency measures introduced by Parliament were slow to take effect. Parliament's refusal to reform the grain marketing system, which it was widely believed favoured the interests of the farmer and landowner, and encouraged speculation, also increased social tension in the countryside. The problem was aggravated by other controversial issues such as the Game Law, and the progress of the enclosuring movement.[66]

This context of wider alienation helps to explain why popular reaction against the discriminatory aspects of the militia was so violent. The apparent indifference of the wealthy and powerful to their privation discouraged many among the labouring poor from taking up arms to defend a social system, which seemed unjust. According to Akenside, for the militia to function smoothly, the trust of the countryside, forfeited by 'Digbying' and an apathetic reaction to famine, had to be restored. He urged the country gentlemen, shocked by the popular animosity demonstrated in the militia and food riots, to regain the confidence of the rural poor by more sincere exertions to protect their welfare. Although Akenside's injunction to England's great landlords to embrace their paternalistic responsibilities, so generously honoured by their ancestors in a former golden age of rural harmony, seems naive and inadequate as a permanent solution to class tension, his poem offers insight into the fundamental lack of trust which lay behind the militia disturbances:

Alas, *your* fathers did by other arts
Draw those kind ties around their simple hearts,
And led in other paths their ductile will;
By succour, faithful counsel, courteous cheer,
Won them the ancient manners to revere,
To prize their country's peace and heav'n's due rites fulfil.[67]

Hostility to the militia among those compelled to serve proved embarrassing to Pitt. He did not abandon the militia, a decision which reflected a belief that it still commanded support in patriot circles. Given the tension created by greater engagement in the German war, defence of the militia offered Pitt the opportunity to demonstrate his unshaken devotion to a cause which still mattered to many. Characteristically, Pitt at first responded aggressively and refused to acknowledge the reality of discontent. He accused the militia's Old Corps Whig enemies of attempting to sabotage it by inciting opposition.[68] With Pitt's backing, Townshend introduced a bill of amendment and clarification, which addressed the most serious criticisms of the protestors. It permitted selection by voluntary recruitment. It expressly stated that enrolment was limited, and that there would be no service overseas. Anxieties regarding pay, sick leave and the welfare of soldiers' families were also addressed. A campaign was undertaken to remove popular fears by the circulation of explanatory manifestos into the countryside, and by their publication in the newspapers. To render delay more difficult by those lukewarm to the militia, more explicit instructions were given for implementing the act. The bill was passed by the Commons on 14 April 1758, and approved by the Lords soon after.[69]

The new session of Parliament opened on 1 December 1757. Pitt had to obtain approval for the maintenance of the Hanoverian army, and a subsidy for Prussia, which was one of the terms of an alliance being negotiated with Frederick II. These expensive new continental commitments required tactful handling to secure the consent of his patriot constituency within the Commons and without doors. Pitt's dilemma was rendered more critical by Frederick II's renewed pressure for the ministry to reinforce the Army of Observation with British troops. Anxious about the compromises already made, Pitt refused to consider the request.[70] The Speech from the Throne omitted any specific reference to Hanover, whose defence was subsumed in George II's pledge to protect 'the rights of my Crown and subjects in America and elsewhere'. Walpole mocked the equivocation 'elsewhere' by which 'Hanover was incorporated into the very language of Parliament', but observed that Pitt escaped serious challenge.[71] During the session, Pitt vindicated financial support for the Army of Observation by emphasising that it was now under British control, and would be employed in the achievement of a national goal in conjunction with Prussia: the containment of French power upon the

continent, leaving Britain free to pursue the maritime-colonial struggle. Pitt's advocacy of the partnership with Frederick II was strengthened by the King's decisive victories over of the French and Austrians at Rossbach in November, and over the Austrians at Leuthen in December 1757, which transformed the military situation in Germany.[72] Pitt played upon the extraordinary outburst of admiration inspired by these spectacular victories to promote the Prussian alliance.

In Parliament on 14 December Pitt made a powerful declaration against the sending of British troops to Germany, he 'would not now send one drop of our blood to the Elbe, to be lost in that ocean of gore'.[73] In making such a striking statement, clearly aimed at patriot opinion, Pitt sought to reassert his claim to be the true champion of British interests. A strong stand against the dispatch of British troops helped to divert attention away from the reversal of his earlier opposition to continental war and subsidy treaties. There is evidence that Pitt may have convinced the Tories to accept the payment of the Hanoverian army and the Prussian subsidy in exchange for a promise against the deployment of British forces.[74] In March, however, an indication of Pitt's pragmatic attitude towards the war in Germany was illustrated by his agreement to send a British infantry battalion to secure the strategic North Sea port of Emden for Frederick II when it was evacuated by the French.

Plans had been finalised for the campaign in North America, where the build-up of British naval and military superiority encouraged the hope of significant progress. Offensives were to be launched on three frontiers: against Louisbourg, Montreal and Fort Duquesne. An attack was also to be made against French trading centres on the Senegal River in Africa. Reports of any success in North America, which would reassure those who feared that imperial interests were being neglected, could not arrive before the autumn. In the meantime, during the spring of 1758, Pitt embraced a series of patriot issues in order to prevent a backlash over the retreat from his recent declaration against the sending of troops to Germany, and to facilitate the smooth passage of the continental military expenditures through the Commons. Pitt's backing for the militia has already been discussed. He also attempted to bolster confidence in his commitment to patriot ideals by championing a bill to extend the scope of habeas corpus, a controversial measure inspired by an incident of illegal impressment into the army. In the Commons, Pitt promoted the Habeas Corpus Bill, and denounced the legal establishment for opposing such an important protection of the people's liberty. The Bill passed the Commons, but was rejected by the Lords early in June 1758.[75] Although the initiative failed, Pitt's passionate attempts:

> To push the barrier back that Freedom braves,
> To mark the bounds of subjects, not of slaves:

were appreciated without doors, and did much to consolidate his reputation as a defender of the constitution.[76] Pitt also supported George Grenville's bill for the more efficient payment of common seamen's wages.[77] Pitt's persuasion of the Cabinet to approve another amphibious operation against the French coast also diverted the gaze of political spectators away from contentious continental developments.

The success of Pitt's efforts to prepare the way for a subsidy of £670,000 for Prussia, and financial provision for Ferdinand's army of over 50,000 men, was demonstrated by the ease with which they were approved by the Commons in April and June 1758. Significantly for Pitt, none of the Tories opposed. Chesterfield commented upon the unprecedented spectacle of costly continental commitments, accepted with so little debate: 'This only is extraordinary, that last week, in the House of Commons, about ten millions were granted, and the whole Hanoverian army taken into British pay, with but one single negative.'[78] On 7 June, a vote of credit containing a subsidy to Hesse-Cassel was also carried in the Commons, offering additional proof of Pitt's tactful handling of the situation.

During the session, Pitt prepared parliamentary and popular opinion for the deployment of British troops to Germany. Ferdinand had proved his competence by a successful offensive, which by April, had driven the French out of Hanover. Without reinforcement, however, Ferdinand like Cumberland before him, faced the prospect of being overwhelmed by French numerical superiority. On 19 April, Pitt dwelt upon the lessons of the past, which emphasised that British interests required the maintenance of a favourable balance of power upon the continent. He argued that in Frederick II, Britain had at last secured a powerful military ally, whose extraordinary victories, if sustained by troops as well as by financial aid, would prevent France from nullifying British imperial gains by her preponderance in Europe. Pitt worked hard to win the acquiescence of his closest allies. Appeals to Bute obtained the consent of Leicester House, although Prince George privately expressed dissatisfaction with Pitt's wavering over such a critical issue. Temple and Beckford also agreed, but their reactions reflected doubts which would be shared by many Tories and patriots in the City. Temple was concerned lest the first step lead to an irreversible process of entanglement. These misgivings were echoed by Beckford, who reported that there would be no objection to a reinforcement of cavalry, which could not be deployed in large numbers in the coastal expeditions or in North America, but that the sending of infantry would arouse fears that British military resources would be diverted to Europe.[79] The decision to send a British contingent to Germany was not made until after Parliament had risen, which provided a respite of several months before the move would have to be justified in the Commons. Pitt hoped that by the opening of the new

session, British victories in North America and Africa would disarm potential opposition.

In the meantime, the expedition against France drew eyes away from the controversial development. A descent was made upon St Malo on 5 June 1758, which Pitt's camp claimed had destroyed 130 French ships, including three men of war and thirty privateers, and diverted 30,000 troops from Germany.[80] In early August, an even greater success was hailed with the capture of Cherbourg, and the demolition of its harbour and fortifications, reputed to have cost the French £2 million to construct.[81] The exploits of the secret expedition were not the only cause of elation during the spring and summer of 1758. Intelligence from India recorded the expansion of the East India Company's influence under the leadership of Clive after his brilliant victory at Plassey in June 1757. The company's operations had received able assistance from a Royal Navy squadron.[82] On 13 June, reports reached England of the capture of the French fort and trading factories at Senegal.[83] Ferdinand's victory over the French at Creveld on 23 June secured the safety of Hanover, and confirmed the more propitious state of affairs upon the continent. Perhaps the most eagerly awaited news arrived on 18 August, when a *London Gazette Extraordinary* announced the conquest of Louisbourg. Five French ships of the line and four frigates had been destroyed, and 3000 prisoners were captured. Later in the year, the report of another victory in North America was received. A raid against Fort Frontenac on Lake Ontario destroyed an important base for the logistical support of France's military and trading posts on the Great Lakes and in the West.[84]

The outcome of the 1758 campaign was not uniformly successful, with a reverse in North America, and the anti-climactic return of the coastal expedition. General James Abercromby's attempt to seize Fort Ticonderoga as the first stage of the offensive against Montreal was repulsed with heavy casualties.[85] After its return from Cherbourg, the expedition made a second descent upon St Malo. The army landed at Lunaire Bay, but was forced to retreat when surprised by a superior French force, and the grenadiers who covered the re-embarkment suffered considerable losses. The bungled attempt and the sacrifice of several hundred soldiers generated controversy, in which blame was directed primarily against the expedition's commander, General Edward Bligh.[86] Some of the fallout, however, was political and threatened Pitt, because the misadventure revived doubts about the strategic wisdom of the coastal expeditions. Fox expressed the criticism that their achievements were disproportionate to the resources they consumed with the metaphor 'breaking windows with guineas'.[87] Scepticism about the expeditions, and anger over the failure at St Malo, were voiced in an ode set to the tune 'The British Grenadiers'. The author dismissed claims regarding the diversionary value of the landings, and the destruction of French shipping, as grossly exaggerated:

But first to give a certain Proof, their landing was not Vain,
They Burnt a Fleet of Fishing Boats, in Number just Thirteen,
They clear'd the Country all around of Pigs, Geese, Cocks and Hens,
For these Exploits who can deny that these were able Men.

The poem concluded with a reproach against the ministers who had planned
and ordered the futile bloodshed:

What happen'd more I cannot say, let Tears proclaim the rest,
And Heaven receive those Grenadiers that perished at *St Cass,*
Like Soldiers brave, they fought, they dy'd, and proved their Antient Race,
May those be d[am]n'd that brought them there, I'll say it to their Face,
To *England* what *Disgrace, Disgrace,* to *England* what *Disgrace,*[88]

Fortunately for Pitt, this was the only important hostile work inspired by
the disappointments at St Malo or Ticonderoga. Literary and other sources
suggest that political opinion in general accepted that the setbacks were the
responsibility of the military commanders, and they did not lead to any
substantial backlash against the ministry.[89] They were overshadowed by the
conquest of Louisbourg and the other victories, which helped to forestall
criticism.[90]

Senegal, Cherbourg, Creveld and above all the acquisition of Louisbourg,
sparked ecstatic celebration, which included bonfires, fireworks and illumina-
tions. National pride was stimulated by ostentatious triumphs. The standards
captured at Louisbourg were paraded from St James's Palace to St Paul's
Cathedral, a symbolically significant act of revenge against the French for
exhibiting the colours taken at Minorca in Notre Dame. Cannon captured at
Cherbourg were dragged from Portsmouth to London, where they were
inspected by the King in Hyde Park, and put on public display. Enormous
crowds attended both processions.[91] Over the ensuing months, Louisbourg
inspired more than fifty addresses of congratulation, including one from Lon-
don and many from other trading centres.[92] Poets and balladeers recorded
the joyful reaction of a nation, whose confidence had been badly shaken by
nearly three years of defeat and disillusionment. Their works chronicled the
heroism of the British soldiers and sailors who conquered in India and at
Cherbourg, Senegal and Louisbourg.[93] A poem by Thomas Newcomb exulted
in the parading of the captured trophies:

See! how the *Gallic* colours droop their head,
 As conscious of their wretched master's shame;
No more their silver light the lilies spread,
 Once shining to assert their monarch's fame:
With faint and fading lustre now they bloom,
The lion blazing in the lilies room.[94]

A verse narrative of the siege of Louisbourg written by a naval officer who participated, was commended by the *Critical Review* as proof that 'we can conquer the French in arts as well as arms'.[95] Tributes were also paid to Prince Ferdinand for gallant behaviour at Creveld, and another victory won on 5 August 1758.[96]

In political terms, the string of successes strengthened Pitt, who was acknowledged to be the catalyst of Britain's revived military fortunes. This trend was encouraged by his supporters in the City, who ensured that he received special recognition in its congratulatory address. Pitt's reputation was enhanced by the grandiose triumphs organised to commemorate Cherbourg and Louisbourg, which Walpole claimed he had instigated to emphasise his personal responsibility, 'Mr. Pitt specifies his own glory as much as he can.' He pretended to contradict a rumour that Pitt had compelled George II to ride one of the cannon paraded to the Tower of London.[97] Charles Jenkinson reported how these spectacles 'contributed very much to heighten popularity'.[98] The response of the patriot philanthropist and collector Thomas Hollis, who had a medal struck to commemorate the conquest of Louisbourg, illustrates how Pitt was identified as the architect of the victory: 'I write to inform you of the taking of Louisbourg, an event, under Providence, and the wisdom and the bravery of the officers, soldiers, and sailors, to be ascribed to WILLIAM PITT.'[99]

Literature that emphasised the commercial and strategic value of Louisbourg, and the successful application of British sea power in the coastal expeditions, illustrates why the victories appealed to Pitt's patriot supporters like Hollis. Newcomb applauded the navy's projection of British power to Asia, Africa and North America, and the economic benefits which followed, building a world empire unrivalled in human history:

> Your daring sails which travel with the day,
> Now meet, now leave behind the distant sun;
> From worlds to other worlds, the stars and they,
> One voyage make, one common journey run:
> Your sovereign pow'r remotest regions own,
> To *Rome*, to Caesar, and to *Greece* unknown.[100]

Vindicta Britannica also stressed the impact of British naval operations upon the European struggle in the economic exhaustion of France through the ever-tightening blockade and the elimination of her trade:

> To *Albion's* naval power alone 'tis lent,
> T'imprison and besiege a continent.[101]

The poem endorsed Pitt's claims that the coastal expeditions made a significant contribution through the damage inflicted on French merchant shipping

and naval installations, and for eliminating nests of privateers that preyed upon British commerce.

What makes Newcomb's poem and other works published at this time significant, is their acceptance of the compatibility of British military intervention upon the continent with the maritime-colonial war. While Neptune or sea power is *Vindicta Britannica*'s principal theme, it does not neglect the importance of the European sphere in the totality of the international struggle, and the part to be played by Mars. Reflecting contemporary sympathy for Frederick II, Newcomb welcomed the deployment of British troops to Germany, where they would fight with George II's ally until the balance of power in Europe had been restored, and a mutually beneficial peace had been achieved:

> While yours, with *Prussia's* matchless troops combined,
> And terror spread o'er ev'ry hostile plain;
> Suffer no lawless tyrant on the *Rhine,*
> On *Iser's* bank, no faithless queens to reign;
> Determin'd ne'er to sheath your patriot sword,
> Till *Europa's* peace and freedom's restor'd.[102]

Literary evidence from 1757–58 illustrates the success of Pitt's manoeuvres to lead the political nation into accepting a greater role in the continental war without alienating his patriot allies at Leicester House, in the City and among the Tories. The coastal expeditions served an important political function in reasserting Pitt's commitment to the naval and colonial war, and turning attention away from the gradual revolution in his continental policy. In accomplishing a reversal of his opposition to subsidy treaties and the dispatch of British soldiers to Germany, Pitt was assisted by good luck as well as by good political management. Frederick II's victories at Rossbach and Leuthen made the military situation in Germany and the domestic political climate more conducive to the deployment of troops. Admiration of Frederick II allowed Pitt to link the defence of Hanover with the popular Prussian alliance. The propitious strategic outlook created by Frederick II's victories allowed Ferdinand to seize the strategic initiative, and his successful offensive justified a reinforcement of British troops if the momentum were to be maintained. The triumph at Louisbourg emerged as a timely vindication of Pitt's foresight and skill as a military leader, and greatly increased his political popularity. As a result of this growing optimism that the tide of war was at last turning in Britain's favour, Pitt was confronted with no serious protest against the sending of troops to Germany when Parliament reassembled in November 1758.[103]

Pitt sought to preserve his patriot reputation by eschewing personal responsibility for the commitment of British troops to Germany, giving the

impression that they were forced upon him by the Pelhamite faction. There were rumours of dissension within the Cabinet over the decision to send troops, which Gilbert Elliot described with a quotation from Dryden, 'Gods war with gods, and jostle in the dark.'[104] The popular belief that Pitt remained opposed to continental measures was cultivated by patriot literature, such as a fictitious report of a French spy driven out of Hanover, which blamed Newcastle for the developments.[105] Pitt nurtured his credibility as the champion of the people and of constitutional liberty in promoting the Habeas Corpus Bill and in redressing grievances against the militia. A verse panegyric from 1758 illustrated the success of Pitt's efforts to nurture his patriot image. It asserted that in slaying the many-headed hydra of political and moral corruption, Pitt had cleansed and unified the country, preparing it for victory.[106]

During 1759, the ministry struck directly at the centre of French power in Canada with an assault upon Quebec via the St Lawrence River, commanded by General James Wolfe, who had distinguished himself at the siege of Louisbourg. A second invasion of Canada was launched through the Champlain-Hudson Valley, led by the new Commander-in-Chief in North America, Sir Jeffrey Amherst, and a third attack was mounted against Fort Niagara, a critical link in France's chain of communication with its forts in the south and west. But the offensive was not to be limited to North America. An expedition was dispatched to follow up the earlier success in West Africa by capturing the French commercial base at Goree. The war was also extended to the Caribbean, with an attack upon the French sugar producing island of Martinique. British naval superiority made it impossible for the French to resupply and reinforce their colonies. In early 1759, to compel Britain to accept peace before France's overseas possessions had succumbed, Louis XV's principal adviser, the Duc de Choiseul, prepared an ambitious plan of invasion. Pitt and the ministry refused to allow the threat to deflect them from offensive military operations in the New World, or to weaken their effort in Germany by the withdrawal of troops. They relied upon the navy's blockade of the French battle fleet, which was divided between Brest and Toulon, to prevent the concentration of force essential to stage a Channel crossing. To bolster home defence, the ministry mobilised the militia, who freed regular soldiers to resist a French landing by taking over the custody of prisoners of war and garrison duties.[107]

The turning point in the war came in 1759, and was one of the most successful campaigns ever waged by British arms. A euphoric people celebrated the unparalleled succession of victories with illuminations, bonfires, fireworks, bell-ringing, and services of thanksgiving. Approximately eighty congratulatory addresses were presented to the King. Horace Walpole claimed to be

deafened by the incessant roar of the cannons that announced the triumphs.[108] An appreciative readership patronised the works of poets, playwrights and novelists, who glorified British exploits upon four continents and three oceans. People of all ranks joined the criers in singing the many ballads composed to commemorate Britain's conquests, and prints provided a striking visual record of military and naval victory.

The year began auspiciously, with the news on 15 January 1759 that Fort Duquesne had fallen to General Forbes during November 1758. Forbes had avenged Washington and Braddock, and occupation of the strategic site promised to guarantee British control over the Ohio Valley and the heart of the continent. On 29 January, the capture of Goree was announced, which eliminated the French presence in West Africa, and gave Britain mastery of its lucrative trade in slaves, gum, ivory and gold.[109] Although the attempt upon Martinique was abandoned, in late February the British took Guadeloupe, which was France's other major sugar producer, and an extremely valuable acquisition.[110] The campaign in North America progressed smoothly. The fleet navigated the St Lawrence to Quebec, where the army disembarked and lay siege to the city. In the interior, the French withdrew before Amherst's advance, destroying their forts at Ticonderoga and Crown Point on 22 and 26 July. Fort Niagara surrendered to Sir William Johnson on 25 July. Reports of these victories reached London in early September 1759. In an ode rejoicing in the conquest of the French forts, Newcomb facetiously complained of the difficult task confronting poets, who struggled to incorporate their French or Native American names into English metrical patterns and rhyming sequences:

> For, ah! so clumsily our wits compose,
> We lose in verse, the fame we win in prose;

Duquesne, Niagara and Frontenac were difficult enough, but:

> TICONDERAGO! that rude ratling sound,
> The drum of every tender ear must wound.
> In poetry, it bears a scurvy part,
> And rumbles in heroics, like a cart;[111]

As autumn and the end of the campaigning season approached, the nation held its breath for news from Quebec. A dispatch from Wolfe was received on 14 October, written by a commander worn down by illness and the army's inability to penetrate the French defences. The ministry published it on 16 October, but to combat pessimistic rumours, the most despondent sections were omitted.[112] Only two days later, this atmosphere of anxiety and apprehension was shattered by the sudden, unexpected announcement of the army's desperate ascent of the Heights of Abraham, the bloody battle, the death of Wolfe, and the fall of Quebec. Walpole reported how the wildest

flights of tragedy could not exceed the intense, conflicting emotions stirred by the news: 'The incidents of dramatic fiction could not be conducted with more address to lead an audience from despondency to sudden exultation . . . They despaired – they triumphed – and they wept – for Wolfe had fallen in the hour of victory!'[113]

Wolfe's fate inspired an outpouring of national grief. Poetic eulogies idolised him as the supreme example of patriotic self-sacrifice. The sorrow experienced by Wolfe's mother and fiancée, Kitty Lowther, added an element of personal pathos to the national tragedy. In the immediate aftermath of Quebec, more than thirty poems, ballads, novels and plays were published lamenting Britain's great martyr who had perished in the arms of victory.[114] Most literary commentary emphasised the great strategic significance of the conquest. Avid interest in Wolfe continued well beyond 1759. His death and the capture of Quebec was selected as the subject of the 1768 Oxford University poetry competition, and its winner Middleton Howard of Wadham College, recited his poem to the institution's benefactors in the Sheldonian Theatre on 6 July.[115]

France's efforts to concentrate its ships of the line for the invasion were frustrated by the Royal Navy. The Toulon fleet made its way out of the Mediterranean, but was intercepted and defeated by Admiral Boscawen off the Portuguese coast at Cape Lagos on 18 August.[116] In November, the fleet at Brest escaped during bad weather, but could not elude Sir Edward Hawke. The French attempted to shake off their pursuers by seeking shelter in Quiberon Bay. On 20 November, undaunted by the treacherous waters and adverse conditions, Hawke attacked the French, who were scattered. Five warships including Admiral Conflan's flagship were either driven ashore, sunk or captured.[117] The two naval victories effectively freed Britain from the threat of large-scale invasion for the remainder of the war. In February 1760, the French naval officer François Thurot, who was to provide a diversion for the invasion of England by a landing in either Scotland or Ireland, temporarily seized Carrickfergus. After abandoning the port, the French squadron of three frigates was overtaken by an equal number of British frigates. In the ensuing battle, Thurot was killed and all of the French ships were taken.[118] The year 1759 was to be distinguished not only for victories in the colonial theatres of war and at sea. On 1 August, Ferdinand inflicted a defeat upon the French at Minden, which delivered Hanover from immediate danger. The brunt of the fighting was borne by the British infantry, who gained great fame for repulsing the charges of France's finest cavalry.[119]

The political nation assigned the great victories of 1759 to Pitt's far-sighted, vigorous prosecution of the war. Thomas Hollis expressed the consensus, not only of patriots, but of virtually all strands of opinion, in the inscription

upon a medal struck to commemorate the conquest of Quebec, which read
'William Pitt Administering'.[120] Poetry and ballads document how the triumphs
of 1759 consolidated Pitt's reputation as a great war leader, and elevated him
to the pinnacle of political popularity. They functioned as important vehicles
in the dissemination of this heroic vision of Pitt. A poem reviewing all the
victories of the 'annus mirabilis' began with a glowing panegyric upon
their author:

> Sacred to PITT, – to Liberty, – and Fame,
> The Seaman's honour, – and the Soldier's name,
> Hail, virtuous period! Memorable YEAR!
> So bright in Council! – and in Arms so clear![121]

The impressive number of literary works dedicated to Pitt suggests extensive
admiration for the secretary of state who was envisaged as the redeemer of
his country. Laurence Sterne dedicated the first two volumes of *Tristram
Shandy*, and Tobias Smollett an edition of his *History of England*, to the
statesman who had rallied a dispirited country and guided it to victory.[122]
Thomas Newcomb devoted his volume of patriotic epigrams and odes to the
director of the war, whose wisdom and zeal had achieved unprecedented
national glory.[123] A poetic tribute to Newcastle attempted to remind its readers
of his vital contribution to success through the efficient management of
national finance. Newcastle's greatest service, however, was made in confer-
ring power to conduct the war upon Pitt:

> Who plac'd our Tully in the consul's chair?
> To whose advise this statesman do we owe?
>
> That well-weigh'd choice, deplor'd by *Britain's* foes,
> And praised with transport by the public voice![124]

Pitt's popularity was augmented by the belief that he had been Wolfe's patron
and friend, and that he was responsible for appointing him to command the
attack on Quebec. As one ballad proclaimed, Wolfe was:

> Call'd by great George the Second forth,
> When Pitt the helm directed,
> Who knew and pointed out his worth,
> Nor was the call rejected.[125]

In the Commons on 21 November, Pitt proposed that a monument to Wolfe
should be set up in Westminster Abbey, in a speech that was described as
a grief-stricken funeral oration. In seconding the initiative, one of Pitt's
supporters expiated on the unique empathy between the two great patriots,
'the general and the minister seemed to have been made for each other'.[126]
Fox doubted the genuineness of the tears Pitt shed, and accused him of

attempting to bask in the reflected glory of Wolfe's martyrdom.[127] Despite Fox's cynicism, the political nation appreciated Pitt's tribute to the fallen warrior and the intention to honour him with a monument. Pitt's responsibility for the victories of 1759, and the bond of passionate devotion to his country which he shared with Wolfe, were emphasised in an imaginary dialogue in the Elysian Fields between the shades of the two commanders who had perished before Quebec. While the Marquis de Montcalm lamented how criminally that he and the French colonies in North America had been neglected by the degenerate court of Louis XV, Wolfe pronounced a fervent tribute to the moving spirit of Britain's war effort:

> He is a man of vast genius and of an uncommon sagacity: His disinterestedness and integrity are without example. He loves his nation, who adores him. He has at his command powerful fleets, troops well disciplined, and all the supplies he wants in money. He makes use of these advantages to raise the nation to the highest pitch of power and greatness.[128]

Pitt's management of the war and his commitment to the expansion of the British empire in North America received a powerful endorsement from General Forbes. The conqueror of Duquesne renamed the captured fort, and the embryonic town which would develop into modern Pittsburgh, after the secretary of state because, 'it was in some measure the being actuated by your spirits that now makes us Masters of the place'.[129]

It was not only as the organiser of offensive war that Pitt received praise during 1759. He impressed many observers by his cool-headed management of the invasion threat. The defiant attitude which Pitt adopted in the Commons reassured opinion without doors, and prevented any panic from destabalising the public funds, despite reports that the French preparations were more ambitious than any since the Armada.[130] The confident tone that Pitt set was exemplified by a farce, which ridiculed the danger of invasion through the character of a country squire, whose terror had unbalanced his mind. Sir Timorous Fearful encircles his house with a moat, buries his money and plate in the garden, and prepares a hiding place in his cellar. In a ludicrous attempt to pass himself off as a Frenchman in the event of a landing, Fearful attempts to learn the invaders' language, and adopt their dress and manners. He refuses to consent to his two daughters' marriage to the lovers of their choice, whom he believes to be French spies. The old gentleman is finally cured of his frenzy, and tricked into approving the matches, by an excess of terror inspired by the ruse of a mock invasion.[131]

The widespread publication in Britain of an epigram posted upon the walls of Versailles, which was bitterly critical of France's dismal military and naval performance, enhanced rejoicing at the abandonment of the invasion. It blamed the interference of Louis XV's mistress, Madame de Pompadour,

for the incompetent direction of the war effort by comparison with France's legendary champion Jean d'Arc, who had triumphed over the English. Walpole sent a translation to one of his friends:

> O yes! Here are flat-bottom boats to be sold;
> And soldiers to be let, rather hungry, than bold;
> Here are ministers richly deserving to swing,
> And commanders whose recompense should be a string.
> O France, still your fate, you may lay at [Pitt's] door
> You was sav'd by a maid, are undone by a whore.[132]

The popular epigram inspired a pictorial interpretation.[133]

During the invasion crisis, Pitt took a risk in calling out the militia after the disorders of 1757. His perseverance in its support was vindicated by the generally enthusiastic response of the citizen soldiers, and the admiration they won by their exemplary behaviour. The professional performance of the two battalions of the Norfolk militia, which were reviewed by George II at Hyde Park on 17 July 1759, impressed the large crowd of spectators.[134] The troops were cheered by the residents of the towns they marched through. Ballads, poems and prints provide further evidence of approval for the militia. A patriotic poem emphasised the doubly valuable contribution made by the militia in protecting Britain's shores, and in allowing its conquests overseas to be pursued by the army without interruption:

> At home to ward the meditated Blow,
> Or drive the distant Battle on the Foe,[135]

Pitt's popularity was boosted by the perception that he was the militia's champion:

> Call'd by thy voice, nor deaf to war's alarms,
> Its willing youth the rural empire arms:[136]

He encouraged the idea by employing the militia whenever possible, and commending it at every opportunity. During the opening of the next session of Parliament, he thanked the militia for the important role it played in home defence.[137] A political print illustrated the approbation inspired by Pitt's advocacy of the militia, and how Newcastle was condemned for his hostility.[138]

Political observers commented upon the unparalleled political harmony during this period, which by allowing the kingdom to mobilise its undivided human and economic resources, became a prerequisite for victory.[139] The critical importance of national unity was rendered more striking by contrast with the humiliating defeats of 1756–57, which were viewed as the consequences of divisive political strife. A poem rejoicing in the great conquests

of 1759 identified national unanimity as the foundation of British success, exemplified by the people's willingness to assist the government in raising a record loan:

> From Arms, and glorious arms, the Muse descends
> To hail the Union of domestic friends;
> Blessing – reserv'd for this distinguish'd Year,
> To *France* as grating, as to *England* dear!
> No party now distracts the public care;
> No breath of Faction taints the ambient air;
>
> No Motion now – but what the House applauds!
> No Speech – but what the gen'rous Nation lauds!
> Mark on what basis Publick Credit stands!
> How soon the People arm the Statesman's hands![140]

Many considered national solidarity to be Pitt's greatest achievement, and praised him for motivating members of all of parties and factions, whether Whig or Tory, patriot or courtier, to transcend their petty, selfish animosities, and answer a higher call to King and country. To Chesterfield, the ease with which the record estimates for 1759 were approved was emphatic proof of the Commons' confidence in the secretary of state, 'This is Mr. Pitt's doing, *and it is marvellous in our eyes.*'[141] Spectators also recognised how the smooth transaction of wartime government was promoted by Pitt's reconciliation of popular political forces to the coalition, another seemingly miraculous development, which won him the unprecedented title of the 'patriot minister'. A paean written at the conclusion of 1759 summarised the now widely accepted perception that Pitt had inspired a national regeneration by his example of selfless patriot virtue and his invincible determination to restore Britain to her former greatness. The poem acclaimed Pitt as the realisation of Britannia's prophecy that she would send a saviour to unite a demoralised and divided country, and lead it to triumph:

> A PATRIOT MINISTER thy Helm shall guide,
> Nor sway'd by sordid Wealth, nor dup'd by Pride;
> Thy Good his Glory; and his noblest Aim
> To build his own on thy superiour Fame.
> *Thy Senate*, freed from Party Rage,
> Thro' him shall awe the wond'ring Age:
> His Wisdom, Truth, and steady Zeal
> Shall nobly guard thy publick Weal:
> His Eloquence, in one commanding Flow,
> Shall rouse thy Sons against their common Foe,
> Shall the dire Spleen of civil Discord charm,
> And nerve with Vengeance one resistless Arm.[142]

NOTES

1 BL, Add. MSS 32,872: Newcastle to Hardwicke, 25 July 1757.
2 Hardwicke to Newcastle, 5 Sept. 1757, Yorke, III. 171.
3 *LM*, Oct. 1757, 496.
4 Corbett, I. 223–6.
5 Walpole to Mann, 25 July 1757, *Corr.*, XXI. 117.
6 BL, Add. MSS 35,398, fo. 376: Birch to Royston, 15 Oct. 1757.
7 *Ibid.*, fo. 348: Birch to Royston, 13 Aug. 1757.
8 *The Book of Lamentations*, 1757, p. 3.
9 BL, Add. MSS 35,398, fo. 348: Birch to Royston, 13 Aug. 1756; Walpole, *Memoirs*, II. 280.
10 *A New Historical, Political, Satirical, Burlesque Ode, on that Most Famous Expedition*, 1757, p. 3.
11 *The State Farce: or, They are all Come Home*, 1758, pp. 8, 13.
12 *The Dream*, BMC 3613.
13 *A New Map of Great Gotham*, BMC 3616.
14 Walpole to Conway, 13 Oct. 1757, *Corr.*, XXXVII. 519.
15 Beckford to Pitt, 22 Oct. 1757, Chatham, I. 281; Wilkes to Grenville, 22 Oct. 1757, Smith, I. 223.
16 Potter to Pitt, 11 Oct. 1757, Chatham, I. 277.
17 *LG*, 13 Oct. 1757.
18 Jenkinson to Grenville, 22 Oct. 1757, Smith, I. 226; 'Extempore', *FFBJ*, 5 Nov. 1757.
19 *The French in a Fright*, 1757.
20 *A Letter from Lewis XV to G[eneral] M[ordaunt]*, 1757, p. 20.
21 George Rodney to Grenville, 23 Sept. 1757, Smith, I. 207.
22 Devonshire to Bedford, 15 Oct. 1757, Bedford, II. 283.
23 *The Rape of the Vineyard*, 1757, p. iv.
24 *An Ode on the Expedition, Inscribed to the Right Honourable W[illiam] P[it]t, Esquire* 1757, p. 5.
25 Chesterfield to his son, 10 Oct. 1757, Chesterfield to Robinson, 17 Nov. 1757, Chesterfield, V. 2249, 2261.
26 *Englands Benefit Night*, BMC 3640.
27 Add. MSS 32,875, fo. 124: Newcastle to Hardwicke, 15 Oct. 1757; 'An Epigram', 'An Extempore Answer', *BA*, 29 Oct. 1757.
28 Walpole to Mann, 12 Oct. 1757, *Corr.*, XXI. 144.
29 BL, Add. MSS 35,398, fo. 393: Birch to Royston, 5 Nov. 1757.
30 Lady Betty Waldegrave to Bedford, 26 Nov. 1757, Bedford, II. 304.
31 Walpole to Conway, 13 Oct. 1757, *Corr.*, XXXVII. 519.
32 Wilkes to Grenville, 22 Oct. 1757, Smith, I. 223.
33 *The Secret Expedition*, 1757; *The State Farce; The Secret Expedition. A New Hugbug Ballad*, 1757; 'A Song', *BA*, 15 Oct. 1757; 'Safe Return of the Fleet', *NC*, 15 Oct. 1757; 'Epigram', 'To the Printer', *BA*, 5 Nov. 1757; 'A Parody', *FFBJ*, 5 Nov. 1757. 'The Expedition', *LEP*, 24, 26 Nov. 1757.
34 *The French in a Fright*.
35 'The Portsmouth Garland', *Lancelot Poverty-Struck*, p. 48; 'An Expeditious Epilogue', *LM*, Nov. 1757, 529.
36 Jenkinson to Grenville, 29 Oct, 1757, Smith, I. 232.
37 *The Whiskers*, BMC 3625.
38 Walpole to Selwyn, 11 Oct. 1757, *Corr.*, XXX. 142.

39 *Ode on the Expedition*, p. 6.

40 *British Worthies*, p. 7.

41 *Land – & – Sea*, BMC 3632.

42 *Rape of the Vineyard*, p. 8; *Letter to M[ordaunt]*, p. 9.

43 BL, Add. MSS 35,398, fo. 401: Birch to Royston, 12 Nov. 1757.

44 Newcastle to Hardwicke, 3 Aug. 1757, Yorke, III. 161.

45 BL, Add. MSS 35,870, fo. 284.

46 Newcastle to Hardwicke, 9 Aug. 1757, Yorke III, 166, 121, fn. 4; Pitt to Grenville, 11 Aug. 1757, Smith, I. 207; Pitt to Bute, 5 Aug. 1757, 'Letters of Pitt to Bute', p. 128.

47 Hardwicke to Newcastle, 11 Aug. 1757, Yorke III. 168.

48 Newcastle to Hardwicke, 15 Oct. 1757; Newcastle to Hardwicke, 8 Oct., 1757, Yorke, III. 187, 189.

49 *The State Farce*, p. 6; *The Triumph of Caesar*, BMC 3615; *The Terror of France*, BMC 3610.

50 *The State Farce*, p. 11.

51 Newcastle to Hardwicke, 8 Oct. 1757, Yorke, III. 186.

52 *The State Farce*, p. 7; *A New Ode . . . on the Expedition*, p. 3.

53 *The Dream*, BMC 3613; *The Truant François*, BMC 3614.

54 *The Soldiers Lamentation*, 1757; *The Truth*, BMC 3629.

55 Newcastle to Hardwicke, 23 Oct. 1757, Yorke, II. 192.

56 *British Worthies*, p. 16.

57 Western, 290–4; Rogers, *Crowds, Culture and Politics*, pp. 64–84; Elijah Gould, *The Persistence of Empire: British Cultural Politics in the Age of the American Revolution* (London, 2000), pp. 72–105.

58 Potter to Pitt, 11 Sept. 1757, Chatham, I. 258; Hardwicke to Charles Yorke 8 Sept. 1757, Yorke III. 32–4.

59 Walpole, *Memoirs*, II. 150.

60 *The National Militia*, [1757].

61 Edward Long, *The Anti-Gallican*, 1757. Born in Cornwall of a Jamaican family, Long studied law, and contributed to the essay paper *The Pratler* during 1756. After his father's death in 1757, he travelled to Jamaica, where he served as private secretary to the colony's lieutenant governor, before being appointed Judge of the Vice-Admiralty Court.

62 Samuel Foote, *The Mayor of Garret*, 1764.

63 Mark Akenside, *An Ode to the Country Gentlemen of England*, 1758, p. 7.

64 *The Church Militant*, BMC 3752.

65 Walpole to Mann, 20 Nov. 1757, *Corr.*, XXI. 152.

66 Rogers, *Crowds, Culture, and Politics*, pp. 76–80.

67 Akenside, *Country Gentlemen*, p. 9.

68 BL, Add. MSS 35,398, fo. 362: Birch to Royston, 22 Sept. 1757.

69 Western, pp. 141–5.

70 Newcastle to Hardwicke, 29 Jan. 1758, Yorke, III. 198; D'Abreu to Wall, 10 Mar. 1757, Chatham, I. 298.

71 Walpole, *Memoirs*, III. 3.

72 *Frederick the Third, King of Prussia*, 1757; *Verses Occasioned by the Victory at Rosbach*, 1758.

73 Walpole, *Memoirs*, III. 3; Cobbett, XV. 829–30.

74 BL, Add. MSS 32,877, fo. 276: Hardwicke to Newcastle, 29 Jan. 1758.

75 Yorke, III. 4–18.

76 *The Patriot Enterprise*, 1758, p. 5; *Virtue, an Ethic Epistle*, 1759, p. 8.

77 Walpole, *Memoirs*, III. 13.

78 Chesterfield to his son, 25 April 1758, Chesterfield, V. 2294.

79 D'Abreu to Wall, 3 Mar. 1757, Bute to Pitt, 28 June, 1757, Temple to Pitt, 3 July 1757, Beckford to Pitt, 10 July 1757, Chatham, I. 295–7; 320; 325, 329–30.

80 Chesterfield to his son, 27 June 1758, Chesterfield, V. 2312.

81 Walpole to Mann, 12 Aug. 1758, *Corr.*, XXI. 226.

82 Walpole to Mann, 21 Mar. 1758, *Ibid.*, 181–2; BL, Add. MSS 35,399, fo. 13: Birch to Royston, 12 Aug. 1758.

83 Chesterfield to his son, 13 June 1758, Chesterfield, V. 2302.

84 BL, Add. MSS 35,399, fo. 59: Birch to Royston, 4 Nov. 1758.

85 M. John Cardwell, 'Mismanagement: the 1758 Expedition Against Carillon', *Bulletin of the Fort Ticonderoga Museum*, XV (1992), 236–92.

86 D[rur]y's Ghost to Lt. Gen. B[lig]h, 1758; *Methodism*, BMC 3661.

87 Chesterfield to his son, 27 June 1758, Chesterfield, V. 2312.

88 *Expedition, an Ode*, 1758, pp. 4, 6.

89 BL, Add. MSS 35,399, fo. 36: Birch to Royston, 23 Sept. 1758; *British Worthies*, p. 7.

90 *The Newsman's Review of the Transactions for the Year*, 1758. At the end of the year, newspaper publishers printed verse chronicles summarising its most important events, which were often sold for the benefit of the hawkers.

91 *LC*, 7, 9 Sept. 1758.

92 *LG*, Aug.–Dec. 1758.

93 William Catton, *A Poem on the Taking of Cape Breton and Cherbourg*, 1758; *Great Britain's Glory*, 1758; Middleton Howard, *The British Genius Reviv'd by Success*, 1758.

94 Thomas Newcomb, *Vindicta Britannica*, 1758, p. 19.

95 *CR*, Dec. 1758, 522; Valentine Nevill, *The Reduction of Louisbourg*, 1758.

96 William Catton, *An Encomium*, 1758; *Great Britain's Glory; Being a Loyal Song on the Taking of Cape Breton*. 1758; *The Lamentations of Louis*, BMC 3631.

97 Walpole to Mann, 9 Sept. 1758, Walpole to Conway, 17 Sept. 1758, *Corr.*, XXI. 238, XXXVII. 571.

98 Jenkinson to Grenville, 7 Sept. 1758, Smith, II. 265.

99 Thomas Hollis, *Memoirs* (London, 1780), I. 80.

100 Newcomb, *Vindicta*, p. 5; 'One Thousand Seven Hundred Fifty-Eight', *BA*, Feb. 1759.

101 *Ibid.*, p. 6.

102 *Ibid.*, pp. 12–13; *Great Britain's Glory; The Sequel to the Lillies of France*, 1759; *The Ballance Turned*, BMC 3675.

103 Dodington, p. 380; Walpole, *Memoirs*, III. 37–8.

104 Elliot to Grenville, 10 July 1758, Smith, II. 248.

105 *Morbleau*, 1758, pp. 26–7.

106 *Patriot Enterprize*, pp. 3–4; *A Rhapsody in the House of Commons*, 1758, p. 7; *British Worthies*, pp. 9–10, 19.

107 Cobbett, XV. 939–41.

108 Walpole to Montagu, 9 Aug. 1759, *Corr.*, IX. 246.

109 *The Bold Sawyer*, 1759.

110 *The Auction Room*, BMC 3693; *Satire on the Defeat of the French*, BMC 3727.

111 Newcomb, *Novus Epigrammatium*, p. 83; 'The Year Fifty-Nine', *GM*, Dec. 1759, 595.

112 Newcastle to Hardwicke, 15 Oct. 1759, Yorke, III. 238.

113 Walpole, *Memoirs*, III. 75.

114 They are too numerous to be listed in a note, but the scale of the literary apotheosis of Wolfe is illustrated by the Bibliography. Many more works were printed in newspapers and periodicals.

115 Middleton Howard, *The Conquest of Quebec*, 1768. Two other entries were also printed.
116 *An Ode: Occasioned by the Success of Admiral Boscawen*, 1759; *The True Patriots*, n.d.
117 *Great News, Great News, &c. From Sir Edward Hawke's Fleet*, 1759; *Neptune's Resignation*, 1759; *Hawke's Triumph over the Mighty Brest Fleet*, 1759; *Britons Glory*, BMC 3688.
118 *Thurot's Defeat*, 1760; *The Surprising Ghost of M. Thurot*, 1760.
119 *The Battle of Minden*, 1759; *Ode to the Glorious Victory . . . Near Minden*, 1759; *The Hero's Garland*, 1760. It was alleged that the victory would have been more decisive had Lord George Sackville, who commanded the British cavalry, not delayed in ordering it to charge. Sackville's behaviour incited charges of cowardice, which were propagated by a hostile press campaign. He was court martialled and dismissed from the army. The issue posed no major political threat to the ministry, although it did contribute to Leicester House's dissatisfaction with Pitt, who refused to assist its protégé.
120 Hollis, p. 89.
121 *One Thousand Seven Hundred and Fifty Nine*, 1760, p. 4.
122 Laurence Sterne to Pitt, Jan. 1760, Chatham, II. 12; Walpole, *Memoirs*, III. 97.
123 Newcomb, *Novus Epigrammatium*, p. iii.
124 'Stanzas Addressed to a Great Minister', *GM*, Dec. 1759, 593.
125 *The British Hero*, 1759.
126 Quoted in Williams, II. 13.
127 Fox to Lady Caroline Fox, 22 Nov. 1759, Ilchester, II. 111.
128 *A Dialogue betwixt General Wolfe, and the Marquis Montcalm*, 1759, pp. 5–6.
129 Forbes to Pitt, 27 Nov. 1758, *The Correspondence of William Pitt When Secretary of State*, ed. G. Kimball (London, 1906) I. 409.
130 Lyttelton to William Lyttelton, 20 July 1759, Phillimore, II. 614.
131 *The Invasion, a Farce*, 1759.
132 Walpole to Conway, 14 Oct. 1759, *Corr.*, XXXVIII. 35; *GM*, Oct. 1759, 496.
133 *The Grand Fair at Versailles*, BMC 3679.
134 Walpole to Montagu, 19 July 1757, *Corr.*, IX. 241.
135 *Virtue*, p. 9; *The Northumberland Garland*, 1759.
136 'To Mr. Secretary Pitt', *LM*, Feb. 1761.
137 Pitt to Bedford, 2 Nov. 1759, Bedford, II. 393; Cobbett, XV. 930.
138 *The Flat Bottom Boat*, BMC 3703.
139 Walpole, *Memoirs*, III. 48.
140 *One Thousand Seven Hundred and Fifty Nine*, pp. 11–12.
141 Chesterfield to his son, 15 Dec. 1759, Chesterfield, V. 2,334.
142 *An Ode, in Two Parts, Humbly Inscrib'd to the Right Honourable William Pitt*, 1760, p. 11.

10

Pitt, patriotism and the peace

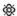

A N ANALYSIS of literary commentary has helped to illuminate how and
why the political nation was reconciled to Britain's growing participation
in the European war during 1757–58. Celebratory poems and ballads from
1759 demonstrate how Britain's deepening commitment was overshadowed
by the glory of its imperial and maritime triumphs. The eclipse was only
temporary however. After the fall of Quebec, and especially after the capture
of Montreal in 1760 completed the conquest of Canada, the attention of the
political nation became increasingly focused upon the continental theatre of
war. Once the vindication of British rights in North America had been
achieved, many observers began to question the utility of the campaigns in
Germany, which had degenerated into a costly and seemingly endless war of
attrition.

Despite receiving British reinforcements in 1760, Ferdinand could do little
more than hold off the French. Frederick II's prospects were even more grim.
Chesterfield compared the apparently limitless armies of his enemies to a
hydra, 'though he may cut off a head or two, there will still be enough to
devour him at last'.[1] By late 1760, it appeared as if Frederick II would finally
be overwhelmed by the combined forces of Austria, France and Russia.[2] The
crisis threatened to transform the Prussian alliance from an asset into a liab-
ility. Continental military expenditure accelerated dramatically after 1757,
fuelled by the steady increase in the number of British troops dispatched to
Ferdinand, which totalled approximately 22,000 by 1760. It was estimated
that financial support for the army had risen from £823,759 in 1757 to the
staggering sum of £3,289,954 by 1759. By 1762, it was calculated that Britain
expended £5 million to maintain 100,000 men in Germany.[3] The political
nation's growing preoccupation with the German war after 1759 was reflected
in literature and prints, which shed light upon the causes and the course of
the controversy.

The rekindling of opposition to continental connections was most menacing to Pitt. He was firmly committed to Hanover and Prussia, yet the Tories and many of his other allies had been the staunchest critics of earlier British intervention in Europe. Even during the height of Frederick II's popularity in 1757 and 1758, there had been indications of deep-rooted opposition to the Prussian alliance and anger against Pitt for supporting it. A poem published in early 1758 in reaction to the celebration of Frederick II's birthday censured the nation for its idolatry. It reproached Pitt for promoting the cult of Frederick II, and reminded him of how violently he had condemned the Prussian king for his violation of international law in attacking Maria Theresa:

> Then roar'd and foam'd Demosthenes' ape,
> That lump of self-conceit in human shape.
> Perfidious m[onarc]h! r[oya]l robber! then
> Were epithets too mild to vent his spleen:
> Now with the stream the patriot-bubble drives,
> And openly declares he but for Pr[ussia] lives;
> Pants with the fiercest ardour for the grace
> Once to behold the royal hero's face.[4]

The author's claim to a Cornish gentleman was consistent with the poem's probable Tory bias.

Although the extreme animosity of *West-Country Thoughts* may not have been representative of Tory views in 1758, one of the war's most controversial political poems, which was published in early 1759, suggests the great difficulty that many experienced in accepting Pitt's intensifying continental policy. Soame Jenyns, MP for Cambridge and a member of the Board of Trade, composed a satire mocking the Tories for abandoning their opposition to military involvement in Europe out of subservience to Pitt. The Tories' acquiescence in the decision to commit British troops to Germany formed the occasion for the poem, which was modelled upon an earlier satire by Swift. Pitt's success in tempting the Tories to sacrifice their principles was metaphorically portrayed as the sexual conquest of a dashing, glib young cavalry subaltern, who seduces a country maiden named Corinna. Like Corinna, the Tories imperceptibly surrender their political virtue to Pitt's alluring combination of flattering appeals, professions of devotion and beguiling eloquence, failing to notice his many broken promises:

> They saw and lik'd: the Siege began:
> Each Hour he some advantage won.
> He ogled first; – she turn'd away: –
> But met his Eyes the following Day:
> Then her reluctant hand he seizes,
> That soon she gives him, when he pleases;

Her ruby Lips he next attacks: –
She struggles; – in a while she smacks:
Her snowy breast he then invades; –
That yields too after some Parades; –
And of that Fortress once possest,
He quickly masters all the rest.[5]

Jenyns was the author of social and political satiric verse admired by contemporaries for his wit, irony and flair for parody. Robert Dodsley had published a collection of his works in 1752. Jenyns was a Pelhamite Whig connected to Hardwicke, whom Walpole dubbed 'the poet laureate of the Yorkes' for the poems he dedicated to the family. Jenyns supported the politics of the Old Corps Whigs in prose as well as verse, most notably in a pamphlet of 1757 that ridiculed militia reform. Jenyns developed an interest in religion and moral philosophy, illustrated by his *Free Inquiry into the Nature and Origin of Evil* (1757), which attempted to explain why evil exists in a universe created by a beneficent God.

Jenyns originally submitted the *Simile* to Hardwicke for distribution among Old Corps Whig circles, but the manuscript found its way into print without the author's knowledge. The poem was widely read by the political elite and the parliamentary classes, and attained a national audience through independent publication, and its printing in the metropolitan and provincial press.[6] Symmer sent a copy to Andrew Mitchell, the British ambassador to Prussia, writing 'that the call for it is prodigious'.[7] Many Tories were stung by the poem's derision of their recent conversion to Hanoverian subsidies and the deployment of British soldiers to Germany, as if salt had been poured into still open wounds. One of Newcastle's agents reported on the galling reflections the poem inspired among Tories in the City, which made it appear 'as if they had prostituted themselves to Mr. Pit'.[8] The attempt made by the Tory essay paper the *Monitor* to refute Jenyns's allegations against the party and Pitt offers additional evidence of its impact.[9] Pitt was incensed by the poem's exposure of his inconsistency, which he feared would undermine his alliance with the Tories. Soon after the *Simile*'s publication, Pitt was rebuked by the Tory Sir John Philipps in the Commons for 'Hanoverizing', and he may have interpreted the rebuff as proof that the Tories were turning against him.[10] Pitt's fury must have been aggravated by the *Simile*'s printing on two successive Saturdays in his own constituency of Bath, so great was the demand.[11] He bitterly complained of the satire's pernicious effect to Newcastle and Lady Yarmouth. Only Hardwicke's protection shielded Jenyns from Pitt's demands that he be dismissed from the Board of Trade.[12]

These literary sources suggest that disillusionment with the continental war developed first among the Tories and spread more rapidly among their ranks after 1759. The trend was encouraged by John Shebbeare, who had

published a *Sixth Letter* in late 1757, a violent denunciation of the malignant influence of the Hanoverian Succession. Its notorious motto, referring to the white horse of Hanover, was taken from *Revelations* VI. 8, 'And I looked, and beheld a pale Horse: and his name that sat upon him was Death, and Hell followed him.' The ministry feared the inflammatory effect of Shebbeare's anti-Hanoverianism in a political climate rendered volatile by Rochefort and Klosterseven. In January 1758, Shebbeare was arrested for seditious libel and a seventh letter suppressed. He stood trial, was convicted on 17 June 1758, and served a prison sentence of three years.[13] Shebbeare resented what he perceived to be Pitt's ingratitude in failing to protect him, for he later claimed that his panegyrics upon Pitt's stand against continental connections during 1755–56 had, 'contributed not a little towards creating the popularity, and thereby to the elevation of Lord Chatham to the seat of prime minister'.[14] While in prison Shebbeare supported himself by writing. His opposition to British participation in the German war and his fury against Pitt for sponsoring it were embodied in an elaborate allegorical history of Britain, the first volume of which was published in 1760. It traced the subversion of the constitution and the degeneration of English society and culture under the tyranny of William III, the Hanoverians, and the Whigs.[15]

Poetry, ballads, fiction and prints suggest that disenchantment with the war in Germany, although most strongly felt within Tory ranks, became more widely diffused during 1760–62. A verse fable published in the summer of 1760 summarised the principal objections levelled against British entanglement in the continental war. It emphasised the strategic, economic and political advantages inherent in Britain's position as an island by imagining it as a kingdom of industrious beavers. The amphibious creatures venture from their lodges to fish and colonise the shores of their lake in the same way that the British pursuit of international trade had motivated them to journey to North America, the West Indies, India and Africa. The beavers triumph when attacked by their hereditary enemies the otters as long as they confine the struggle to their native element, the water. Unfortunately for the beavers, they are linked to the shore by their king, the defence of whose continental dominion embroils them in exhausting conflict on land:

> Mean-while, at home, in various ways
> Their wealth's consum'd, their strength decays;
> Recruits and payment of allies
> Demand exorbitant supplies;
> While e'en by battles fought and gain'd
> Their little state is only drain'd.[16]

The beavers achieve complete victory in their original maritime-colonial war by driving the otters from the lake, and seizing their fishing grounds and

colonies. Interest dictates that the beavers escape from the potentially fatal land war and make peace. The clause which forbade Britain from making a separate peace with France without Frederick II's consent contributed to the unpopularity of the Prussian alliance after 1759. Pitt declared that the ministry would never accept a settlement that excluded Britain's allies or 'give up an iota of our allies for any British consideration'.[17] Given the desperation of the Prussian cause, and the vulnerability of Hanover and Hesse, it appeared as if the only way that Britain could extricate itself from an unequal and seemingly interminable war in Europe, was by appeasing France and Frederick II's other enemies with the sacrifice of her own acquisitions. The beavers were bound by similarly onerous treaty obligations to their allies:

> Vain conquest! if constrain'd at last,
> To sully all their glory past,
> By giving back each dear bought prize,
> To save their poor or weak allies;[18]

Although Pitt considered the possibility of peace after the conquest of Quebec, he wished to negotiate it from a commanding position, and argued that France could only be coerced to the council table by increasing pressure upon her in all theatres of war. The cavalier attitude to national finance that Pitt sometimes adopted when urging the nation to extend its efforts did little to assuage growing fears of bankruptcy. During the 1759 debate on the army estimates, he declared that 'to push expense was the best economy'.[19] Thus it appeared that Pitt wished to intensify the war when many were anxious over its escalating cost and the accumulating national debt. *The Beavers* concluded with a ferocious attack upon Pitt for betraying his opposition to continental measures, plunging Britain deeper into the quagmire, and forfeiting imperial interests for the sake of Hanover and Prussia:

> Mean-while, with grief, the patriot few,
> Who best the Beaver-interest knew,
> Saw him, on every slight pretence,
> Abuse the public confidence;
> And enter into every measure,
> Contriv'd to squander blood and treasure:
> Beheld the waste of both increase
> To purchase war, instead of peace;
> The fruits of half their labour thrown
> Away, in quarrels not their own.[20]

Later in 1760, criticisms of the continental connection would be forcefully expressed in Israel Mauduit's influential pamphlet *Considerations On the Present German War*.[21]

Literary works and prints demonstrate how condemnation of the German war was fomented by claims that the cost to the British taxpayer was inflated by the allegedly endemic incompetence and corruption within the German commissariat. Rumours circulated of fraudulent exaggeration of the expense of provisions, forage, and munitions, and the presentation of bills for destroyed, captured, or fictitious goods. These charges were recorded in a print, in which the commander of the British forces in Germany, the Marquis of Granby, complains to Britannia of the exorbitant expense of the war and the venality of his allies, '*I find these Leeches are Sucking the blood and brains of my Country.*' Three German soldiers stand behind Granby's back, sniggering at how easily they have exploited Britain's generosity.[22] Accusations of corruption were also levelled at British officers and agents responsible for the army's logistical management. Samuel Foote's play *The Commissary* reflected popular perceptions of the wealth acquired by unscrupulous British agents through the character of Zac Fungus, who went out to Germany as a cart driver, but returned with a huge fortune, and embarked upon a comic attempt to transform himself into a gentleman.[23]

Increasing criticism of Prince Ferdinand was related to the turn of opinion against the German war. In part this stemmed from allegations that he was implicated in the fraud which reputedly riddled the commissariat.[24] Many begrudged the generous financial gratuities bestowed upon him, including an allowance of £12,000 as commander of the allied army, and an Irish pension of £2000 a year. In 1759 he received a gift of £20,000 as a reward for his services.[25] Frederick II had recommended Ferdinand to the command, who was connected to him by marriage. Their relationship stimulated suspicions of divided loyalties: that Ferdinand sacrificed British strategic interests in order to aid Frederick II. Although this charge was difficult to prove, in early 1760 the British ministry was angered by Ferdinand's unauthorised dispatch of 12,000 men to reinforce Frederick II, which left Hanover exposed.[26] Pressure upon Frederick II in the east became so great during the spring of 1760, that he withdrew his remaining contingent from Ferdinand. This encouraged opponents of the Prussian alliance, who asserted that Britain paid a subsidy to Frederick II and defended his western flank against France, but received nothing in return. As the author of *The Beavers* complained, that animal:

> . . . hires the poor, at his expense,
> To stand up in their own defence:[27]

These allegations against Ferdinand, and condemnation of the German war and Prussian alliance as ruinous drains upon British resources, were recorded in a popular novel written by Charles Johnstone, the author of the successful *Chrysal, or the Adventures of a Guinea*. The narrator of *The Reverie*

describes how he had acquired the power to travel invisibly among the courts and camps of the belligerent powers, and observe the secret motivations and intentions of their rulers, ministers and generals. A visit to Ferdinand reveals a cynical mercenary, who ignores the pleas from his British paymasters to bring the war to a decisive conclusion, because either victory or defeat would deprive him of the official and unoffical profits of command. Ferdinand protracts the war by a parade of aimless diversionary manoeuvres and skirmishes. When it is necessary to delude the ministry with the appearance of action, he uses the army's British soldiers as cannon fodder, exploiting their bravery and gullibility, by pitting them against superior French forces. If victorious he may claim the glory, while their defeat excuses a retreat and the demand for more reinforcements and supplies.[28]

A journey to the camp of Ferdinand's French adversaries emphasises how Britain's strength was being sapped by subsidy treaties and the fruitless continental struggle, 'a folly that will certainly reduce them to beggary if they persist much longer'.[29] The French anticipate an imminent British financial collapse, which will precipitate peace, and the restoration of their colonies.[30] Johnstone's portrait of Frederick II was also designed to undermine the Prussian alliance. The narrator's first impression of Frederick II is positive. He appears as a beneficent ruler, whose dreams of social reform have been frustrated by a war forced upon him by the hatred of his enemies. He mourns its destructiveness and despises military glory. It is as a poet and philosopher that he burns to distinguish himself. Admiration turns to disgust when it appears that Frederick II's greatest aim is to expose the fallacy of religion, and to deny the existence of a Christian god of infinite power, wisdom and goodness. The narrator is revolted by Frederick II's plan to immortalise himself by replacing the world's discredited religions with his own philosophical system, 'This contemptible instance of vanity sullied the lustre of the monarch's other qualities, and made me so sick of ambition in every shape, that I could bear the sight of him no longer.'[31] Johnstone's description of the central European war from the perspectives of Frederick II, Maria Theresa, and Elizabeth of Russia highlights the absence of any common cause between Britain and Prussia. His attack upon Frederick II's notorious atheism disputed the claim that he was a Protestant hero or that the alliance could be justified in terms of religious fraternity.

Pitt was conscious of the political threat posed by the shift of opinion against the continental conflict. In Parliament, he responded with strong defences of the German war and the Prussian alliance by emphasising their diversionary value, most notably in the Speech from the Throne in 1758, and a number of later tributes to Frederick II and Ferdinand.[32] Pitt argued that the ministry's continental strategy had drawn France into a self-destructive conflict in Germany, leaving Britain free to concentrate the bulk of her naval

and military power for victory in North America. If not occupied in central Europe, France would have overrun the Low Countries, leading to a much graver risk of invasion. In 1761, when defending Britain's participation in the continental war from a critic who taunted him with his earlier use of the millstone metaphor, Pitt replied that he had shifted the burden to the French, 'As Germany had formerly been managed, it had been a millstone about our necks; as managed now, about that of France.' He also encapsulated this claim in the famous phrase of conquering America in Germany.[33] Pitt's assertion is vulnerable to challenge, especially upon its assumption that France would have been able to dispute British naval superiority if not so deeply engaged in the continental war. It also failed to consider the disparity in resources between Britain's North American colonies and New France. Nevertheless its apparent clarity, simplicity and precision made it a convincing proposition to many contemporaries.

The argument of conquering America in Germany was endorsed in literature and graphic art. A striking vindication of Pitt's claim appeared in a print (Plate 17) celebrating the victories in North America, Africa and at Minden. It conveyed the judicious balance of his continental system, and the way in which it harmonised British and Hanoverian interests, through the symbolic cooperation of the lion and the horse. Instead of being mortal enemies, as in

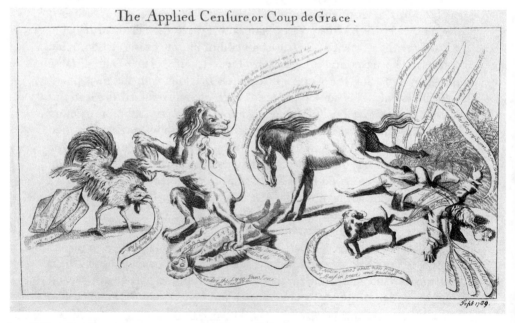

The Applied Censure, or Coup de Grace.

17 *The applied censure*

so much anti-Hanoverian propaganda, the horse provides vital assistance to the lion by guarding its back and kicking down the King of France, forcing his armies to evacuate Hanover, Hesse and Westphalia. The lion is left un-molested to savage the French cock with his claws, compelling it to surrender colonial conquests including Louisbourg, Duquesne, Crown Point, Niagara, Senegal and Goree. The lion expresses deep gratitude for its ally's diversion of its enemy's strength, 'O Pretty! O Pritty! Thou hast save[d] me a great deal of labour & trouble, I have crush'd the Cock & secured America'.

The *Simile* generated a number of replies, which absolved Pitt and the Tories from forsaking their devotion to the maritime-colonial war. One of the most salient was probably written by the social reformer John Brown, who had become a supporter of Pitt.[34] It contained a vicious personal attack upon Jenyns the political placeman by comparison with a fallen friend of Corinna, Doll Common, who travels to London to become a whore. In Brown's version of the tale, the virtuous Corinna marries her patriotic suitor. The divinely sanctioned union of Pitt and the Tories is metaphorically blessed with the birth of the conquests Senegal, Louisbourg and Duquesne, and the proud mother is expecting another child:

> And if the babe that swells my womb,
> To a propitious birth shall come,
> O'er joy'd I'll bless the happy day,
> And call our child *America*.[35]

At least three other verse counter-attacks were published, which played upon Jenyns's original metaphor, and Brown's extension of it. The Tories' ideological purity was defended in *Corinna Vindicated*, which narrated how they had rejected the wooing of Walpole, the Pelhams and Fox, before placing their trust in the honourable Pitt. Another work with a Tory bias substituted Britannia's name for Corinna, and described how she had been debauched by her foreign suitor William III. The treatment of her Hanoverian quack doctors aggravates the disease. Her health is finally restored by the patriot physician Pitt.[36] A third panegyric upon Pitt presented Doll Common repenting of her sins and her unjust condemnation.[37]

Pitt was aware of how his political popularity was jeopardised by grow-ing dissatisfaction with the continental war.[38] In the Commons he continued to deny that he was responsible by insisting upon his limited executive authority within the coalition.[39] Recognising that the spiralling expense of the German war was one of the principal causes of the backlash against it, he disclaimed control over its financial management. He also attempted to appear as a watchdog against unnecessary expense. On one occasion he reassured the Tories of his commitment to economy by summoning them to the Commons to scrutinise an estimate for military expenses submitted by

the Hanoverian government.[40] In 1761 Newcastle ordered an inquiry into the German commissariat in part to defend himself from Pitt's efforts to scapegoat him for its great cost.

The extent to which Pitt appreciated the ability of the press to influence political opinion has been overlooked, but during August 1758 he employed his authority as secretary of state to prevent the dissemination of a hostile ballad. The street-singer had been seized and carried before the magistrate John Fielding. He revealed the identity of the author, and the printer James Howe, who had already been pursued for producing the spurious King's Speech in 1756. Fielding sent agents in disguise to purchase what remained of the ballad edition from Howe, and asked Pitt for instructions on how to proceed.[41] Pitt ordered Fielding to 'use all means which the Law puts in your power as a Justice of the Peace, to prevent so infamous and scurrilous a libel getting out into the Publick'.[42] Unfortunately, a copy of the ballad has not survived. It probably was a reaction against the ministry's decision to dispatch British troops to Germany, or a denunciation of Pitt for condoning the measure, which had been announced about a month before. This would explain Pitt's eagerness to have it suppressed.

During 1760, Pitt was beginning to reconsider his support for the war in Germany, partly in response to pressure from political opinion. When informed of Pitt's sentiments, Hardwicke agreed that 'what Mr. Pitt says will be the way of thinking of nine parts in ten of the people of England'.[43] During the 1760–61 parliamentary session, the Prussian subsidy and funds for the Army of Observation were approved, but Commons' support for the measures was strained, and Pitt exposed himself as little as possible when presenting them.[44] Pitt's sensitivity to opposition against the expansion of British military engagement in Germany prompted him once again to pretend that the decision to send reinforcements had been imposed upon him by the King and the Pelhamite majority in the Cabinet. The propagation of this fiction was confirmed by rumours going about London that Pitt knew nothing of the dispatch of three battalions of guards until their embarkation orders had been issued.[45] The discrepancy between appearance and reality that continued to characterise popular perceptions of Pitt's attitude to the continental war was illustrated by a print demanding the recall of British troops from Germany. Pitt asserts that he had been powerless to combat the continental initiatives of his colleagues, '*Did I not always rail against Continental Connections till they were Cram'd down my Throat & I must have been Choak'd If I had not acquiesced?*'[46]

George III's accession on 25 October 1760 profoundly affected the balance of power within the government and its attitude towards the conduct of the war. The young king and his adviser the Earl of Bute wished to end the

conflict as soon as practicable. A panegyric by John Lockman, secretary of the Free British Fishery Society, dedicated to George while still Prince of Wales, illustrated the identification of hopes for peace with the new reign:

> Young PRINCE! Tho' Blood-stained lawrels proudly shine,
> O be the Olive Wreathe forever Thine![47]

George III and Bute were hostile towards military operations in Germany and suspicious of Frederick II. The new king resented Newcastle and the Old Corps Whigs for the tyranny they had exercised over his grandfather, and wished to rule without the restriction of party division. George III and Bute felt betrayed by Pitt's refusal to consider their views after they had aided him to achieve power, and by the renunciation of his opposition to continental intervention. Attempts to achieve a rapprochement shortly before George II's death had failed, when Pitt asserted that he would accept no constraint upon his independent right to determine policy.[48] Soon after the accession, Dodington sent a manuscript poem for the entertainment of his ally Bute, George III and the Dowager Princess. It expressed the court's antipathy toward Newcastle and Pitt for their presumption to monopolise power, and its plan eventually to supplant them:

> Quoth Newcastle to Pitt, 'tis in vain to dispute,
> If we'd quarrel in Quiet, we must make Room for Bute:
> Quoth Pitt to his Grace, to bring That about,
> I fear my dear Lord You, or I, must turn out:
> Not at all, quoth the Duke, I meant no such Thing,
> To make Room for us all, we must turn out the King.
> If that's all your Scheme, quoth the Earl, by my troth,
> I shall stick by my Master, and turn ye out, Both.[49]

For those outside high political circles, the central question of the new reign: which politician would enjoy royal favour and control over executive authority, was expressed in a famous bon mot by Mrs Hardinge, the wife of the physician of the Tower of London, who asked what type of fuel the King would burn in his chamber: Scottish, Newcastle or Pitt coal.[50] Mrs Hardinge's witticism probably inspired a political print, which offers insight into popular reaction to the political changes. It depicted three altars from which Britannia must select the fire which emits the greatest heat and light. The perception that the source of Newcastle's influence had been extinguished with the death of the old king, and that he represented a past of outmoded party struggle, was emphasised by the altar dedicated to north-eastern coal, which is smouldering and appears to be dying out. The campaign of abuse which would develop against Bute, instigated by accusations that he was an insidious royal favourite and a Scot who promoted his fellow north Britons,

was foreshadowed by a newly raised altar, which burns fiercely but produces heat upon only one side. Britannia's preference for coal mined in the West Country, to whose protective, purely blazing flame she owes her life, illustrated the belief that Pitt was indispensable to government as the victorious war leader who enjoyed popular support.[51]

Discussion of the constitutional implications of Bute's status as a royal favourite, charges that he encouraged the King in designs of extending royal power, and English prejudice against him as a Scot, are beyond the scope of this work and have been ably treated elsewhere.[52] What is of major significance is the impact that Bute's growing influence had upon the direction of the war and the ministry's disposition towards peace. The radical divergence of opinion between Pitt and the court was illustrated in the acrimonious argument over George III's first speech to the Privy Council, which described the war as 'bloody and expensive' and conveyed the King's desire to pursue an 'honourable and lasting peace'. Before it could be printed, Pitt demanded alterations to remove what he considered to be implied criticism of the war, and a failure to demonstrate Britain's commitment to her European allies. An 'expensive but just and necessary war' was substituted for the first phrase, and 'in concert with our allies' was added to the second. George III was offended by Pitt's censorship of his first act as king, which motivated him to resist dictation more strongly in the future.[53]

In 1761 Britain renewed negotiations with France with the intention of achieving a pacification of Europe. Bute had replaced Holdernesse as secretary of state, and occupied a central role in the Cabinet discussions. Newcastle, Bedford, Hardwicke and Devonshire were disposed towards peace. Newcastle was conscious of the war's financial burden, and the accumulating national debt, which reached approximately £150 million in 1762, more than double what it had been in 1755. Bedford was the most inclined to treat. He advocated a quick settlement before Britain's position would be weakened by the conquest of Hanover, and he feared diplomatic isolation if Europe's other great powers were antagonised by too aggressive demands.[54] Pitt appeared sincere in the desire to reach a settlement, provided it reflected the extraordinary success of British arms and guaranteed future national security. The North American fishery emerged as the critical issue in the negotiations. Pitt, perhaps with a view to disable France's naval power, insisted that it should be completely excluded. Bute wished to achieve a peace which would reward Britain for the great sacrifices of the war and glorify the king.[55] Initially he supported Pitt, but ultimately endorsed the views of the more moderate ministers, who were willing to concede French participation in the fishery.[56]

France had been pursuing an alliance with Spain, whose support could be used to pressure Britain into making concessions or to carry on the war if it remained inflexible. The Bourbon Family Compact, which committed

Spain to military intervention, was ratified on 15 August 1761. During the negotiations, France had begun asserting that Spanish maritime and colonial complaints against Britain, such as a share in the fishery, should be included in the discussions. The expectation of fighting on with greater success determined France to reject the offer of a compromise over the fisheries, although the talks were protracted while plans of military cooperation with Spain were prepared. Pitt calculated that war with Spain was inevitable, and pressed for a pre-emptive strike. The other members of the Cabinet hoped to avoid an extension of the war when there was no certain evidence of Spain's hostile intentions. Pitt however, refused to depart from his demand for immediate aggressive action, and after a final debate of the issue on 2 October 1761, officially resigned three days later.[57] Soon after the negotiations were broken off as indications of a pact between the Bourbon powers increased.

It is not easy to assess Pitt's motives in resigning. Clearly he believed that a union of the Bourbons was imminent and represented a grave threat to Britain. He may have wanted to seize the opportunity to expand British commercial and imperial supremacy at Spain's expense. The decision must also have been influenced by the political revolution of the new reign. During the 1757–60 coalition, Pitt had appeared essential to George II and Newcastle, giving him a major voice in the direction of the war. Since the accession of George III and the rise of Bute, Pitt had become more isolated in the Cabinet. During the peace negotiations he had been compelled to compromise over the fishery question.[58] The erosion of Pitt's political influence and chronic ill-health may have encouraged a yearning for retirement. Pitt's acceptance of a £3000 pension for his life, and the lives of his wife and eldest son, and a barony for his wife, suggested an intention to withdraw from active politics. It is also possible that Pitt's resignation over an issue of such national importance was an attempt to revitalise his image as national saviour, and rally the popular support, which had been the source of his political power and independence.

Pitt's resignation incited a fierce controversy over its causes, motivation, justice and significance. The discussion expanded to include argument over his political and personal integrity, pretensions to patriotism, and record as a war leader. Literature formed an integral part of the debate, at times making a leading contribution. It documents the great diversity of opinion revealed by the crisis and assists in tracking its development. So great was the demand for literary commentary, that it stimulated sales of *Resignation* – Edward Young's poem of religious consolation to Frances Boscawen on the death of her husband – by a misunderstanding that it was a political piece on Pitt.[59]

From 6 October 1761, the press had reported rumours of Pitt's resignation.[60] On 10 October, the ministry published official notification of his departure and the grant of the pension and peerage. During the interval,

Pitt's acceptance of the rewards had been denied by Beckford and his sup-
porters in the press, a falsehood which only intensified the backlash against
him when it was confirmed. The City's initial reaction of surprise, confusion
and disbelief developed into fury at Pitt's apparent desertion of the country
in exchange for a bribe. On 12 October, Rigby reported what several days
earlier would have been unthinkable, 'Mr. Pit is to be burnt in effigy tonight
in great pomp.'[61] The next day a meeting of the Common Council adjourned
without fulfilling its intention of expressing confidence in Pitt.

Pitt was shocked by the turn of opinion, and wrote a letter of self-
justification to Beckford, which was published in the *Public Ledger* on
17 October, and extensively reprinted in the metropolitan, Scottish, Irish and
provincial press. He asserted that he resigned after refusing to compromise
his opinion regarding action to be taken against Spain 'of the highest import-
ance to the honour of the crown, and to the most essential national interests'.
In response to the gross misrepresentation that the marks of the King's
approbation were 'a bargain for my forsaking the public' Pitt emphasised
that the pension and peerage were unsolicited and followed his resignation.[62]
Pitt's letter exonerated him in the eyes of many of his patriot allies in the
City.[63] The Common Council lamented his loss, and declared its gratitude for
his services in reanimating the nation and nurturing its commerce. Instruc-
tions to the City MPs were also voted, demanding that Pitt's vigorous pro-
secution of the war be maintained. Evidence of support for Pitt in the rest of
England, Scotland and Ireland appeared in the form of nine other addresses
of thanks.[64]

If Pitt's resignation was a gambit to remobilise popular backing, then the
issue of war with Spain was well chosen, according to some literary reaction.
The revelation of the Family Compact was as a powerful confirmation of his
claim to be a vigilant guardian of the state, 'This will be a great triumph to
Mr. Pitt, and fully justify his plan of beginning with Spain first.'[65] This idea was
conveyed by a print (Plate 18) in which Britannia reclines beneath a withered
English oak, and mourns the loss of her protector Pitt, whose portrait she
leans upon. The French and Spanish plot her destruction behind her back.
A following wind urges Britannia's fleet to strike Spain before her enemies
have consummated their conspiracy, yet the warships remain at anchor:

> That Fleet so late Britannia's Pride,
> Design'd to Scourge encroaching Spain,
> Ah me! must now be laid a Side,
> No British Broadsides soon shall shake the Main.[66]

Comparison of Pitt with the Elizabethan heroes who thwarted the Spanish
Armada reinforced his portrayal as a prophetic national champion,[67] and anti-
Papist religious bigotry incited animosity towards Spain.[68] Pitt's pre-emptive

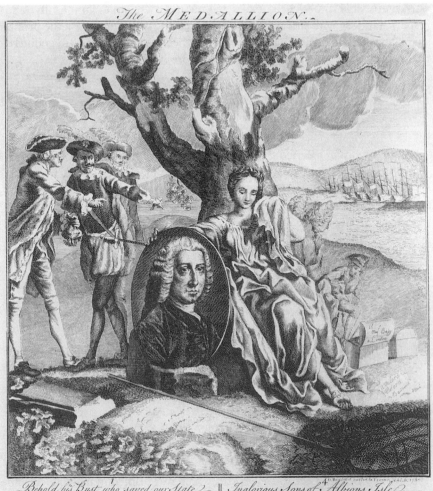

18 *The medallion*

strike probably appealed to many within the mercantile community, and especially those with privateering interests, who were tempted by the profits of an attack upon Spain's trading empire in the New World. A ballad endorsed his plan to seize the Spanish plate fleet before it reached Cadiz:

> To bang proud Spain was his intent,
> As he had done Monsieur;
> And boldly take their rich galloons,
> And bring the Treasure here.[69]

Pitt's advocates asserted that his resignation was the result of a Machiavellian intrigue by Louis XV's foreign minister the Duc de Choiseul, who realised that France could never recover its lost colonies either by war or peace unless her implacable arch-enemy were disposed of first. Spain was exploited as a pawn in the diplomatic game to drive Pitt from office by playing on the pacifism of his Cabinet colleagues. According to a popular ballad, France's negotiator François de Bussy was instructed:

> And, if at Court and Council-Board,
> *Refactory* you find 'em
> Empty your Box of *Spanish Snuff*
> Into their Eyes – and blind 'em!

When Pitt finds his warnings of the imminent danger of the Family Compact rejected by the majority of the Cabinet, he grieves at the success of Bussy's treachery:

> Oh! Oh! cries PITT, I *smell a Rat*;
> Adieu, my *Masters* all:
> For why? My *Pow'r* is at an *end-*
> This Bussy works my *Fall?*[70]

This idea was neatly put in an acrostic, which was printed in newspapers and periodicals:

> Britannia for Arms, Arts and Virtue renown'd,
> Unconquer'd and fear'd by the Nations round,
> Secur'd in her Rights whilst the Bulwark was PITT,
> Sagacious and bold none in Council so fit,
> Yet at last to a Monkey was forc'd to submit.[71]

Pitt's allies were sensitive to allegations that he squandered the prospect of peace and propelled Britain into war with Spain by his intransigence. A memorial printed by the departing Spanish ambassador had pointed the finger squarely at Pitt.[72] It probably inspired a verse dialogue between Britain's representative in Spain, the Earl of Bristol, and Charles' III's minister, Richard Wall, which praised Pitt for resisting Spain's efforts to bully the ministry into

concessions.[73] During the negotiations, news arrived of the capture of Belleisle and Dominica, and of Pondicherry which made the British supreme in India.[74] These new victories justified Pitt's insistence upon advantageous terms. Now that the great war leader was gone, authors revealed anxiety about the future of the conflict. Admiration for Pitt as the moving spirit of victory, outrage that he had been forced from office, and prophecies of the disastrous consequences of his loss, were expressed by allusion to an incident at George III's coronation, which had occurred shortly before his resignation. Reports circulated that a diadem had fallen out of the King's crown during the ceremony, and Pitt's panegyrists exploited the incident to emphasise his achievements and how vital he had become to the war effort:

> NE'ER yet in vain did Heav'n its Omens send,
> Some dreadful ills unusual Signs portend!
> When Pitt resign'd, a Nation's Tears will own
> *Then* fell the *noblest Jewel in the Crown.*[75]

Pitt's explanation that he resigned to avoid being 'responsible for measures which I was no longer allowed to guide', evoked fierce controversy. Some of his admirers interpreted it as a claim that he had been individually responsible for the victorious management of the war, a view they shared. He was compared to Moses who led his people out of darkness and into the promised land:

> Then we did prosper, God was on our Side;
> PITT was the Pillar for our Guard and Guide;
> He like the Clouds of Fire, in England rose
> A Light to Us, a Terror to our Foes.[76]

Resignation was defended as the honourable alternative when there was disagreement over a question of such critical national significance. Pitt demonstrated his integrity by an honest expression of opinion, and a departure to avoid division within the government. His decision proved that his silence could not be bought, and that he did not cling to office merely for love of power, but followed the dictates of conscience.[77] The pension and peerage were welcomed as a just acknowledgment of the King and people's gratitude for his great services. Their acceptance did not prevent Pitt from continuing to advise from the Commons. His health had been undermined by the strains of war, and compassion for its impact upon his family demanded a provision for their future. Censure of the rewards was construed as condemnation of George III's judgement and generosity. Pitt's refusal of the gift would have been a personal insult to the King, leaving it open to misinterpretation as a corrupt attempt to influence his future conduct.[78] One of the most powerful vindications of Pitt came from Charles Churchill in a poem which reflected

his growing engagement with politics, encouraged by his friendship with John Wilkes, another fervent admirer of Pitt:

> What honest man but would with joy submit
> To bleed with CATO, and retire with PITT?
> STEADFAST and true to virtue's sacred laws,
> Unmov'd by vulgar censure or applause,
> Let the WORLD talk, my Friend; that WORLD, we know,
> Which calls us guilty, cannot make us so.[79]

While Pitt's advocacy of war with Spain may have struck a chord among certain commercial interests in the City, literary sources suggest that there was considerable hostility to extending the war. Walpole mocked Pitt's aggressive attitude towards Spain by dubbing him Mr. Secretary Cortez and accused him like the Conquistadors, of lusting after the gold of Mexico and Peru.[80] Literary condemnation of the expensive stalemate in Germany reflected growing war weariness by 1761. Several contributions to the debate reproached Pitt for warmongering and deplored the widening of the conflict. In a cutting satirical poem, which dramatised the stormy Cabinet sessions that culminated in his resignation, Pitt launches into a frenzied tirade that his vendetta against France will be pursued until the last drop of British blood has been shed. When warned that Jupiter may intervene upon the side of the enemy, Pitt threatens to declare war upon the gods themselves:

> We'll send a fleet, shall batter heav'ns high wall
> And force an answer categorical.
> His ships and thunder are an arrant jest:
> Let's try if Jove or we can thunder best.[81]

Pitt is portrayed as a man driven insane by delusions of martial glory and the thirst for further conquests, the product of his own egotism and the adulation of the mob. The sober Hardwicke concludes that Pitt's ravings have demonstrated his unfitness to govern:

> Thy brain's on fire; thou talk'd of scaling heav'n:
> No stronger proof of madness need by giv'n.
> Hence 'tis our duty, ere it is too late,
> To take thy burthen, and secure the state.[82]

Pitt's declarations that Britain could somehow find the funds to intensify the war were flatly contradicted by one poet, who felt that the existing burden of debt and taxation was more than enough, 'New wars and new supplies.' – The old shall do.'[83]

When war with Spain was proclaimed, Birch observed that it: 'was received with few and faint Acclamations from the people in the Streets, while the Spectators of better rank both there & every where else shew'd a deep

Concern on the Occasion'.[84] He recorded the common complaint that Pitt had wrecked the prospect of an honourable peace with France, and imperilled Britain's ability to retain its conquests by provoking Spain. The belief that the negotiations had failed because Pitt was set against peace led to accusations that he adopted an offensively belligerent and overbearing tone in his communications with France and Spain.[85] Pitt's diplomatic correspondence with the Bourbons was parodied in a fictitious series of negotiations with Newcastle, which were designed to cement an alliance against George III. It insinuated that Pitt, 'His Sublime Mightiness of Hayes', subjected Newcastle's overtures to the same imperious treatment he had given the French: 'They were . . . entertained with Disdain and Contempt. Many Objections were raised to the Plan proposed for the Basis of the Negotiation; Alterations whereof were delivered in a peremptory Stile, and dictated with an Air of Haughtiness and Despotism.'[86] An advocate of peace disputed the Pittite interpretation of the coronation omen, suggesting instead:

> Perhaps the *Death* of Faction's meant,
> Of Envy, Pride, and Discontent:
> That all domestic Feuds will cease,
> And every Enemy to Peace.[87]

One of the most devastating literary satires upon Pitt was a versification of his letter of resignation by Philip Francis, instigated by his patron Henry Fox. The great influence of Francis's poem is emphasised by the publication of five editions by early 1762. Walpole claimed that a motion for a pro-Pitt address from Leicester was abandoned after a member of the corporation read out a copy.[88] Its great impact lay in its ironic transformation of Pitt's defence into self-accusation:

> HAVING found with Surprise, that my late Resignation,
> Both in Manner and Cause, by Misrepresentation
> Hath been grossly abus'd: that his majesty's Grace,
> Which follow'd, *spontaneous*, my quitting my Place,
> Hath been slander'd most basely, and viley perverted
> To a Bargain, for having the Publick deserted,
> The Truth of these Facts I am forc'd to proclaim,
> And the Manner, no Gentleman surely will blame.[89]

Francis developed his attack through annotations to the verses and a section of general reflections with material supplied by Fox. Some alleged that Fox had written them himself. The most damning condemnation focused upon the constitutional implications of Pitt's claim to guide. Pitt's use of the expression to describe his role in government left him vulnerable to accusations that he aspired to a dangerous and illegal supremacy as prime minister. Francis admonished Pitt for an arrogant presumption to dictate to the King

and Cabinet: 'To controul his Majesty's Prerogative; to take from Him his private Right of judging; to govern his Council, and to guide his Measures.'[90] He reinforced his charges with accurate paraphrases of the Cabinet meetings, including a rebuke of Pitt by Granville. Some of Pitt's allies appear to have been embarrassed by the phrase 'to guide'. Birch met one who regretted that 'approve' had not been employed instead.[91] When faced with repeated censure in the Commons over his apparent demand for unrestricted executive authority, Pitt attempted to qualify his use of the expression, limiting it to the freedom 'to guide his own correspondence' as secretary of state, an equivocation adopted by some of his literary apologists.[92]

Pitt's declaration that he resigned because he was no longer allowed to guide exposed him to another grave criticism. Francis seized upon Pitt's apparent claim to have exercised control over the strategic direction of the war to accuse him of being individually responsible for entangling Britain in the continental conflict in violation of all his patriot rhetoric in opposition and government. The accession of George III, a monarch notoriously indifferent to Hanover, had made it increasingly difficult for Pitt to maintain the façade of his disapproval of the German war by shifting the blame upon the court. Francis undermined it further by charging that Pitt had sold himself to George II to realise his ambition for power in 1757, becoming the slavish minister 'who so largely gratified his favourite Passion: who poured forth the Blood and Treasures of Great Britain into Hanover'.[93] Other satires assailed Pitt for his hypocritical volte-face regarding the continental war, a dissipation of resources which now hindered the nation's ability to defend itself against Spain.[94]

According to Francis and other critics, Pitt had abused the faith of the people, so fraudulently acquired by his patriot posturings, to bolster his grip upon power and beguile them into supporting the German war. The mob violence which marred the Lord Mayor's Banquet on 9 November 1761 reinforced the charge of demagoguery. Pitt had been invited to attend by Beckford, who instigated demonstrations in support of the former secretary of state. Pitt was more loudly cheered than the King, Bute was insulted, and rubbish was thrown at the coaches of some of the ministers. George III was offended and Pitt was embarrassed by his role in the spectacle.[95] In a verse dialogue, a responsible citizen warned a fiery City patriot of the dangers provoked by inflammatory Pittite appeals to the mob at the expense of the King and constitutional government:

> Would you distract their thoughts, and turn their heads?
> You know how soon sedition spreads.
> Thin are their skulls, and with such nonsense fill 'em,
> They'll ask their king's name, – Is it G[eorge] or W[illiam]?[96]

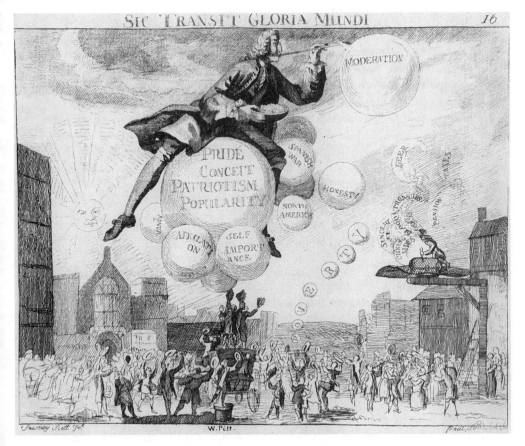

19 *Sic transit gloria mundi*

One of the most impressive attacks upon Pitt's misuse of the people's confidence was a print (Plate 19) which depicted him as a giant, floating above a cheering crowd upon a soap bubble labelled Pride, Conceit, Patriotism and Popularity. It was supported by smaller ones marked North America and Spanish War, while the most recent bubbles he had blown, including Blood and Treasure, Pension, and Changing Sides have floated away. A dream vision explained the scene, which concluded with the bursting of the bubbles, and Will Prigg's colossal fall to earth.[97]

Pitt's colleagues and many observers speculated that he resigned to escape mounting indignation over the financial burden of the war, and the odium which would be heaped upon the minister bold enough to negotiate an inevitably controversial peace.[98] In the Commons in late 1760, Pitt had confessed the impossibility of gratifying unrealistic popular expectations of retaining

most of Britain's conquests, 'Some are for keeping Canada; some, Guadeloupe: who will tell me which I shall be hanged for not keeping?'[99] The poet Hugh Dalrymple composed a scathing poetic denunciation of Pitt following his resignation. He portrayed it as a selfish, cowardly desertion to evade the unpopular task of concluding a peace, which would be compromised by the ruinous continental war he had promoted. Dalrymple conveyed the charge by allusion to a famous French expression inspired by Rabelais, whose alleged miserliness reduced him to depression following the presentation of the bill after dinner:

> Imagining he apprehended
> A Reck'ning when the Game was ended.
> And so he seiz'd it when he saw,
> A fair Occasion to withdraw.
> As Politicians can't endure,
> Of *Rabelais*, the *Quart de Heure*.[100]

Poets employed the image of a pilot abandoning the ship of state as it struggled through storms and shoals to censure Pitt for forsaking his duty to complete the voyage upon which he had embarked, and safeguard the conquests of the war with a consummate peace.[101]

Chapters 7 and 8 demonstrate how Pitt had been distinguished from other politicians for aspiring to a higher level of political morality, which was viewed as an extension of the exemplary character he maintained in private life. Pitt's fame for patriot virtue had been based upon the pillars of integrity, altruism, independence and public spirit. During the dark days following the loss of Minorca, he had attracted the support of many Britons, who looked to him as the only leader capable of inspiring the national moral regeneration they believed was required to save the country from defeat. By appearing to violate these lofty ideals of civic virtue – by placing self before country – Pitt's acceptance of the pension and peerage caused bitter disillusionment, and provoked accusations of betrayal, which inflicted irreparable damage upon his patriot reputation. Literary sources assist in recapturing the profound shock and alienation experienced by many of Pitt's supporters, who had revered him as the one contemporary figure who transcended the venal politics of the age. The Lord Mayor of London, Sir Samuel Fludyer, refused to accept the revelation of the pension and peerage until he heard it from Pitt himself. Birch recorded an encounter with an admirer, who was overwhelmed by the news. He repeated '*I am sorry for it*' over and over, and 'broke from me with great Emotion'.[102]

The complexities of practical politics and the compromises essential to government made it difficult for any proponent of patriotism to live up to its high moral code of uncompromising public and private virtue. *Patriot*

Policy's association of patriotism with religion suggested its excessive idealism, and the almost divine self-sacrifice it demanded. Pitt's fall from patriot grace was exemplified by a poem, which charged that, in succumbing to the temptations of pension and peerage, he had revealed himself to be susceptible to the same base instincts which governed other politicians. He makes a simple, shameful confession of his fallibility:

> And let them all this truth convey,
> That *P[it]t* was form'd of common clay;[103]

The pension was damaging because it appeared to contradict Pitt's declarations of political independence and contempt for wealth. Dr Johnson's definitions of 'pension' and 'pensioner' in his 1755 *Dictionary*, 'mean pay given to a state hireling for treason to his country' and a 'slave of state hired by a stipend to obey his master' help to explain the intensity of the accusations of opportunism, hypocrisy and greed launched against Pitt for the apparent betrayal of his patriot principles. One of the most vicious poetic attacks threw the most famous symbol of Pitt's patriot independence back into his face. He returns his gold box to the City because it will not hold the price he received for deserting the country, recanting his patriot views, and surrendering his political freedom:

> You tell me, Sirs, both one and all,
> My golden box was made too small;
> My meas'ring depth and breadth you've found,
> 'Twill not take in three thousand pound:[104]

To some extent, Pitt was the victim of the unrealistic expectations placed upon patriot politicians. Much of the backlash, however, was stimulated by his earlier self-righteous abuse of others, such as Campbell or Fox, for accepting sinecures and honours, and arrogant proclamations of his own rectitude. Only the year before, Pitt had reproached his estranged sister Anne for accepting a pension. In revenge, Anne circulated reports of their correspondence in which he refused to apply upon her behalf, 'having never been a Sollicitor for favours, upon any occasion, how can I become so now without contradicting the whole Tenor of my Life', and of the 'repugnancy' he felt 'to see my name placed on the Pensions of Ireland'.[105] Francis exploited these compromising rumours to highlight Pitt's hypocrisy in his reply to the *Monitor*'s defence.[106] Soon after resigning, Pitt had advertised the sale of his coach horses and his departure from the town house he rented in St James's Square in the newspapers, gestures perhaps made to emphasise that he planned to retire to a life of virtuous thrift and simplicity.[107] In light of the £3000 annuity, these displays were dismissed as artifices to promulgate the lie of his altruism:

> Yet, lest this pimping Pension Story,
> Should tarnish *patriotic* Glory,
> He took at once to thrifty courses,
> And wisely *advertis'd* his Horses:
> As who should say; 'Tis all a Lie:
> I can't afford a *Sett*; not I![108]

The barony offended some who had admired Pitt as the champion of the common man against aristocratic power and privilege. The yearning after social rank which it revealed was inconsistent with his former expressions of disdain for the empty vanity of titles, illustrated by his declaration to the Commons in June 1758 that he would be prouder to be an Alderman of the City of London than a peer.[109] The widespread revulsion against patriotism inspired by Pitt's resignation was recorded in Johnstone's *The Reverie*, where it becomes the greatest folly of the age, exemplified by the careers of Beckford and Shebbeare as well as Pitt.[110]

In contrast to the controversy incited by Pitt's dismissal in 1757, the overall literary reaction of 1761–62 was hostile, reflecting the great difference in circumstances. It was one thing to be dismissed for ostensibly refusing to compromise his patriotic ideals, and another to join the Old Corps faction he had previously despised, embrace their continental measures, and forsake his duty to secure an honourable peace by retreat with a pension. In 1757, Pitt's reputation had been strengthened by his patriot martyrdom, but in 1761 comparison with Judas appeared to be more apt according to his harshest judges. An analysis of the literary debate offers insight into the political reaction to Pitt's resignation. Popular ballads and works with a City bias remained most loyal, suggesting the resilience of Pitt's support among the extra-parliamentary classes and in London. Even at the height of Pitt's popularity, during the years of imperial triumph between 1758 and 1760, there had been an undertone of dissent, largely Tory, over Britain's increasing involvement in the German war, and condemnation of him for espousing it. During the resignation controversy, the failure of Tory writers to rally to Pitt, in contrast to the crisis triggered by the *Simile*, points to the growth of alienation among the party. The wide dissemination and great impact of Francis's parody suggests that anti-Pitt literature encouraged disillusionment among wider political opinion. Most poetry and prose such as Francis's *Letter Versified*, which would have appealed to a more polite readership, expressed dissatisfaction, a trend consistent with the decline of Pitt's support among the parliamentary classes, and especially the Tories, reflected in the disappointing number of addresses of thanks when compared with the gold box campaign of 1757.

During 1762, Britain's prosecution of the war was rewarded with further success. Martinique's capture in February was followed by the seizure of other

French West Indian islands, and the conquest of Havannah in August and Manila in October proved the vulnerability of Spain's colonial empire.[111] In May 1762, Bute succeeded Newcastle at the Treasury, who resigned as a result of the growing policy, political and personal divisions within the ministry.[112] Newcastle's decision was precipitated by the cancellation of Frederick II's subsidy, which reflected the court's wishes to disentangle Britain from the expensive, unpopular legacy of continental commitment it had inherited from George II.[113] Newcastle's departure after a career which spanned three reigns, attracted praise for devotion to the Hanoverian state as well as jubilation that the Old Corps oligarchy had finally been broken.[114] Walpole recognised the predicament faced by Bute now that he was identified as first minister and responsible for the conduct and conclusion of the war, 'misfortunes would remind us of Mr. Pitt's glory; advantages will stiffen us against accepting even such a peace as he rejected'.[115] Literary response to the conquest of Martinique, and to the temporary French recapture of Newfoundland in June 1762, bear out the truth of Walpole's analysis. Pitt's allies claimed that the victory was the result of his meticulous planning, while the vulnerability of Newfoundland was blamed upon Bute's negligence.[116]

After Pitt's departure, the ministry launched new overtures of peace to France, and formal negotiations began during the spring of 1762. In September, the Duke of Bedford was dispatched to Paris and the Duc de Nivernois arrived in London to conclude negotiations. The preliminaries were signed in Paris on 3 November. They were debated in Parliament on 9 and 10 December 1762, and formally ratified on 10 February 1763. According to the terms of the treaty, Britain acquired Canada, Cape Breton, Senegal, several West Indian islands, and Belleisle was exchanged for Minorca. The fortifications at Dunkirk were to be destroyed. An advantageous settlement was achieved in India. Spain surrendered Florida and confirmed the British right to cut logwood in central America. Martinique, Guadeloupe, Goree, Maria Galante and St Lucia were returned to France, and Spain recovered Havannah and Manila. France was permitted to retain a right to the Newfoundland fishery, with two unfortified islands for the drying of catches.[117]

Pitt, Beckford, Newcastle, Hardwicke and Temple opposed the preliminaries on 9 December; Pitt being so ill that he had to be carried into the Commons. He condemned the proposed terms for failing to recognise Britain's unprecedented conquests and compensate it for the extraordinary cost of the war in a speech which lasted approximately three and a half hours. In returning Guadeloupe and Martinique, and in conceding the fishery, Britain had squandered the opportunity to permanently cripple French commercial competition and maritime power. He declared that another year of war would have coerced the French into surrendering the fishery and other advantages. He deplored the abandonment of Frederick II, and contrasted

Britain's diplomatic isolation with the unity of her Bourbon rivals, who would soon recover their strength and pose a future threat. The impact of Pitt's speech was marred by its length, poor organisation, repetitiveness and the debilitating effect of illness. Walpole praised sections for their beauty and conviction, but concluded 'that thunder was wanting to blast such a treaty; and this was not a day on which his genius thundered'.[118]

Any settlement to a war of such intensity, expense and success was bound to be controversial as it entailed compromise and the loss of some of Britain's conquests. Conflict over the Peace of Paris was stimulated by the renewal of political strife following the departures of Pitt and Newcastle, and by an unprecedented degree of political manipulation of the press. Partisan press conflict between the Bute and Pelham factions and Pitt's champions Beckford, Temple and Wilkes had fuelled the dispute following his resignation. It increased once Bute emerged as head of the government, and Pitt and Newcastle resolved to oppose the preliminaries. With the assistance of Fox, Dodington, Jenkinson, and other experienced managers of the press, Bute mounted a sustained propaganda campaign. Newspaper articles, pamphlets, and the essay papers the *Briton* written by Tobias Smollett, and the *Auditor* by Arthur Murphy, championed Bute and the peace. He also set up a network of coffee-house spies to measure the pulse of opinion.[119] The *North Briton*, written by John Wilkes and Charles Churchill, emerged as the most compelling vehicle of the opposition press. There was even an international element to the conflict, with Prussian agents in London instructed by Frederick II to whip up anger against Bute for sacrificing his interests.[120]

Bute's belief in the press's capacity to mould opinion and foment antipathy was also illustrated by attempts to suppress hostile comment. During the crucial weeks before the opening of the 1762 Parliamentary session, the authors, printers and publishers of the *Monitor* were arrested and its production disrupted.[121] Many interpreted the tactic as an effort to silence the *North Briton*. Additional evidence of attempts to intimidate the press was provided by the secretary of state Lord Egremont's summons to Charles Say, the printer of the anti-Bute, anti-peace *Gazetteer*, 'who had both chocolate & good advice given him by his Lordship, tho' he is likely to pay dearly for his Entertainment'.[122] Birch also reported the private sale of a scandalous anti-Bute print, whose price was increased by rumours that the messengers of the press were in quest of it.[123] A print queried Bute's pretensions to altruistic artistic patronage by mocking his recruitment of mercenary writers and painters to defend and glorify his ministry (see Plate 2). These allegedly included Johnson who received a pension (nearest Bute), and Hogarth whose patent as serjeant painter was renewed (probably second from the right). Poetry, ballads, drama, fiction and prints occupied a prominent place in the peace debate, testifying

to its extraordinary intensity and diversity of opinion. *The Grumblers of Great Britain* satirised the political nation's obsession with the issue and the passion it evoked. It portrayed two coffee-house politicians, an ardent critic and an advocate of the peace, disputing its merits and supporting their arguments with reference to some of the leading examples of literary commentary (see Plate 3).

The publication of a considerable number of largely non-partisan poems deploring the destructiveness of a global conflict, which had raged since 1754, suggests the development of widespread war weariness by 1762. They lamented the thousands of combatants and civilians who had been killed and maimed, and the waste of national wealth.[124] Large areas of Europe and North America had been devastated, causing famine, pestilence and poverty. These commentators yearned for the restoration of the arts of peace. Many of these blessings were economic, in the relief from taxation and other financial burdens, in industrial and agricultural innovation, and in the revival of international trade, which would heal the wounds of war. There was also a yearning for the renewal of the cultural, scientific and literary arts, which could only flourish under the benevolent conditions of peace.[125] These poets welcomed the Treaty of Paris as honourable and advantageous.[126] Several emphasised that delivery from the evils of war was of greater importance than anything that could be gained from prolonging it. By 1762, it appears as if Frederick II's popularity was undermined by the belief that he would frustrate Britain's attempts to make peace once Russia's withdrawal from the war opened the prospect of offensive operations against Austria:

> Trophies enough, great King, you've won,
> And Deeds of hardy Prowess done,
> To shine in future Story;
> Sheath, then, O sheath the murd'rous Blade,
> By War no more the Man degrade,
> To raise the Hero's Glory.[127]

Many celebrations of peace were panegyrics on George III, who was regarded as its author. Eulogies of George III reflected the hope that he was the patriot king whose reign would be distinguished by patronage of the arts of peace, reflecting the tradition of his father.[128] Several praised Bute for teaching George III to cherish the virtues of peace, culture and patriotism:

> BUTE! to th' inspiring Muses dear;
> Whose Thirst of Science All revere:
> Thou, whose Politeness wins our Hearts:
> Thou, Judge of Statesmen, and their Arts:
> Behold where waits Thy Favourite TRUTH:
> O! lead Her to the ROYAL YOUTH.[129]

Bute was also commended for being the architect of a settlement that liberated Britain from the horrors of war:

> FROM scenes of blood, and all the ills of war,
> Britain now happy, freed by thy wise care.
> Let us no more in fruitless wars engage,
> For private profit, or for party rage:[130]

Acclamation of the peace was by no means universal, and evaluation of its terms was profoundly political. Poems and ballads critical of the peace subjected Bute to vehement abuse, much of which was inspired by Pitt's uncompromising opposition. The treaty was denounced as a surrender of the great territorial and commercial benefits Britain had sacrificed so much to gain, an even greater national disgrace than Utrecht or Aix-la-Chapelle.[131] The return of both Guadeloupe and Martinique was condemned as a lost opportunity for Britain to dominate the sugar trade, and retaining Goree would have given her control of the trade in slaves and gum which was used in the manufacture of printed cloth.[132] Barren Florida was dismissed as poor compensation for Havannah. The revenues of these valuable acquisitions would have contributed to the reduction of the enormous national debt created by the war.[133] These economic arguments received elucidation in an elaborate allegorical fable of the war, which depicted it as the struggle between two kingdoms of birds.[134] The restitution of Havannah was resented because of the immense loss of life suffered by the soldiers and sailors, approximately one-third of whom died of disease. Great significance was attached to control of the Newfoundland fishery. In a poem echoing Pitt, Britain's genius emphasised its importance as an endless harvest of wealth and the foundation of naval power:

> Her spacious seas, which annual blessings bear,
> Like certain fruits of the revolving Year;
> Whose riches with Peruvian treasures vie;
> Whose unexhausted sources never die:
> Where, with the produce, I the Seaman gain
> To lead my fleets triumphant o'er the Main.[135]

Writers who shared Pitt's view that a strong peace was vital for national security also saw the fishery as critical. They claimed that stripping France and Spain of the fishery and their more valuable colonies would have made it impossible for them recover sufficient strength to challenge Britain's naval and commercial supremacy. On 4 March 1763, during debate on the army estimates, Pitt declared that the peace 'was hollow and insecure, and *that it would not last ten years*'.[136] Pitt's determination to prosecute the war until a secure peace could be obtained was endorsed in a ballad. It envisaged the

making of peace as the cooking of soup, and asserted that Pitt alone would retain enough ingredients to produce a nourishing, wholesome broth that would nurture national wealth and power:

> Let your Soup, if you have it, be lasting and strong,
> To stick to the Ribs of the Old and the Young;
> High season'd and rich, it will add to your Vigour,
> And give you fresh Courage to draw Sword and Trigger.[137]

Many authors following Pitt maintained that Britain possessed the economic resources to fight on until France and Spain yielded the fishery and additional commercial and colonial advantages. One of Bute's political writers, Edward Richardson, had written an influential pamphlet advocating peace on the grounds that its opponents overestimated the financial exhaustion of France while underestimating the strain upon Britain. Richardson's work, popularly known as the Wandsworth Epistle, was circulated for free at the Royal Exchange and into the country through the post. His thesis was challenged in an ironic verse parody, which accused Bute of defeatism:

> Then to think of the weight of such annual expenses,
> Is enough to deprive a poor *Scot* of his Senses.
> Already *France* feels her distress to the full,
> Which is not, I own, yet the case with *John Bull*;[138]

Poets charged that Bute's nerve failed, and that he had grasped at peace just when France was on the verge of total collapse, and Britain could have dictated her own terms:

> Who says that War shall idly cease,
> We strengthen War, the War makes Peace;[139]

In a utopian fantasy of Britain during the twentieth century, the future George VI introduces an era of security, power and prosperity by pursuing Britain's enemies until they were decisively defeated.[140]

Bute's critics charged that he was desperate to end the war at any price for political self-interest, because it exposed his incompetence as a leader and encouraged demands for the return of his popular rival Pitt. The indictment that Bute betrayed the country to bolster his tyrannical, corrupt rule was conveyed in John Wilkes's revival of the drama *The Fall of Mortimer*, which drew a parallel with the medieval favourite's patched-up peace with Scotland during the reign of Edward III. Wilkes attacked Bute in the mock dedication, which described how the advantages of England's just war of revenge were thrown away: '*Edward* might have compelled them to accept of any terms, but ROGER MORTIMER, from personal motives of his own power and ambition, hastily concluded an ignominious Peace, by which he sacrificed all the glories of a successful War.'[141]

The accusation that Bute's influence over the young George III derived from his adulterous relationship with the King's mother was conveyed through a mock biblical satire, in which Bute was depicted as Gisgal of Hebron and Augusta as Bethsheba. Gisbal attempts to consolidate his usurpation by driving the allegorical equivalents of Pitt and Newcastle from power, and bringing Israel's war with the Philistines to an immediate and disgraceful end.[142]

Opponents of the peace censured the choice of Bedford as Britain's pleni-potentiary. He was blamed for extreme pacifism, diplomatic inexperience, and naivety, which were exploited by the French negotiators:

> Brave in the field, in council they are tools,
> Make war like lions, and make peace like fools.[143]

The Reverie caricatured Bedford as the Great Compounder in its fictional condemnation of the peace talks.[144] Scurrilous personal assaults were launched against Bedford, in which his eagerness to make peace was explained by the wish to relieve his enormous estate from the Land Tax. Bedford confessed his dishonourable cupidity when arguing with Pitt over why the war must be stopped:

> 'No *'state* have you in War to risque –
> We land-men pay the Shot–'
> 'Yea, but I've *that* to lose,' quoth Pitt,
> 'Some Dukes I know, have not!'[145]

Attempts to convince extra-parliamentary opinion of the merits of the peace were damaged by Bute's recruitment of Fox to manage its passage through the Commons, reputedly in exchange for his long desired peerage. Fox himself admitted that his involvement would be 'adding unpopularity to unpopularity'.[146] His unholy alliance with Bute was recorded in prints with the image of a fox wearing a kilt.[147] A dramatic satire portrayed the allegedly unprecedented bribery that Fox employed to purchase a Commons major-ity.[148] Churchill condemned the sordid spectacle:

> *Hirelings*, who valued naught but gold,
> By the best Bidder bought and sold,
> Truants from Honour's sacred Laws,
> Betrayers of their Country's cause,[149]

Ballads and graphic art employed an imaginative array of metaphors to sym-bolise Bute, Bedford and Fox imposing a pernicious peace upon the nation. They were portrayed lulling George III to sleep with bagpipe music, choking the British lion with lilies and thistles, as quack doctors administering emetics to Britannia, barbers cutting John Bull's throat and butchers chopping apart his carcass, French cooks forcing pea soup down the people's throats, corrupt

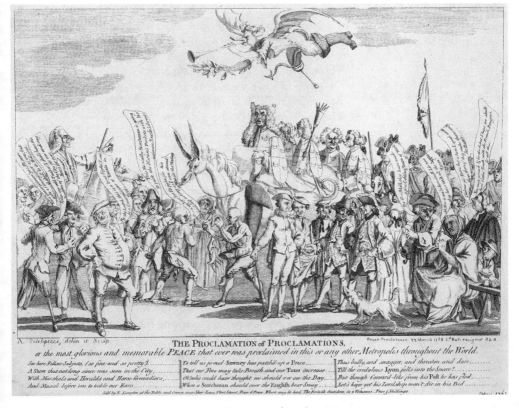

20 *The proclamation of proclamations*

auctioneers, cheating card players, and undertakers burying the lion.[150] Approximately eighty prints hostile to the Treaty of Paris were published during 1762–63. An engraving (Plate 20) condemning its proclamation in March 1763, depicted the herald riding a horse with ass's ears and cloven hooves. He is overshadowed by a demonic Fame wearing a jackboot to symbolise Bute's dictation of the peace. In the centre foreground a smug Bute receives the congratulations of grateful Frenchmen and Spaniards. The protests of a crippled sailor and the demon's wooden leg represent the peace as a national tragedy, where so much had been sacrificed in vain.

Bute and the peace were defended by a number of accomplished works of literature. Many were counterattacks against Pitt, whose condemnation of the peace reinvigorated the debate about the credibility of his patriotism. Assessments of Pitt's record as war minister and of the motives and intentions of his opposition dominated the controversy. During 1762, he championed the increasingly unpopular continental conflict and urged the ministry not to

withdraw from the Prussian alliance.[151] Pitt's claims of honest conversion to
the German war and of its diversionary value were dismissed by those who
indicted him for selling out to George II and the Pelhams:

> This king of kings, with mod'rate drain
> Of only – ninety thousand men,
> And eighty millions Sterling,
> Conquer'd, as in HIS map you'll see,
> All Canada in Germany,
> The *reck'ning* paid at Berlin.[152]

Another poet, who poured scorn upon Pitt's volte-face regarding the con-
tinent and his infatuation with Frederick II, advised him to share his pension
with his 'magnanimous Ally'.[153] Hostile literature illustrates how Pitt's resig-
nation and his open advocacy of the German war undermined his protest
against the peace. Pitt's critics also seized upon the inconsistency of his rejec-
tion of terms, most notably the concession of the fishery to France, which he
had accepted while secretary of state. Pitt's attacks upon the government so
soon after he had accepted the pension, and given his word to George III to
avoid factious disturbance, were represented as dishonest and ungrateful.
All of these apparent hypocrisies reinforced accusations that Pitt's renewed
opposition was sham patriotism, an attempt to incite popular discontent
against the peace, and exploit it to bring down the Bute ministry.

Richard Bentley charged that Pitt's attacks upon Bute and the peace were
stimulated by envy and frustrated ambition:

> *Sleep* in his pleasing bands had all things ty'd,
> All but the eyes of disappointed PRIDE.
> She lay revolving in her anxious mind,
> How *Resignation* had too much resign'd;[154]

In a comic drama, Hugh Baillie developed the theme that Pitt's resignation
and opposition to the peace were a premeditated plan to recover his compro-
mised popularity, ruin Bute, and compel George III to submit to his guid-
ance. Pitt confesses the excellence of the terms secured by Bute, and repeats
the geo-political arguments against acquiring too many tropical colonies such
as Martinique, Guadeloupe and Havannah, which would drain the human
resources of the mother country, and infect it with the moral corruption that
had ruined the Spanish empire.[155]

Hugh Dalrymple supported the accusations of opportunistic mock patri-
otism by a parody of Pitt's great speech against the preliminaries, which was
designed to recapture unthinking popular adulation. He ridiculed the spectacle
of Pitt's dramatic entrance, heralded by the applause of the mob, carried by
his servants, and wrapped in black velvet. Pitt's specious arguments against the

peace, punctuated by sham sighs and groans expressing the pain of illness and grief at Britain's fate, were dismissed as the worst exhibition of tragic acting:

> The Groundlings cry, *Alas! Poor Man!*
> *How ill he is! How pale! How wane!*
> *Yet such his Love of* us *and* STRIFE,
> *He'd rather run the risque of Life,*
> *Than leave the* BLEEDING LAND *a Prey*
> *To* B[U]TE, PEACE *and* OECONOMY!*[156]*

The rediscovery of an ancient Welsh manuscript purporting to record the prophecies of Merlin provided the vehicle for a hostile review of Pitt's career since 1754–55, culminating in his opposition to the peace. It describes the self-destruction of a patriot charlatan who is finally devoured by his own lies and broken promises, 'the champion vanishes out of sight, by jumping down his own throat and swallowing himself'.[157] Hogarth's famous engraving *The Times* portrayed the patriotic Bute attempting to extinguish the flames of conflict, while Pitt the warmonger, elevated upon stilts above an admiring mob, fans them with a bellows. Hogarth emphasised the self-seeking nature of Pitt's opposition by the millstone hanging about his neck marked with his £3000 pension.[158]

Pitt was vindicated by a lengthy, detailed panegyric upon his achievements as war minister. It praised him as a national hero, who had won the great imperial conquests in North America, Asia and Africa by harmonising British and Hanoverian interests. The author endorsed Pitt's plea to prevent future conflict by decisively reducing French maritime-colonial power:

> In Counsel resolute – You spoke your Mind
> 'Gainst Peace, – that leaves the Seeds of War behind,[159]

This was the only substantial poetic defence of Pitt, however, and its isolation suggests the extent of dissatisfaction with his stand against the peace.

Analysis of political literature commenting upon the Treaty of Paris provides valuable insight into the debate over its terms. Unlike most of the war's other controversies, the attitude of the approximately eighty publications was almost equally divided, illustrating the great diversity of opinion inspired by such a complex question. Contemporary historical sources also differ over the popularity of the peace. Their observations, when compared with the tone and arguments adopted by literary works, shed light upon the general response of the political nation. Commentators emphasised that protest against the peace was most violent among Pitt's mercantile supporters in the City of London, who opposed a premature end to the war, and demanded that Britain retain more of her commercial acquisitions.[160] The perception that

the City's vigorous backing of Pitt was motivated by the profits of war was
frequently recorded:

> My compliments to the City of *London*,
> The capital thrives, tho' the kingdom be undone;
> Tho' love of their country's the motive pretended,
> While peace is decried, and grim slaughter defended,
> Yet tear off the mask, which conceals love of pelf,
> You'll find their affections all centr'd in self.[161]

Yet even City opinion was divided, as demonstrated by the congratulatory
address to George III, presented in May 1763 by Sir Charles Asgill when its
Lord Mayor Beckford refused. It was signed by approximately 900 mer-
chants.[162] Demonstrations against the peace indicate that it was also unpop-
ular among London's extra-parliamentary classes. Bedford had been hissed
as he travelled through London to Dover to embark for France.[163] Bute was
violently abused by the crowd of protestors, which gathered outside Par-
liament for the opening of the 1762 session, and Pitt was cheered for his
opposition during the preliminary debates.[164] Walpole recorded the large
number of 'seditious papers posted up at every corner' and that there were
'satiric prints enough to tapestry Westminster Hall'.[165] The majority of
ballads, broadsides and prints distributed in the capital were hostile to the
peace, suggesting that they reflected and influenced popular animosity.[166]

It is also difficult to assess attitudes towards peace outside London. In July
1763 a ballad celebrated the defeat of an attempt by the ministerial party in
Surrey to organise an address in its favour.[167] Later in the month, the county
electors thanked their members for opposing it. The embarrassing advocacy
of the peace among Pitt's constituents in Bath, who drew up an address
praising it as 'adequate and advantageous', illustrates that not all of his sup-
porters shared his views. Pitt's indignant refusal to present the address led to
a quarrel with his patron, Ralph Allen.[168] The accusation that Bedford con-
cluded a hasty peace to relieve the tax burden upon his estate, often made by
writers sympathetic to the City, is interesting because it implies the existence
of the basic division between landowners and the mercantile interest noted
by some observers.[169] Poems such as the *Simile* suggest that dissatisfaction with
the expense and duration of the war developed first among Tory country
gentlemen. Their war weariness may have spread more widely among other
landowners by 1762, who reaped few of war's economic benefits but shouldered
much of the expense.

The Tory parliamentary party broke with Pitt over the peace. Shebbeare's
Sumatrans, a glowing panegyric on Bute and George III, who offered peace,
economy, political regeneration, and the prospect of participation in
non-party government, illustrates why the Tories abandoned the bellicose

patriotism of Pitt for the pacific patriotism of the court. Shebbeare's com-
mendation of the court's promises to eradicate moral and political corrup-
tion emphasised another reason why Tory and wider patriot opinion became
disenchanted with Pitt. His acceptance of a pension revived condemnation of
his failure to fulfil patriot expectations of constitutional reform. By joining
with Newcastle, he was accused of exploiting and perpetuating the Old Corps
system of corruption to keep himself in power. *A Prophecy of Merlin* quoted
Pitt's famous parliamentary declaration of alliance with Newcastle in level-
ling the charge:

> A man whose eloquence shall be as false as his patriotism or his politics, shall
> from out of the legions of corruption *borrow* a majority, and in return for so
> high a favour shall most graciously *lend* them his own unembarrassed face for
> a skreen.[170]

Richard Glover's change of allegiance from Pitt to Bute was also indicative
of how Pitt's compromises over the continent and political renewal had alien-
ated many former patriot supporters. Glover was returned to Parliament
in 1761 on Bute's interest, whom he defended in the press. By May 1762,
Glover would be debating with Pitt over the futility and extravagance of the
German war.[171] The significant majorities with which the Treaty of Paris was
approved in the Commons in December 1762, 319–65 and 227–63, suggest
that its terms were acceptable not only to the Tories, but also to a majority of
the parliamentary classes.[172] Hardwicke had maintained that Parliament and
the rest of the country were much more favourably disposed to peace than
London.[173] Most publications advocating peace tended to appeal to a more
polite readership, reinforcing the idea that it enjoyed greatest support among
propertied opinion.

NOTES

1 Chesterfield to his son, 25 June 1759, Chesterfield, V. 2355.
2 BL, Add. MSS 35,399, fo. 128: Birch to Royston, 22 July 1760.
3 *LC*, 31 May 1759; *AR*, 1762, 2.
4 *West-Country Thoughts on East-Country Folly*, 1758, p. 5.
5 Soame Jenyns, *A Simile*, 1759, pp. 2–6.
6 *IJ*, 24 Feb. 1759; *GM*, Feb. 1759, 80; *LM*, Feb. 1759, 96; *LC*, 1 Mar. 1759; *MR*, Mar. 1759, 275; *UC*, 24 Feb. 1759; *SM*, Feb. 1759, 89; Chesterfield to his son, 27 Feb. 1759, Chester-field, V. 2342.
7 BL, Add. MSS 6839, fo. 126: Symmer to Mitchell, 13 Feb. 1759.
8 BL, Add. MSS 32,488, fo. 278: Gordon to Newcastle, 28 Feb. 1759.
9 *Mon*, 17, 24 Feb. 1759.
10 Walpole, *Memoirs*, III. 55.
11 *BA*, 17, 24 Feb. 1759.
12 BL, Add. MSS 35,418, fo. 81: Newcastle to Hardwicke 15 Feb. 1759.

13 BL, Add. MSS 36,202, fos 261–315.

14 John Shebbeare, *An Answer to the Queries*, 1775, p. 36; *A Sixth Letter*, 1757.

15 John Shebbeare, *The History of the Sumatrans*, 1760, I. 215–21, 299–301.

16 *The Beavers*, 1760, pp. 8–9.

17 Walpole, *Memoirs*, III. 38.

18 *The Beavers*, pp. 15–16.

19 Walpole, *Memoirs*, III. 83.

20 *The Beavers*, pp. 22–3.

21 *AR*, 1760, 51–5; Karl Schweizer, 'Israel Mauduit: Pamphleteering and Foreign Policy in the Age of the Elder Pitt', in S. Taylor (ed.), *Hanoverian Britain and Empire* (Woodbridge, 1998), pp. 198–209.

22 *Old Time's Advice to Britannia*, BMC 3826.

23 Samuel Foote, *The Commissary*, 1765.

24 Dodington, p. 414.

25 Walpole, *Memoirs*, III. 52, 85.

26 Savory, p. 190.

27 *The Beavers*, p. 12.

28 Charles Johnstone, *The Reverie*, 1762, II. 1–28.

29 *Ibid.*, 83.

30 *Ibid.*, 81–4.

31 *Ibid.*, II. 142–3.

32 Cobbett, XV. 930–4; Dodington, p. 380.

33 Walpole, *George III*, I. 70–1; 65.

34 Add. MSS 35,399, fo. 169: Birch to Royston, 7 Oct. 1760.

35 *Mon*, 17 Feb. 1757.

36 *Corinna Vindicated. To Which is Added, an Answer to the Simile*, 1759. *Corinna Vindicated* and *Doll Common* were reprinted in many newspapers and periodicals.

37 *The Pittiad: a Satire*, 1759.

38 Newcastle to Hardwicke, 31 Oct. 1759, Yorke, III. 241.

39 Walpole, *Memoirs*, III. 54.

40 *Ibid.*, 41.

41 SP 36/140, fo. 138: John Fielding to Robert Wood, 23 Aug. 1758.

42 *Ibid.*, fo. 139: Robert Wood to John Fielding, 23 Aug. 1758.

43 Hardwicke to Newcastle, 14 Oct. 1760, Yorke, III. 347.

44 Rigby to Bedford, 22 Dec. 1760, Bedford, II. 426; Cobbett, XV. 981–5.

45 BL, Add. MSS 35,399, fo. 130: Birch to Royston, 26 July 1760.

46 *Old Time's Advice to Britannia*, BMC 3826.

47 John Lockman, *Truth*, 1758, p. 8.

48 Prince George to Bute, Dec. 1758, 4 May 1760, Sedgwick, pp. 19, 45.

49 Dodington to Bute, 22 Dec. 1760, Dodington, p. 407.

50 Walpole to Mann, 5 Dec. 1760, *Corr.*, XX. 459.

51 *The Quere?* BMC, 3735.

52 John Brewer, 'The Misfortunes of Lord Bute: A Case Study of Eighteenth-Century Political Argument and Public Opinion', *Historical Journal*, XVI (1973) 3–43; Schweizer, *Lord Bute*, 1–10.

53 Devonshire, p. 51.

54 Bedford to Bute, 9 July 1761, Bedford, III. 23.

55 Bute to Bedford, 12 July 1761, Bedford, III. 32–4.

56 Karl Schweizer, 'Lord Bute, Pitt and the Peace Negotiations with France', *Lord Bute*, pp. 41–55.

57 Devonshire, 111–39; Hardwicke's Notes, Newcastle's Minutes, Yorke, III. 275, 279–80.
58 Hardwicke to Royston, 22 Aug. 1761, Yorke, III. 321.
59 BL, Add. MSS, 35,399, fo. 286: Birch to Royston, 1 June 1762.
60 Brewer, *Party Ideology*, pp. 217–38; Peters, *Pitt*, pp. 205–39; Schweizer, 'Lord Bute and the Press: the Origins of the Press War of 1762 Reconsidered', *Lord Bute*, pp. 83–99.
61 Rigby to Bedford, 12 Oct. Bedford, III. 54.
62 Pitt to Beckford, 15 Oct. 1761, Chatham, II. 158–9.
63 Devonshire, p. 144.
64 Walpole, *George III*, I. 58.
65 Chesterfield to his son, 21 Nov. 1761, Chesterfield, V. 2388.
66 *Britannia. A New Song*, 1761.
67 'The Earl of Essex', *LEP*, 29 Oct. 1761.
68 1760, *BMC* 3745.
69 *The Tears of Old England for the Loss of Mr. Pitt*, 1761.
70 *The Unhappy Memorable Old Song of the Hunting of Chevy Chase*, 1761; *Merit Triumphant*, BMC 3814.
71 'Acrostick', *FFBJ*, 24 Oct. 1761; *Bussy and Satan*, 1762.
72 Cobbett, XV. 1129.
73 'Poetic Conference', *LC*, 16 Jan. 1762.
74 *The Siege of Belleisle*, 1761; *The Belleisle March*, 1761; *Chevy Chase*.
75 'On Mr. Pitt's Resigning the Seals', *LEP*, 22 Oct. 1761; 'On a Late Resignation', *LC*, 31 Oct. 1761.
76 'On Mr. Pitt's Resignation', *LEP*, 20 Oct. 1761; *Chevy Chase; Tears of Old England*; 'Inscription', *NM*, 9 Nov. 1761.
77 *Sydenham, A Poem, Addressed to the Right Honourable William Pitt Esq.* 1761, pp. 16–18.
78 'The Friend of England', *FFBJ*, 14 Nov. 1761; *Merit Rewarded*, BMC 3814.
79 Charles Churchill, 'Night', 1761, *The Poetical Works of Charles Churchill*, ed. Douglas Grant, (Oxford, 1956), 60–1.
80 Walpole to Conway, 25 Sept. 1761, *Corr.*, XXXVIII. 120.
81 *The Conciliad*, 1761, p. 26.
82 *Ibid.*, p. 27.
83 'The Important Question', *LC*, 27 Oct. 1761.
84 BL, Add. MSS 35,399, fo. 270: Birch to Royston, 9 Jan. 1762.
85 Devonshire, p. 111.
86 *The Coalition*, 1761, p. 9.
87 *BC*, 5 Nov. 1761.
88 Walpole, *George III*, I. 81.
89 Philip Francis, *A Letter from a Right Honourable Person. And the Answer to it. Translated into Verse*, 1761, pp. 6–7.
90 Francis, *A Letter*, pp. 8, 26.
91 BL, Add. MSS 35,999, fo. 161: Birch to Royston, 19 Oct. 1761.
92 Walpole, *George III*, I. 77; 'The Pen, the Seal, and the Mouths', *LEP*, 5 Nov. 1761.
93 Francis, *A Letter*, p. 19.
94 *The Quack-Iliad*, 1761, pp. 10–12; *A Peep Through the Key-Hole*, 1761, pp. 27–35.
95 Thomas Nuthall to Lady Chatham, 12 Nov. 1761, Chatham, II. 167.
96 'The Important Question', *LC*, 27 Oct. 1761.
97 *Gulliver's Flight*, 1762.
98 Chesterfield to Newcastle, 26 Oct. 1761, Chesterfield, V. 2383; Dodington to Bute 8 Oct. 1761, Dodington, p. 426.

99 Walpole, *George III*, I. 24.

100 Hugh Dalrymple, *Rodondo*, 1763, p. 20.

101 'To Mr. P[itt]', *LC*, 5 Nov. 1761.

102 BL, Add. MSS 39,399, fo. 258: Birch to Royston, 12 Oct. 1761.

103 *The Box Returned*, 1761, p. 5.

104 *Ibid.*, p. 1.

105 Williams, I. 206.

106 Philip Francis, *A Letter from the Anonymous Author of the Letters Versified to the Anonymous Writer of the Monitor*, 1761, p. 15.

107 *LC*, 13 Oct. 1761.

108 Dalrymple, p. 2; *Dialogue Between a Great Commoner and His Lady*, 1761.

109 Elliot to Grenville, 10 July 1758, Smith, I. 248.

110 Johnstone, I. 38–74; II. 232–8.

111 'Song', *LC*, 1 Apr. 1762; 'A New Ballad', *FFBJ*, 3 Apr. 1762; *Havannah's Garland*, 1762.

112 Newcastle to Joseph Yorke 14 May 1762, Yorke, III. 355–8.

113 Schweizer, *Frederick the Great*, pp. 284–96.

114 *An Epistle to His Grace the Duke of N[ewcastl]e on his Resignation*, 1762; Samuel Bishop, *An Ode to the Earl of Lincoln*, 1762; *An Ode to Duke Humphry*, 1762; *An Ode to the Memory of a Late Eminently Distinguished Placeman*, 1763; John Hall-Stevenson, *A Pastoral Cordial*, 1763.

115 Walpole to Mann, 1 July 1762, *Corr.*, XXII. 47–8.

116 *The Late Administration Epitomised; an Epistle in Verse to the Right Honourable William Pitt*, 1763, p. 26; *Punch's Politicks*, 1762, p. 16; *An Hieroglyphical Address*, BMC 3866.

117 Z. Rashed, *The Peace of Paris*, 1763 (Liverpool, 1951).

118 Walpole, *George III*, I. 147; James Hayes to Neville, 10 Dec. 1762, Rigby to Bedford, 13 Dec. 1762, Bedford, III. 168–70; Tom Ramsden to Jenkinson, 13 Dec. 1762, Jenkinson, p. 104.

119 BL, Add. MSS 39,399, fo. 294: Birch to Royston, 10 July 1762.

120 Robert Spector, *Political Controversy*; Peters, *Pitt*, pp. 240–64; Brewer, *Party Ideology*, pp. 217–38; Schweizer, *Frederick the Great*, pp. 302–3; Rea, pp. 3–40.

121 SP 44/87, fos 153–8.

122 BL, Add. MSS 39,399, fo. 355: Birch to Royston, 18 Sept. 1762.

123 Ibid, fo. 338: Birch to Royston, 28 Aug. 1762.

124 *On the Golden Age*, 1762; *The Effects of War and Peace*, 1763.

125 *Ode on the Return of Peace*, 1763; Bennet Allen, *A Poem on the Peace*, 1764.

126 Thomas Delamayne, *The Oliviad*, 1763; *On the Proclamation of Peace*, 1763; Philip Doyne, *Irene*, 1763; *A Poetic Chronology*, 1763.

127 'Ode', *DM*, 4 Feb. 1763.

128 *Britannia, a Poem*, 1762; *An Epistle to the King*, 1762; Abraham Portal, *War. An Ode*, 1763; Henry Jones, *The Royal Vision*, 1763; Mary Latter, *A Lyric Ode, on the Birth of His Royal Highness the Prince of Wales*, 1763.

129 David Mallet, *Truth in Rhyme*, 1761, p. ii; *The Royal Favourite*, 1762, p. 8.

130 'To J[ohn] E[earl] of B[ute]', *LEP*, 16 Sept. 1761; *Pro and Con, or the Political Squabble*, 1763; *The Blood-Hounds*, 1763.

131 *An Ode to Lord B[ut]e, on the Peace*, 1762, p. 14; Henry Howard, *Dedicated to the Glorious Sixty-Five*, 1763; 'On the Present Peace', *LEP*, 30 Nov. 1762.

132 'Epigram', *GM*, Feb. 1763, 91.

133 *A Set of Blocks*, BMC 3916.

134 *Curious and Authentic Memoirs Concerning a Late Peace*, 1762.

135 Delamayne, p. 21.

136 Walpole, *George III*, I. 162.
137 Henry Howard, *Pe[ac]e-Soup-Makers*, 1762; *The Caledonian Pacification*, BMC 3902; 'A Short Method for a Long Peace', *GM*, Apr. 1762, 187.
138 Edward Richardson, *A Letter to a Gentleman in the City*, 1763; *Wandsworth Epistle in Metre*, 1763.
139 'Ode', *FFBJ*, 12 June 1762; *England's Scotch Friend*, 1762; *LEP*, 7 Sept. 1762.
140 *The Reign of George VI*, 1763.
141 William Hatchet, *The Fall of Mortimer*, 1763, p. iii. At least four editions were printed.
142 *Gisbal an Hyperborean Tale*, 1762. Bute's patronage of James Macpherson's Ossianic poetry was ridiculed by the pretence that the work was a lost epic by Fingal.
143 'Epigram', *GM*, Dec. 1762, 594.
144 Johnstone, II. 279–86.
145 *Chevy Chase; A Rum Letter*, 1762; *The Congress*, BMC 3887.
146 Fox to Bedford, 13 Oct. 1762, Bedford, III. 134; *The Peace-Botchers*, 1763.
147 *An Antidote*, BMC 3845.
148 *The Blessings of P[eace]*, 1763.
149 Churchill, 'The Ghost', III. 1763, Grant, p. 117.
150 *The Trophys Exchang'd*, BMC 3968; *Englands Scotch Friend*, BMC 3961; *The Evacuations*, 1762; *Shave Close*, BMC 3959; *The Caledonian Slaughter-House*, BMC 3907; *Pe[ac]e-Soup-Makers*, 1762; *The Political Brokers*, 1762; *The Game of Hum*, BMC 3935; *The Lion Entranced*, BMC 3922.
151 Walpole, *George III*, I. 105–6.
152 *The Blood-Hounds*, p. 17; *The Parallel*, 1762.
153 *Verses Addressed to the Minister*, 1763, p. 6.
154 Richard Bentley, *Patriotism, a Mock-Heroic*, 1763, p. 3.
155 Hugh Baillie, *Patriotism! A Farce*, 1763, pp. 2–11.
156 Dalrymple, p. 35; 'A Simile', *LC*, 16 Dec. 1762.
157 *A Prophecy of Merlin*, 1762, p. 3; *The Minister of State, a Satire*, 1762.
158 *The Times, Plate I*, BMC 3970.
159 *Late Administration Epitomised*, p. 28.
160 BL, Add. MSS 39,399, fos 341–4: Birch to Royston, 4 Sept. 1762; Symmer to Mitchell, 20 Nov. 1762, Chatham, II. 169.
161 *Wandsworth Epistle*, p. 10.
162 Churchill, 'The Ghost', IV, Grant, p. 150; *The Extraordinary Address*, BMC 4058.
163 BL, MSS 39,399, fo. 355: Birch to Royston, 18 Sept. 1762.
164 Rigby to Bedford, 26 Nov. 1762, Bedford, III. 160.
165 Walpole to Conway, 9, 28 Sept. 1762, *Corr.*, XXXVIII. 173, 181.
166 The overwhelming antipathy of political prints is interesting because it is at odds with the roughly even attitude of literary works. Hogarth's *The Times* was one of the very few to endorse the peace. This requires further investigation, especially in the light of suggestions that it reflected a high degree of partisan patronage, BL, Add. MSS 6839, fo. 285: Symmer to Mitchell, 10 Sept. 1762.
167 *The Battle of Epsom*, 1763.
168 Churchill, 'The Ghost', IV, Grant, p. 166; *A Sequel to the Knights of Bath*, BMC 4060. To justify his refusal, Pitt published his correspondence with Allen in *BBJ*, Gee, p. 96.
169 BL, MSS 6839, fo. 241: Symmer to Mitchell, 20 Nov. 1761.
170 *Prophecy of Merlin*, p. 9.
171 Walpole, *George III*, I. 104–5.
172 Fox to Bedford, 12 Nov. 1762, Bedford, II. 154.
173 Hardwicke to Newcastle, 27 Nov. 1762, Yorke, III. 435–6.

11

Conclusion

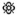

Poetry, ballads, drama and fiction were powerful forms of political commentary. Poetry's rhetorical and imaginative appeal, its ability to concentrate a depth of meaning into a well-turned couplet or striking metaphor, made it an effective weapon of political persuasion. Ballad illustrations and prints added an impressive visual dimension. Readers and hearers took great pleasure in the aesthetic attraction of metre, rhyme, song and image. They appreciated the ingenuity, wit and applicability of the great variety of narrative techniques, allegorical strategies, symbols and allusions employed by authors. References to the most well-known contemporary books and writers, such as the Bible, Shakespeare and Bunyan, and to folk tales and fables, made political messages accessible to the widest possible audience. The parody of important documents, which had been published in the press, such as Byng's dispatch, Pitt's letter to Beckford and the 1756 Speech from the Throne, provided the opportunity for direct satiric attack.

Political literature disseminated during the war revealed a great diversity in artistic quality and political maturity. This is evident in poetry and ballads, which ranged from imitations of classical models, Swift and Pope, to popular street songs and ephemeral verse posted upon the walls of St James's Palace, the Royal Exchange and other public places. It is political literature's universality that renders it such an illuminating source. This is exemplified by works patronised and written by members of the political elite and their agents such as Newcastle, Fox, Bute, Bedford, Temple, Rigby, Newcomb, Francis, Murphy and Mallet. Authors representing the commercial and professional ranks included the physician Shebbeare, the merchant Glover, the ropemaker Reed, the lawyer Long, the clergymen Free and Bacon, the bookseller and playwright Dell, the novelist Johnstone, and the innkeeper Freeth. The voice of the common people was heard through the ballad singers. Taken together these works demonstrate the survival of a vibrant literary-political culture, which embraced all stations of society. Literary commentary continued

to function as a significant component of the political press during the 1750s and 1760s, alongside the pamphlet, essay journal and increasingly important newspaper.

Political literature's extensive readership and audience is confirmed by the frequency, avid interest and appreciation with which it was advertised, extracted and reviewed in newspapers and literary journals, and discussed and copied into the diaries and correspondence of contemporaries. The experiences of John Siswick and John Freeth illustrate how literature circulated among a popular audience in taverns and coffee-houses, and through the performance of ballads. The composition of satiric poetry and ballads by politicians such as Hanbury Williams, Jenyns, Dodington and Wilkes illustrates the tradition of its dissemination among the world of the court, ministry and Parliament. The publication of these insiders' perspectives conveyed familiarity with issues, conflicts and personalities to the middling orders and the extended political nation. In this context, literature was often of greater political significance than the newspapers, whose proprietors generally lacked the same access to privileged information and were out of touch with ministerial politics. Ballads and poems were usually printed anonymously, or under a fictitious imprint, allowing their authors and publishers greater freedom and security to include politically sensitive material. Newcastle, Fox, Hardwicke, Pitt and Bute's political opponents circulated damaging personal attacks, which influenced perceptions of their public reputations and private lives, and helped to undermine their political credibility. The revelation of Fox's censorship of Byng's letter severely damaged his reputation. Literature played an important role in conveying the substance of parliamentary debates to a more extensive audience. Powerful phrases, images and ideas echoed without doors, becoming important slogans or rallying cries in political debate. Notable examples included Pitt's Rhône and Saône speech, Fox's claim to conduct the Commons, the millstone as a metaphor for continental war, Hardwicke's opposition to the Militia Bill, and Pitt's claim to have conquered America in Germany. When the information literature and prints communicated through the reporting of parliamentary proceedings, and in the satires upon the political struggles and personal clashes between opposition and government, and between factions within the government itself, is tested against the historical record, one is impressed by its scope and accuracy.

Political literature documents the dominant issues confronting the British political nation during the Seven Years War. It illustrates the widespread conviction that imperial expansion, overseas trade, national wealth and state power were closely connected. It records the belief in the great economic and strategic value of the British colonies in North America, and in the urgency of promoting their expansion into the Ohio Valley, Acadia and the other disputed regions. Literary sources reveal an absolute certainty of the justice

of British claims, and a determination to resort to force rather than to sacrifice any of the nation's territorial rights. Literature's uncompromising, confrontational attitude encouraged the political nation's demands for military action against France.

The development of this spirit of aggressive imperial expansionism after the conquest of Canada is suggested in later works, which advocated war against Spain, the exclusion of France from the Newfoundland fishery, and the permanent reduction of Bourbon commercial and colonial rivalry in North America, the Caribbean, India and Africa. The relatively little attention authors devoted to India is interesting, reflecting its geographic remoteness, the war's North American origins, and a strong identification with the fate of her colonists, fellow Britons who shared the threat from France. Literature's modest coverage also reflected the view that trade with India was not as central to imperial power and prosperity as Atlantic commerce.

Although there was a general consensus about the imperial and commercial aims of the war, the strategic question of how it should be waged – and whether national self-interest could best be realised by participation in or isolation from European alliances – stimulated intense debate. It was complicated by Britain's dynastic connection to Hanover. Political literature and prints which advocated an exclusively naval and colonial war expressed the depth and strength of hostility towards Hanover, which was diffused throughout British society. Its political volatility was illustrated by the violent reaction to the Maidstone affair and the Convention of Klosterseven. Argument over the merits of Britain's engagement in the continental conflict emerged as the war's dominant strategic controversy. Literary evidence helps to explain its initial acceptance by association with Frederick II and the Prussian alliance, and the gradual turn against its expense, indecisiveness and apparent futility after the conquest of Canada in 1760. Poetry, ballads, fiction, prose satire and prints also illuminate the diverse, complex debate over the terms of the peace.

Political literature yields valuable insight into the cultural and ideological framework of contemporary political debate, illustrating the resurgence of patriotism in the crisis of national confidence precipitated by the fall of Minorca. Military defeat was blamed on the destructive effects of political venality and corruption, and on the vices of self-interest, luxury, effeminacy and francophilia, which allegedly ran through the governing elite and threatened to spread more widely within British society. This fear was reflected in the bitter attacks upon Byng, Newcastle, Fox, Hardwicke and Anson, and inspired an urgent call for political, cultural and moral regeneration. Ballads and poetry functioned as important catalysts in the revival of Pitt's patriot reputation, which was defined by public spirit, independence, altruism and integrity. Literary sources suggest how he was able to tap into this

disillusionment with contemporary political morality and turn it to his advantage. Patriotism's emphasis on national duty and military virtue was reflected in literary pleas for the creation of a constitutional militia. The exigencies of war and the euphoria of victory after 1758, however, diverted attention away from the demands for reformation of the political system. The intense soul-searching of 1756–57 encouraged the excess of national pride stimulated by the conquest of an empire unparalleled in history. For poets who constructed the great national drama of the war with the benefit of hindsight, the calls for national renewal became almost a self-fulfilling prophecy. Victory was celebrated as the reward for the British nation's great sacrifices, and as confirmation that it retained its inherent political, cultural and military superiority, and God's providential blessing. Political literature indicates a cyclical movement in patriotism's credibility as a political ideology between 1754 and 1763. Its revival and disgrace were closely linked to the career of Pitt, who embraced it in opposition to cultivate influential extra-parliamentary support and to promote his ministerial aspirations. Pitt's apparent betrayal of patriot military strategy, in entangling Britain in a bloody and expensive continental war, and of its ideals of selflessness and independence, in accepting a pension, compromised his political reputation.

It is the immediacy and spontaneity of political literature that renders it of such value in helping to identify political opinion and trace its movements. This is illustrated by the development of popular indignation against Byng and the Newcastle ministry after Minorca's fall, the genesis of Fox's unpopularity and the growth and decline of Pitt's patriot reputation. The ability of political literature to shape as well as record opinion is suggested by the parodies of Byng's letter, the panegyrics lamenting Pitt's dismissal, the satiric campaign against Fox, the Tories' reaction to A Simile, the publication of works hostile to the continental war after 1759, Francis's versification of Pitt's letter, and the abuse of Bute over the peace. Newcastle, Hardwicke, Fox, Pitt and Bute's employment of the political press, scrutiny of its productions, and attempts to suppress hostile publication by legal action, illustrate their conviction of its capability to influence popular and parliamentary opinion.

The greatest challenge in seeking to evaluate the significance of literature, and of the political press as a whole, in its relation to opinion, is to determine their impact upon the innermost circle of politicians, who dominated ministerial politics by virtue of royal confidence, parliamentary support and predominance in the House of Commons. The Newcastle ministry's mishandling of the war ignited a flame of condemnation, which fanned outward after Minorca to consume significant sections of the propertied classes and the extended political nation, and threatened to engulf Parliament itself. Political literature acted as a powerful 'accelerator' encouraging the development of anti-ministerial hostility, which was expressed through the petitions, effigy

burnings and the mobbing of Newcastle. It contributed to the ministry's collapse by exacerbating the divisions between its rival factions. This was achieved by fomenting the extra-parliamentary opposition campaign which exerted such powerful pressure from without, and more directly, by playing upon the jealousy, resentment, distrust and anxiety of its members, most notably in the case of Fox, who proved to be the weak link in the ministerial chain. Pitt's success in the ministerial struggles of 1756–57 was promoted by George II, Devonshire, and Newcastle's belief that he commanded popular support, in stark contrast to Fox, a perception promulgated by political commentary and the gold box campaign. These examples of the influence of literature, opinion, and extra-parliamentary action upon high politics caution against too narrow a concentration on the formal structures of power and the tactical struggles of individual ministers, which can make them appear artificially detached, as if they occupied the deceptive calm at the centre of a hurricane. By exploring the interaction of these forces, a fuller understanding of the political history of the Seven Years War is achieved, one which restores the atmosphere of crisis surrounding the central protagonists, and suggests how it affected their personal and political motivations, assessments and actions.

Select bibliography

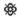

MANUSCRIPT SOURCES

British Library
Egerton MS
Francis Papers
Hardwicke Papers
Holland House Papers
Mitchell Papers
Newcastle Papers

Public Record Office
Chatham Papers, PRO 30/8
State Papers Domestic, SP 36–7, 44
Treasury Board Papers, T1
Treasury Solicitors Papers, TS11

PRINTED PRIMARY SOURCES: LITERATURE

1753
Foote, Samuel. *The Englishman in Paris.*

1754
Cibber, Colley. *Verses to the Memory of Mr. Pelham.*
The Emulation of the Insects.
Garrick, David. *An Ode on the Death of Mr. Pelham.*
His Majesty King George the Second.
Jones, Henry. *Verses to His Grace of Newcastle.*
A Letter to the Author of the Ode on Mr. Pelham's Death.
An Ode to the Duke of Newcastle.
Shebbeare, John. *The Marriage Act.*
The Triumph of Death.
Verses on the Subject of Death.

1755

The Courtier and Patriot.
De Boissy, Louis. *The Frenchman in London.*
Duck, Stephen. *Caesar's Camp.*
An Excellent New & Long Historical Ballad Upon the Times.
The First Satire of the First Book of Horace Imitated.
Forrest, Theodosius. *The Roast Beef of Old England.*
Great Britain's Resolution to Fight the French.
The History of Tom Dunderhead.
Humorous and Diverting Dialogues.
The King of France's Instructions to a French Spy.
Mallet, David. *Britannia.*
Marriot, James. *Two Pieces Presented to his Grace the Duke of Newcastle.*
An Ode on the Powers of Eloquence.
The Orator's Political Meditation.
Earl Poulett. *Sibyline Leaves.*
The Press-gang.
Sailor's Song, to the South.
A Sea-piece.
Shebbeare, John. *Lydia.*
State Poems.
The Voice of Truth.

1756

An Address from the Regions Below to A[dmiral] B[yn]g.
Admiral B[yng]'s Catechism.
Admiral Byng's Complaint.
Admiral Byng in Horrors.
Admiral B[yng] Seiz'd with Panic.
Admiral Byng's Letter to Secretary Cleveland.
All is Out or Admiral Byng's Complaint.
Averay, Richard. *Britannia and the Gods in Council.*
The Block and Yard Arm.
Boh Peep-Peep Boh, or A[dmira]l Bing's Apology to the Fribbles.
Britain, Strike Home.
The British Hero And Ignoble Poltroon Contrasted.
Bungiana.
Byng Return'd.
Capt. Andrew's Ghost.
Catton, William. *A Poem on Lord Blakeney's Bravery.*
The Chronicle of B[yn]g.
Condescension and Humility.
Cooper, John. *The Genius of Britain.*
The Converts.
Dedicated to the Captains Kirby, Constable, Warles.
Dell, Henry. *Minorca. A Tragedy.*
The Devil the Dutch the King of France.
A Dream Note.

Duncome, John. *Poems.*
England's Alarum Bell.
England's Warning.
The Fifteenth Ode of the First Book of Horace Imitated, and Applied to Mr. F[ox].
Foote, Samuel. *The Englishman Return'd from Paris.*
Free, John. *An Ode of Consolation upon the Loss of Minorca.*
The Freeholder's Ditty.
Garrick, David. *Lilliput.*
Glover, Richard. *A Sequel to Hosier's Ghost.*
His Majesty's Most Gracious Speech to Both Houses of Parliament.
The History of Reynard the Fox.
The Hue and Cry After Admiral Bung.
Invasion: an Occasional Ode.
A Late Epistle to C[levelan]d.
A Letter from a Cobler.
A Letter From a Committee of Sailors to Admiral B[yng].
The Life and Memoirs of Mr. Epigram Tristram Bates.
The Lyon, the Leopard, and the Badgers.
The Merry Topers.
The Ministry Chang'd.
More Birds For the Tower.
Newcomb, Thomas. *Novus Epigrammatium Delectus.*
A New Song.
A New System of Patriot Policy.
The Newsman's Present to His Worthy Customers.
Newton, Benjamin. *The Levee.*
The Observator of the Times.
Ode on the Present Times.
The Old British Foxhunter's Cry.
Oliver Cromwell's Ghost.
One-Thousand, Seven-Hundred, and Fifty-Six.
A Pathetick Address.
A Poem on the Declaration of War.
A Ray of Truth, Darting Thro' the Thick Clouds of Falsehood.
Reed, Joseph. *A British Philippic.*
The Royal Conference.
A Rueful Story, Admiral B[yn]g's Glory.
A Rueful Story or Britain in Tears.
The Seventeenth Epistle of the First Book of Horace Imitated.
The Sham Fight.
Shebbeare, John. *Letters on the English Nation.*
The Soldier's Song.
Some Further Particulars to the Case of Admiral Byng.
The Speech of a Patriot Prince.
The State Farce: a Lyrick. Written at Clermont, and Inscribed to His Grace the Duke of Newcastle.
The Wonder of Surrey!
The Wonder of Surry! The Wonder of Surry!
Wonder Upon Wonder.

1757
Admiral Byng in the Elysium Shades.
An Allusion to the Tenth Ode of the Second Book of Horace; on a Report of the Right Honable. H[enry] F[ox], Esq; Quitting all Public Employments.
An Answer from Lien Chi.
Bacon, Phanuel. *The Occulist.*
——. *The Taxes.*
The Book of Lamentations.
Britain, A Poem.
Britannia in Tears: an Elegy Occasioned by the Dismission of the Right Honable. W. P[it]t.
Brown, John *Estimate of the Manners and Principles of the Times.*
The Case of the Hon. Admiral Byng.
Change of Diet.
The Chronicle of the Short Reign of Honesty.
A Copy of Verses, on the . . . Battle Near the City of Prague.
Court and Country.
Dell, Henry. *The Frenchify'd Lady Never in Paris.*
The Fall of Public Spirit.
The Father of the City of Eutopia.
The Female Court-martial.
For Our Country. An Ode, as Presented to the Right Honourable William Pitt.
Four Hundred and Forty Six Verses, Containing Harsh Truths.
Frederick the Third, King of Prussia.
Free, John. *Poems on Several Occasions.*
The French in a Fright.
A Full and Particular Account of a Most Dreadful and Surprising Apparition.
The Ghost of Ernest.
The Hanoverian Treaty.
The Insects Chuse a Minister.
An Irregular Pindaric Ode. To His Majesty's Ship Deptford.
Jack Catch's Glory.
A Lamentation for the Departure of the Hanoverians.
Lamport, Edward. *An Ode Most Humbly Inscribed to the Right Hon. Lord Blakeney.*
A Letter From Lewis XV. to G[enera]l M[ordaun]t.
A Letter From Marshal Saxe.
A Letter From the C[our]t M[artia]l upon Admiral Byng.
A Letter From the Duke of Richelieu.
Long, Edward. *The Anti-Gallican.*
Murphy, Arthur. *The Englishman From Paris.*
The National Militia.
A New Historical, Political, Satirical, Burlesque Ode, on that Most Famous Expedition.
The Newsman's Present, to His Worthy Masters and Mistresses.
A New Song in Praise of the Durham Militia.
An Ode on the Expedition. Inscribed to the Right Honourable W[illiam] P[it]t, Esquire.
Past Twelve O'clock.
The Patriot, or a Call to Glory.
A Poem for the Better Success of His Majesty's Arms Against the French this Spring, with Byng's Tryal Versyfied.
A Poem. Occasioned by the Militia Bill.

A Poetical Epistle From Admiral Byng, in the Infernal Shades.
*A Poetical Epistle Occasioned by the Late Change in the Administration. Addressed to the
 Right. Hon. William Pitt Esq.*
The Poets Address to the Right Dis-Honourable William Pitt.
The Portsmouth Grand Humbug.
The Prayer; or the Muse on Her Knees for Britannia.
The Rape of the Vineyard.
The Rival Politicians.
The Secret Expedition.
The Secret Expedition. A Farce.
The Secret Expedition. A New Hugbug Ballad.
The Shooting of Admiral Byng, on Board the Monarque.
Smollett, Tobias. *The Reprisal.*
The Soldiers Lamentation.
The Sorrowful Lamentation and Last Farewell to the World, of Admiral Byng.
The Speech of the Honourable Admiral Byng.
The Speech of William IV.
The Times.
Thoughts Occasioned by the War.
*A Too Hasty Censure, Feb. 15, 1757. And a Too Necessary Retraction, Mar. 20, 1757. Verses
 Relative to the Late Unhappy A[dmira]l.*
A True Portrait of the E[nglish] N[ation].
Two Very Singular Addresses.
The Voice of Britain, a Poem, on . . . the Dismission of the Right Hon. William Pitt.
Walpole, Horace. *A Letter From Xo Ho.*
The Wisdom of Plutus.

1758
Admiral Vernon's Ghost.
Akenside, Mark. *An Ode to the Country Gentlemen of England.*
Albion Restored.
Bacon, Phanuel. *Humorous Ethics.*
British Worthies.
Catton, William. *A Poem on the Taking of Cape Breton and Cherbourg.*
——. *An Encomium on the Magnanimous Ferdinand, Prince of Brunswick.*
Characters of the Age.
Dobson, William. *The Prussian Campaign.*
D[ru]y's Ghost to Lt. Gen. B[lig]h.
The Eulogy of Frederic, King of Prussia.
Expedition, an Ode.
Falques, Marianne-Agnes. *Frederic Le Grand.*
Frederick II, King of Prussia. *An Epistle from the King of Prussia, to Monsieur Voltaire.*
——. *An Ode, Written by the King of Prussia Immediately After the Victory at Rosbach.*
——. *The Relaxation of War, or, the Hero's Philosophy.*
Glorious England's Garland.
Great Britain's Glory; Being a Loyal Song on the Taking of Cape Breton.
Jones, Henry. *The Patriot Enterprize . . . Inscribed to the Right Hon. William Pitt.*
The King.
Lockman, John. *Truth: a Vision.*

Lucubrations of Lancelot.
Morbleau.
Murphy, Arthur. *The Upholsterer.*
Neville, Valentine. *The Reduction of Louisbourg.*
Newcomb, Thomas. *Vindicta Britannica.*
——. *An Ode to the King of Prussia.*
The Newsman's Review of Transactions for the Year.
An Ode on His August Majesty, Frederick King of Prussia.
The Patriot Enterprise.
Phillips, Edward. *Britons, Strike Home.*
A Rhapsody in the House of Commons. Inscribed to the Right Honourable William Pitt.
Six Excellent New Songs.
The State Farce: or, they are all Come Home.
West-Country Thoughts on East-Country Folly.
Whitehead, William. *Verses to the People of England.*

1759
Abraham's Plains.
The Art of Preserving.
The Battle of Minden.
The Bold Sawyer.
Britain in Tears.
Britannia. A New Song.
The British Hero.
Corinna Vindicated. To Which is Added, an Answer to the Simile.
Daphnis and Menalcas.
Death of General Wolfe.
A Dialogue Between the Ghost A[dmira]l B[yng], and the Substance of a G[enera]l.
A Dialogue Betwixt General Wolfe, and the Marquis Montcalm.
Doll Common.
The D[u]t[c]h Alliance.
The Encouraging General.
Frederick the Great.
General Wolf.
Gilchrist's and Hotham's Bravery.
Gordon, Alexander. *The Prussiad.*
Great News, Great News, &c. From Sir Edward Hawke's Fleet.
Hawke's Triumph over the Mighty Brest Fleet.
An Hue and Cry After a Nameless Coward.
The Invasion, a Farce.
Jenyns, Soame. *A Simile.*
The Justification.
The Lamentations of the People of France.
Lockman, John. *To the Honourable George Townsend.*
The Loyal British Volunteers Farewell.
Mallet, David. *Tyburn to the Marine Society.*
A Monody on the Death of Major-Genl Wolfe.
Neptune's Resignation.
A New Song on Lord George Standfast.

The Newsman's Annual Address, for the Year.
The Northumberland Garland.
An Ode: Occasioned by the Success of Admiral Boscawen.
Ode to the Glorious Victory Obtained by the Allied Army in Germany . . . Near Minden.
An Ode, Sacred to the Memory of General Wolfe.
The Pittiad: a Satire.
The Proceedings of a Court Martial.
The Sequel to the Lillies of France.
The Siege of Quebec.
A Simile and Doll Common.
A Tragi-comic Dialogue.
The True Cause of a Certain G-l Officer's Conduct.
Virtue: an Ethic Epistle.
A Vision in Westminster Abby.
Worsdale, James. *Gasconado the Great.*

1760
The Battle of Warburg.
The Beavers.
The Bellisle March.
Bickerstaffe, Isaac. *Thomas and Sally.*
Brown, John. *An Additional Dialogue of the Dead, Between Pericles and Aristades.*
Butler, Hilary. *The Mayor of Wigan.*
Catton, William. *Sacred to the Memory of that Renowned Hero, Major General Wolfe.*
The Chronicle of the Derbyshire Regiment.
A Chronicle of the War Between the Felicianites, and Gallianites, and their Allies.
City Latin.
Cockings, George. *War: An Epic Poem.*
The Dawn of Hope.
An Elegiac Epistle to His Most Sacred Majesty King George III.
A Famous Sea-fight.
The Gentle Sailor.
The Guards Resolution.
The Hero's Garland.
Howard, Henry. *A Congratulatory and Admonitory Poem.*
The Humours of Portsmouth.
I Thomas Hodgson, Late Private Centinel in the 53rd Regiment of Foot.
The Jolly Sailors Song.
The Jolly Tars Garland.
King Henry V.
Liberty's Garland.
Lyttelton, George. *Dialogues of the Dead.*
The Marquis of Granby's March.
A Monody on the Death of the Sacred Majesty King George II.
Nedham, Marchamont. *Invocation of Neptune.*
A New Song.
Newcomb, Thomas. *Novus Epigrammatium Delectus.*
The Newsman's Present to his Worthy Customers.
An Ode in Two Parts, Humbly Inscrib'd to the Right Honourable William Pitt.

An Ode on the King of Prussia.
On the Death of King George the Second.
On the Golden Age.
On the Loss of the Ramilies.
On the Victory at Zorndorff.
One Thousand Seven Hundred and Fifty Nine.
Quebec: a Poetical Essay.
Shebbeare, John. *The History of the Sumatrans.*
The Soldier's Catechism.
Soldier's Departure From His Sweetheart.
A Song for Devonshire Militia-men.
The Surprizing and Heroic Atchievement at Revenshaugh Toll.
The Surprising Ghost of M. Thurot.
Taciturna and Iocunda.
The Tars of Old England's Garland.
The Tears of Britannia.
Thurot's Defeat.
The True Patriot.
Verses Addressed to the King.

1761
The Antiquarian School.
The Box Return'd.
Britannia: a Chronological Poem.
Britannia: A Song.
A Burlesque on the Bellisle March.
The Coalition.
A Collection of Loyal Songs.
A Congatulatory Ode to the Queen.
A Dialogue between a Great Commoner and His Lady.
An Epistle to His Grace the Duke of N[ewcastl]e.
Francis, Philip. *A Letter from the Anonymous Author of the Letters Versified to the Anonymous*
 Writer of the Monitor.
——. *A Letter to a Right Honourable Person. And the Answer to it, Translated into Verse.*
Grove, Joseph. *Two Dialogues in the Elysian Fields.*
Hiffernan, Paul. *The Wishes of a Free People.*
An Honest New Ballad, to a Lasting Peace.
Lloyd, Robert. *Poems.*
Lockman, John. *Verses on the Demise of the Late King.*
Mallet, David. *Truth in Rhyme.*
May, Henry. *Poetic Essays.*
The Mashall's [Marshall] Humble Offering to Each Gentleman Soldier.
Massie, Joseph. *Magna Charta.*
A Mirrour for the Critics.
A New Song. On the Battle in the Wood.
A New Song, on the War with Spain.
The Newsman's Present.
A Peep Through the Key-hole.
Prince Pitt!

The Quack-Iliad.
Reynard's Prosecution of the Unfortunate Bruin.
Samson, William. *The Conciliad.*
The Siege of Belleisle.
Sydenham, A Poem, Addressed to the Right Honourable William Pitt Esq.
Tarratoria.
The Tears of Old England, for the Loss of Mr. Pitt.
Thornton, Bonnell. *Plain English.*
The Unhappy Memorable Old Song of the Hunting of Chevy Chase.

1762
The Asses of Great Britain.
Bishop, Samuel. *An Ode to the Earl of Lincoln.*
Britannia, a Poem.
A Briton, the Son of a Briton.
Curious and Authentic Memoirs Concerning a Late Peace.
England's Scotch Friend.
An Epistle to His Grace the Duke of N[ewcastl]e on His Resignation.
An Epistle to the King.
The Evacuations.
The Exhortation.
The Favourite.
Gisbal, an Hyperborean Tale.
On the Golden Age.
The Grumblers of Great Britain.
Gulliver's Flight.
The Havannah's Garland.
Howard, Henry. *A New Humorous Song, on the Cherokee Chiefs.*
——. *The Pe[ac]e-Soup-Makers.*
Jack Tar's Garland.
John Bull's House Sett in Flames.
Johnstone, Charles. *The Reverie.*
The K[ing]'s A[ss].
Langhorne, John. *The Viceroy.*
The Minister of State, a Satire.
A New Song on the Birth-day of His Most Gracious Majesty.
An Ode to Duke Humphry.
An Ode to Lord B[ute], on the Peace.
Ogden, James. *The British Lion Rous'd.*
Pandemonium College.
The Parallel.
The Peace: a Poem.
The Political Brokers.
The Progress of Lying.
A Prophecy of Merlin.
Punch's Politicks.
The Quack Doctors.
The Request.
The Royal Favourite.

A Rum Letter.
Shebbeare, John. *History of the Excellence of the Sumatrans.*
A Speech Without Doors.
The Stocks.
The Staff of Gisbal.

1763
Baillie, Hugh. *Patriotism! A Farce.*
The Battle of Epsom.
Bentley, Richard. *Patriotism, a Mock-heroic.*
Birth of a Prince of Wales.
The Blessings of P[eace].
The Blood Hounds.
The Cabal.
Catton, William. *Poems on Several Occasions.*
The Conjurers.
Dalrymple, Hugh. *Rodondo.*
Delamayne, Thomas. *The Oliviad.*
Doyne, Philip: *Irene.*
The Effects of War and Peace.
The English Britons.
Folly, a Satire on the Times.
Genius and Valour.
The Guardian Angel.
Hall-Stevenson, John. *A Pastoral Cordial.*
Hatchett, William. *The Fall of Mortimer.*
Howard, Henry. *Dedicated to the Glorious Sixty-Five.*
——. *Fun a la Mode.*
——. *The Masquerade.*
In and Out, and Turn About.
It's All of a Peace.
Jones, Henry. *The Royal Vision.*
The Late Administration Epitomised; an Epistle in Verse to the Right Honourable William Pitt.
Latter, Mary. *A Lyric Ode, on the Birth of His Royal Highness the Prince of Wales.*
Lockman, John. *Frederic of Prussia.*
The Marquis of Granby.
Memoirs of the Life and Adventures of Tsonnonthouan.
Newcomb, Thomas. *On the Success of the British Arms.*
Ode on the Duke of York's Second Departure From England.
Ode on the Return of Peace.
An Ode to the Memory of a Late Eminently Distinguish'd Placeman.
The Peace-Botchers.
Peregrinations of Jeremiah.
A Poetic Chronology.
A Poetical Wreath of Laurel and Olive.
Portal, Abraham. *War. An Ode.*
Pro and Con or the Political Squabble.
On the Proclamation of Peace.
The Reign of George VI.
The Rural Conference.

Satires on the Times.
Stirling, James. *An Ode on the Times.*
To Each Gentleman Soldier.
To the Gentlemen Freeholders of the County of Gloucester.
The Triumph of the Brutes.
Two New Comic Satiric Dialogues.
Verses Addressed to No Minister.
Verses Addressed to the Minister.
——. *Wandsworth Epistle in Metre.*
The Windsor Apparition.

1764
Allen, Bennet. *A Poem on the Peace.*
Foote, Samuel. *The Mayor of Garret.*

1765
Foote, Samuel. *The Commissary.*

1768
Howard, Middleton. *The Conquest of Quebec.*

WORKS REVIEWED IN LITERARY PERIODICALS

The Apparition to a Great Man; or Admiral Byng's Outcry for Justice, 1760.
Bussy and Satan, 1762.
Chronicle of the Reign of Adonijah, 1763.
A Dialogue of Mars and Britannia, 1763.
The Dream; or, England Invaded, 1756.
An Epistle from Schah Hussein, 1757.
Epistle to the King, 1763.
Essay on a Drum Head, 1758
Frederic Victorieux, 1757.
The History of the War, 1760.
Howard, Middleton. *The British Genius Reviv'd by Success,* 1758.
An Hue and Cry After a Nameless Coward, 1757.
The Imperial Russian Miscellany, 1755.
Jonathan Wild's Advice to His Successor, 1758.
A Letter From an Officer in the Ottoman Army, 1759.
A Letter to A[dmira]l B[yn]g, 1756.
Letter of M. Voltaire, to the People of England, 1756.
Morey, Thomas. *The Retrospect,* 1760.
Much Ado About Nothing, 1759.
Newcomb, Thomas. *An Ode to the King of Prussia,* 1758.
Ode on His Majesty's Return, 1755.
The Recruiter for Germany, 1762.
Soldier's Amusement, 1760.
The Soliloquy of the Most Renowned the Marshal Duke of Belleisle, 1759.
The Subscription Soldier, 1760.
Triumph in Death, or Death Triumphant, Exemplified in the Death of Wolfe, 1759.

The Triumvirade, 1763.
Verses Occasioned by the Victory at Rosbach, 1758.
Verses Relative to the Late Unhappy A[dmiral], 1757.
Verses to the Right Honourable Robert Lord Clive, 1761.
Wales, William. *Ode to the Right Hon. William Pitt, Esq.*, 1762.

PAMPHLETS AND BROADSIDES

An Appeal to the People: Containing, the Genuine and Entire Letter of Admiral Byng, 1756.
A Collection of Several Pamphlets . . . Relative to the Case of Admiral Byng, 1756.
A Copy of a Paper Delivered by the Honourable Admiral Byng . . . Immediately Before His Death, 1757.
The Enquiry is not Begun!, 1757.
An Essay on Political Lying, 1757.
General B[lakene]y's Account, 1756.
German Cruelty, 1756.
The Hanoverian Treaty, 1757.
Ferne, Charles. *The Trial of the Honourable Admiral John Byng . . . Published by Order of the Right Honourable the Lords Commissioners of the Admiralty*, 1757.
Hervey, Augustus. *If Justice is Begun?*, 1757.
——. *Speech of the Honable Admiral Byng, Intended to Have Been Spoken on Board the Monarch*, 1757.
——. *The Unfortunate Case of Two Swedish Generals*, 1756.
A Letter to a Member of Parliament in the Country . . . Relative to the Case of Admiral Byng, 1756.
Mallet, David. *The Conduct of the Ministry Impartially Examined*, 1756.
——. *Observations on the Twelfth Article of War*, 1757.
Mauduit, Israel. *Considerations on the Present German War*, 1760.
The Patriot Unmasked, 1761.
Richardson, Edward. *A Letter to a Gentleman in the City.*
The School-Boy in Politics, 1756.
A Second Dialogue Between Prejudice and Reason, 1763.
Shebbeare, John. *A Letter to the People of England on the Present Situation and Conduct of National Affairs*, 1755.
——. *A Second Letter to the People of England. On Foreign Subsidies, Subsidy Armies, and Their Consequences to this Nation*, 1755.
——. *A Third Letter to the People of England on Liberty, Taxes, and the Application of Public Money*, 1756.
——. *A Fourth Letter to the People of England. On the Conduct of the M[inist]ers in Alliances, Fleets, and Armies*, 1756.
——. *A Sixth Letter to the People of England*, 1757.
Some Further Particulars in Relation to the Case of Admiral Byng, 1756.
The Voice of the People: a Collection of Addresses to His Majesty and Instructions to Members of Parliament, 1756.

PERIODICALS AND NEWSPAPERS

Aris's Birmingham Gazette
The Auditor
The Bath Advertiser
Belfast News-Letter

Berrow's Worcester Journal
Bodley's Bath Journal
Briton
Con-test
Crab-Tree
Critical Review
Derby Mercury
Felix Farley's Bristol Journal
Gazetteer and London Daily Advertiser
General Magazine of Arts and Sciences
Gentleman's Magazine
Ipswich Journal
Leicester and Nottingham Journal
Literary Magazine
Lloyd's Evening Post, and British Chronicle
London Chronicle
London Evening Post
London Gazette
London Magazine
Monitor
Monthly Review
Newcastle Courant
Newcastle Journal
Northampton Mercury
North Briton
Norwich Mercury
Political Controversy
Public Advertiser
Read's Weekly Journal
Schofield's Middlewich Journal
Scots Magazine
St James's Chronicle
Test
York Courant

MEMOIRS AND CORRESPONDENCE

Almon, John, *Anecdotes of the Life of the Right Honourable William Pitt* (London, 1792).

Aspinal-Oglander, C. (ed.), *Admiral's Wife: Being the Life and Letters of the Hon. Mrs Edward Boscawen* (London, 1940).

Boswell, James, *Life of Johnson* (Oxford, 1980).

Carlyle, Alexander, *Anecdotes and Characters of the Times*, ed. J. Kinsley (London, 1973).

Churchill, Charles, *The Poetical Works of Charles Churchill*, ed. Douglas Grant (Oxford, 1956).

Clark, J. C. D. (ed.), *The Memoirs and Speeches of James, 2nd Earl Waldegrave 1742–1763* (Cambridge, 1988).

Cobbett, William, *The Parliamentary History of England* (London, 1806–20).

Costin, C. (ed.), *The Law and Working of the Constitution* (London, 1961).

Coxe, William, *Memoirs of the Administration of the Right Honourable Henry Pelham* (London, 1829).

Debrett, J. (ed.), *The History, Debates and Proceedings of Both Houses of Parliament* (London, 1792).

Dickins, Lilian (ed.), *An Eighteenth-Century Correspondence* (London, 1911).

Dodington, George Bubb, *Political Journal*, ed. John Carswell and Lewis Dralle (Oxford, 1965).

Foote, Samuel, *Memoirs of Samuel Foote*, ed. William Cook (London, 1805), II. 206.

George III, *Letters from George III to Lord Bute 1756–1766*, ed. Romney Sedgwick (London, 1939).

Gibbon, Edward, *Memoirs of My Life*, ed. G. Bonnard (New York, 1969).

Glover, Richard, *Memoirs of a Celebrated Literary and Political Character* (London, 1814).

Grenville, *The Grenville Papers*, ed. William Smith (London, 1852).

Hanbury Williams, Charles, *The Works of the Right Honourable Sir Charles Hanbury Williams* (London, 1822).

Hervey, Augustus, *Augustus Hervey's Journal*, ed. David Erskine (London, 1953).

Hollis, Thomas. *Memoirs of Thomas Hollis*, (London, 1780).

Johnson, Samuel, *The Political Writings, Yale Edition of the Works of Samuel Johnson*, ed. Donald Greene, X (New Haven, 1977).

Jonson, Ben, *Volpone* (Edinburgh, 1968).

Lyttelton, George, Lord, *Memoirs and Correspondence*, ed. Robert J. Phillimore (London, 1845).

McAleer, J. (ed.), *Ballads and Songs Loyal to the Hanoverian Succession* Augustan Reprint Society 96, (Los Angeles, 1962).

Nugent, Claud (ed.), *Memoir of Robert, Earl Nugent* (London, 1898).

Osborn, Sarah Byng, *Letters of Sarah Byng Osborn*, ed. J. McClelland (Stanford, 1930).

Pease, T. (ed.), *Anglo-French Boundary Disputes in the West, 1749–1763* (Springfield, 1936).

Pitt, Hester, *So Much Loved, So Much Adored: Letters to Hester Pitt, Lady Chatham*, ed. V. Birdwood (London, 1994).

Pitt, William, *Correspondence of William Pitt, Earl of Chatham*, ed. W. S. Taylor and J. Pringle, (London, 1838).

——, *Correspondence of William Pitt When Secretary of State*, ed. G. Kimball (London, 1906) I. 409.

Percival, Milton (ed.), *Political Ballads Illustrating the Administration of Sir Robert Walpole* (Oxford, 1916).

Richmond, Herbert (ed.), *Papers Relating to Minorca* (London, 1913).

Rogers, Samuel, *Recollections of the Table-Talk of Samuel Rogers,* ed. M. Bishop (London, 1952).

Russell, John, *Correspondence of John, Fourth Duke of Bedford*, ed. Lord John Russell (London, 1843).

Sedgwick, R. (ed.), 'Letters From William Pitt to Lord Bute, 1755–1758', *in Essays Presented to Sir Lewis Namier*, ed. R. Pares (London, 1956), pp. 108–66.

Shelburne, William, *Life of William Earl of Shelburne*, ed. Lord Edmund Fitzmauric (London, 1875–76).

Shenstone, William, *The Letters of William Shenstone*, ed. Marjorie Williams (Oxford, 1939).

Stanhope, P. D., *The Letters of Philip Dormer Stanhope, 4th Earl Chesterfield*, ed. B. Dobrée (London, 1932).

Torrens, W. M., *History of Cabinets* (London, 1894).

Turner, Thomas, *The Diary of a Georgian Shopkeeper*, ed. G. H. Jennings (Oxford, 1979).

Waldegrave, James, Earl Waldegrave, *The Memoirs and Speeches* (London, 1821).

Walpole, Horatio, *Memoirs of Horatio, Lord Walpole*, ed. W. Coxe (London, 1802).

Walpole, Horace, *Horace Walpole's Correspondence*, ed. W. S. Lewis *et al.* (New Haven, 1937–83).

——, *Memoirs of George II*, ed. John Brooke (New Haven, 1985).

——, *Memoirs of the Reign of King George III*, ed. D. Jarrett (London, 2000).

Weatherly, E. H. (ed.), *The Correspondence of John Wilkes and Charles Churchill* (Columbia, 1954).

Wyndham, M. *Chronicles of the Eighteenth Century* (London, 1924).

Yorke, Philip, C., *The Life and Correspondence of Philip Yorke, Earl of Hardwicke*, (Cambridge, 1913).

PRINTED SECONDARY WORKS

Andrewes, C., 'Anglo-French Commercial Rivalry, 1700–1750', *American Historical Review*, XX (1914–15), 539–56, 761–88.

Atherton, Herbert M., *Political Prints in the Age of Hogarth: A Study of the Ideographic Representation of Politics* (Oxford, 1974).

Baugh, D., 'Great Britain's "Blue-Water Policy", 1689–1815', *International History Review*, X (1988), 33–58.

Baxter, S., 'The Conduct of the Seven Years' War', in S. B. Baxter (ed.), *England's Rise to Greatness* (Berkeley, 1983), pp. 335–44.

Black, Jeremy, *The English Press in the Eighteenth Century* (London, 1987).

——, *Pitt the Elder* (Cambridge, 1992).

Boyce, D., 'Public Opinion and Historians', *History*, LXIII (1968), 214–28.

Breen, T. H., 'An Empire of Goods: The Anglicisation of Colonial America, 1670–1776', *Journal of British Studies*, XXV (1986), 467–99.

Brewer, John, 'The Misfortunes of Lord Bute: A Case Study of Eighteenth-Century Political Argument and Public Opinion', *The Historical Journal*, XVI (1973), 3–43.

——, *Party Ideology and Popular Politics at the Accession of George III* (Cambridge, 1976).

——, *The Sinews of Power: War, Money and the English State 1688–1783* (London, 1989).

Bromley, J., 'Britain and Europe in the Eighteenth Century', *History*, LXVI (1981), 394–412.

Browning, Reed, *The Duke of Newcastle* (New Haven, 1975).

Capraro, R., 'Political Broadside Ballads in Early Hanoverian London', *Eighteenth Century Life*, XI (1987), 11–21.

Cardwell, M. John, 'Mismanagement: the 1758 Expedition Against Carillon', *Bulletin of the Fort Ticonderoga Museum*, XV (1992), 236–92.

Carretta, Vincent, *The Snarling Muse: Verbal and Visual Political Satire From Pope to Churchill* (Philadelphia, 1983).

Carter, A., *The Dutch Republic in Europe in the Seven Years War* (London, 1971).

Clark, D., 'News and Opinions Concerning America in English Newspapers, 1754–1763', *Pacific Historical Review*, X (1941), 75–82.

Clark, J. C. D., *The Dynamics of Change: The Crisis of the 1750s and English Party Systems* (Cambridge, 1982).

——, 'The Politics of the Excluded: Tories, Jacobites and Whig Patriots, 1715–1760', *Parliamentary History*, II (1983), 209–22.

Clayton, T., 'The Duke of Newcastle, the Earl of Halifax and the American Origins of the Seven Years' War', *The Historical Journal*, XXIV (1981), 571–603.

Clayton, Timothy, The English Print 1688–1802 (London, 1997).

Colley, L., *Britons: Forging the Nation, 1707–1837* (London, 1992).

——, *In Defence of Oligarchy: The Tory Party 1714–1760* (Cambridge, 1982).

Corbett, J., *England in the Seven Years' War: a Study in Combined Strategy* (London, 1918).

Crawford, T., 'Political and Protest Songs in Eighteenth-Century Scotland I: Jacobite and Anti-Jacobite', *Scottish Studies*, XIV (1970), 1–33.

——, 'Political and Protest Songs in Eighteenth-Century Scotland II: Songs of the Left', *Scottish Studies*, XIV (1970), 105–31.

Dann, Uriel, *Hanover and Great Britain 1740–1760* (London, 1991).

Dickinson, H. T., *Liberty and Property: Political Ideology in Eighteenth-Century Britain* (London, 1977).

——, *Politics and Literature in the Eighteenth Century* (London, 1974).

——, *The Politics of the People in Eighteenth-Century Britain* (New York, 1995).

——, 'Popular Politics in the Age of Walpole', in J. Black (ed.), *Britain in the Age of Walpole* (London, 1984), pp. 45–69.

Dobrée, B., 'The Theme of Patriotism in the Poetry of the early Eighteenth-Century', *Proceedings of the British Academy*, XXXV (1949), 49–65.

Downie, J. A., *Robert Harley and the Press: Propaganda and Public Opinion in the Age of Swift and Defoe* (London, 1979).

——, *To Settle the Succession of the State: Literature and Politics 1678–1750* (London, 1994).

——, J. A., 'Walpole, the Poet's Foe', in J. Black (ed.), *Britain in the Age of Walpole* (London, 1984), pp. 171–88.

Feather, John, 'The Power of Print', in J. Black (ed.), *Culture and Society in Britain 1660–1800* (Manchester, 1997), pp. 61–2.

Ferdinand, C. Y., *Benjamin Collins and the Provincial Newspaper Trade in the Eighteenth Century* (Oxford, 1997).

Floud, Roderick, and McCloskey, D. N. (eds), *The Economic History of England Since 1700* (Cambridge, 1981).

Foster, James, 'Smollet's Pamphleteering Foe Shebbeare', *Publications of the Modern Languages Association*, LVII, (1942), 1053–100.

Fox-Strangeways, G., Earl of Ilchester, *Henry Fox, First Lord Holland, His Family and Relations* (London, 1920).

Frégault, Guy, *Canada: The War of the Conquest*, trans. Margaret Cameron (Toronto, 1969).

George, Dorothy, *English Political Caricature to 1792: A Study of Opinion and Propaganda* (Oxford, 1959).

Gerrard, Christine, *The Patriot Opposition to Walpole: Politics, Poetry, and National Myth* (Oxford, 1994).

Gibbs, G., 'English Attitudes towards Hanover', in A. Birke (ed.), *England and Hanover* (London, 1986), pp. 33–53.

Gould, Elijah, *The Persistence of Empire: British Cultural Politics in the Age of the American Revolution* (London, 2000).

Goldgar, Bertrand, *Walpole and the Wits: The Relation of Politics to Literature, 1722–42* (Lincoln, Neb., 1976).

Hanson, L., *Government and the Press 1695–1763* (London, 1967).

Harris, Michael, *London Newspapers in the Age of Walpole* (London, 1987).

——, 'Print and Politics in the Age of Walpole', in J. Black (ed.), *Britain in the Age of Walpole* (London, 1984), pp. 171–89.

Harris, Robert, *A Patriot Press: National Politics and the London Press in the 1740s* (Oxford, 1993).

——, *Politics and the Nation: Britain in the Mid-Eighteenth Century* (Oxford, 2002).

Hoover, Benjamin B., *Samuel Johnson's Parliamentary Reporting* (Los Angeles, 1953).

Horden, John, *John Freeth (1731–1803) Political Ballad-writer and Innkeeper* (Oxford, 1993).

Horn, D. B., 'The Duke of Newcastle and the Origins of the Diplomatic Revolution', in J. H. Elliott (ed.), *Diversity of History* (London, 1970), pp. 245–69.

Hughes, H., 'A Precursor to *Tristram Shandy*', *Journal of English and Germanic Philology*, XVII (1918), 227–51.

Ilchester, Earl of, and E. Langford-Brooke, *The Life of Sir Charles Hanbury Williams Poet, Wit and Diplomatist* (London, 1928).

Jarrett, D., 'The Myth of "Patriotism" in Eighteenth-Century English Politics', in J. S. Bromley (ed.), *Britain and the Netherlands*, V (The Hague, 1975), 120–40.

Jennings, Francis, *Empire of Fortune: Crowns, Colonies and Tribes in the Seven Years War in America* (New York, 1988).

Jordan, G, and Rogers, N., 'Admirals as Heroes: Patriotism and Liberty in Hanoverian England', *Journal of British Studies*, XXVIII (1988), 201–44.

Kelch, Ray, *Newcastle: A Duke Without Money* (London, 1974).

Kramnick, Isaac, *Bolingbroke and His Circle: The Politics of Nostalgia in the Age of Walpole* (Cambridge, Mass. 1968).

Langford, Paul, *The Excise Crisis* (Oxford, 1975).

——, 'William Pitt and Public Opinion, 1757', *English Historical Review*, LXXXVIII (1973), 54–79.

Laprade, William, *Public Opinion and Politics in Eighteenth-Century England* (Cambridge, 1936).

Luff, Peter, A. 'Henry Fox and the Lead in the House of Commons', *Parliamentary History*, VI (1987), 33–46.

Lillywhite, Bryant, *London Coffee Houses: A Reference Book of Coffee Houses of the Seventeenth, Eighteenth and Nineteenth Centuries* (London, 1963).

McKelvey, James, *George III and Lord Bute* (Durham N.C., 1973).

Middleton, Richard, *The Bells of Victory: The Pitt–Newcastle Ministry and the Conduct of the Seven Years' War* (Cambridge, 1985).

Money, John, *Experience and Identity: Birmingham and the West Midlands 1760–1800* (London, 1977).

Moore, C., 'Whig Panegyric Verse 1700–1760: A Phase of Sentimentalism', *Proceedings of the Modern Language Association*, XLI (1926), 362–401.

Morgan, K., *Industrialisation, Trade, and Economic Growth From the Eighteenth Century to the Present Day*, ed. P. Mathias and J. A. Davies (Oxford, 1996), pp. 1–14.

Munsche, P., *Gentlemen and Poachers: The English Game Laws 1671–1831* (Cambridge, 1981).

Namier, Lewis, and Brooke, John, *The History of Parliament. The House of Commons 1754–1790* (3 vols., London, 1971).

Namier, Lewis, *The Structure of Politics at the Accession of George III*, 2nd edn (London, 1960).

Newman, Gerald, *The Rise of English Nationalism* (London, 1987).

Nicholson, E., 'Consumers and Spectators: The Public of the Political Print in Eighteenth-Century England', *History*, LXXXI (1996), 5–22.

Owen, J. B., *The Rise of the Pelhams* (London, 1957).

——, 'The Survival of Country Attitudes in the Eighteenth-Century House of Commons', in J. S. Bromley (ed.), *Britain and the Netherlands*, IV (The Hague, 1971), 42–70.

Palmer, Roy, *The Sound of History: Songs and Social Comment* (Oxford, 1988).

Pares, Richard, 'American Versus Continental Warfare 1739–1763', *English Historical Review*, LI (1936), 429–69.

Peters, Marie, *The Elder Pitt* (London, 1998).

——, 'Historians and the Eighteenth-Century Press: A Review of Possibilities and Problems', *Australian Journal of Politics and History*, XXXIV (1988), 37–50.

——, 'History and Political Propaganda in Mid-Eighteenth Century England: The Case of the Essay Papers', *Studies in the Eighteenth Century*, VI (1987), 66–77.

——, 'The Myth of William Pitt, Earl of Chatham, Great Imperialist: Part I: Pitt and Imperial Expansion 1738–1763', *Journal of Imperial and Commonwealth History*, XXI (1993), 31–73.

——, '"Names and Cant": Party Labels in English Political Propaganda c. 1753–1763', *Parliamentary History*, VII (1984), 103–27.

——, *Pitt and Popularity: The Patriot Minister and London Opinion during the Seven Years' War* (Oxford, 1980).

Pocock, J. G. A., *The Machiavellian Moment: Florentine Political Thought and the Atlantic Republican Tradition* (Princeton, 1975).

——, *Virtue, Commerce and History: Essays on Political Thought, Chiefly Eighteenth Century* (Cambridge, 1985).

Pope, Dudley, *At 12 Mr. Byng was Shot* (London, 1962).

Rashed, Z., *The Peace of Paris 1763* (London, 1951).

Rea, R., *The English Press in Politics 1760–1774* (Lincoln, Neb., 1963).

Rogers, Nicholas, *Crowds, Culture, and Politics in Georgian Britain* (Oxford, 1998).

——, 'Popular Protest in Early Hanoverian London', *Past and Present*, LXXIX (1978), 70–100.

——, *Whigs and Cities: Popular Politics in the Age of Walpole and Pitt* (Oxford, 1989).

Rosebury, Lord, *Chatham: His Early Life and Connections* (London, 1910).

Rule, John, *The Vital Century: England's Developing Economy 1714–1815* (London, 1992).

Sagarra, Eda, 'Frederick II and his Image in Eighteenth-Century Dublin', *Hermathena*, 142 (1987), 50–8.

Savelle, Max, *The Diplomatic History of the Canadian Boundary 1749–1763* (New Haven, 1940).

Schneller, Beverly, 'Mary Cooper and Periodical Publishing, 1743–61', *Journal of Newspaper and Periodical History*, VI (1990), 31–5.

Schweizer, Karl, *Frederick the Great, William Pitt, and Lord Bute: The Anglo-Prussian Alliance, 1756–1763* (London, 1991).

——, 'Israel Mauduit: Pamphleteering and Foreign Policy in the Age of the Elder Pitt', in S. Taylor (ed.), *Hanoverian Britain and Empire* (Woodbridge 1998), pp. 198–209.

——, (ed.), *Lord Bute: Essays in Re-interpretation* (Leicester, 1988).

——, 'The Seven Years' War', in J. Black (ed.), *Origins of War in Early Modern Europe* (Edinburgh, 1987), pp. 242–60.

Sedgwick, Romney, 'The Duke of Newcastle's French Cook', *History Today*, V (1955), 308–16.

——, *The History of Parliament: The House of Commons: 1715–1754* (London, 1970).

——, 'William Pitt and Lord Bute: an Intrigue of 1755–1758', *History Today*, VI (1956), 647–54.

Shepard, Leslie, *The Broadside Ballad: A Study in Origins and Meaning* (London, 1962).

Sher, Richard, 'The Favourite of the Favourite: John Home, Bute and the Politics of Patriot Poetry', in Karl Schweizer (ed.), *Lord Bute: Essays in Re-interpretation*, (Leicester, 1988), pp. 181–222.

Shields, D., *Oracles of Empire. Poetry, Politics, and Commerce in British America, 1690–1750* (Chicago, 1990).

Skinner, Quentin, 'The Principles and Practice of Opposition: The Case of Bolingbroke versus Walpole', in Neil McKendrick (ed.), *Historical Perspectives*, (London, 1974), pp. 93–128.

Spector, Robert, *Arthur Murphy* (Boston, 1979).

——, *English Literary Periodicals and the Climate of Opinion During the Seven Years' War* (The Hague, 1966).

——, *Political Controversy: A Study in Eighteenth-Century Propaganda* (Westport, 1992).

Stephens, F. and George, D. (eds), *Catalogue of Prints and Drawings in the British Museum. Division I. Political and Personal and Political Satires* (London, 1870–1954).

Sutherland, Lucy, 'City of London and the Devonshire-Pitt Administration, 1756–57', *Proceedings of the British Academy*, XLVI (1960), 153–7.

——, 'Henry Fox as Paymaster General of the Forces', *English Historical Review*, LXX (1955), 222–57.

Speck, W. A., *Literature and Society in Eighteenth-Century England 1680–1820* (London, 1998).

——, 'Political Propaganda in Augustan England', *Transactions of the Royal Society*, 5th series, XXII (1972), 17–32.

——, *Society and Literature in England 1700–1760* (Dublin, 1981).

Szechi, Daniel, *The Jacobites* (London, 1994).

Targett, Simon, 'Government and Ideology during the Age of Whig Supremacy', *The Historical Journal*, XXXVII (1994), 289–317.

Treadwell, Michael, 'London Trade Publishing 1675–1750', *Library*, IV (1982), 99–134.

Tunstall, Brian, *Admiral Byng and the Loss of Minorca* (London, 1928).

Wellenreuther, Hermann, 'Pamphlets in the Seven Years' War: More Change than Continuity?', Anglistentag 1995 Greifswald, *Proceedings*, ed. J. Klein (Tubingen, 1996), 59–72.

Western, J. *The English Militia in the Eighteenth Century* (London, 1965).

Williams, Basil, *The Life of William Pitt, Earl of Chatham*, 2 vols (London, 1914).

Wilson, Kathleen, 'Empire, Trade and Popular Politics in Mid-Hanoverian Britain: The Case of Admiral Vernon', *Past and Present*, CXI (1988), 74–109.

——, 'Inventing Revolution: 1688 and Eighteenth-Century Popular Politics', *Journal of British Studies*, XXVIII (1989), 349–86.

——, *The Sense of the People: Politics, Culture and Imperialism in England, 1715–1785* (Cambridge, 1995).

UNPUBLISHED THESES

Cardwell, M. John, 'Arts and Arms: Political Literature, Military Defeat and the Fall of the Newcastle Ministry, 1754–56' (Oxford University, DPhil thesis 1998).

Fraser, E., 'The Pitt Newcastle Coalition and the Conduct of the Seven Years' War 1757–1760' (Oxford University, DPhil thesis 1976).

Gee, Austin, 'English Provincial Newspapers and Public Opinion During the Seven Years' War' (Canterbury University, New Zealand, MA thesis 1989).

Luff, P., 'Henry Fox, the Duke of Cumberland, and Pelhamite Politics, 1748–57' (Oxford University, DPhil thesis 1981).

Schneller, Beverly, 'Mary Cooper, Eighteenth-Century London Bookseller, 1743–1761' (Catholic University of America, PhD thesis 1987).

Index

Literary works are listed under authors' names; page numbers given in *italic* refer to illustrations; the letter 'n' after a page number refers to a note.